W9-BRS-637

PHOTOSHOP
LIGHTROOM ADVENTURE

Mastering Adobe's next-generation tool for digital photographers

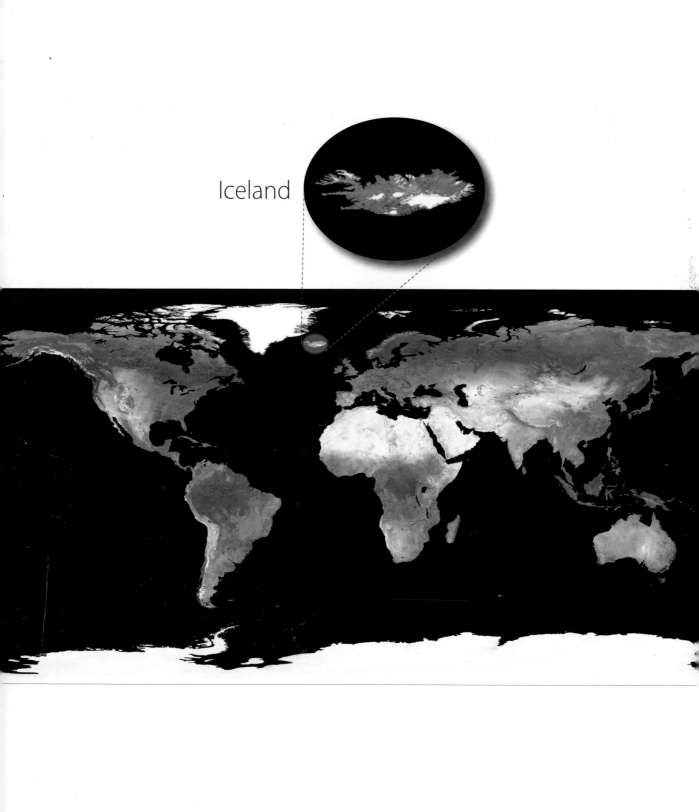

Iceland

PHOTOSHOP
LIGHTROOM ADVENTURE

Mastering Adobe's next-generation tool for digital photographers

Mikkel Aaland

O'REILLY®

BEIJING • CAMBRIDGE • FARNHAM • KÖLN • PARIS • SEBASTOPOL • TAIPEI • TOKYO

Photoshop Lightroom Adventure BY MIKKEL AALAND

Editor: **Colleen Wheeler**

Production Editor: **Philip Dangler**

Technical Editor: **Doug Nelson**

Copyeditor: **Michele Filshie**

Cover Design: **Jan Davis**

Cover Photo: **George Jardine**

Interior Design: **Michael Kavish**

Graphic Production: **Ron Bilodeau**

Copyright © 2007 Mikkel Aaland. All rights reserved.

Published by O'Reilly Media, Inc., 1005 Gravenstein Highway North, Sebastopol, CA 95472.

O'Reilly books may be purchased for educational, business, or sales promotional use. Online editions are also available for most titles (*safari.oreilly.com*). For more information, contact our corporate/institutional sales department: 800.998.9938 or *corporate@oreilly.com*.

The O'Reilly logo is a registered trademark of O'Reilly Media, Inc. *Photoshop Lightroom Adventure*, the cover images, and related trade dress are trademarks of O'Reilly Media, Inc.

Visible Earth image on page ii provided courtesy of NASA (*http://visibleearth.nasa.gov/*).

Many of the designations used by manufacturers and sellers to distinguish their products are claimed as trademarks. Where those designations appear in this book, and O'Reilly Media, Inc. was aware of a trademark claim, the designations have been printed in caps or initial caps. Adobe Photoshop™ is a registered trademark of Adobe Systems, Inc. in the United States and other countries. O'Reilly Media, Inc. is independent of Adobe Systems, Inc.

While every precaution has been taken in the preparation of this book, the publisher and author assume no responsibility for errors or omissions, or for damages resulting from the use of the information contained herein.

Print History: July 2007, First Edition.
ISBN-10: 0-596-10099-X
ISBN-13: 978-0-596-10099-5

[F]

Printed in Canada.

To Paul Persons,
who made every day an adventure

Acknowledgments

Both the book and the Iceland Adventure were a huge challenge and neither could have been done without the help and support of many people. The adventure began with an act of faith by O'Reilly's Mark Brokering, Laurie Petrycki, and Steve Weiss, who took my word that Adobe was working on an "awesome" but secret project that warranted a book. "Trust me," I said, and they did. The seed for combining a how-to book with an adventure was planted at a dinner in Orlando, Florida with Adobe's Jennifer Stern, Dave Story, and author/photographer Peter Krogh. Jennifer let me know several books were in the works on Lightroom and suggested I come up with a unique angle. The seed grew when I expressed my concerns about doing a "conventional" book with Steve Weiss and then found myself describing a long-time dream of leading a group of photographers into the field and actually shooting photos together. Steve said, "Go for it, man," and I did.

From there, a rapid succession of people jumped in to help, starting with Adobe's George Jardine, who helped me wind through the Adobe labyrinth to build support. Adobe's Jennifer Stern became our angel as she found the money for the Iceland project and gave us continual support. Adobe's Addy Roff, coincidently from Icelandic descent, was a huge help. Adobe's Mal Sharma and Kevin Connor were also very supportive. Brian Sheffield from Icelandair was invaluable, working with a tight budget and putting me in touch with just about the entire population of Iceland. Einar Gustavsson and Olafur Hand from the Iceland Tourist Board became early supporters. Photographer and O'Reilly Digital Media Evangelist Derrick Story quickly became my righthand man and confidant, lining up sponsors, coordinating the O'Reilly end of things, and creating an amazing Adventure web site complete with blogs and podcasts. Betsy Waliszewski from O'Reilly helped with many of the logistics, and her sister, Barbara Camacho of Graystone Travel, helped with all the travel arrangements. Michael Reichmann, an experienced workshop leader with many visits to Iceland, helped with the adventure preparations, as did photographers John McDermott and Richard Morgenstein. Thanks, as always, to my agent at Studio B, Neil Salkind, and David Rogelberg.

The Adventure would not have been an adventure without the "team" who made the trip. They are listed in the Adventure Team section that follows. My thanks and appreciation goes to all of them.

Other thanks go to: Thomas Knoll and Lightroom Product Manager Tom Hogarty; Adobe's Troy Gaul, Eric Scouten, Julie Heiser, Kevin Tieskoetter, Donna Powell, Bill Stotzner, Julieanne Kost, and Matt Snow; Anna Maria Sigurjonsdottir; Kirsti Maki, Icelandair; Maria Roff; O'Reilly's Sara Winge, Tara McGoldrick, Theresa Pulido, Sarah Kim, Sara Peyton, and Ron Bilodeau; Tanya Chuang, Sandisk; Arsaell Hardarson, Director of Marketing Icelandic Tourist Board; Leonard Koren; Expo Imaging's Erik Sowder, John Baker, and George Ziegler; Greta Blaengsdottir and Tryggvi Josteinsson, Radisson SAS Hotel Reykjavik; Steingrímur Árnason, Apple Store Reykjavik; Russell Hart; Harris Fogel ; Fred Shippey; Dan Steinhardt and Stig Andresen, Epson; Arnar Már Arnflórsson and Arndís Anna Reynisdóttir, Hertz; Paul Agus and Ida Zoubi, Cafe Trieste; Bruce Yelaska; Cheryl Parker; Renato Gruenenfelder, director, Fosshotel, Iceland, Suzanne Caballero, Lowepro; Christopher Lund; Ari Magg; Doug Nelson, for his awesome technical editing; Lightroom 1.1 pre-release beta testers, especially Sean McCormack; Katrin Eismann, Martin Evening; Deke McClelland; Ed Schwartz; Dave Drum; Michael Kavish for his original book design; Jan Davis for designing a great cover and Russell Brown for referring us to Jan, and much more.

And finally, I want to thank Mark Hamburg for creating Lightroom; my O'Reilly editor, Colleen Wheeler, who is smart, committed, and an author's dream; and my wife Rebecca and my daughters, Miranda and Ana, who share my love of Iceland and photography and make everything worthwhile.

Contents

Foreword

by George Jardine

Pro Photo Evangelist
Adobe Systems, Inc.

Why Iceland? Most of us have probably seen an interesting photo or two, or a map showing the wildly rambling coastline of this wonderful and mysterious island country. And perhaps most of us have also thought that it must be a very cold and remote place that we would probably never visit. But little did I know how perfect the idea of this book and the Iceland Adventure would be for Adobe's work-in-progress at the time, code-named Shadowland.

In the winter of 2005, the skunkworks project I had been working on at Adobe Systems for the previous two years seemed to be losing the struggle for birth, and like many whose true passion in life is photography, I found myself beginning to believe my own hype that I would really "rather be out taking photographs than sitting behind the computer" in my Silicon Valley office. And it was during these months, when optimism was running somewhat less than during the bloom of springtime, that the idea of traveling to Iceland was first brought to my attention by a very dear and old friend. We'd talked about taking an adventure together for years, entertaining ideas that always seemed to give way to our "better judgement." A few weeks later, I received a postcard from her, with a map of Iceland on the front. There was no written message. Just the map. The intrigue of Iceland was beginning to draw me in.

A few months later, almost everything about the Shadowland project had suddenly changed. Management at Adobe Systems decided to paint with much broader strokes, and had pushed a very rough new Photoshop Lightroom out onto the stage of public beta. All of the sudden, public forums were buzzing like crazy, and concrete plans for shipping were rapidly becoming clearly focused for the first time in years of development.

It was about this time that Mikkel first contacted me about his "Iceland Adventure" book idea. Mikkel had been one of our early alpha testers, and was pretty excited about the potential of an end-to-end workflow solution for digital photographers. Not knowing the seed had already been planted in my mind, he must have thought Iceland would be a hard sell. He laid the groundwork for me with a somewhat drawn-out preamble, explaining how he felt strongly that this book absolutely had to have a unique story. Even before I heard the word "Iceland," I was agreeing with him. (Friends have frequently come to me with ideas for projects they want funding for, and, just as frequently, I have found myself asking "but where is the story?") By the time he brought himself around to saying "I want to take ten photographers to Iceland," I was pretty much saying, "Let's do it!" This project had a fabulous story behind it, and it resonated perfectly with the Zen of Project Lightroom.

Field-testing Lightroom with working professional photographers was an interesting idea in itself. It turned out to be a stroke of brilliance. The utterly unique and uncomplicated landscape of Iceland provides a perfect backdrop for Mikkel's book, and for an entirely new application, both of which were very simply designed from the beginning to help you make your pictures better.

COVER PHOTO: George Jardine

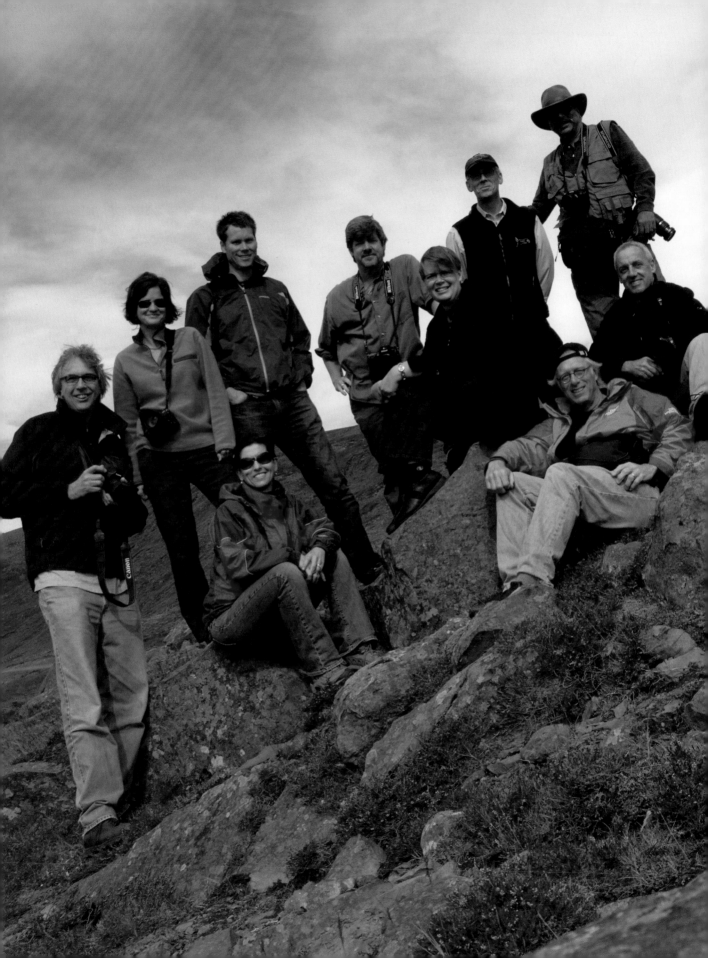

Introduction

Adobe Lightroom is a revolutionary, all-in-one imaging application. It was created from the ground up for serious photographers who'd rather spend most of their time shooting and not all day sitting in front of a computer. Lightroom makes it easy to import, edit, organize, process, and share digital images in an integrated work environment. Because Lightroom is non-destructive and doesn't alter a single pixel of the original image file—be it RAW, JPEG, or TIFF—it is lightening fast. You'll be amazed at how quickly you can change white balance, optimize exposure, create a slideshow or a web gallery, or prepare one—or a hundred—images for print.

Who should read this book?

Anyone using Lightroom, be they an amateur photographer or a professional, should find this book useful. I've done my best to explain in easy-to-follow text, complemented with hundreds of illustrations, how to get the most out of this amazing application. I've also included numerous double page photo spreads throughout the book, which I hope you'll enjoy and find inspiring as well.

Written for Lightroom 1.1

Lightroom has gone through several versions, including the public beta of 2006 and the release of Lightroom 1.0 in February 2007. This book is written for Lightroom 1.1, the latest version of the software. There is a significant difference between 1.1 and 1.0, and I highly recommend that registered Lightroom 1.0 users go to the Adobe website (*www.adobe.com*) and download the free upgrade.

About the Adobe Lightroom Iceland Adventure

Both the title for this book and most of the content grew out of the Adobe Lightroom Iceland Adventure, a unique collaboration between 12 professional photographers and 5 Adobe Lightroom team members. The Adventure took place at the end of July in Iceland, when the group experienced nearly 24 hours of daylight. Iceland has long been known as Nature's Lightroom, a very appropriate place to work with Adobe Lightroom, the product.

The idea for the Adventure started when I envisioned a small group of serious professional photographers sequestered with several of the Adobe people involved with creating Lightroom in an adventurous and visually exciting location to road-test Lightroom. I couldn't think of a better way to see if Adobe was on track to making a product that truly met the needs of us photographers. I approached Adobe and they agreed to sponsor the ambitious project. (Other sponsors are listed at the end of the introduction.)

And road test the product we did! At the end of a long day of shooting, we all gathered in workrooms, fired up our computers and got to work. We liked a lot of what we saw, and we learned a lot about the product. We also found things lacking, or things that didn't work the way we wanted. Because we were working with beta versions of Lightroom, it was very satisfying to express our concerns to the Adobe people on the adventure and have a fix, sometimes by the next day. I'm happy to say that many of our suggestions have been realized in the final release product.

The fact is, everyone got something out of the project. The photographers were unpaid, but they got a trip and experience of a lifetime. Adobe got real-time feedback. And me...well...I got the chance to write the book you are holding.

Platform Differences

For the most part, Lightroom is the same for the Mac and PC platforms. There are some minor cosmetic differences between the platforms, and a few more significant ones, which I have noted throughout the book. PC users, for example, who have Photoshop Elements loaded, will find it easy to import libraries from Element's Organizer, which is not an option for Mac users. When keyboard commands differ between platforms I've included both. For example, to select all images I write: ⌘+Shift+A (Ctrl + Shift+A), with the Mac command first, followed by the PC command in parentheses. For the sake of simplicity, I only say "right-click" and don't include the keyboard command for the Mac (ctrl+click), which is necessary for single button mouse users. (Most Mac users are now using multi-button mice, so I hope this omission isn't too big of a deal.)

For More Information

You can address comments and questions concerning this book to the publisher:

O'Reilly Media, Inc.
1005 Gravenstein Highway North
Sebastopol, CA 95472
(800) 998-9938 (in the United States or Canada)
(707) 829-0515 (international or local)
(707) 829-0104 (fax)

We'll list errata, examples, and any additional information at:

http://www.oreilly.com/catalog/9780596100995

To comment or ask technical questions about this book, send email to:

bookquestions@oreilly.com

You can also find more information by going to O'Reilly's general Digital Media site:

digitalmedia.oreilly.com

Also, check out the O'Reilly's Inside Lightroom site, where I join other Lightroom users in a daily blog:

digitalmedia.oreilly.com/lightroom

I'm such a big fan of Lightroom and want to do everything I can to make your experience with the application as rewarding as possible. Feel free to email me at *mikkel@cyberbohemia.com* with any suggestions or questions you have and I'll do my best to answer. Or check out my personal web site:

www.shooting-digital.com

Let the Adventure begin!

Mikkel Aaland
San Francisco, 2007

Adobe Lightroom Iceland Adventure Sponsors

Premium sponsors:

Adobe Systems, Inc (*www.adobe.com*)

IcelandAir (*www.icelandair.com*)

The Iceland Tourist Board (*www.icelandtouristboard.com*)

ExpoImaging (*www.expodisc.com*)

Lowepro (*www.lowepro.com*)

Sponsors include:

Epson, Sandisk, FossHotel, Hertz, Radisson SAS Hotels, 66° North, and Graystone Travel

The Adventure Team

It wouldn't have been an adventure without these intrepid contributors. They've been generous with letting me use their beautiful photographs throughout this book.

Bill Atkinson Although Bill is now a full-time nature photographer, his name is also well known in the field of software design. Bill is empowered in his own art by the accuracy and fine control made possible with the digital printing process. See his work at *www.billatkinson.com*.

Russell Brown Russell's job at Adobe is to facilitate the exchange between digital designers and software developers. In addition, he's the prolific creator of an entertaining collection of Photoshop tips and tricks, some of which can be found at *www.russellbrown.com*.

Angela Drury Angela is a fine art photographer whose work has received numerous awards and been shown in shows around the country. Her work has also been featured in several publications, including the premiere issue of Darkroom magazine. More at *www.angeladrury.com*.

Melissa Gaul Melissa is an accomplished photographer and a member of the original Adobe Lightroom engineering team based in Minnesota. Her midnight Lightroom instructional sessions for the Adventure team were well-attended and much appreciated.

Jóhann Gudbjargarson Jóhann has lived all his life in Iceland. He has a degree in computer science and his hobbies are books, computers, traveling and photography (talk about being lucky being on this adventure). Johann's work can be seen at *http://gudbjargarson.net*.

Maggie Hallahan Maggie is an accomplished photographer with over twenty years of experience shooting advertising and editorial assignments. Her work has appeared in numerous magazines and can be seen online at *www.maggiehallahan.com*.

John Isaac John is an award winning photojournalist and documentary photographer who has traveled to more than 100 countries in his photographic career. He was a photographer for the UN for 20 years. His work can be seen at *www.johnisaac.com*.

George Jardine George took his degree in photography in 1972. He has photographed food, fashion, architecture and sports, with his work appearing in many well-known publications. George is currently the Pro Photography Evangelist at Adobe.

Peter Krogh Peter owns and operates a full-service commercial photography studio in the Washington, DC area. Peter is both an award-winning photographer and the author of the definitive work on digital asset management. His work can be seen at *www.peterkrogh.com*.

John McDermott John is a San Francisco photographer who shoots corporate annual reports, portraits, and sports for editorial and advertising clients. But mostly, he'd rather be wandering the streets of some strange city pretending to be Cartier-Bresson or Jay Maisel. You can see his work at *www.mcdfoto.com*.

Richard Morgenstein For over twenty years, Richard has photographed people for magazines, corporations, and private clients. The common denominator in Richard's work is his interest in all kinds of people, their passions, and their environments. See his work online at *www.richardmorgenstein.com*.

Michael Reichmann Michael is a fine-art landscape, nature, and documentary photographer with more than 40 years of experience. He is a well-known photographic educator and author, and the publisher and primary author of The Luminous Landscape web site, *www.luminous-landscape.com*.

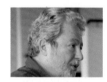

Addy Roff Addy works for Adobe and basically solves problems and makes life better for everyone around her. "Addy" is short for something exotic and Icelandic, which only George Jardine has ever been heard to utter in public. To quote an adventure blog post, "The horses loved Addy."

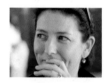

Sigurgeir Sigurjonsson Sigurgeir is a photographer based in Reykjavìk and has a broad selection of clients in Iceland and other countries. He is presently working two books: the Icelandic horse and a new book on Iceland that will be out in the summer and autumn 2007. See his work at *www.portfolio.is*.

Derrick Story Derrick is the digital media evangelist for O'Reilly (*http://digitalmedia.oreilly.com*). He's the author of Digital Photography Hacks and Digital Photography Pocket Guide. You can listen to his photo podcasts and read his tips at www.thedigitalstory.com.

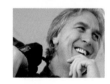

Martin Sundberg Martin specializes in capturing imagery of people who are passionate about what they do, while they are doing it. By land or by sea, he embraces every opportunity to make pictures that move and inspire. Martin is based in San Francisco. His work can be found at *www.martinsundberg.com*.

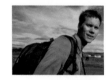

Sonja Thórsdóttir Sonja is Icelandic and has lived in Iceland most of her life. Her main hobby is photography and traveling all over the world. Sonja thought the adventure was a wonderful opportunity to be able to combine this and join a team of great people in Iceland.

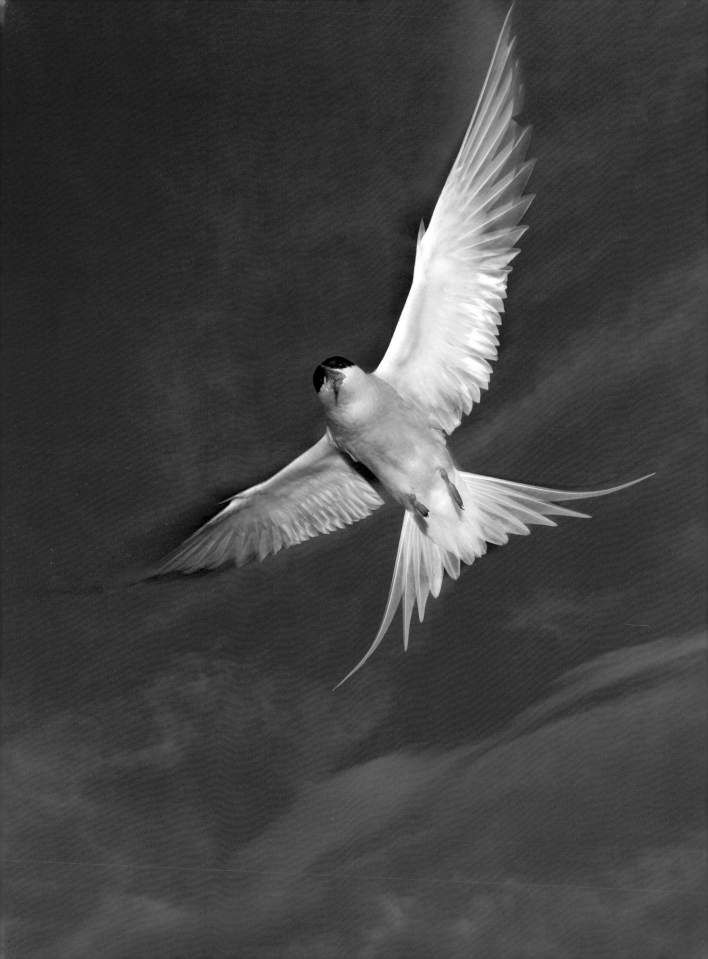

The Lightroom Workspace Revealed

Lightroom is designed to streamline the process of importing, processing, and sharing your digital images. Many photographers will find the controls and menus extremely intuitive and will quickly grasp the underlying logic behind the modular design. Although much can be discovered by simply experimenting on your own, there is a lot to the application that doesn't immediately meet the eye. In this chapter, I'll take you on a short Lightroom test drive and give you a general overview of this groundbreaking application.

Chapter Contents

1

PHOTO CREDIT: Peter Krogh

Lightroom Modules

Lightroom is based on a modular system. At this time, the Lightroom modules are Library, Develop, Slideshow, Print, and Web. Let's start by taking a general look at each of these modules. In later chapters, I'll explain in detail how to use them in a coordinated way.

The modules are listed in the upper-right corner of the workspace in the Module Picker. *Figure 1-1* They should appear as shown here when you open the application, but depending on the size of your screen and how you've customized the work area, they may be hidden. Clicking on the name in the Module Picker takes you to that particular module.

> NOTE *When you open Lightroom for the first time, you won't see any images. You must first import your photos into Lightroom, which is the subject of Chapter 2.*

You can set the Module Picker to remain visible by selecting Window→Panels→Show Module Picker from the menu bar. *Figure 1-2*

If the modules are hidden, they can be revealed at any time by clicking on the triangle icon at the top middle of the screen. *Figure 1-3*

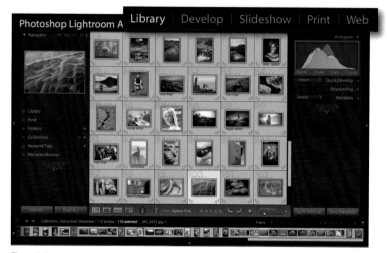

Figure 1-1

Figure 1-2

Figure 1-3

NOTE *There is some functionality crossover between modules. For example, you can perform basic image processing in the Library module, and you can import from within the Develop module (although you'll end up back in the Library module). In general, however, each module provides a workspace designed for a specific set of tasks.*

You can enter a module by clicking on the name of the module in the Module Picker or by using one of the following keyboard commands:

- *Library* ⌘+Opt+1 (Ctrl+Alt+1)
- *Develop* ⌘+Opt+2 (Ctrl+Alt+2
- *Slideshow* ⌘+Opt+3 (Ctrl+Alt+3)
- *Print* ⌘+Opt+4 (Ctrl +Alt+4)
- *Web* ⌘+Opt+5 (Ctrl+Alt+5)

Library Module

In the Library module you can import, export, organize, sort, rate, and tag your images with keywords. *Figure 1-4* You can also apply some simple image processing to any number of selected images, or, if you prefer, you can apply a custom preset created in the Develop module to an entire batch of selected images.

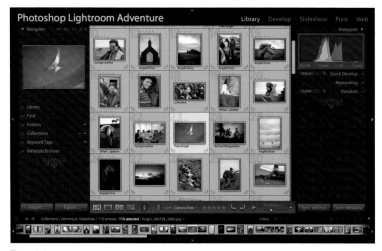

Figure 1-4

Develop Module

The Develop module is where you'll find some of the most powerful features of Lightroom. *Figure 1-5* Not only does the Develop module provide an outstanding RAW converter, but all the controls work equally well on JPEG or TIFF images. (Of course, RAW files provide the most flexibility and often the best quality.) Everything you do to your image here is nondestructive. With Lightroom, you are creating a sequence of instructions that are applied to the image on export. No pixels are changed in the original image, even when you use the Remove Spots (Clone/Heal) or Remove Red Eye tools.

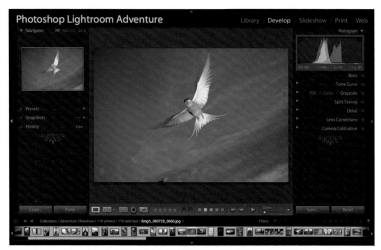

Figure 1-5

Slideshow Module

After you organize, edit, and sort your images in the Library and process the files in the Develop module, you'll probably want to share the results. The Slideshow module allows you to make a simple—yet effective—slide show. *Figure 1-6* You can personalize each slide with a custom Identity Plate (which we'll cover in the last section of this chapter), add text based on EXIF data, or add custom text to your liking. You can also add sound and convert your slide show into the PDF format for offline viewing. (Chapter 10 is devoted entirely to working with the Slideshow module.)

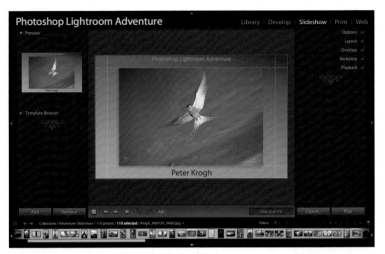

Figure 1-6

Print Module

The Print module, like the rest of Lightroom, is equally suited for processing single or multiple images. It's also set up to print some of the more popular sizes and print configurations (such as contact sheets), which you can also easily customize. *Figure 1-7*

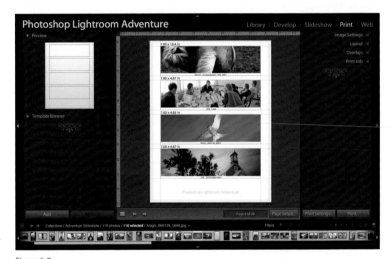

Figure 1-7

TIP *To get quickly back to the Library module from other modules, I often simply use the G key (the shortcut for Library Grid). I use D to take me to the Develop module.*

Web Module

The Web module creates both HTML- and Flash-based web galleries quickly and easily. Several presets are available, but you can also easily create your own. You can add text-based or image metadata or simply type in your own. (Chapter 11 is devoted to the Web module.) *Figure 1-8*

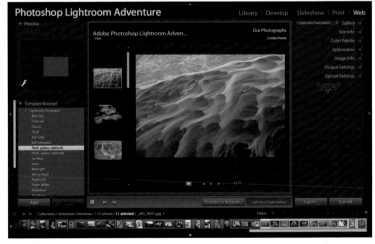

Figure 1-8

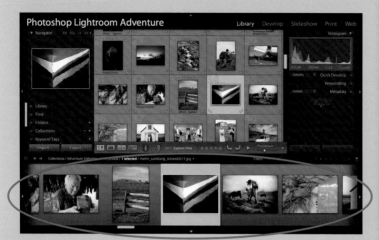

Figure 1-9

Figure 1-10

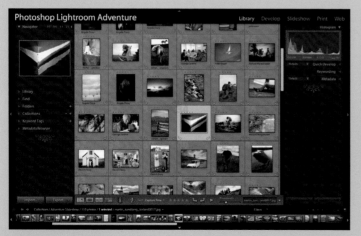

Figure 1-11

The Filmstrip

The filmstrip, located at the bottom of the Lightroom workspace, is the common denominator between the modules. The filmstrip contains thumbnail versions of all the images displayed in the main window of the Library module, and these images can be rearranged directly from the filmstrip, affecting the Slideshow, Print, and Web sequencing. The filmstrip can vary in size. Here, for example, it is as large as it can get relative to the entire interface. *Figure 1-9*

To change the size of the filmstrip, place your cursor on the line between the filmstrip and the main work area; it will turn into the shape shown in *Figure 1-10*. Click and then drag to change the size of the filmstrip.

You can't make the filmstrip larger or smaller than the examples shown here, and you cannot position the filmstrip anywhere but on the bottom of the window. *Figure 1-11*

You can control what information (ratings, etc.) appears on the thumbnails in the filmstrip and other filmstrip functionality in Lightroom's Preferences, under the Interface tab.

(Continued)

The menu command Window→Panels→ Show Filmstrip can be used to turn the film-strip off. *Figure 1-12* The filmstrip can also be turned off by clicking the small triangle at the bottom of the window. Another click on the same triangle will make it reappear.

If you're in the Library's Grid view, with thumbnails visible in the main window for easy selection, the filmstrip may seem redundant. However, in just about any other Library viewing mode, or in any other module, the filmstrip is quite handy. You can quickly find individual images or select multiple images without going back into the Grid view in the Library module.

Figure 1-12

To scroll through the filmstrip simply click the arrows at either end (circled). *Figure 1-13* You can also use the scroll bar (circled) at the bottom of the filmstrip to move from left to right and review hidden thumbnails. The arrow keys on your keyboard can also be used to scroll from image to image in the filmstrip.

Figure 1-13

To select an image from the filmstrip, simply click on the desired thumbnail. A selected thumbnail will be outlined like the one shown in *Figure 1-14*. To select multiple im-ages sequentially in the filmstrip, choose the first, then hold the Shift key and then click on the final image in the sequence; the images between the selected thumbnails will also be selected. For non-contiguous selection or to deselect, use ⌘+click (Ctrl+click).

Figure 1-14

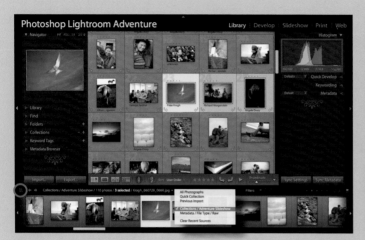

Figure 1-15

You can use the navigator arrows on the left side of the filmstrip (circled) to toggle back and forth between current and formerly used modules. *Figure 1-15* Click on the grid icon to the left of these arrows and you'll be taken to the Library Grid mode, regardless of which module you are currently in. You can even switch between collections, or follow "bread crumbs" to previously selected images without going back to the Library module by using the pop-up menu, which I circled on the right. (Click on the arrow next to the file name to reveal the pop-up menu.)

Figure 1-16

Viewing filters can also be applied directly from the filmstrip (circled). Viewing filters will be covered in Chapter 3. *Figure 1-16*

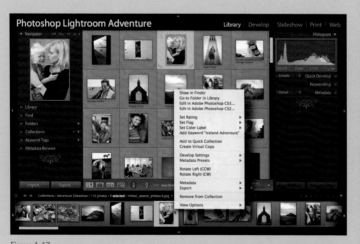

Figure 1-17

If you right-click on any thumbnail in the filmstrip, you get the contextual menu shown in *Figure 1-17*. This menu contains many commonly used commands such as Develop Settings, Rotate, and Create Virtual Copies. It also includes filmstrip view options.

In the appropriate chapters of the book, I will go into more detail on using the filmstrip while working in different modules.

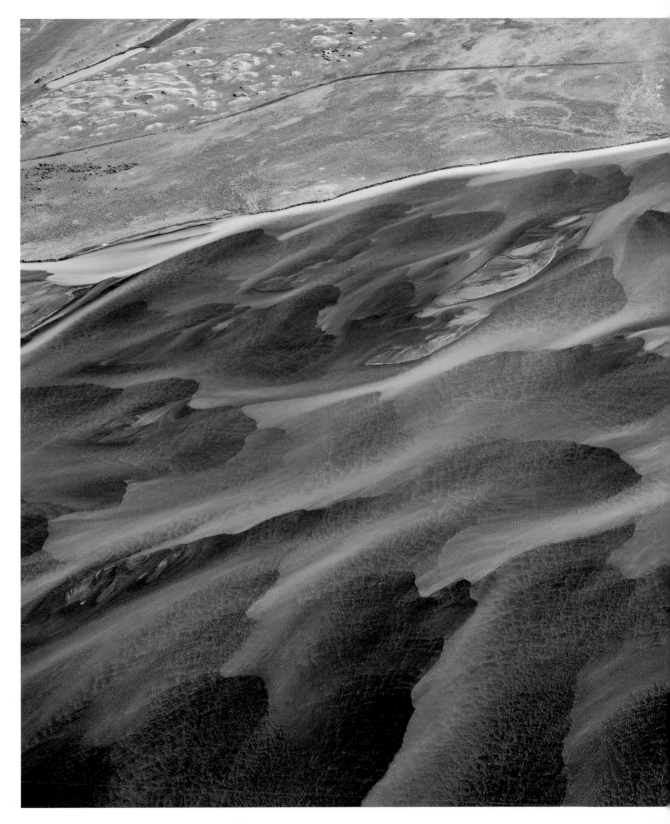

Sigurgeir Sigurjónsson

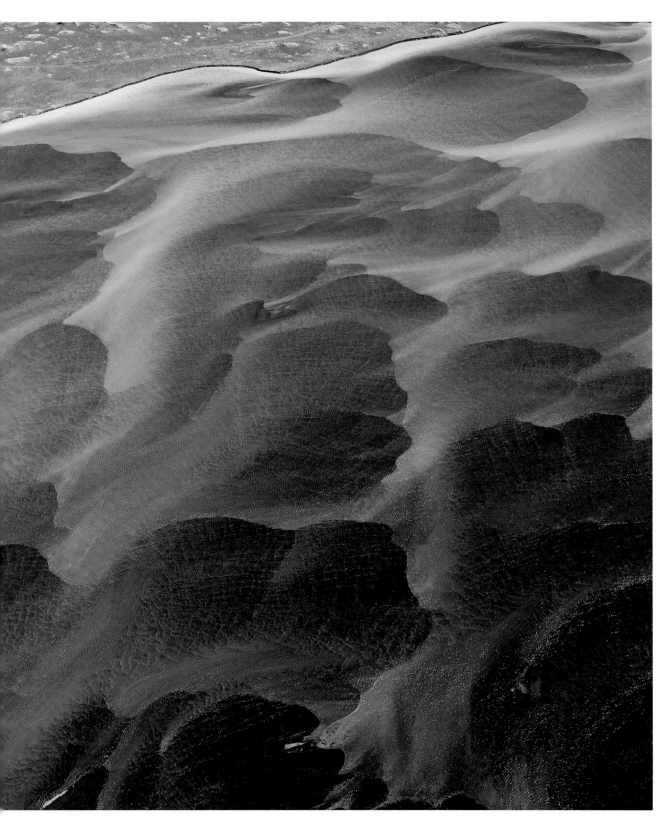

I met Sigurgeir at the Keflavik Airport a year before the Iceland Adventure. Actually I met his book, *Lost in Iceland,* which had just been released. I was stunned at the beauty of his photographs, and taken by the words that accompanied the images. "Some people claim that in the silence of Iceland's wilderness, you come closest to hearing God." In many ways, I organized the Adventure as an excuse to get to know this great photographer. He ended up joining us on the adventure, and shot this photograph as he hung out from the window of a helicopter.

Organizing the Lightroom Workspace

The Lightroom workspace is extremely malleable. You can easily enlarge or shrink the various windows to suit your viewing and working preferences, whether you are on a laptop in the field or using your cinema display in the studio.

Let's start with the obvious and then move on to more hidden ways of organizing the Lightroom workspace. Everything here applies to all the modules.

The Obvious

If you are like me, if you see certain icons you naturally want to click on them to see what they do.

See the triangle-shaped icons on the side panels and top and bottom? (I circled them in red.) This is a quick way to get extra real estate. *Figure 1-18*

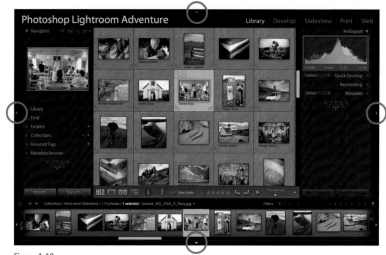

Figure 1-18

I positioned my mouse and clicked on them one at a time. Now I have a screen that shows only my preview images without any extra clutter. *Figure 1-19* To reveal the side panels and the filmstrip and menu bar, simply click on the triangle again. (Rolling your cursor over the triangle while any of the panels are hidden will temporary reveal them. They will disappear when the cursor is moved away.)

Figure 1-19

Figure 1-20

You can also resize the entire Lightroom window to fill a specific area on your screen by placing your cursor on the bottom right of the window, then clicking and dragging the window to the desired size. *Figure 1-20*

Menu commands

Menu commands are another obvious way of controlling the look of your Lightroom work area. Under the Window menu you have several options. The Mac menu (left) will be slightly different from the Windows version (right). *Figure 1-21*

Figure 1-21

Screen Mode options

You can change screen modes directly from the menu bar (Window→ Screen Mode). *Figure 1-22* However, learning to use the keystroke F to toggle between screen modes will make your workflow much more efficient. Again, the menu will look slightly different on Mac (left) and Windows (right).

Figure 1-22

Normal (or Standard) Screen Mode

When you set your Screen Mode to Normal (called Standard in Windows) this is what you get. *Figure 1-23* The menu bar is visible at the top and all the panels and module picker are visible as well. Of course, you can further customize the screen mode by hiding the panels or module picker by clicking on the small side triangles as described previously. (For this example, I've gone from thumbnail view or "Grid View" to single image view or "Loupe View." These are specific viewing options within the Library module, which I'll discuss in more detail in Chapter 3.)

Full Screen with menu bar

Setting your Screen Mode to Full Screen with Menubar gives you this. The screen looks similar to the Normal (or Standard) screen, however it will fill up your display screen and you won't have screen resize capabilities. *Figure 1-24*

Full Screen

With Full Screen the menu bar is gone, unless you roll your mouse over it. Side panels and filmstrip remain unless you choose to hide them. *Figure 1-25*

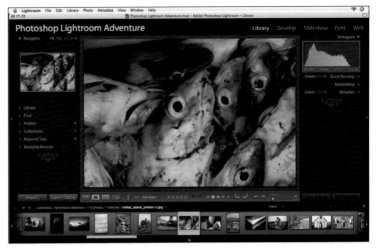

Figure 1-23

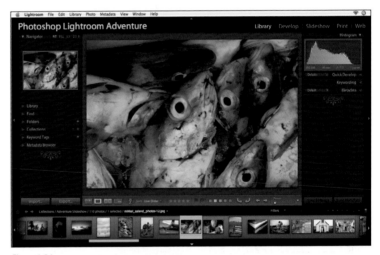

Figure 1-24

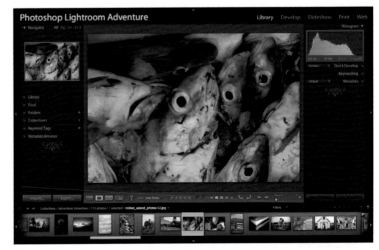

Figure 1-25

Figure 1-26

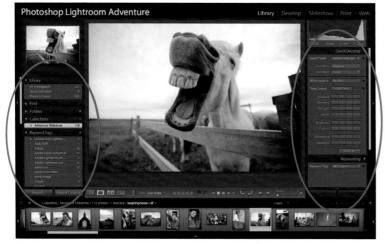

Figure 1-27

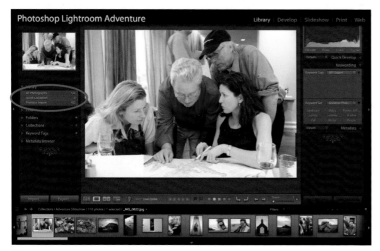

Figure 1-28

Full Screen and Hide Panels

This mode maximizes the image viewing area, yet maintains some of the viewing and sorting tools. *Figure 1-26*

Not So Obvious

There are a couple not-so-obvious commands that will help you more efficiently organize and frame the Lightroom work area.

For example, by default, all the panes in all the side panels (circled) will open sequentially and remain open when you click on them. *Figure 1-27*

If you hold the Opt/Alt key while clicking on any side panel pane (like the one circled) only that pane will open, in the so-called Solo mode. *Figure 1-28* To return to the default behavior, hold the Opt/Alt key and click on the pane again. This behavior is on a panel by pane basis.

You can also control the behavior of the panes by right-clicking anywhere on the pane header (except on the triangle). You will get the contextual menu shown here. *Figure 1-29* If you select Solo mode, you will duplicate the behavior described previously (the same effect as when you hold the Opt/Alt key while clicking on the pane.) You can also hide individual panes by deselecting the check mark next to their name. The choices are applied on a panel-by-panel basis.

You can swap, customize, or remove the Panel End Marker at the bottom of the left or right panel. Right-click on the bottom of a panel which brings up a contextual menu. *Figure 1-30* (Custom Panel End Markers are PNG files which are placed in the Panel End Marker folder. Once there, the file becomes available in the Panel End Marker contextual menu.)

TIP Photoshop users are probably familiar with using the Tab key to hide tool palettes. Selecting the Tab key in Lightroom hides (or reveals) the side panels and is a quick way to maximize the image viewing area.

Setting Interface Preferences

Lightroom Interface preferences can also be used to customize the look and feel of the workspace. Open the Preferences (under the Lightroom menu on a Mac, under the Edit Menu on Windows) and click on the Interface tab. *Figure 1-31* Here you will find choices for many things from the look of the Panel End Mark, to Lights Out levels, to Background colors and texture, and filmstrip view options.

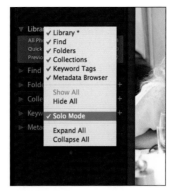

Figure 1-29

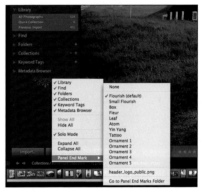

Figure 1-30

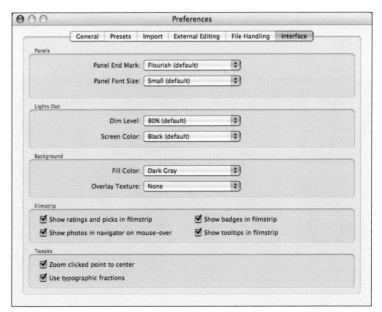

Figure 1-31

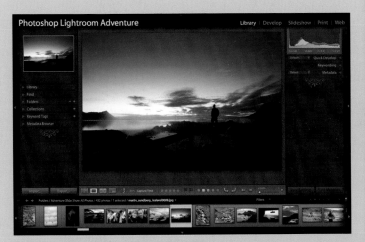

Figure 1-32

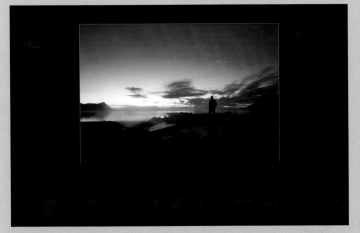

Figure 1-33

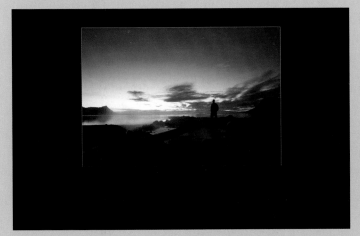

Figure 1-34

Lights On Lights Out

This falls in the category of way cool, especially for those who like to toggle between working on their images and viewing (or showing off) their images without distraction. *Figure 1-32* shows the viewing area with the Lights On, the default setting. All the panels and filmstrip are clearly visible.

Figure 1-33 shows the viewing area with Lights Dim selected. The panels and filmstrip are still visible, albeit dimmed.

Figure 1-34 shows the work area with Lights Out. Now the image is easily viewable with no distractions.

To control the Lights Out feature, you can use the menu control Window→Lights Out. It's far easier, however, just to select the L key and toggle between states. In the Lightroom Preferences, under the Interface tab, you can set Dim Level and/or Screen Color.

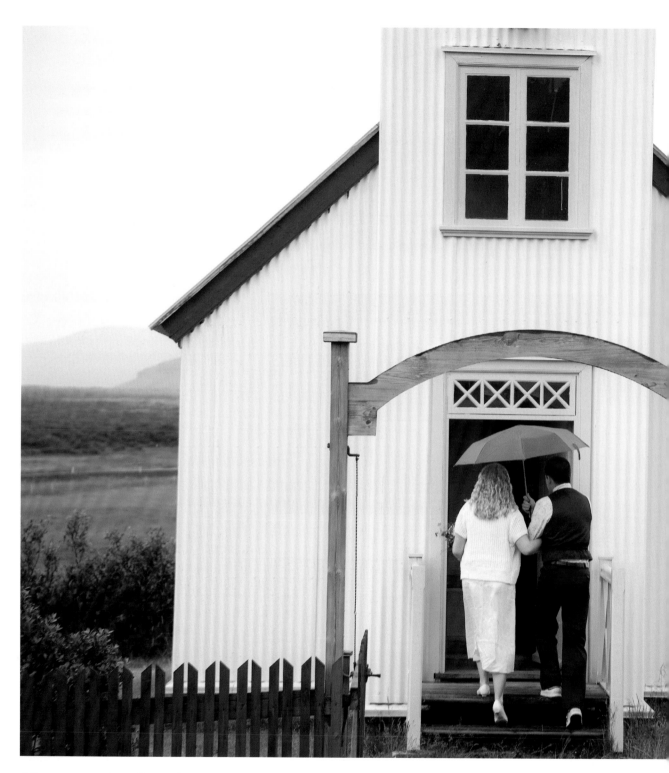

Derrick Story

Derrick Story arrived in Iceland determined to photograph a wedding, something he does regularly back home in California. Before leaving for Iceland he spent a lot of time trying to organize a wedding shoot, but everything fell through at the last moment. Determined not to let it bother him, Derrick turned his camera on other subjects and relaxed into the adventure. But one day, to his amazement, a wedding seemed to materialize out of thin air in front of him. A Swedish couple, charmed by an old Icelandic church in the middle of nowhere, had decided to get married there. And Derrick just happened to be there too, unexpectedly becoming the couples "official" photographer.

Creating Identity Plates

You can personalize the Lightroom environment by creating Identity Plates that appear throughout the application for a nice aesthetic touch. They also have very practical purposes as they can be used to identify Slideshows, Web Galleries, and Prints. Here's how to set up an Identity Plate of your own.

First, select Edit→Identity Plate Setup (Windows) or Lightroom→Identity Plate Setup (Mac). This brings up the dialog box shown in *Figure 1-35*. If you select "Use a stylized text identity plate" (circled), you can type your name or descriptor in the text field. Choose a font, font style, and size from the pop-up menus below. Change the color by clicking on the color swatch next to the type size and selecting a color.

If you select Enable Identity Plate at the top of the dialog box, your work will appear in the upper-left corner of the Lightroom workspace (circled) and you can view the effects of your type and color choices. *Figure 1-36*

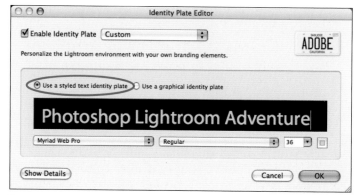

Figure 1-35

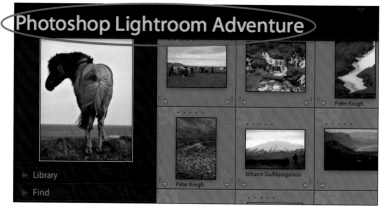

Figure 1-36

If you select Use a graphical identity plate (circled) you can import a pre-made graphic by dragging it from your desktop to the box or navigating to the file by selecting Locate File. *Figure 1-37* The graphic can be a PDF, JPG, GIF, PNG, TIFF, or PSD file but no larger than 60 pixels high. Keep in mind, the graphical identity plate may be adequate for screen viewing but too low a resolution for printed output.

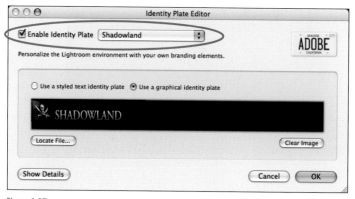

Figure 1-37

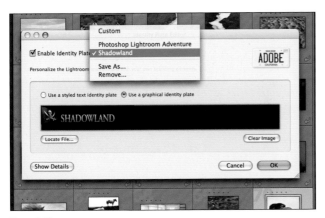

Figure 1-38

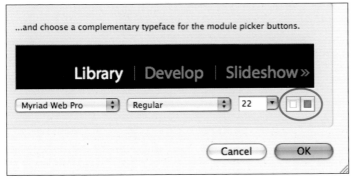

Figure 1-39

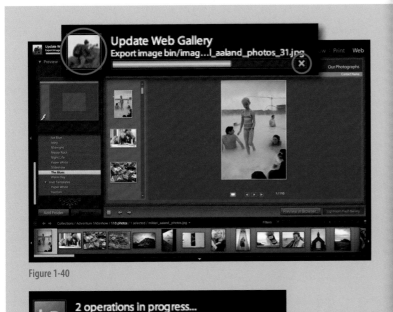

Figure 1-40

Figure 1-41

Create Multiple Identity Plates

You can create as many Identity Plates as you want, but only one can be used at a time. To do this, choose Save As from the Enable Identity Plate menu, and give your identity plate a name. When you next select the pop-up menu, the new name will appear. *Figure 1-38*

Customize Module Picker Buttons

In the Identity Plate Editor you can also customize the font, size, and color of the Module Picker buttons to create a complementary typeface to go with your personalized one. *Figure 1-39*

The first color picker box to the right of the font size sets the color of the current selected module, and the second box sets the color for unselected modules (circled).

Reading the Progress Bar

Lightroom can process many tasks simultaneously. For example, you can export a batch of DNGs and build a Flash Web gallery at the same time. Keep track of the progress of each operation with Lightroom's Progress Bar *Figure 1-40*, found at the top-left corner of the Lightroom display window. A small thumbnail (circled) indicates which image the operation is currently working on. Cancel an operation by clicking on the X (circled). When two or more operations are in progress, click on the arrow (circled) *Figure 1-41*, and toggle between the status indicator of each operation.

Importing Images into Lightroom

You don't "open" image files in Lightroom like you do in Photoshop, or "browse" to image files as you do with Adobe Bridge. You must first "import" images into Lightroom, either directly from your digital camera, or from your hard drive or other storage device. On import, Lightroom creates an image preview and a link between the preview and the original image file. When you work on your image in Lightroom, the program keeps a record of any changes in a database catalog and never touches a pixel in your original image. But I'm getting ahead of myself. Let's first see how to import images into Lightroom.

Chapter Contents

PHOTO CREDIT: Peter Krogh

Importing Images into Lightroom

There are several ways to import your images into Lightroom. There are also several things you can do on import that will make your job easier when you are ready to organize, edit, rate, and process your images in Lightroom. Let's start the process.

The Import Button

The most obvious way to start the Import process is by clicking on the Import button at the bottom of the left panel in the Library module (circled). *Figure 2-1*

Of course, if you don't see the button, just click on the triangle to the left of the workspace to reveal the side panel, or press the Tab key. After you select Import, you'll be prompted to navigate to the folder/files you wish to import.

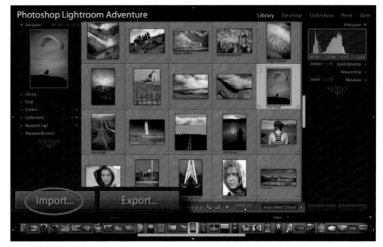

Figure 2-1

Use the Keyboard or Menu Command

The Import Photos command can also be found under the File menu. (Windows and Mac menus are slightly different.) *Figure 2-2* You can also start the import process with the keyboard shortcut ⌘+Shift+I (Ctrl+Shift+I). This command is available in all the modules; however, regardless of where you start, you'll always end up in the Library module after import.

Figure 2-2

Use the Drag and Drop Method

You can drag and drop images from your desktop (or an application like Adobe Bridge) directly into Lightroom by dragging the images onto the Lightroom application icon. *Figure 2-3* This will launch Lightroom and bring up the Import Photos dialog. You can also drag an image into the display window of the Library module and the import will begin.

Figure 2-3

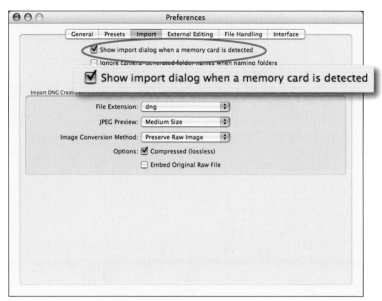

Figure 2-4

Figure 2-5

NOTE *You can choose the type of sound (or no sound) to alert you when import (or export) is complete. To do this:*

1. *Open the Preferences→General tab.*
2. *Select the desired alert (or None) from the pop-up menu.*
3. *Typically you would select different sounds for import and export so you can differentiate between the two.*

Import Automatically from Card or Camera

In Lightroom's Preferences/Import tab, "Show import dialog when a memory card is detected" is selected by default. *Figure 2-4* This means when Lightroom is running, import will start automatically when Lightroom detects that you've inserted a memory card or hooked up a digital camera to your computer.

To disable this auto import "feature":

1. Open Preferences (Lightroom→ Preferences on Mac, File→Preferences in Windows).

2. Under the Import tab, deselect "Show import dialog when a memory card is detected." When a card is detected, Lightroom won't do anything.

Auto Import from Watched Folder

If you select File→Auto Import→Enable Auto Import, you can drag and drop files or folders of images into a specially created location, for example, on your desktop, and import occurs automatically. *Figure 2-5* (See the last section of this chapter for specifics on setting this option.)

Import from Catalog

You can import images from another Lightroom catalog by selecting File→ Import from Catalog from the menu bar. I'll get more into creating and using catalogs in the next chapter.

Import from Elements

Windows users also have the option to import catalogs directly from Photoshop Elements or Album 2.0 if either is installed. Keywords are automatically imported as well.

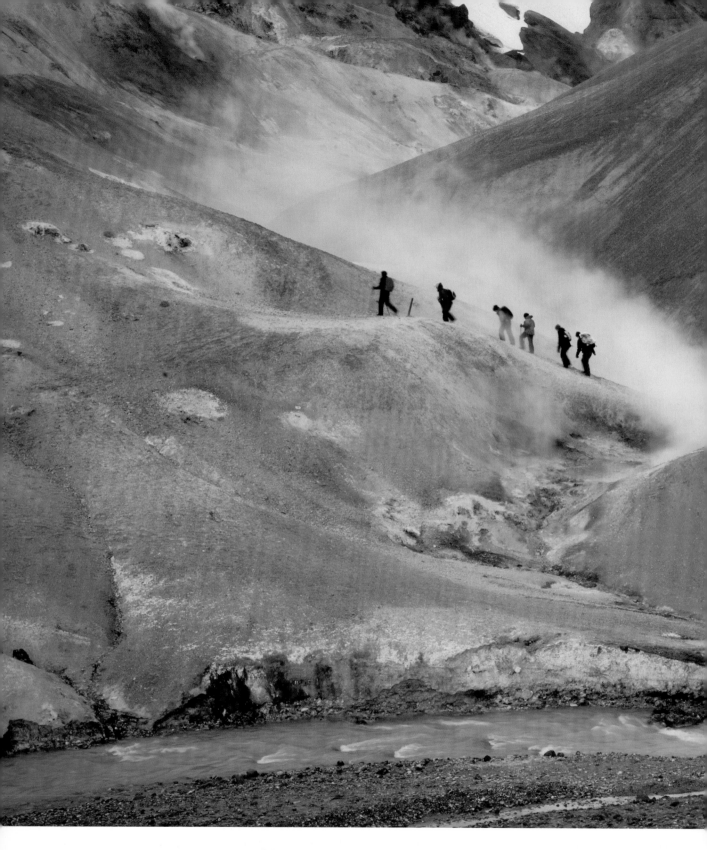

Maggie Hallahan

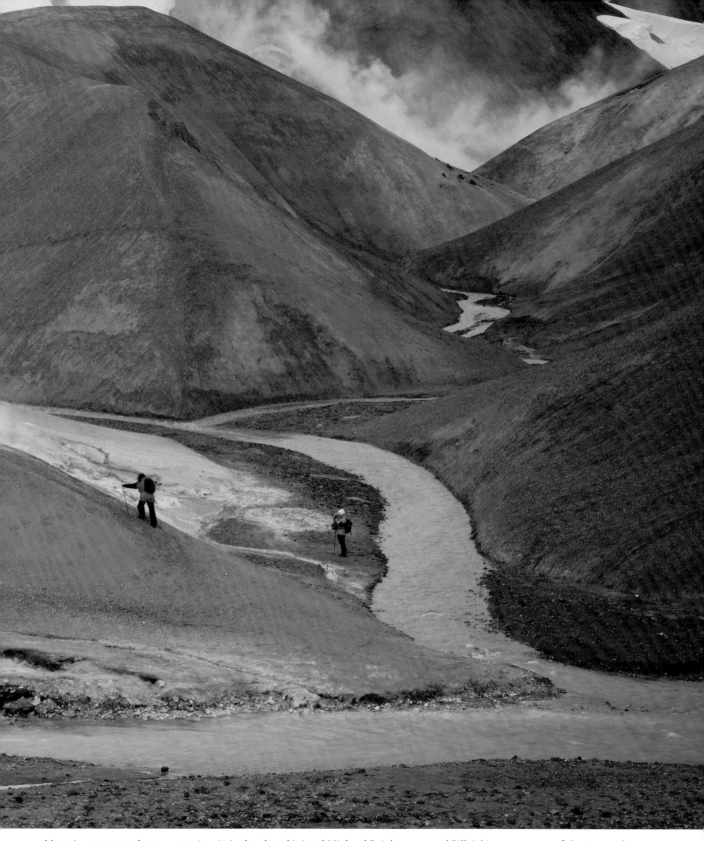

Maggie got up early one morning in Iceland and joined Michael Reichmann and Bill Atkinson on one of their marathon 8-hour drives. At one location, Maggie plopped herself down and watched a small group of hikers patiently remove their boots and wade across the steaming river. She placed her camera on a tripod and waited for the perfect moment. Finally, everything lined up. A burst of steam shot out of the hillside just as the hikers filed past. To get the hyper depth of field she shot at f/22 at 1/10th of a second. In Lightroom, she bumped up the green saturation slightly, decreased the yellow saturation, and gave the image a slight vignette. She also slightly cropped the top and bottom.

Import Photos Dialog Options

After taking the first step to import your images, you are faced with several options via the Import Photos dialog box. Choosing the correct options here can make a big difference later, as you work with your images in Lightroom. Let's go through the process and see how to make appropriate choices.

After you select Import from the Lightroom workspace window, and after you navigate to and select the folder or files you want to import, you'll get a dialog box that looks something like this. (Windows and Mac dialog boxes will look slightly different.) *Figure 2-6* If you are using a watched folder (covered later in this chapter) to import your images, you won't get this dialog box.

If you select Show Preview from the bottom left of the dialog box, thumbnail versions of the files are viewable on the right side of the box. A slider (circled) under the viewing area allows you to change the size of the thumbs. You can also select individual files directly from the thumbnails or use the Check All or Uncheck All buttons as well.

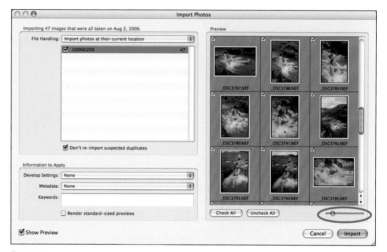

Figure 2-6

File Handling

The first decision you will need to make is how Lightroom handles your original files on import. Your choices are shown in *Figure 2-7.* Here's what each option offers:

Import photos at their current location

> If you choose this option, Lightroom will not move your original files regardless of where they reside. It will create a "link" to the file which remains until you move or delete the file. If, at a later point, you move a file from its original location and Lightroom can't find the original file,

Figure 2-7

Figure 2-8

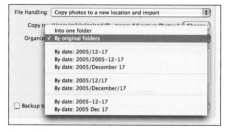

Figure 2-9

Figure 2-10

Figure 2-11

Figure 2-12

you will be prompted by Lightroom to "search" for the new location. (More on reconnecting missing files in Chapter 3.) Checking the box next to "Don't re-import suspected duplicates" ensures that any duplicates of existing photos in the library will not be imported. *Figure 2-8* If you choose this option, you won't be able to rename your files on import as you can with the following options.

Copy photos to a new location and import

If you choose this option in the Import Photos window, the dialog box will change to reflect more options. You can choose any location you want to copy your images to by selecting Choose (circled). *Figure 2-9* By default, on the Mac and in Windows Vista, the image files are placed in the Pictures folder. (For earlier versions of Windows, they are placed in the My Pictures folder.)

Lightroom makes a complete copy of your files and places them in folders organized by an option of your choice. The default Organize choice is "By original folders," but you can also choose to organize them all in one folder or by date. *Figure 2-10* You can designate a backup location (circled in *Figure 2-11*), which creates another set of your image files at a designated location of your choice. You can also apply a File Naming template to each file (circled). *Figure 2-12* As mentioned earlier, this is something you can't do if you reference them only in the current location. The main drawback to using "Copy photos to a new location and import" is that it seriously slows the import process, especially if your image files are large.

Move photos to new location and import

This option (circled) is similar to the previous one, except it actually moves the original file and places it in a predetermined location on your hard drive. *Figure 2-13* Because it isn't "copying" the file, only moving it, the process doesn't take as much time as the previous choice. Be aware that when using this option with a card reader or your digital camera as source, Lightroom deletes the files from the card/camera after moving them.

Copy photos as Digital Negative (DNG) and import

This choice turns your original RAW files into DNG and places the DNG files in a predetermined folder on your hard drive. *Figure 2-14* The original files are left in their original location. (DNG stands for Digital Negative, a standardized, openly documented RAW file format championed by Adobe.) You can also convert a TIFF or JPEG file into a DNG. (Important DNG creation preferences are found under Lightroom's Preferences/Import tab.)

Rendering Previews

If you click the Render standard-sized previews check box (circled), a 1440-pixel preview will be generated on import by default. *Figure 2-15* If you don't select it, Lightroom uses pre-existing preview files generated by your digital camera, the size of which varies from camera to camera. The files will import faster into Lightroom, but the quality of the preview thumbnails may not be to your liking. Not to worry, Lightroom eventually generates an appropriate-sized preview when you select and work on the image.

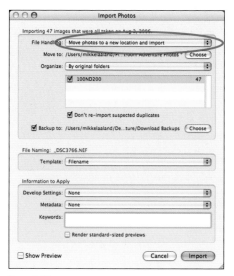

Figure 2-13

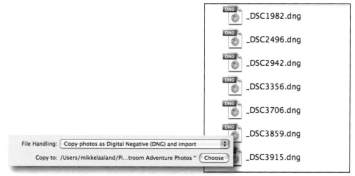

Figure 2-14

Figure 2-15

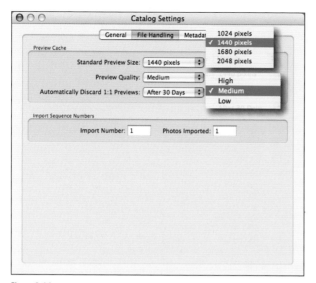

Figure 2-16

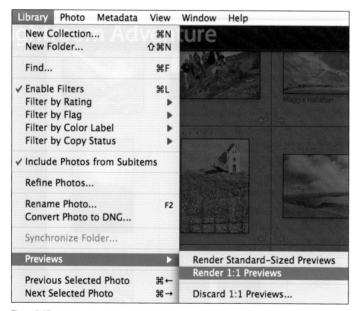

Figure 2-17

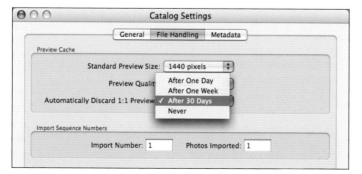

Figure 2-18

Setting preview image sizes in Catalog Settings

Let's briefly leave the Import Dialog box to discuss the preview preference choices, which are found in the Catalog Settings dialog box under the File Handling Tab. (Select File→Catalog Settings from the menu bar or, in Lightroom's Preferences/General tab, select Go to Catalog Settings.) Here you can set the size of the "Standard" preview. *Figure 2-16* Obviously, the larger the preview, the slower the import. You can also set the Preview Quality to High, Medium, or Low, which can be important if memory is an issue. All these settings apply on a catalog-by-catalog basis.

Manually building previews

After import, you can instruct Lightroom to build or render standard-sized or 1:1 previews in the Library module, by selecting Library→Previews from the File menu. *Figure 2-17* Depending on how many images are selected, this may take some time. (1:1 previews are used in the Develop module and are generated automatically when you select and work on an image there. "Pre-rendering" 1:1 previews may save you a little time in the Develop module, but it isn't necessary.)

Discarding previews

Since 1:1 previews are essentially full resolution versions of your image, they can take up a lot of storage space. You only really need these 1:1 previews when you process an image or print, so you may find it useful to purge your system from time to time. You can do this manually by selecting Library→Previews→Discard 1:1 Previews, or you can set up a Lightroom catalog preference (File→Catalog Settings) so the 1:1 previews are automatically purged at an interval set by you. *Figure 2-18*

File Format Support

Lightroom supports the following file formats: JPEG, TIFF, PSD, RAW, and DNG. At this time, Lightroom doesn't support any video format. Although Lightroom supports the PSD file format (it better!), if your PSD file contains layers, only a flattened composite will appear in the Lightroom viewing window. Individual layers are not accessible in Lightroom, although the original file with layers is kept intact. If you shoot JPEG plus RAW, Lightroom offers you the choice of importing only the RAW file or both of the file formats. (Make the choice in Lightroom's Preferences/Import dialog box.)

As you may already know, there is no such thing as a single RAW file format. Every camera manufacturer has their own and it varies between models. In order to support the latest RAW formats, Lightroom engineers are kept busy updating the application. This means you have to keep busy as well, checking the Adobe site frequently to see if updates are available. You can set a Lightroom preference to check automatically for you. To do this:

1. Open Lightroom preferences (Lightroom→Preferences on a Mac, Edit→Preferences in Windows).

2. In the General tab, select Automatically check for updates (circled). *Figure 2-19*

You can also go under the Help menu and direct Lightroom to check for updates. *Figure 2-20*

NOTE: *At this time Lightroom only supports photos up to 10,000 pixels in length or width for a maximum image size of 100 million pixels.*

Figure 2-19

Figure 2-20

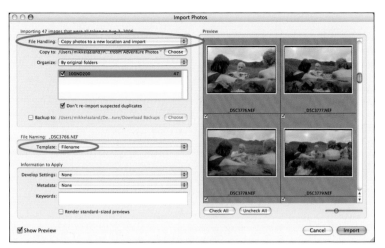

Figure 2-21

Figure 2-22

Renaming Files on Import

OK, now back to the Import Photos dialog box. You can rename files on import, but in order to do so, you must first choose "Copy Photos to a new location and Import", or "Move Photos to a new location and Import", or "Copy Photos as DNG and Import" from the File Handling pop-up menu (circled). *Figure 2-21*

With these choices, the renaming features are enabled (circled). The renaming features are not enabled if you select Import Photos at their Current Location.

Why rename?

Digital cameras generate unique file names but you'll probably want to customize these file names on import to make them more useful and to lessen the chance of inadvertently overwriting them at a later date. Most digital cameras are capable of generating eight-character file names. *Figure 2-22* If you set your camera to generate sequential numbers and don't reset every time you erase files from card memory, you are off to a good start. However, what happens if you shoot with multiple cameras by the same manufacturer? The chances of creating image files with the same name goes up and so does the chance you'll overwrite one file with another.

To avoid this potentially disastrous situation, Peter Krogh, a member of the Iceland Adventure team and author of the definitive work, *The DAM Book: Digital Asset Management for Photographers*, recommends you create a unique file name the first time you "touch" your image file and never change it. (Derivatives, of course, get their own unique file name later.) A good time to do this, he argues, is when you import images into Lightroom.

Creating custom file names

Although several presets are available in the Filename Template Editor pop-up menu, I prefer create a custom file-naming nomenclature recommended by Peter Krogh. *Figure 2-23*

To do this:

1. Select Edit... (circled) from the Filename pop-up menu.

2. The Filename Template Editor will appear. *Figure 2-24* Directly in the field window (circled) type in your name, followed by an underscore. Use the Delete key to correct any errors.

3. Choose Date (YYYYMMDD) in the Additional field pop-up menu and click Insert. (You'll have a choice how the year, month, and day are displayed. I prefer the YYYYMMDD format.) The actual date will be derived from camera EXIF data. Type an underscore after the Date field.

4. Choose Filename under the Image Name field and click Insert. Again, the actual file name is derived from camera EXIF data.

As you "build" and customize the file name an example will appear above the field window. When you are finished, select Save as New Preset from the Preset pop-up menu. *Figure 2-25* Name the preset and then click Done. Next time you select the pop-up Template menu, the new preset will appear as a renaming option.

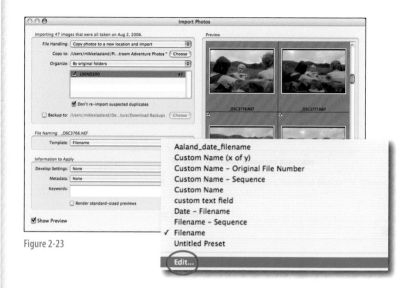

Figure 2-23

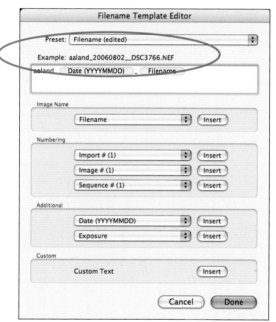

Figure 2-24

Figure 2-25

Figure 2-26

Figure 2-27

Figure 2-28

Rename After Import

You can always rename your files after import in the Library module. After selecting the images you wish to rename:

1. Select Library→Rename Photo... from the menu bar. *Figure 2-26*

2. In the resulting dialog box, select your new naming protocol from the File Naming pop-up menu, or type in custom text in the Custom Text field. *Figure 2-27* An example of the new file name will appear at the bottom of the dialog box.

3. Bring up the Filename Template Editor by selecting Edit from the File Naming pop-up menu. Here you can create a new file name template based on numerous criteria. See previous page for more on this.

Proper Punctuation

To create file names that are readable by all systems, you should follow certain universal rules. For example:

- Avoid all punctuation except underscores, dashes, and a single period prior to the file extension. You can set a Lightroom preference to automatically correct file names with unacceptable punctuation. Do this in the Lightroom Preferences in the File Handling tab. *Figure 2-28*

- Use no more than 31 characters.

- Every file name should have a 3-letter extension preceded by a period.

You can also rename while exporting, but I'll get into that in Chapter 9.

Applying Other Information on Import

Let's go back again to the Import Photos dialog box. *Figure 2-29* Here you can apply a custom develop setting and create and apply a custom metadata preset on import. You can also, if you want, apply a set of keywords on import which can be used later for sorting, editing, and filtering your images (circled).

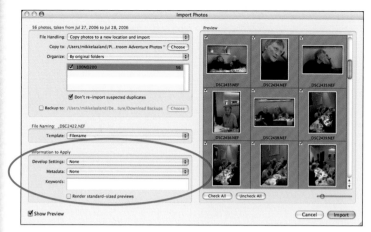

Figure 2-29

Develop options on import

Lightroom ships with several Develop presets. *Figure 2-30* In later chapters, I'll show you how to create your own custom develop presets, which will also show up in the Import dialog window, as mine have shown up here. For example, I created a preset that automatically boosts color saturation, among other enhancements. Remember, even if you apply these presets to your images, Lightroom doesn't touch the original image file. It just applies the preset to the previews. You can change the settings at any time with no loss in image quality.

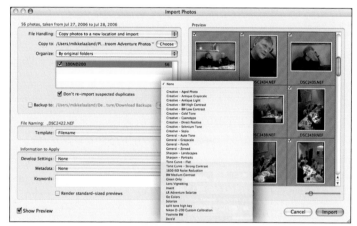

Figure 2-30

Metadata presets for import

I find the metadata preset on import feature one of the most useful of all. Instead of applying my name, copyright notice, and contact information on an image by image basis, I can do it all at once on import. You can create as many presets as you want, covering just about any image ownership or rights issue imaginable. To do this:

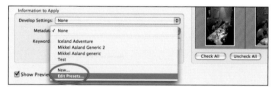

Figure 2-31

1. Select New or Edit Presets from the pop-up menu (circled). *Figure 2-31*

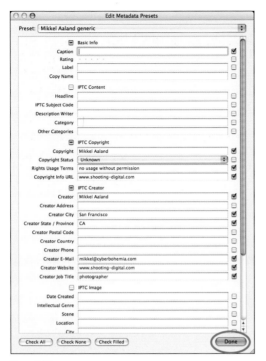

Figure 2-32

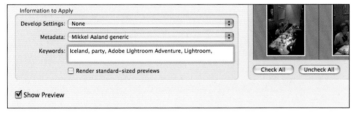

Figure 2-33

Figure 2-34

2. In the resulting New Metadata Preset dialog box, fill in the appropriate IPTC data fields. *Figure 2-32*

3. Name and then select Create to save your preset.

4. Next time you open Lightroom and select Import, your new preset will appear in the Metadata pop-up menu. (To delete unwanted metadata presets appearing in this pop-up menu, see "Deleting Metadata Presets" below.)

Editing metadata presets

To edit existing presets, simply select Edit Presets from the Metadata pop-up menu. Use the resulting Edit Metadata Presets dialog box to make changes. Select Done when you are done.

Add keywords on import

You can also add keywords that describe the content of your images on import, which is useful for shoots that contain common themes or content. *Figure 2-33* Keep in mind, that for many images you'll want to add content-specific keywords on an image-by-image basis, and that is something you can do more effectively in the Lightroom Library module. I'll get into how to do this in Chapter 3.

Deleting metadata presets

Lightroom stores import metadata presets in the Lightroom folder on your hard drive. *Figure 2-34* The only way to delete one of these presets is to open the Metadata Presets folder and trash the preset file directly from your desktop. After you do this, it will no longer clutter your Import dialog box's Metadata pop-up menu. (Go to the Lightroom folder by selecting Help→Go to Lightroom Presets Folder from the menu bar.

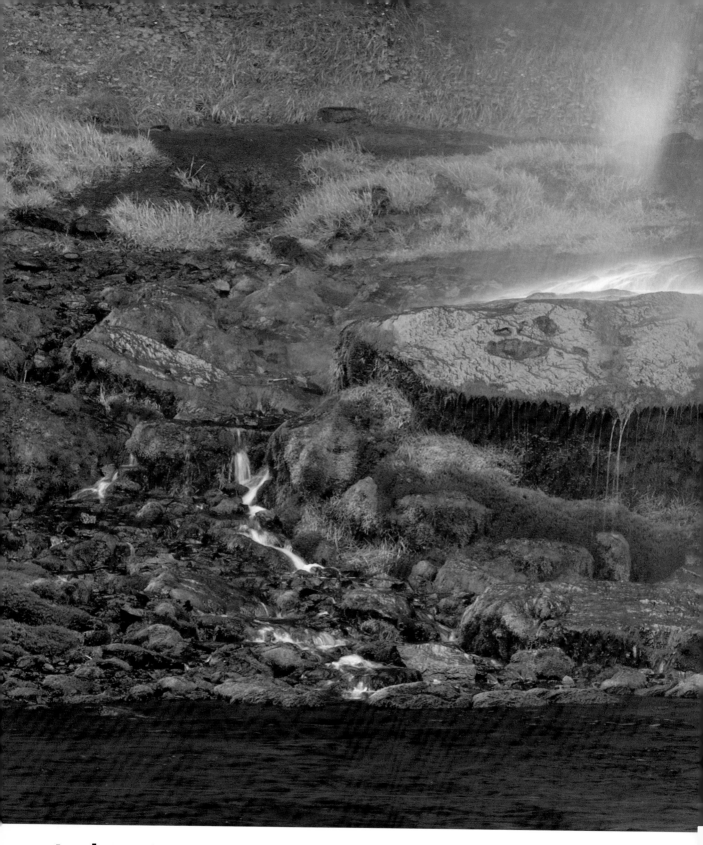

John Isaac

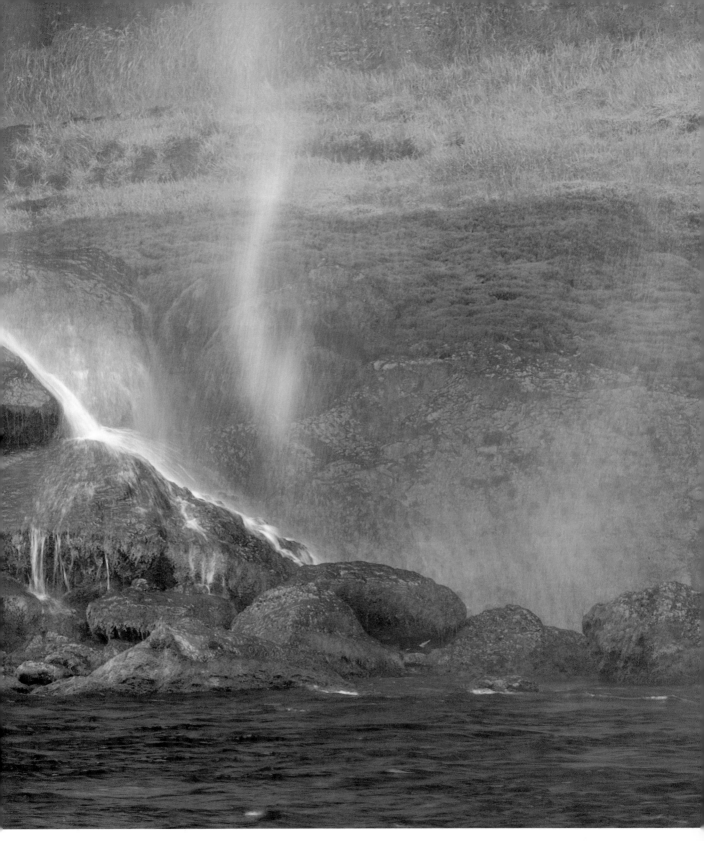

When facing a majestic landscape, it's tempting to try and include everything with a wide shot. John Isaac took the opposite tact here. He opted to isolate a small part of the scene and shot with a 600mm lens instead. Later, in Lightroom's Develop module, John gave the image a light touch, increasing the saturation slider just slightly to "give the photo a little body," he explains.

Import Based on Camera Serial # or ISO

You can set your Lightroom preferences to automatically apply a custom develop default setting on import based on a camera's serial number. If you shoot multiple digital cameras and want to apply your own customized default RAW conversion to each one automatically this option is very useful.

You can also set your Preferences to apply a different default based on a specific ISO. Higher ISO settings typically result in more electronic noise and you may want to create a default setting that automatically applies noise reduction.

To do either, start in the Develop module and use the Develop module controls as desired. (Chapter 4 goes into detail about using the Develop module.) Then:

1. In the Develop module, select Develop→Set Default Settings from the menu bar. This brings up the dialog box shown above. *Figure 2-35* Choose to either establish the current settings as the default or to restore the Adobe defaults.

2. Next, open Lightroom's Preferences and in the Presets tab check the "Make default specific to camera serial number" check box. *Figure 2-36* You can also select "Make default specific to camera ISO setting."

Now, on import, when Lightroom encounters either a specified camera model or a specified ISO setting, it will automatically apply the customized default.

In the Preferences/Import tab you can also restore all the Adobe defaults and discard the customized settings files (circled). *Figure 2-37*

Figure 2-35

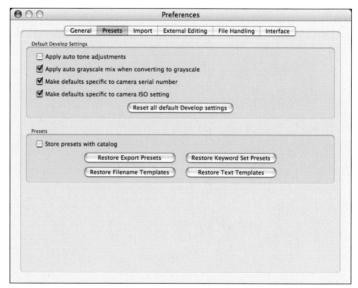

Figure 2-36

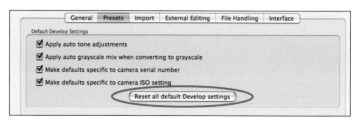

Figure 2-37

Figure 2-38

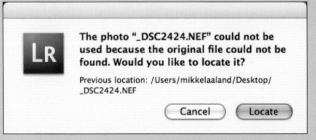

Figure 2-39

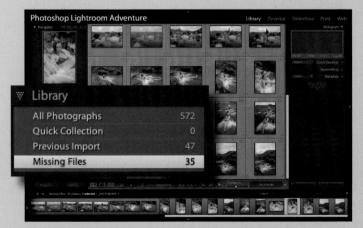

Figure 2-40

Finding Missing Files

Missing files can occur when you are not connected to an external source that contains your files or if move your files to another directory. If Lightroom can't locate a file, you get a warning question mark icon (circled) in the thumbnail frame. *Figure 2-38*

What should you do? Start by clicking on the question mark. This will bring up this screen. *Figure 2-39* Select Locate and navigate to your files in the directory. Use the directories search function to help. If you are missing multiple files from one location, all you need to do is locate one of the files: Lightroom will automatically link to the others.

You can also see at a glance all the files that are missing by looking in the Navigator panel, in the Library pane. *Figure 2-40*

Creating & Using Watched Folders

By enabling Lightroom's Auto Import feature from the menu bar, you can automatically import photos into the Lightroom Library module using a designated watched folder. Let's see how to set up and use this feature.

Start by enabling Auto Import from the file menu. *Figure 2-41* Then:

1. Choose File→Auto Import→Auto Import Settings.

2. In the Auto Import Settings dialog box, set the following: *Figure 2-42*

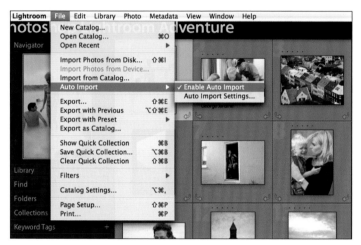

Figure 2-41

Watched Folder Select Choose, and, in the resulting Auto Import Settings dialog box, select an existing folder (it must be empty) or make a new folder and give it a name such as "Lightroom Imports."

Destination Select Choose and create or choose a folder where the images from the previously described folder will end up. If you don't do anything, Lightroom automatically names the folder Auto Imported Photos and places the managed images in the Pictures folder (Mac OS X, Windows Vista), or My Pictures folder (Windows XP).

File Naming Here, you can specify file name protocol, as described earlier.

Figure 2-42

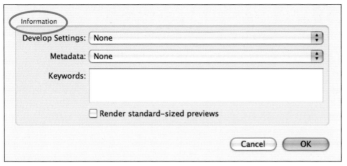

Figure 2-43

Information Here you can select Develop Settings presets or Metadata presets and add keywords. *Figure 2-43* Choose carefully. Your choices will apply to all images placed in the Watched Folder.

When you are finished with the Auto Import Settings, click OK. The next time you are ready to import a single image or a folder full of images, simply drag and drop the file into the watched folder and the import will start automatically. No dialog box will appear, but the status bar in the top left of the Library module will give you an indication of the progress.

Figure 2-44

Tethering a Digital Camera

You can tether a digital camera directly to your computer and view images in near real-time in Lightroom. *Figure 2-44* You'll need a supported digital camera (not all are) with separate capture software. You won't be able to control your camera or release the camera shutter via Lightroom; that's for the camera software to do. But you can create a nearly seamless workflow of capture, import, and edit, and display. To do this:

1. Set up your camera's capture software and attach your camera.

2. Create a watched folder. (See previous section for details.)

3. Point your capture software to the Lightroom Watched Folder. That's it. Now when you shoot, your files are automatically sent to Lightroom and are ready for editing and viewing.

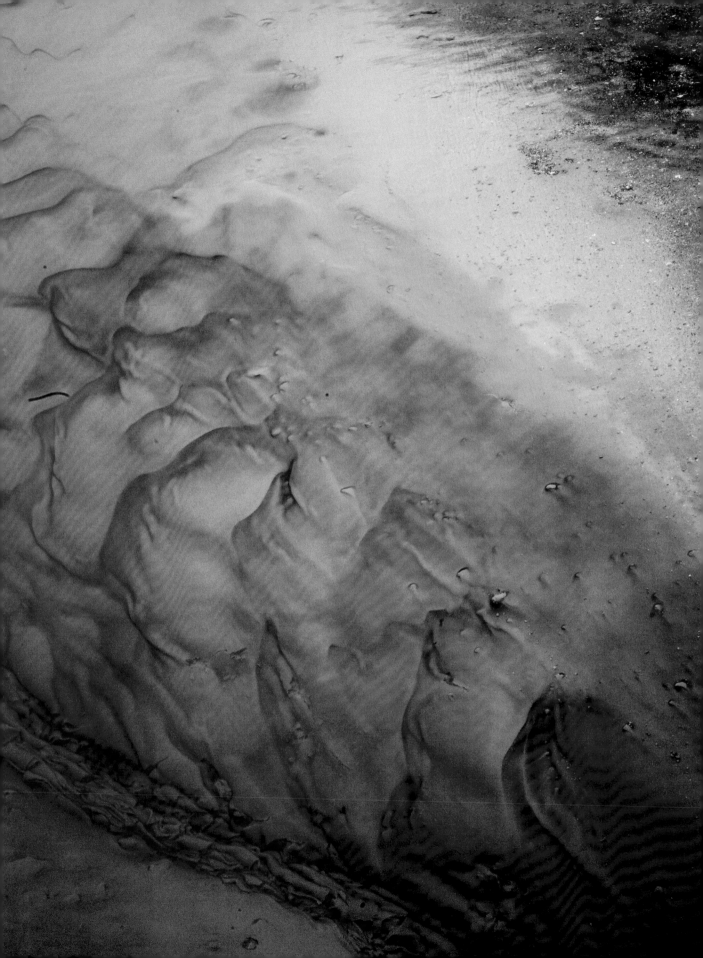

Using the Library Module

The next stop after importing images into Lightroom is the Library module, where you'll do your editing, rating, and sorting. It's also where you can add appropriate keywords and other metadata, as well as perform some basic image processing on one or multiple images at the same time. You'll be amazed at how easy it is to select, zoom in, and examine images for sharpness and content, as well as compare images in a side-by-side view. No longer will the thought of dealing with hundreds of images seem daunting. It might even seem like an adventure!

Chapter Contents

The Library Module Revealed

At first glance, Lightroom's Library module has similarities to Adobe Bridge and other image "browsers." Scalable previews in the viewing area can be easily sorted, edited, and have keywords and ratings applied. But, as you will see, there is much more to the Library module.

The Library module consists of the view control panel on the left, the activity control panel on the right, and the main viewing window in the middle. *Figure 3-1* The left and right panels are divided into panes with specific functions. Near the bottom of the window is the toolbar and filmstrip. As we learned in Chapter 1, the panels, toolbar, and filmstrip can easily be hidden or, in some cases, resized, maximizing the viewing area.

Let's take a quick look at the basic components of the Library module, see what they do, and then get into specific Library module-related tasks.

The Left Panel (View Controls)

The left panel consists of the Navigator and other panes through which you can control and refine what is displayed in the main viewing window.

The Navigator pane

The Navigator pane displays the current active selection. *Figure 3-2* While several images can be *selected* at once, only one image is considered *active*. (See "Selecting Thumbnails in Grid View & Filmstrip," later in this chapter.) Clicking on the image in the Navigator pane immediately takes you from the thumbnail (or Grid) view in the main viewing area into the single-image Loupe view where different magnification levels can be quickly

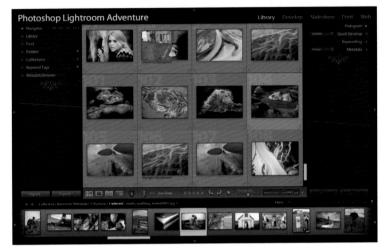

Figure 3-1

Figure 3-2

NOTE *It's possible to import and integrate one catalog (or part of a catalog) with another catalog. To do this select File→Import from catalog and navigate to a catalog. After you select open, the Import from Lightroom catalog dialog box will appear, where you can further refine your import options.*

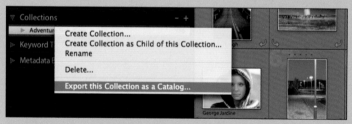

Figure 3-3

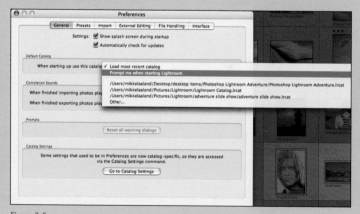

Figure 3-4

Figure 3-5

Lightroom Catalogs

Lightroom saves its image database as a *catalog*. (In earlier versions of Lightroom the database was called a *library*.) You can create multiple catalogs, but only one catalog can be open at a time. Catalogs can be created (or integrated with each other) as a backup strategy or as a way of sharing all or parts of a collection of images between, for example, an in-the-field laptop and a desktop unit, or between users of the same computer.

You can create a new catalog while Lightroom is running by selecting File→New Catalog from the menu, or, on startup of the application hold the Option (Alt) key and select Create New Catalog from the Select Catalog dialog box. *Figure 3-3* Name the catalog what you want but be sure to keep, or add if necessary, the .lrcat extension.

Selected images can also be exported as a Catalog (File→Export as Catalog). Collections or Folders located in the left panel can also be exported as a Catalog (Right-click on the Folder or Catalog name and select Export...this Folder as a Catalog from the contextual menu.) *Figure 3-4*

To open an existing catalog, go to File→ Open Catalog or File→Open Recent. Choose a catalog, and Lightroom will relaunch and open with the new catalog (after making sure that's what you want to do). You can also hold the Option (Alt) key while launching Lightroom and choose a Catalog from the Select Catalog dialog box. This dialog box will open automatically if you set your Lightroom preferences as shown in *Figure 3-5*.

Quick Collections

Think of a Quick Collection as a temporary holding area during an edit session. Select a thumbnail and use the B key to place the image in the Quick Collection. Type B again to remove it. Quick Collections can be saved and renamed and then included as a permanent Collection category. (File→ Save Quick Collection). *Figure 3-6* To empty a Quick Collection, select File→Clear Quick Collection. To display the contents of a Quick Collection, click on Quick Collection in the Library pane or use the menu command File→Show Quick Collection. If you have set your Library module View Options (View→ View Options) to Include Quick Collection Markers, a shaded dot (circled) will appear in the thumbnail, designating its inclusion. *Figure 3- 7* Clicking this dot will remove the image from the Quick Collection. Click it again to add it back to the Quick Collection.

Figure 3-6

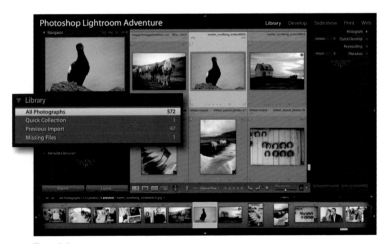

Figure 3-7

applied. (Press the G key to return to the Grid view.) Clicking and holding on the image in the Navigator will temporarily put you in Loupe view. Releasing the mouse will put you back in Grid view.

Library pane

In the Library pane—not to be confused with the Library module—you'll see several categories. (Three are always showing, but if you have missing files, duplicate images, or a previous export, at least three other categories will appear.) *Figure 3-8* If you click on any of the categories, the appropriate thumbnails will be displayed in the main viewing window.

Figure 3-8

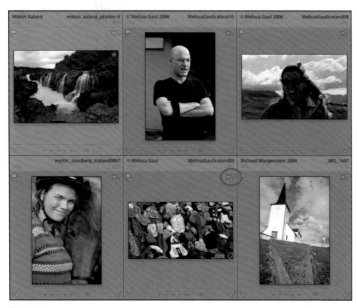

Figure 3-9

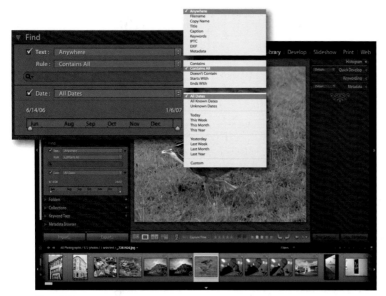

Figure 3-10

- *All Photographs* is a total accounting of all the images in your active library.

- *Quick Collection* shows the number of images you've placed in the Quick Collection. (See previous sidebar.)

- *Previous Import* includes only the images from the last import.

- *Previous Export as...* includes images last exported as a new catalog.

- *Missing Files* includes those files whose original files are off-line or otherwise not available. This category will not show up unless you have missing files. Missing files are also marked with a question mark (circled) on the thumbnail frame. *Figure 3-9*

- *Already in Catalog* appears when you have duplicate files in your catalog. You can erase them by right-clicking on the pane and selecting Remove this Temporary Collection.

Find pane

As your catalog of images grows, it gets harder and harder to find a specific image. The Find pane is a sophisticated search feature that allows you to search for a single or multiple images using different criteria based on text and/or date. With a search criteria selected, only those images that meet the criteria will be displayed in the display window. You can search your entire catalog, or select a specific folder or collection to search. Shown here I typed in the words Lightroom Adventure, selected Text/Anywhere, Rule/Contains All and a Date/All Dates. *Figure 3-10* (Other search capabilities are found in the Keyword Tags and Metadata Browser panes.)

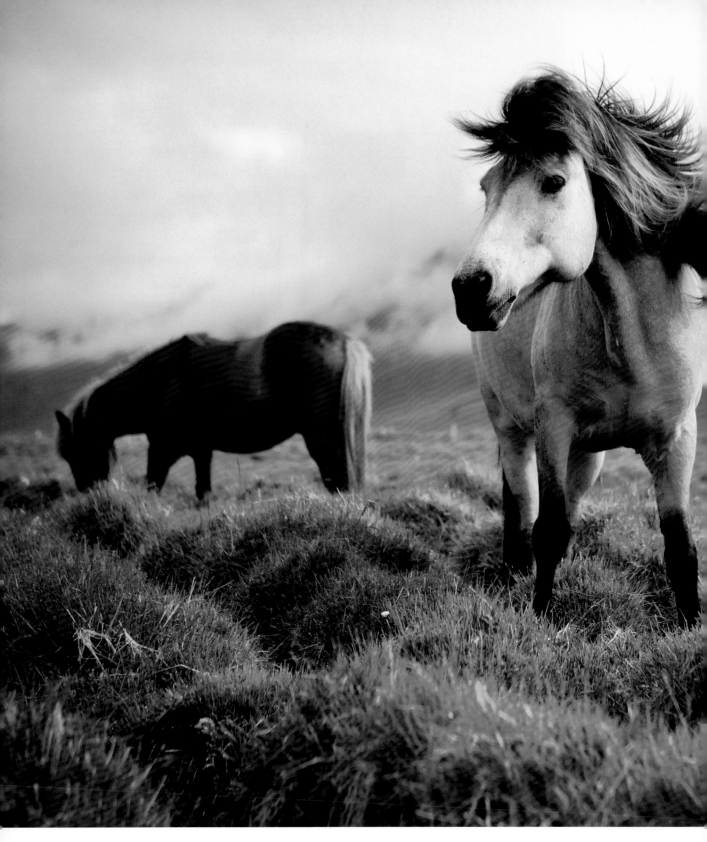

Martin Sundberg

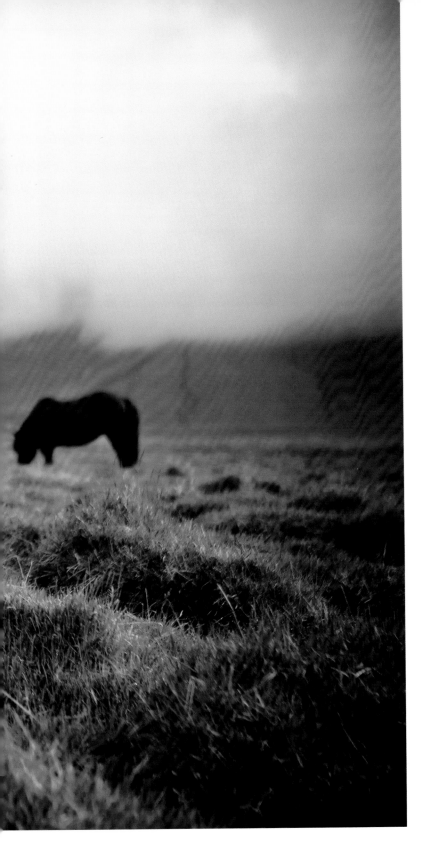

Martin caught this horse at just the right moment, but it was no accident. He hid behind a wet grassy berm, watching and waiting for a long time until the horses forgot he was there and this scene unfolded in front of him for him to capture. Martin "made" this image, not in the Photoshop way of making an image, but with a camera, patience, and traditional photographic techniques. He used Lightroom to minimally process it, bumping up saturation and adding a vignette around the corners.

Folders pane

The Folders pane displays a folder/data hierarchy based initially on your import settings. The number to the right of the folder name tells you how many files are in that folder. Click on the folder name and the corresponding thumbnails will appear in the main display window. *Figure 3-11*

You can move and change the folder order—and even rename folders in the Folders pane—but do this knowing Lightroom must actually change and/or move the original folders on your hard drive.

To rename a folder, place your cursor over the name, double-click, and type, or right-click on the name and choose Rename from the pop-up menu. *Figure 3-12* Then type in the new name. Lightroom automatically changes the name of the original folder on your disk as well. If the folder is missing, its name will be in red characters. Right-click on the folder name, and then select Locate Missing Folder from the contextual menu. *Figure 3-13*

To move a folder, hold your cursor over the folder name, click, and drag it to a new location. You can drag it on top of another folder to create a subfolder or "child." You can also use the contextual menu (right-click) and select Create Folder as a Child of this Folder. A triangle next to the folder name indicates that there is a subfolder. You can have subfolders within subfolders. Use the contextual menu to delete unwanted folders.

When you move a folder to a new location, Lightroom needs to move the original folder as well. *Figure 3-14*

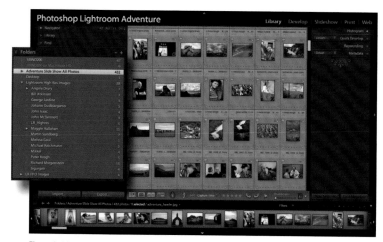

Figure 3-11

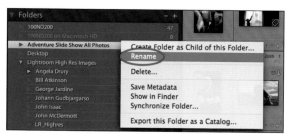

Figure 3-12

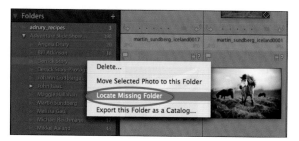

Figure 3-13

Figure 3-14

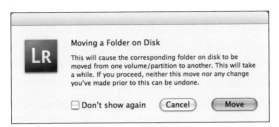

Figure 3-15

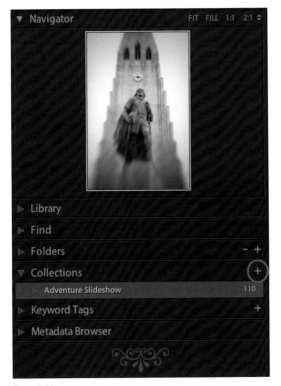

Figure 3-16

Figure 3-17

If you try to move a folder whose original folder is located on one disk to another location on the same disk you'll get a dialog box informing you that the corresponding folder will move as well. If you try to move a folder whose original folder is located on one disk to another separate disc you'll get a dialog box warning you this move may take time and cannot be undone. *Figure 3-15*

Collections pane

Collections are just what the name implies: collections of images based on particular criteria determined by you. When you first start up Lightroom, there are no collections in the Collections pane until you create one. *Figure 3-16* You can create as many collections as you want, and an image can reside in multiple collections. To create a new collection click on the plus sign (circled) and type in a name, or right-click and choose Create Collection from the pop-up menu. You can change the name of a collection later by double-clicking its name or right-clicking and choosing Rename from the pop-up menu. *Figure 3-17* You can also move collections around and create subdirectories, or "children." Simply drag a collection on top of another collection, or use the contextual menu (right-click) to Create Collection as Child of this Collection. You can have subdirectories within subdirectories. When you click on a collection name, the main display window shows only those images in that specified collection . You can create a new Lightroom catalog based on a specific collection by using the Export this Collection as a Catalog command from the contextual menu.

Keyword Tags pane

Any keyword associated with an image will appear under the Keyword Tags pane. *Figure 3-18* The numbers to the right tell you how many images in your catalog include that particular keyword. Click on the keyword and the corresponding images will be displayed in the display window. Keywords can be grouped hierarchically by dragging and dropping one keyword on top of another. To expand and view a grouping, click on the triangle to the left (circled). Dragging a keyword from the Keywords Tags pane to an active image in the display area will apply that keyword to that image. Right-click on a keyword to bring up more options from the contextual menu. (More on assigning and using keywords later in this chapter.)

Metadata Browser pane

Another useful way of finding or organizing images is via the Metadata Browser. *Figure 3-19* Here you can search for images by data automatically supplied by your camera's EXIF data or other metadata embedded in an image file. You could, if you want, find all the images with an assigned ISO of 1600, or all images in your collection shot with a particular focal length, or by camera model or serial number. When you click on a metadata criteria, the images meeting that criteria will be displayed in the image display window. You can establish multiple criteria if you wish. For example, if you want to find images taken at a certain focal length, contained in a particular folder or collection, hold down the ⌘ key (Ctrl key in Windows) and click on the folder and collection. Now the search includes both the focal length, folder, and

Figure 3-18

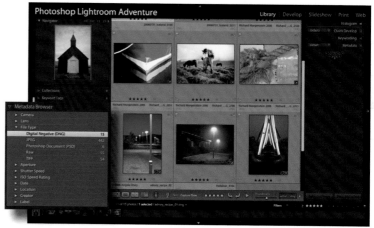

Figure 3-19

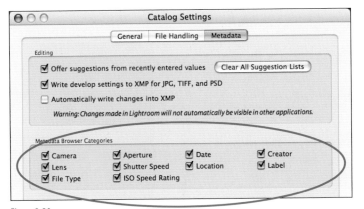

Figure 3-20

collection criteria. You can keep clicking while holding the ⌘ key (Ctrl key) through as much criteria as you want. To deselect, click on the criteria again, holding the ⌘ key (Ctrl key).

> NOTE *You can choose which metadata criteria is displayed in the Metadata Browser by going to the Catalog Info dialog box, under the Metadata tab (File→Catalog Settings). Figure 3-20*

The Right Panel (Tools)

Moving over to the right panel (sometimes called the "activity panel"), we find the Histogram, Quick Develop, Keywording, and Metadata panes. At the bottom of the panel are controls for synchronizing settings and metadata between images.

The Histogram

Figure 3-21

At the top of the right panel is the Histogram. *Figure 3-21* Here you'll see a graphical representation of the color and tonal values contained in the active image. This histogram, unlike the one found in the Develop module, isn't interactive. It is for information only. Just as useful, in my opinion, is an at-a-glance accounting of camera data as ISO, focal length, f-stop, and shutter speed (circled).

Quick Develop pane

Under the Histogram is the Quick Develop pane. *Figure 3-22* Here you can apply some common image corrections to single or multiple images. You can also apply presets (created in the Develop module) and even apply proportional cropping. I'll go into more detail on using Quick Develop later in this chapter.

Figure 3-22

What the Thumbnails Reveal

You can set Lightroom to reveal a lot of useful data at glance directly from the thumbnails in Grid view. By default, Lightroom has Show Extras selected. If you don't want thumbnails to display extra information, select View→Grid View Style and deselect Show Extras. *Figure 3-23*

You can also press the J key to cycle through view styles.

To determine exactly what information is displayed on the thumbnails, start by selecting View→View Options from the file menu. Or, right-click on a thumbnail and select View Options from the contextual menu. If you select Show Grid Extras and Expanded Cells, the frame of the thumbnails is larger, and you can display more information on it than you can with Compact Cells. *Figure 3-24*

As you can see, you have a lot of choices, ranging from including Quick Collection Markers to File Name to Cropped Dimensions. You can view in real-time the effect of your choices on the viewable thumbnails, both in the main viewing area, and in the filmstrip. (The thumbnails in the filmstrip are only affected by the choices in Lightroom's Preferences, under the Interface tab.)

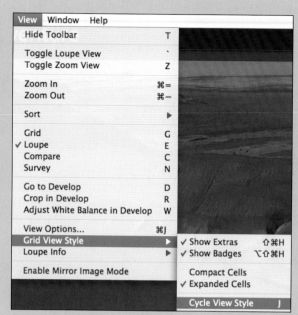

Figure 3-23

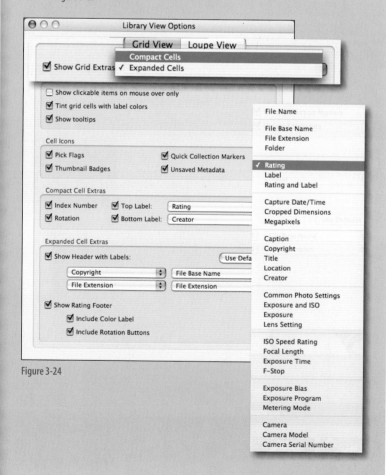

Figure 3-24

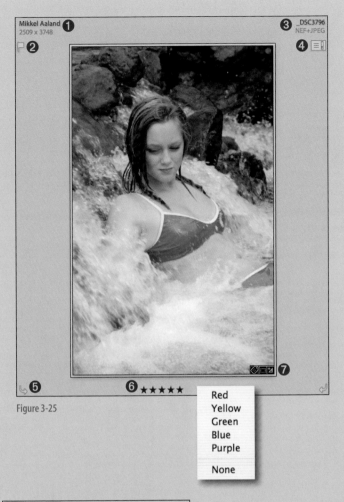

Figure 3-25

Red
Yellow
Green
Blue
Purple

None

Figure 3-26

Take, for example, the Expanded Cells thumbnail shown here. *Figure 3-25* It shows just a sampling of extra data.

❶ Shows copyright and cropped image dimension in pixels.

❷ Shows Pick flags.

❸ Shows the file name and extension.

❹ Indicates metadata has been changed.

❺ Shows left and right rotation icons. (If "Show clickable items on mouse over only" is selected in View Options, these will only appear when the mouse is rolled over the thumbnail.)

❻ Shows the Star Rating and Color Labels. (You can add or subtract stars them directly from the thumb by tapping an appropriate numerical key. Click on the Color Label icon to bring up a list of colors.)

❼ Shows thumbnail badges representing, from left to right, metadata, cropping, and develop changes. Click on an icon and you will be taken to the appropriate module or panel.

A Compact Cell thumbnail (left) will display a slightly more limited amount of extras, without the same amount of room around the edges as the Expanded Cell view (right). *Figure 3-26*

Remember, you can change the size of the thumbnails with the slider in the toolbar (T). If you make the thumbnails too small, the data described here will barely be visible.

Keywording pane

We saw in Chapter 2 how you can create and add keywords to a batch of images on import. With the Library module's Keywording pane, not only can you view which keywords are associated with any image, you can edit the keywords and even create as many Keyword Sets as you like. (A few premade Keyword Sets, including Outdoor Photography, Portrait Photography, and Wedding Photography are included with Lightroom.) *Figure 3-27* I'll go into more details on creating and applying keywords later in this chapter.

Metadata pane

Cameras generate metadata which is incorporated into an image file. In the Metadata pane, you can view this so-called EXIF data, and even correct some of it, such as the capture date and time. *Figure 3-28* You can also add metadata of your own using standard IPTC fields and create presets that will appear in the pop-up menu in the upper left of the Metadata pane. I'll get into this and more later in the chapter.

Sync Settings and Sync Metadata

At the bottom of the right panel are the Sync Settings and Sync Metadata buttons, which are active when more than one image is selected. These controls are used when you want to synchronize a batch of images using the same develop settings or same metadata. I'll get into this in more detail later.

Toolbar Menu Strip

The toolbar, found at the bottom of the viewing area, is where you'll find several useful, not so easily classified, tools and mode changing controls. *Figure 3-29*

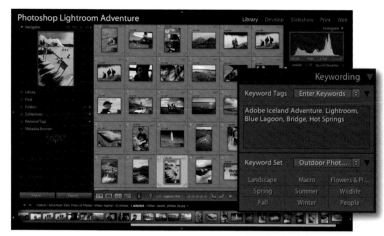

Figure 3-27

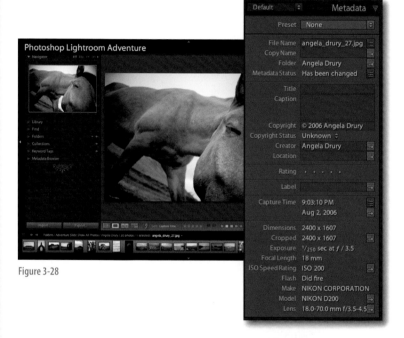

Figure 3-28

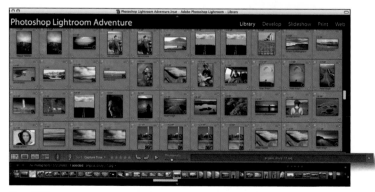

Figure 3-29

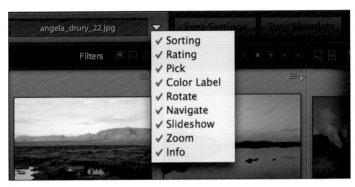

Figure 3-30

Figure 3-31

Figure 3-32

Figure 3-33

Figure 3-34

Figure 3-35

Figure 3-36

Figure 3-37

Why does my toolbar looks different than yours? Well, if you are in the Grid view and click on the inverted triangle on the far right of the toolbar, you will get the list shown in *Figure 3-30*. (In the Loupe view, the list is slightly different.) Only the checked items will be displayed on the toolbar. You can selectively check and uncheck this list to customize the toolbar. Let's go over the icons, starting from the far left.

Figure 3-31 These icons represent the view options: Grid, Loupe, Compare and Survey. Click to select.

Figure 3-32 This is the Painter, used for spraying specific keywords, labels, ratings, flags, settings, rotation, and metadata on single or selected images. Presets can be sprayed on as well. (It's not available in the Loupe view.)

Figure 3-33 This is where you set the Sort order for the Grid view and filmstrip. You have several choices ranging from Capture Time to Aspect Ratio.

Figure 3-34 Here are the rating options. You can rate by star, Flag as pick, Flag as rejected, and color.

Figure 3-35 The arrows change the orientation of images from clockwise to counterclockwise. Batch rotate is possible with multiple selections.

Figure 3-36 Click this triangle to start an impromptu slideshow of the selected images. (The look and feel of the slide show is determined in the Slideshow module, covered in Chapter 10.)

Figure 3-37 Last but not least is the slider that controls the size of the thumbnails in the Grid view. (The Loupe view has a Zoom slider control.)

NOTE *Critical keyboard command alert! Use the T key to toggle the toolbar menu strip off and on.*

Menu Commands

There are many ways to do the same thing in Lightroom. The menu commands, for example, often duplicate controls found in the panels or in the toolbar. However, there are a few menu commands that don't have an icon or display equivalent. For example, the all important Stacking function is done via the Photo→Stacking menu. *Figure 3-38* (It can also be done via the contextual menu, see below.) Enable Mirror Image Mode, which reverses all the images in the viewing area, is done via the View menu. I'll be sure and note these commands in the appropriate sections.

Figure 3-38

Contextual Menu

You can also bring up a contextual menu that contains many of the critical commands by right-clicking anywhere on the thumbnail in the Grid view or filmstrip, or on the image in any of the other views. *Figure 3-39*

Figure 3-39

Keywords are especially useful as your catalog grows and you need ways to find individual images or groups of similar images. Keywords, which can become part of your image file when you export, also make it easier for others to find your images. Not surprisingly, there are many ways to create and add keywords.

Creating & Applying Keywords in the Library Module

Keywords are words or phrases that describe or are related to the content of an image. Images can be tagged with keywords that then become associated with that image file. Keywords can be applied to a single image, or a batch of selected images. Here are some of the different ways you can use Lightroom to edit, create, and apply keywords.

Use the Keywording Pane

When you select a thumbnail in the Library module Grid view, if it has any keywords attached to it, they will show up in the Keywording pane under Keyword Tags. *Figure 3-40* If you select multiple images, all the keywords associated with all the images will appear. An asterisk next to a word indicates the keyword is applied to only some of the images.

Select Enter Keywords from the Keyword Tags pop-up menu to add or edit keywords directly in the text field. Selecting Keywords & Parents from the pop-up menu displays both the Parent and Child tags from the Keywords Tags pane. Selecting Will Export shows you which keywords will export with the image file. You can select which keywords to export from the Keyword Tags pane contextual menu under Edit Keyword Tag.

You can also add new words based on a Keyword Set or Recent Keywords. Choose from the Keyword Set pop-up menu and then click on the appropriate word that

Figure 3-40

NOTE Keywords are stored in Lightroom's database. To insure keywords are embedded into exported JPEG, TIFF, or PSD files, do not select Minimize Embedded Metadata in the Export dialog box. To insure keywords are attached to proprietary RAW files in an XMP sidecar file, select "Automatically write changes into XMP" from the Metadata tab in the Catalog Settings dialog box (File→Catalog Settings).

appears under Keyword Set. The word, along with a comma, will be added to the Keyword Tags text field. You can create your own Keyword Set preset by choosing Save Current Settings as New Preset from the pop-up menu. You can also edit or delete sets from this menu. When you hit Return, the new words are added to the image database.

Apply Keywords with the Painter

The Painter, found in the Library module toolbar (circled), is a handy way of adding keywords (and other information) to a single thumbnail or a group of selected thumbnails. *Figure 3-41* Simply click on the Painter spray can icon (it will disappear) and choose a criteria from the pop-menu (it appears when you click next to the word Paint in the toolbar). *Figure 3-42* If you select Keywords, for example, a type field box appears where you can type in a word or phrase. Place your cursor (circled) over a thumbnail and click to add the keyword or keywords. Clicking on the thumbnail again removes the phrase or word, or whatever you sprayed on with the Painter. Place the Painter back in its dock when you are finished by clicking on the empty circle in the toolbar.

Drag and Drop Keywords

Finally, you can add keywords by selecting the word in the Keyword Tags pane and dragging and dropping the word on top of a thumbnail or selection of thumbnails in the display window. A plus sign will appear over the thumbnail with the keyword (circled). *Figure 3-43*

NOTE *To import a set of keywords you've created in another application, such as Adobe Bridge, select Metadata→Import Keywords. To export keywords created in Lightroom for use in another application, select Metadata→Export Keywords.*

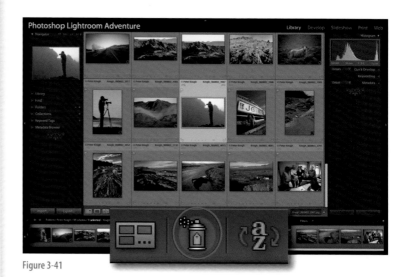

Figure 3-41

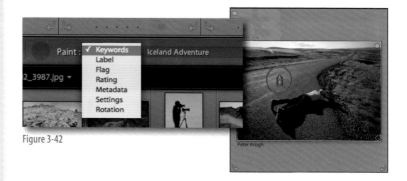

Figure 3-42

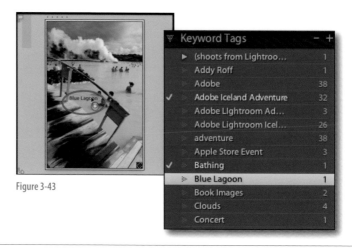

Figure 3-43

Metadata is all the "extra" data associated with an image file. Keywords, which were discussed in the previous section, are metadata. EXIF metadata is mostly fixed camera-provided information. IPTC metadata is data you enter into set categories. The gateway to viewing and working with this metadata is Lightroom's Metadata pane.

Using the Metadata Pane

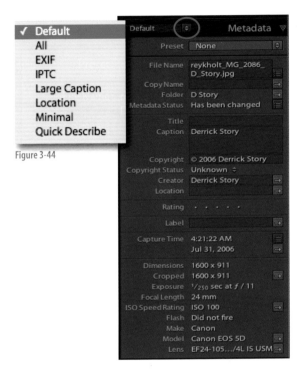

Figure 3-44

With Lightroom's Metadata pane, you can view as much metadata as you want (except keywords, which are listed in the Keywording pane). Click on the up and down arrows at the top of the pane to see your choices (circled). *Figure 3-44* If you choose All, the metadata list will be quite long and you'll have to scroll through it, unless, of course, you have a mega-large monitor. (It's even too long for me to show on this page!). The Default view, which is shown here, is much more manageable.

Adding and Changing Metadata

Let's work our way down the Default view and see what can and can't be done.

File Name. To change the file name, select the box to the right of the field (circled). *Figure 3-45* This brings up the Rename Photos dialog. *Figure 3-46* Choose custom text field from the File Naming pop-up menu and type in the new name. You can also choose from one of the Presets or select Edit, which brings up the Filename Template Editor, which allows you to further customize a file name. Any changes you make are also made to the original file.

Copy Name If this is a copy, clicking on the arrow will bring you to the original. *Figure 3-47*

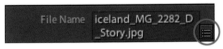

Figure 3-45

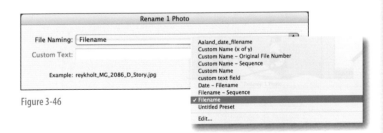

Figure 3-46

Figure 3-47

Folder If you click on the arrow next to this field, you'll be taken to the Folder pane in the right panel, and the folder containing the selected image will be highlighted. *Figure 3-48*

Metadata Status If there is a discrepancy between the information in the Lightroom database and the original file, you can resolve it by clicking on the metadata icon.

Title, Caption, Copyright, Creator, Location Titles, captions, copyright ownership, creator, and location can be read, added, or edited in their text fields. Copyright State is selected from the pop-up menu. Click on the arrow to the right of Creator or Location and other images meeting the same criteria in your catalog will appear in the main viewing window. *Figure 3-49*

Rating & Label Click on an appropriate number of stars. Type in Red, Yellow, Green, Blue, or Purple. (Or just select a color label from the toolbar.) Click on the arrow to the right of Label to display similarly labeled images. *Figure 3-50*

Capture Time You can change the Capture Time to compensate for an improper time and date. (When was the last time you changed your camera date and time to accommodate daylight savings time or a different time zone?) To do this, click on the arrow to the right of the Date Time field (circled). *Figure 3-51*

This will bring up the Edit Capture Time dialog box, in which you can set the correct time and date. *Figure 3-52*

Figure 3-48

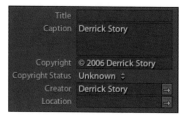

Figure 3-49

Figure 3-50

Figure 3-51

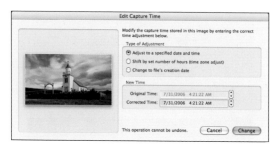

Figure 3-52

Figure 3-53

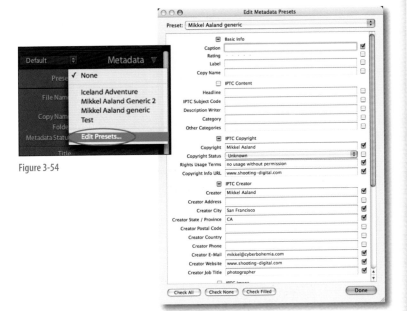

Figure 3-54

Dimensions, Cropped, Exposure, Focal Length, ISO Speed Rating, Flash, and Make, Model, Lens None of these can be changed, but click on the arrow to the right of the Cropped entry, and you'll be taken to the Develop module Crop Overlay tool. Click on the arrow next to ISO, Model, or Lens and all the images with the same criteria will be displayed. *Figure 3-53*

(The other fields in the other views, are pretty much self-explanatory.)

Create and Save Metadata Presets

You can save your metadata entries as a preset. Click on the up and down arrows to the right of the word Preset. Select Edit Presets from the pop-up menu (circled). Edit or check your data in the Edit Metadata Preset dialog box. *Figure 3-54* Select Save Current Settings as New Preset from the Preset pop-up menu. Name your preset and select Done. Next time, the preset will be available in the Preset pop-up menu. It will also be available when you Import images from the Import dialog box.

Batch Apply Metadata

If you want to globally apply similar metadata to a batch of images, select the images. Type in the information in the Metadata pane that you want to include, knowing that some EXIF fields can't be changed. That's all. All the selected images will now have these common metadata entries.

TIP Selectively sync metadata from one master image file (the active image) to a group of selected images by clicking the Sync Metadata button at the bottom of the right panel. In the resulting dialog box, check the boxes you want synchronized and then click Synchronize. (The Sync Settings button, next to the Sync Metadata button, is for synchronizing Develop module settings, which I'll explain at the end of this chapter.)

Selecting Thumbnails in the Grid View & Filmstrip

There is more to selecting a thumbnail than just placing your cursor over it and clicking. Where you place your cursor and which keys you press makes a difference. Let me show you what I mean.

Here, in the Library module Grid mode, I've placed my cursor over the first thumbnail on the left and clicked. It is now active, as signified by the lighter shade of gray frame. *Figure 3-55*

Figure 3-55

Here I've held the ⌘ key (Ctrl key in Windows), placed my cursor over the thumb to the far right, and clicked. Both thumbnails are now selected, but not the ones between. Only the thumbnail to the far left is active, as signified by an even lighter shade of gray frame. (Now we have three shades of gray.) *Figure 3-56*

Figure 3-56

Here, I held the Shift key, placed my cursor over the thumbnail to the far right, and clicked. Now all the thumbnails between the one to the far left (originally selected) and the far right are selected. Again, only the thumbnail to the far left is active, as signified by the lightest shade of gray frame. *Figure 3-57*

Figure 3-57

- *Selected* means the image will be included in any slideshow or print. You can also apply any preset to a group of selected images.

- *Active* means this is the photo the other selected photos synchronize to. (More on this later in the chapter.)

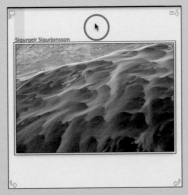

Figure 3-58

Figure 3-59

Figure 3-60

Figure 3-61

To deselect just one thumbnail when multiple thumbnails are selected, hold the ⌘ key (Ctrl key) and click on the thumbnail. To deselect all the thumbnails except one, simply click outside the image area, on the frame of the one you want to remain selected. *Figure 3-58* If you click on the image area, this makes that thumbnail active, while keeping the others selected as well.

You will also need to position your cursor correctly if you want to move a thumbnail to a collection or folder, or to another position in the main viewing area. Here I've placed my cursor outside the image area (circled), on the frame, clicked and dragged. The thumbnail doesn't move. *Figure 3-59*

Here I've placed my cursor over the image area (not the frame) and dragged. You can see a tiny version of the thumbnail move with my cursor. *Figure 3-60* I can move this thumbnail (or thumbnails, if I have multiple selections) to another location, or place it in any folder or collection of choice in the left panel. (Note! If you are viewing All Photographs from the Library pane, you cannot, I repeat, cannot, physically rearrange thumbnails within the main viewing area. You can sort images, however, which I'll get into later in the chapter.)

Selecting thumbnails in the filmstrip is similar to selecting thumbnails in the Grid Mode. *Figure 3-61* What happens when you select images in the filmstrip is dependent on what viewing mode (Grid, Loupe, Compare, or Survey) you are in. I'll note the difference in the appropriate sections.

Editing a Day's Shoot in Iceland

Let's walk through an editing session using images from a day's shoot in Iceland. In the end, I'll edit down to two specific groups of images: one group of "keepers" destined for a slideshow and/or print, and another group ready to email to some of the subjects in the shoot.

First, I import the images from a wonderful day hiking with fellow Adventure team member Bill Atkinson in the mountains near Nesbud. (Importing is covered in Chapter 2.)

The images are displayed here in the Library module's Grid view. *Figure 3-62* Notice how I have optimized the main viewing area of Lightroom by closing the right panel and collapsing the filmstrip. I'm working on a laptop and screen space is limited. I keep the toolbar visible. (The T key toggles it on and off.) I'll bring back the filmstrip later, in the Loupe view and when I filter my images.

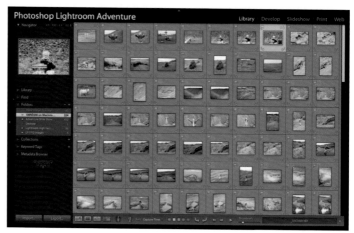

Figure 3-62

Setting Thumbnail Size

I can control the size of the thumbnails in the Grid view with the Thumbnails slider, found in the toolbar. At this point, I keep the thumbnails relatively small so I can view as many of them as I can at once. *Figure 3-63* But they're not so small (circled) that I can't view the extras such as Rotation Buttons and Color Labels.

Figure 3-63

Sort Order

I want to view the images sequentially, as they were shot, so I set the sort order to Capture Time from the drop-down. *Figure 3-64* Actually, I could have also set the Sort order to File Name. My camera is set to create sequential file names, so the effect is the same.

Figure 3-64

NOTE Many digital cameras add orientation information to the EXIF data, and Lightroom will read this and orient the shots correctly. If your thumbnail isn't shown in the proper orientation, you can use the rotate command to get it right. Simply click on the rotate icon in the toolbar, right-click on an image or thumbnail and use the contextual menu, or, depending on your Grid view option settings, rotate directly from the thumbnail.

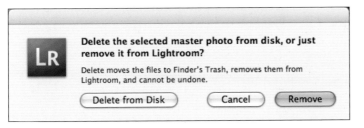

Figure 3-65

Figure 3-66

Figure 3-67

Deleting Images While in Grid View

To properly view and edit my images, I'm going to use Lightroom's single-image Loupe view. But before I go to that view, I often do a quick scan in the Grid view for duds. Since I don't like making decisions based on thumbnails, I am talking *obvious* duds, like completely black or white frames. Deleting is easy. Just hit the delete key. You'll get the dialog box shown here where you decide how serious you really are about "permanently" deleting a photo. *Figure 3-65* Remove just deletes the Lightroom reference to the file, while Delete places the actual original file in the Trash or Recycle Bin.

Loupe View

OK, on to the Loupe view, where you can examine an image at different magnifications. It's called the Loupe view after a specially made magnifying glass often used in traditional photography. *Figure 3-66* There are several ways to get into Loupe view: hit the E key, double-click on the thumbnail in Grid view, or just click on the image in the Navigator. You can also click on the Loupe view icon in the toolbar (circled). You can even use the clumsiest method of all: View→Loupe. I mostly use E, which stands for EASY! When I'm in the Loupe view, I usually reveal and enlarge the filmstrip so I can see my other images at a glance.

Setting magnification levels

Next, I'm going to set magnification levels in the Navigation pane. I'll start by setting my magnification level to Fit by clicking on that word (circled). *Figure 3-67* The white border around the preview indicates the entire image will be visible in the viewing window.

Here, I set the Navigator to 1:1 (circled) which is good for checking image sharpness. *Figure 3-68* Note where the white frame is now. I can move the frame around to different locations and when I hit the space bar or click my mouse it will snap to this spot on any selected image.

You can also choose higher magnifications if you wish. Click on the triangle to the right and a pop-up menu will give you choices.

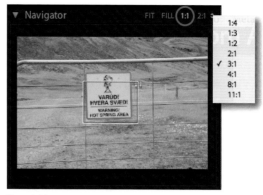

Figure 3-68

Customizing the Loupe view

You can customize what is displayed in the Loupe view in the View Options. (View→View Options/Loupe View tab) *Figure 3-69*

In an earlier figure (*Figure 3-64*), you can see I set the options to display Creator, Date Time, Exposure, and ISO. I selected "Show briefly when photo changes," so the data only stays over my image for a few seconds. You can set up two info displays with different information and toggle between them with the I key.

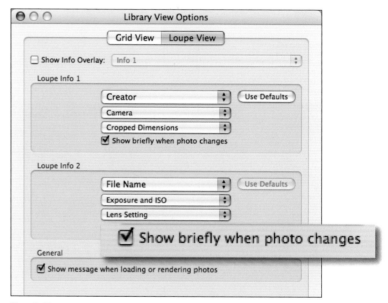

Figure 3-69

Moving between images

Move to the next image by simply hitting the right arrow key on your keyboard or the Navigate arrows that can be set to display in the toolbar (circled). *Figure 3-70* If you want to skip over images, scroll to the desired image in the filmstrip and select it there. You can also go back into the Grid view and select the image there, before returning to the Loupe view. (Remember: G takes you to Grid view, and E takes you to Loupe.)

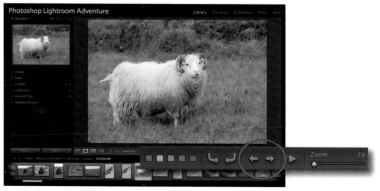

Figure 3-70

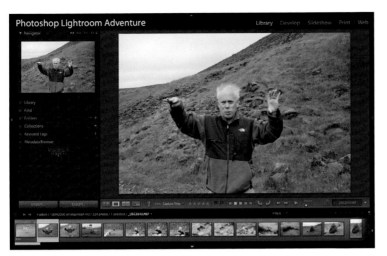

Figure 3-71

Figure 3-72

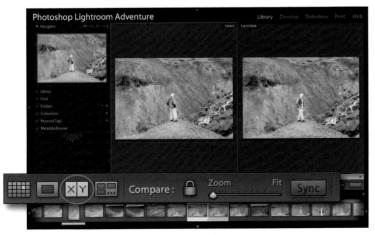

Figure 3-73

Zooming in Loupe view

Next, I want to zoom in and check for lack of sharpness or other technical flaws. This part is fun! As I wrote earlier, magnification levels are set in the Navigator. In this case, I'll start with Fit. *Figure 3-71*

Then, I set my Navigator level to 1:1 which is shown in *Figure 3-72*. (2:1 also works for me at this stage.) Lightroom remembers the last level used, and when I press the space bar, click on the image in the display window, or use the Z key, zooooommmm. I go right to the previous magnification. Hit the Space bar (or other zoom shortcut) and zooooommmm, again. A magnification will hold as you cycle through other images until you press the space bar, click on the image, or select Z again. (As I mentioned earlier, you can move the white frame in the Navigator tab to view another portion of your image.)

If you think this is cool, next I am going to show you one of the coolest Lightroom features of all: Compare view.

Compare View

I love the Compare view. Here's how to get to it. You must have at least two images selected, either in the Grid view, or in the filmstrip. Then, select the compare icon in the toolbar (circled), or press the C key. You should see something like this. *Figure 3-73*

Magnify in tandem

If I click on either image in the main viewing area or hit the space bar, both images will magnify to 1:1. I can set other zoom levels with the Zoom Slider. *Figure 3-74*

If I click the lock icon to unlock it, I can magnify the selected image only. *Figure 3-75* With the hand tool that automatically appears when I zoom in, I can locate specific parts of the image and, for example, check for focus directly in the main viewing window. If locked, the images will move together. Clicking Sync (circled) in the toolbar (or right-clicking on the images in the main viewing area and selecting Sync Focus from the contextual menu) puts both images into the same relative position, regardless of whether they are locked together.

Select vs. Candidate

See the words Select and Candidate at the top of the main viewing window? *Figure 3-76* The Select image remains visible while you use the keyboard arrow keys (or the arrows in the toolbar) to select new Candidate images for comparison. (You can also select new Candidates directly from the filmstrip.) To make a Select image a Candidate, or vice versa, click either the Swap or Make Select icons from the right side of the toolbar. *Figure 3-77* You can also right-click on either image and use the contextual menu to Swap Images.

Rating in Compare view

At the bottom of each image in the Compare view are rating controls; you can use them to apply stars, colored labels, or picks on the fly. *Figure 3-78*

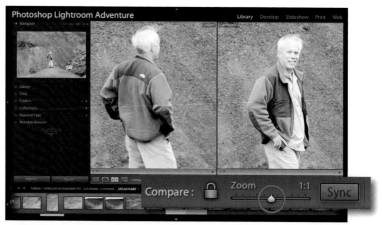

Figure 3-74

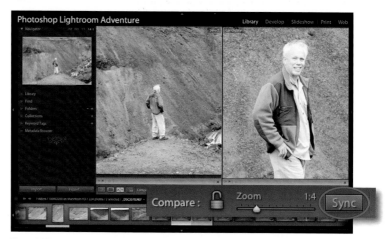

Figure 3-75

Figure 3-76

Figure 3-77

Figure 3-78

Figure 3-79

Survey View: Compare More Than Two

You don't have to restrict yourself to comparing only two images at time. You can compare as many as reasonably fill the main viewing area. Back in the Grid view, select the images you wish to compare. *Figure 3-79*

Figure 3-80

Now select the Survey icon from the toolbar (circled). Depending on how many images you selected, you'll see something like this. *Figure 3-80* (At some point, selecting too many images for the Survey view becomes counterproductive. The images become so small you might as well go back to viewing them in the Grid view.)

You can't change the magnification levels in the Survey view. (If you try, you are brought back to the Loupe view). But you can easily reduce the number of images in the main viewing area by clicking on the X in the lower right corner of each image. *Figure 3-81* You can also apply ratings from the main display window, toolbar, or contextual menu to the selected image, which is the one with the white border. To select another image, just click on it.

OK, let's not forget we are on a mission, not just looking at pretty pictures. We must make decisions! Which brings us to rating, flagging, and assigning values.

Figure 3-81

Applying Stars, Flags, and Colors

There are three distinctly different ways to rate or tag images in Lightroom: Stars, Flags, and Colors. *Figure 3-82* Rating controls are located in the toolbar, or, depending on how you set your view preferences, you can apply stars directly from the thumbnails. You can also set the Painter tool from its pop-up menu to spray Labels, Flags, or Rating on single or selected thumbnails. There are several useful key commands, as well:

- *Stars* Typing a number 0–5 will assign that many stars.

- *Flags* Each option has a keystroke:

 P is a "Pick"

 U is "Unflagged"

 X is a "Reject"

- *Colors* all but Purple have a keystroke:

 6 is Red

 7 is Yellow

 8 is Green

 9 is Blue

To delete a color, simply type the key command again. You can stick to one rating method or use a combination of all three. (If you have used Adobe Bridge, Stars and Colors should be very familiar.)

For this example, I'll use two methods. I'll assign a blue color to the images I'm going to email to some of the people Bill and I met on our hike. *Figure 3-83* I'll assign a 5-star rating to my "keepers", the ones I want for a slideshow and to print. *Figure 3-84* (I'm not yet used to using the Flags, but I can see their potential.)

Why don't I just create a Collection for each category and place my picks there?

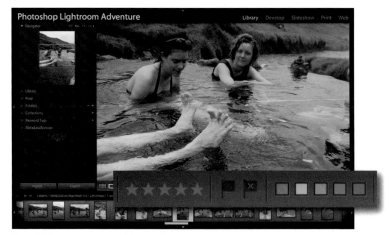

Figure 3-82

Figure 3-83

Figure 3-84

Good question. Theoretically, all the ratings live with the image until you remove them, but I tend to use ratings and labels as a temporary, on-the-fly solution and don't rely on them for a permanent organizing strategy. It's just too easy to inadvertently change a rating or label, or forget the rationale for using it in the first place. Eventually, as you'll see, I do end up creating and using Collections.

Filters

What good are the tags, flags, and color codes if you can't filter them preferentially? Lightroom's filters are found at the top-right of the filmstrip. *Figure 3-85*

Some are also found under the Edit menu. To enable filters, select Library→ Enable Filters or use the keyboard command ⌘+L (Ctrl+L). Filters can also be controlled directly from the filmstrip by clicking on the switch icon at the end of the filmstrip (circled). *Figure 3-86* Clicking on the appropriate rating (i.e., star, flag, or color) will filter everything but that selection. Deselect by clicking on the rating again or, for color labels, right-click and select None in the contextual menu.

You can select multiple ratings, i. e., five stars *and* red labels. You can also choose to filter stars according to various criteria. Clicking on the equals symbol (or less than or equal to, or greater than or equal to symbol) lets you pick one of those options. *Figure 3-87*

Here, I enabled the 5-star *Rating is Equal to* filter and you can see my choices are all displayed in the display window. *Figure 3-88*

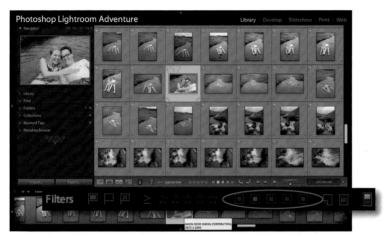

Figure 3-85

Figure 3-86

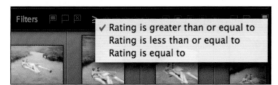

Figure 3-87

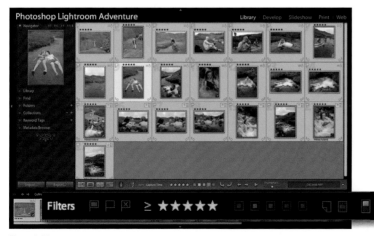

Figure 3-88

Creating a Collection from Picks

Before I filter the Blue labels I'm going to place the 5-stars in a collection. I can add them to an existing collection by selecting them all and dragging them into the preexisting folder in the Collections pane. Or I can select all (⌘+A on a Mac, Ctrl+A in Windows) and then, in the Collections pane, click on the + sign (circled). *Figure 3-89*

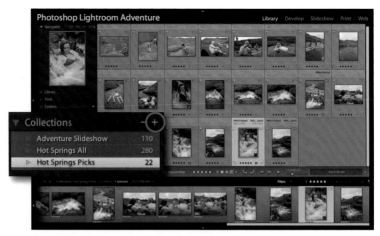

Figure 3-89

In the Create Collection dialog box, I check "Include selected photos" and "Create as a child of 'Hot Springs All Photos'" and type in a name for my collection. *Figure 3-90* Then I click Create. Now all my 5-star picks are ready for printing or sharing via the Slideshow or Web modules.

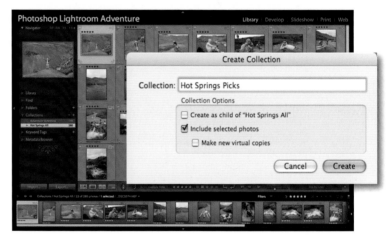

Figure 3-90

Next, I deselect the star ratings by clicking on them, then I filter the Blue-labeled picks. *Figure 3-91* Note the blue outline in the thumbnails. I've set my View Options preferences to show color labels. (View→ View Options)

This time, I create a collection called Email Photos and place the Blue labeled picks there, ready for export.

I'm done, at least for now.

> NOTE *If there were some overlap between my selections, it wouldn't have mattered. Images can reside in multiple Collections.*

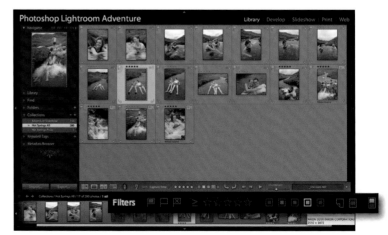

Figure 3-91

You can create multiple versions of the same image—say, one in black and white, the other with a radical crop—and have all the versions available to you in a Stack or in a Collection. Since Lightroom saves only a set of processing instructions, very little extra space is taken on your hard drive. Let's see how to do it.

Using Virtual Copies to Create Multiple Versions

First we need to create a virtual copy. Do this in by selecting the image you wish to work on. Now place your cursor over the thumbnail or image. (You can do this in the Grid or Loupe view.) Right-click and bring up the contextual menu. *Figure 3-92*

Figure 3-92

Select Create Virtual Copy from the pop-up menu. You can create as many virtual copies as you want. I'm going to create three copies. Your copies will be adjacent to each other, and copies are indicated by a turned page icon in the lower left corner (circled). *Figure 3-93* If you double-click on this turned-page icon, you will return to the original image, regardless of where it is.

What you do next is up to you. In my example, I cropped one version into the Develop module to give it a panorama aspect ration. In another, I've converted it to black and white. In yet another I enhanced the color values. *Figure 3-94*

Figure 3-93

Figure 3-94

You can stack the images or create collections with different names and drag and drop individual versions into the appropriate collection. You can have the same image in as many collections as you wish. You can also add different keywords or other metadata to each virtual copy. You can also use the filmstrip filter to display only Virtual Copies. (Click on the turned-page icon in the filter criteria bar.)

Creating & Using Stacks

Stacks are another useful way to organize your images. Imagine a traditional light table (if you can!) and remember how you could set one slide on top of another, creating a relational stack. Well, that's pretty much what you do with Lightroom stacks.

Start in the Grid view by selecting a group of related images that you want to stack together. The images must be stored in the same folder and you can't stack from within a collection. (To select multiple sequential images, click on a thumbnail, then hold the Shift key and click on the last thumbnail in the sequence. All the thumbnails between will also be selected.) *Figure 3-95*

Figure 3-95

Next, right-click on one of the selected thumbnails. Be sure to click on the image area, not the outer frame. As long as the selected images are stored in the same folder, this should bring up the contextual menu shown here. *Figure 3-96* You can get the same options by selecting Photo→Stacking from the menu bar.

Your selected images will be collapsed into one and the visible image will display a number in the upper left corner indicating the number of stacked images (circled). *Figure 3-97* You can change the order of an image in a stack via the Stacking menu or the following keyboard commands:

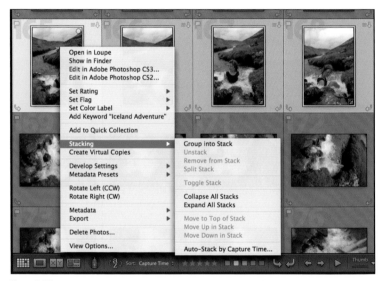

Figure 3-96

- *Shift + [* Move up in Stack

- *Shift +]* Move Down in Stack

- *Shift + S* Move to top of Stack

You can also remove images from a Stack via the Photo menu, or by right-clicking on a thumbnail and choosing Remove from Stack from the contextual menu.

Figure 3-97

Figure 3-98

Figure 3-99

Figure 3-100

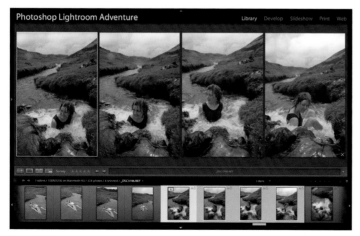

Figure 3-101

Working with Stacks

To expand a stack, right-click to bring up the contextual menu and select Expand Stack, or simply click on the stack icon in the top thumbnail. You also can choose to Expand All Stacks if you have multiple stacks and you want to view all the contents. Numbers in the upper left corner of the thumb will indicate the grouping order (circled). *Figure 3-98*

Your collapsed stack will look like this in the filmstrip (circled, top). *Figure 3-99* If you select the stack in the filmstrip and double-click on it, you will see the top image in the Loupe view. Click on the stack thumbnail in the filmstrip and the stack will expand as shown here (circled, bottom), and you can use your arrow keys to select and view the other images in the Loupe view one by one.

You can also select the Survey view (circled in *Figure 3-100*) and, when you expand the stack in the filmstrip, all the images will appear in the main viewing window. *Figure 3-101* (Obviously, the larger the stack, the smaller the images in the main viewing window.)

To split a stack, first expand it, then click on one of the middle thumbnails and select Split from the contextual menu. This will make two stacks: one including all to the left, and one containing the selected image and all to the right.

Unstacking Stacks

To unstack a stack, go to the contextual menu and select Unstack. The images will now appear as distinct thumbnails, as they were before stacking.

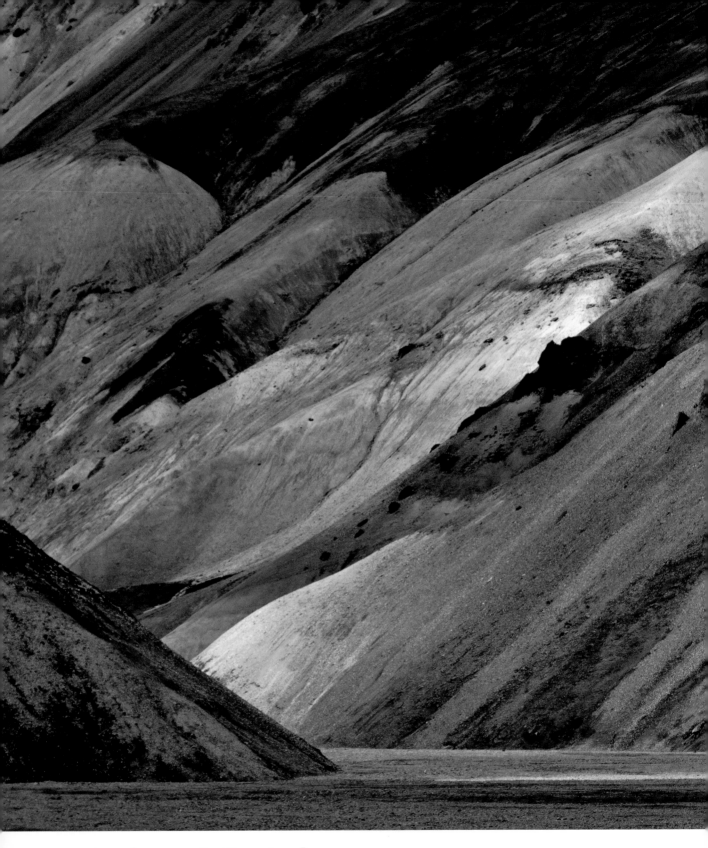

Michael Reichmann

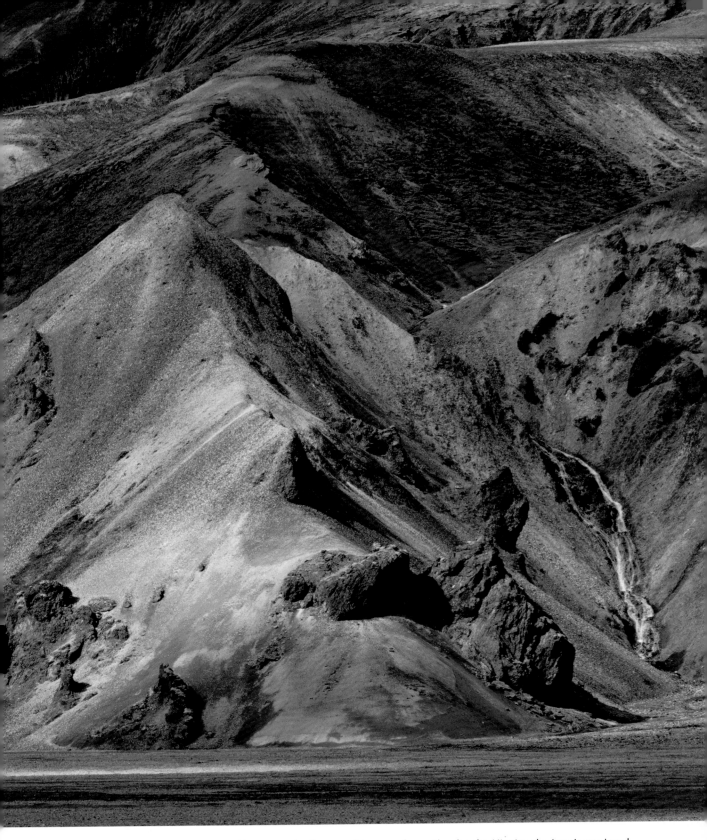

I've known Michael for many years and he wrote the foreword to one of my other books. His site, the Luminous Landscape, is considered one of the most respected sources for information on digital imaging. Unfortunately, I didn't see much of Michael on the Iceland adventure. He and Bill Atkinson spent much of the time in "the wild," tracking down glorious shots such as this one. But later, when Michael sent me a collection of his favorite shots, I was knocked out. He did indeed capture the Luminous Landscape of Iceland.

Using Quick Develop

The Library module contains streamlined image processing capabilities via Quick Develop. Quick Develop is especially handy if you want to apply a simple white balance correction or a relative exposure bump to a large group of selected images.

You'll find the Quick Develop tools under the Histogram in the right side panel of the Library module. To expand any pane, click on the arrow key (circled, top). To reveal the Crop Ratio and Treatment choices, you need to click on the up and down arrows (circled, bottom) *Figure 3-102* When you apply Quick Develop settings, the image previews, regardless of what viewing mode you are in, will update accordingly. The image in the Navigator window will also update to reflect your adjustments.

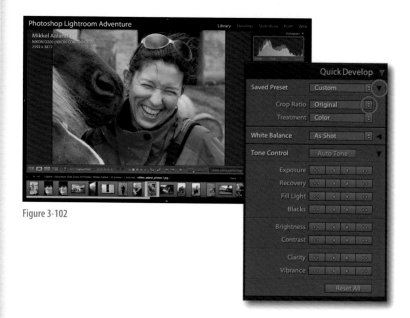

Figure 3-102

Applying Saved Presets

Several presets ship with Lightroom which apply settings ranging from Aged Photo conversion to Zero'd to your selected images. *Figure 3-103*

You can also make your own presets in the Develop module, which will appear in the Saved Preset pop-up menu as well. (I'll get into creating Develop presets in subsequent chapters.)

To apply a preset to one image, select that image and choose the appropriate preset. To apply a preset to a batch of images, select all the images you wish in the display window and then choose the appropriate preset. Pressing ⌘+Z (Ctrl+Z) reverts to the previous setting and clicking the Reset button at the bottom right of the Quick Develop pane takes you back to the original camera settings.

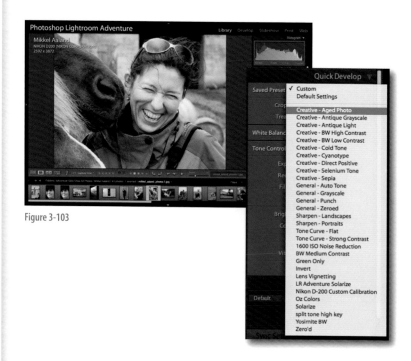

Figure 3-103

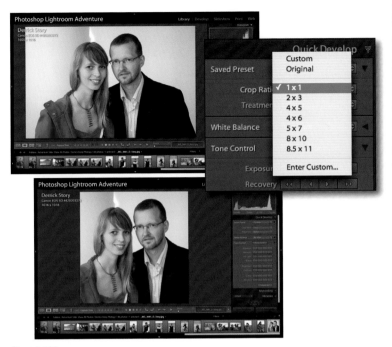

Figure 3-104

Figure 3-105

Figure 3-106

Crop ratio

The crop command in Quick Develop doesn't crop to a user-defined area, but applies a preset aspect ratio or a ratio of your choice. *Figure 3-104* It's really useful when you have a batch of images that you want to fit to a specific proportion, such as a standard-size commercial print. (If you want to improve composition or eliminate unwanted parts, I suggest you use the Develop module's Crop Overlay tool covered in Chapter 4.)

Treatment: Color or Grayscale

Under Treatment, you can choose between Color and Grayscale. *Figure 3-105* Tweak the conversion using other Quick Develop Exposure controls. However, you won't have the fine tuning (i.e., Grayscale Mix controls) of the Develop module to really make a special black and white conversion (See Chapter 5).

> NOTE *You can always convert to grayscale at any time in the Library module by selecting an image and pressing the V key, which toggles between black and white and color.*

White Balance

White Balance (WB) settings can be changed here. *Figure 3-106* You can leave the setting to reflect the camera setting (As Shot) or choose Auto or a range of other options. Your selected image will immediately change to reflect your choice. White balance controls will affect JPEG and TIFF images, although they are much more effective on RAW files. You can fine-tune your white balance settings with the Temp and Tint controls. The single arrows make minor adjustments, while the double arrows make coarser ones.

Tone Controls

Clicking on the Auto Tone button can be a quick way to improve an image. Auto Tone works by automatically adjusting tonal and color values, and for some images it does a good job. For others, it's a disaster. The only way to find out is to try.

Under the Auto Tone button, there's a range of useful tone controls. The Clarity adjustment, for example, gives a nice punch to an image that is especially evident when you go to print. *Figure 3-107* You need to click on the arrow (circled) to reveal all the choices. The effect of these controls on your images mirror those found in the Develop module, which I'll go into more detail in the following chapters. The primary difference is in the way they are applied via the > and >> buttons. Again, the > button is for minor adjustments and the >> is for more coarse adjustments.

> *Tip: Hold the Option/Alt key and the Clarity and Vibrance controls change into Sharpening and Saturation.*

Quick Develop for Multiple Images

The ability to easily and quickly apply a particular look or tonal correction to a batch of images is one of the really cool things about Lightroom, and what sets it apart from the previous generation of image processing software.

To do this:

1. Select the images you wish to work on in the image viewing area. *Figure 3-108* Pressing ⌘+A (Ctrl+A) selects all. Using ⌘+D (Ctrl+D) deselects all. The histogram will only reflect values of the active image.

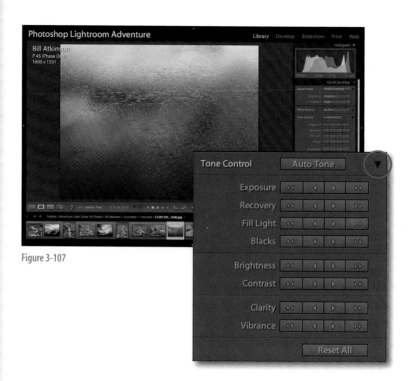

Figure 3-107

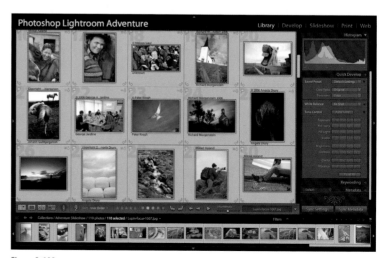

Figure 3-108

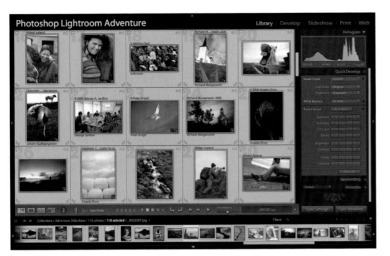

Figure 3-109

Figure 3-110

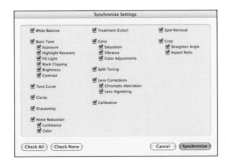

Figure 3-111

2. Select the appropriate white balance or tone controls. (In this example, I selected grayscale.) The changes will be visible in all the selected thumbnails. *Figure 3-109* Use Reset to revert back to your original camera settings.

When you select multiple images and work with the Quick Develop pane in the Library module, remember you are applying relative changes to each image. For example, if you start with one image that is overexposed 1 stop, say, and another is 1.5 stops over, if you increase the Exposure value, the starting point for the first is image is 1 stop over and the starting point for the other is 1.5. (This may seem totally logical to you, but, as you will see, when you apply previous settings to one or multiple images in the Develop module, you are applying exactly the same settings in a nonrelative way, which may or may not be effective.)

Sync Settings

What if you want to apply some, but not all, of the settings from one image to a batch of images? Then you use the Sync Settings option at the bottom of the righthand panel. *Figure 3-110*

Make your corrections to the active image. Then select one or more other images. Click on Sync Settings. When the Synchronize Settings dialog box appears, choose only the settings you wish to apply to the other images and then select Synchronize when you are done. *Figure 3-111*

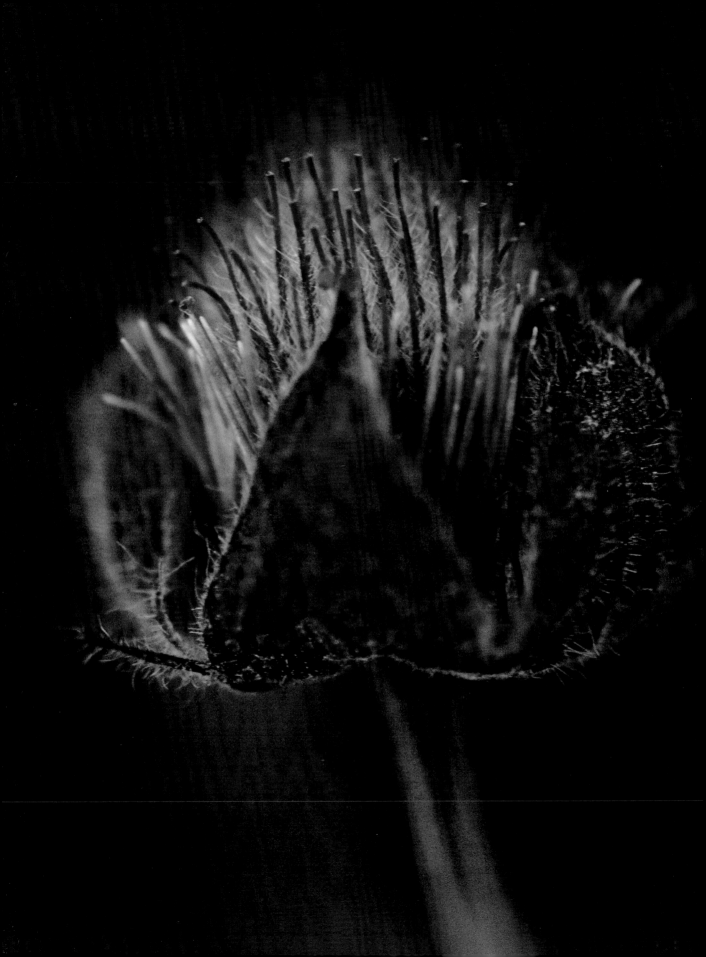

The Develop Module

The Develop module is where the heavy image processing occurs. Here you'll find sophisticated, yet easy to use, tone and color developing controls. You'll also find cropping, straightening, and basic retouching tools for removing or altering unwanted image defects. With all these tools at your fingertips, you'll be able to create a look that is uniquely yours and save it as a preset, ready to apply to other images. This chapter introduces this powerful module and goes into detail on using its view modes, retouching options, and cropping tools. In subsequent chapters, I'll provide more details on mastering the Develop module's tonal and color capabilities and creating useful presets based on the work of several Iceland Adventure team members.

Chapter Contents

PHOTO CREDIT: Angela Drury

The Develop Module Revealed

Let's start with an overview of the Develop module tools. Then, later in the chapter, I'll get more specific on how you can use the tools to get the most out of your digital images. Like the Library module, the Develop module is divided into five main parts.

The view control panel is on the left, the adjustment control panel is on the right, and the main display window is in the middle. *Figure 4-1* The panels are divided into panes with specific functions. Near the bottom of the window are the toolbar and filmstrip.

As we learned in Chapter 1, the left and right panels, toolbar, and filmstrip can easily be hidden by clicking on the triangle icon, maximizing the viewing area. Let's take a expanded look at the basic components of the Develop module and see what they do.

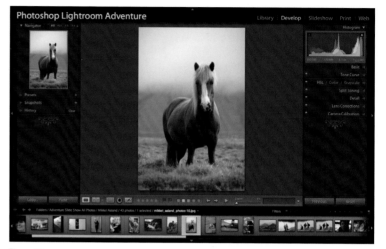

Figure 4-1

> *TIP* Regardless of which Lightroom module you are in, press the D key and you will be taken to the Develop module. Pressing the G key will always take you back to the Library's Grid view.

The Navigator Pane

This should look familiar by now. The Navigator displays the current active selection. *Figure 4-2* Not only is it useful for at-a-glance reference, but it is where you set the magnification level for the zoom controls (circled, left). (For more on the magnification controls, see Chapter 3.)

A white frame (circled, right) shows the area of magnification; by clicking on and moving the frame, you reposition the image in the main viewing area as well.

Figure 4-2

Figure 4-3

Figure 4-4

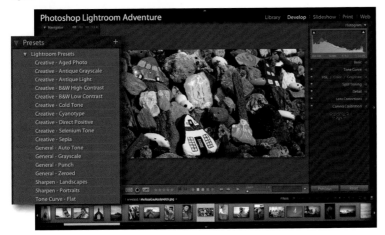

Figure 4-5

Changing Navigator window size

You can make the Navigator window (and entire left panel) larger by placing your cursor (circled) over the right edge and dragging. This won't affect the size of vertical images, but you'll get a lot more real estate to display horizontal images when you enlarge the panel. The figure on the left is collapsed, and the figure on the right is expanded as far as the panel will go. *Figure 4-3*

Previewing in the Navigator pane

Wanna see something really cool? Open the Presets pane and wave your cursor over the presets (circled, left). The image in the Navigator window immediately changes to reflect the settings. *Figure 4-4*

The Navigator will also show you in real time your cropped photo (right), before you even apply the crop! (I'll describe how to apply a crop overlay later in this chapter.)

Presets Pane

Lightroom ships with several presets listed in the Presets pane. *Figure 4-5* As I just noted, if you pass your cursor over your Preset of choice, you can observe the effect in the Navigator window. If you like what you see, just click on the Preset name and it will be applied to the image in the main display window. The Presets shown here are organized in folders, for example, Lightroom Presets and User Presets. You can create more folders by selecting Develop→New Preset Folder from the menu bar. You can also create custom Presets, and later in the chapter I'll show you how.

Snapshots Pane

The Snapshots pane is analogous to Photoshop's History palette snapshot. You can "freeze" a moment in your work and save all your settings in a Snapshot, which can be retrieved at a later date. *Figure 4-6* You can save as many Snapshots as you like. Click on the snapshot name and the saved settings will apply. The keyboard shortcut ⌘+Z (Ctrl+Z) will undo the effect of the snapshot. (Future versions of Adobe Camera Raw, I'm told, will actually read Lightroom Snapshots. (This will be a great way to bring multiple versions of the same image into ACR.) Snapshots apply only to the image you are working on. Even if you clear the History, your snapshots will remain. To create a snapshot, click on the [+] sign. To remove, select and then click on the [-] sign. Naming is done by clicking on the text and typing.

> TIP *Make the side panels go away or reappear at any time by hitting the Tab key. Hit the L key repeatedly to cycle between lights on, dim, and off.*

History Pane

Every adjustment you make in the Develop module is recorded in the History pane. *Figure 4-7* You can step backward either sequentially or in jumps by placing your cursor over the state and clicking. You can view various states in the Navigator window by just passing your cursor over them. History states are saved automatically and are available when you re-launch the application or reselect an image. There is no limit to the number of history states recorded. To clear the History tab, select Clear.

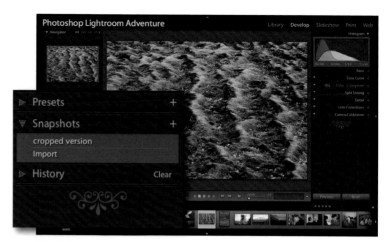

Figure 4-6

Figure 4-7

Figure 4-8

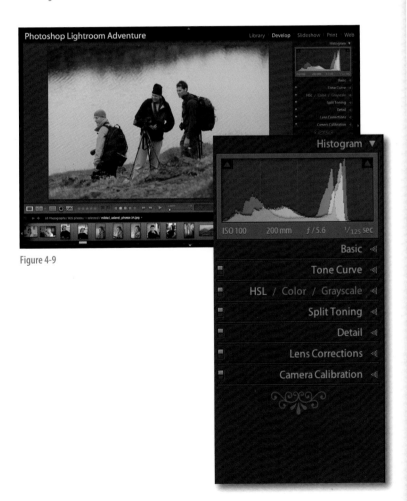

Figure 4-9

Copy and Paste

Copy and Paste buttons are another way to transfer adjustments from one image to another. When you click Copy, you get the Copy Settings box, where you can select which settings you wish to transfer. *Figure 4-8* Then, with one, or multiple images selected in the Filmstrip, select Paste and your selected settings will apply to the selected images.

Image Adjustment Panel

Anyone familiar with the controls found in Adobe Camera Raw (ACR) should feel right at home here with Lightroom's Develop module adjustment panel. *Figure 4-9* And anyone using ACR in CS3 should feel even more at home: the ideas behind the controls are just about exactly the same.

The Histogram pane at the top of the panel gives you a real-time readout of the tone and color distribution of the active image. (This histogram is interactive, meaning you can actually make tonal adjustments directly from it.) Basic camera data is placed conveniently under the histogram and over- and underexposure warning controls are found at the top left and right of the Histogram as well. (Right-click on the histogram to customize the display.)

The image adjustment panel is roughly divided into four color and tone controls followed by Detail (sharpening and noise reduction), Lens Corrections, and Camera Calibration. With the exception of the

Basic pane, adjustments made in the pane can be turned on and off with the switch icon on the left (circled) *Figure 4-10* I'll provide much more detail on using these controls later in the chapter.

Figure 4-10

Previous/Sync and Reset Buttons

At the bottom of the image-adjustment panel are the Previous and Reset buttons. *Figure 4-11* When you have more than one thumbnail selected in the filmstrip, the word Sync appears instead of Previous. *Figure 4-12* Choose Previous when you want to apply the settings of the previous image to the current image and bypass the Synchronize Settings dialog box. Choose Sync when you have a lot of images you want to apply specific settings to. After you click Sync, the Synchronize Settings dialog box appears, where you can choose which settings you want to apply from the primary selected image. Use the Reset button to return your image to the default settings. Holding the Option (Alt) key changes Reset to Set Default which, if clicked, makes the current settings the new default.

Figure 4-11

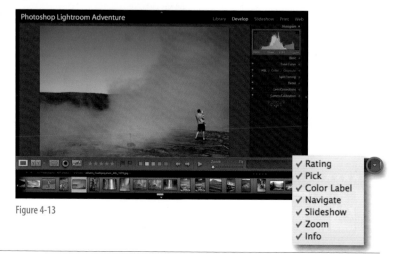

Figure 4-12

The Develop Toolbar

The Develop toolbar contains the Loupe and Before/After view icons. It also includes a crop overlay tool, a red eye removal tool and a Clone/Heal tool for getting rid of unwanted dust or other artifacts. *Figure 4-13* You can set the toolbar with the pop-up menu (circled) to display tools for rating, pick, color label, navigate, slideshow, zoom, and info. The toolbar will look different depending on how you set your options.

Figure 4-13

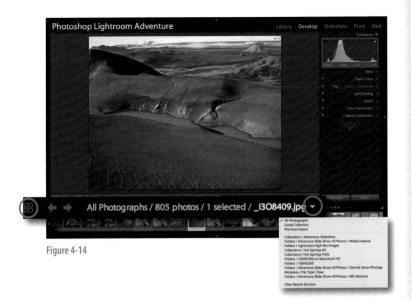

Figure 4-14

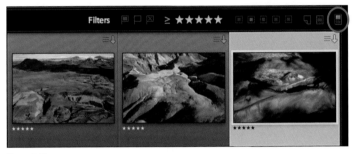

Figure 4-15

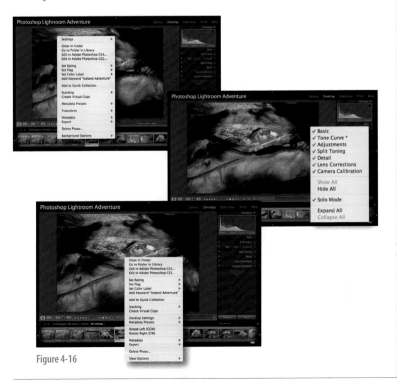

Figure 4-16

Filmstrip in the Develop Module

Images selected in the Library module show up in the Develop module filmstrip. *Figure 4-14* Clicking on the icon to the far left (circled) will take you back to the Library module grid view. The left and right arrow icons will take you back and forth between previously visited modules. You can navigate to other image collections directly from within the Develop module by clicking on the arrow to the right of the Folders path (circled) and navigating from the pop-up menu that appears.

To the far right of the filmstrip are the filter controls (which we explored in detail in Chapter 3). Here you can set filter criteria and turn filtering on or off with the switch icon (circled). *Figure 4-15*

The toolbar, as noted in Chapter 1, can be customized or made to disappear altogether.

Contextual Menu Commands

Rght-click on an image in the main viewing window to access a range of useful commands (top). *Figure 4-16* Right-click on a pane header in one of the side panels to get viewing options which vary from panel to panel (middle). I find the "Solo" mode particularly useful. Right-click in the filmstrip on a thumbnail to access another set of commands (bottom).

> NOTE *Many of the commands discussed here are duplicated in the menu bar under Develop, Photo, and View.*

Develop View Options

If you thought the viewing modes in the Library module were useful, wait until you get up to speed with the ones in the Develop module. Not only can you view your images with the standard Loupe single image mode, but the Compare mode is simply awesome.

Loupe View

The most commonly used view is the Loupe view, which displays a single image that is easily magnified via the Navigator pane, a click of the mouse, or the Zoom slider in the toolbar. *Figure 4-17* When you enter the Develop module, you'll be taken to the previously used view mode. Select the Loupe view icon (circled) or use the D key to bring you to the Loupe view. (In the Library module, pressing E took you to the Loupe view.) Control informational overlays via the Develop View Options dialog box. (Develop→View Options)

Compare View

The Compare view icon is found in the toolbar, sandwiched between the Loupe view icon and the Crop Overlay icon (circled). *Figure 4-18* If you click on the triangle you will see a pop-up menu that shows you Compare choices. (If the toolbar isn't visible, press the T key to reveal it.)

You can select the compare view of choice from the pop-up menu or by clicking on the compare icon cycles through the various options as well. Farther to the right in the tool bar are the Before & After controls, where you can choose to copy or swap settings between before and after versions. *Figure 4-19* shows you the Before/After Left/Right view without magnification.

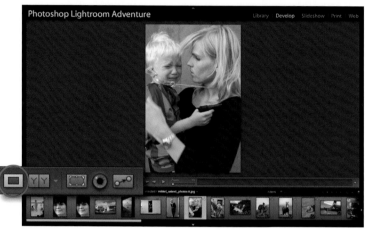

Figure 4-17

Figure 4-18

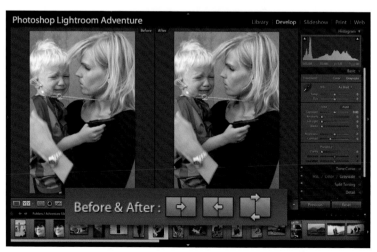

Figure 4-19

Figure 4-20

Figure 4-21

Figure 4-22

Figure 4-23

Figure 4-20 shows you the Before/After Left/Right view with magnification. Note both images zoom to the same magnification. You can also use the Hand tool, which appears automatically in this view, or the Navigator, to move within both image areas simultaneously and analogously.

Figure 4-21 shows you the Before/After Split view with magnification. I find this view especially useful for checking color changes and the effect of noise reduction settings.

Figure 4-22 shows you the Before/After Top/Bottom view.

Figure 4-23 shows you the Before/After Top/Bottom Split view.

> TIP *Right-click on either the Before or After view to bring up a contextual menu with options to apply a Snapshot or develop preset directly to the image, and much more.*

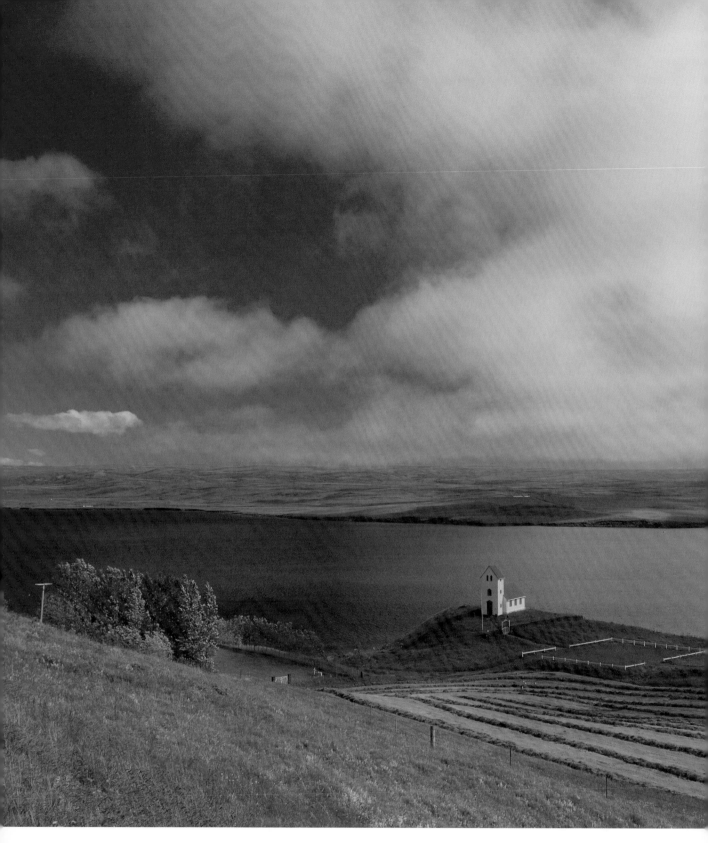

Mikkel Aaland

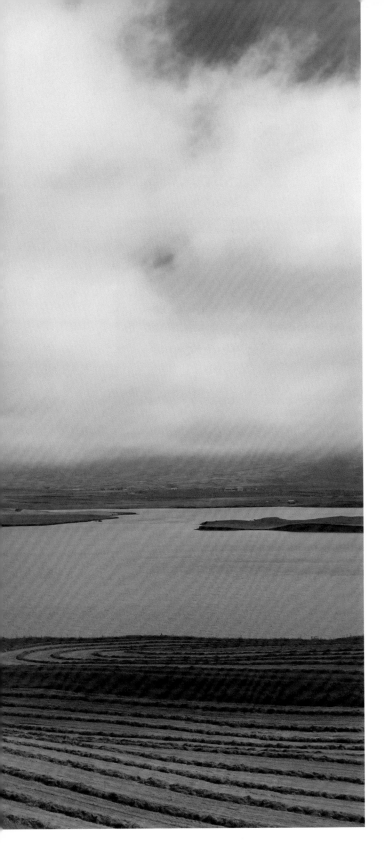

I think everyone on the Iceland Adventure team stopped and photographed this lonely church near Nesbud at one time or another. It was difficult to choose which shot to use in this book; they were all so beautiful. I finally settled on my own shot, because with an off-axis horizon it was the most flawed. It took Lightroom's crop and straighten tools to make it right, and provides yet another testimonial to the application's usefulness.

Cropping in Develop Module

Cropping in the Develop module can be used to improve an image by isolating critical content, sizing an image to a specific aspect ratio, or straightening an off-axis horizon line. Of course, like everything else in Lightroom, cropping is completely changeable at any time.

The Crop Overlay tool is located in the toolbar. (Type T if the toolbar isn't visible.) Click on the crop overlay icon (circled) and you are ready to go. *Figure 4-24*

There are several ways to use the Lightroom Develop module's Crop Overlay tool. You can set the crop area and then drag the image around within the stationary crops marks. You can also use the Crop Overlay tool (like the familiar Photoshop Crop tool) to frame the crop area exactly where you want it. (The Photoshop Crop tool actually crops away pixels, while Lightroom creates a non-destructive overlay.)

Figure 4-24

Standard Crop with Maintained Aspect Ratio

Here, I select the crop icon and the crop handles appear on the perimeter of the image. *Figure 4-25* The lock icon is locked (circled), which keeps the current aspect ratio regardless of crop size.

Figure 4-25

Grab the handles and shrink the window as shown here. *Figure 4-26* If you want, you can place your cursor inside the bounding box and move the image around until you have it positioned exactly as you want it. (If you place your cursor outside the bounding box, you can rotate the image.)

Figure 4-26

Figure 4-27

When you hit return, your cropped image appears and you are out of the Crop mode. *Figure 4-27* To return to the Crop mode, simply click on the crop icon in the toolbar again.

> NOTE *If you are in the Crop mode and right-click, you get a contextual menu. Useful commands include Reset Crop, Constrain Aspect Ratio, Crop to Same Aspect Ratio, and some of the Transform options.*

Standard Crop with Unrestricted Aspect Ratio

In this example, I've unlocked the aspect ratio (circled) by clicking on the lock icon. *Figure 4-28*

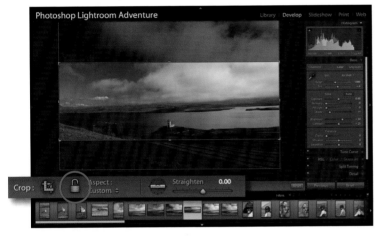

Figure 4-28

Now you can move the bounding box into any aspect ratio you want. I'll use this feature to create a panorama. *Figure 4-29*

Figure 4-29

Using a Crop Preset

You can use a preset crop ratio as well. (Like you can in the Library module). When you click on the triangle next to Original, the pop-up menu is shown. *Figure 4-30*

If you select Enter Custom, you can set your own aspect ratio that will appear in the menu next time you use it. It will also appear as a choice in the Library module crop tool. Here, I've created a preset for the popular 16:9 aspect ratio (circled).

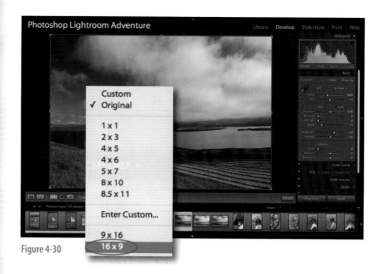

Figure 4-30

Crop Directly on Image

If you select the crop tool icon in the toolbar, you can use the familiar crop to the image technique (as done in Photoshop). The tool disappears from the toolbar and appears after you make your crop selection. *Figure 4-31*

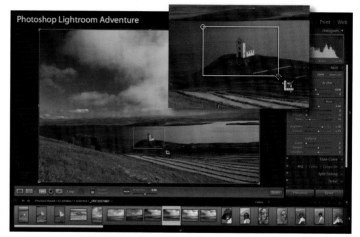

Figure 4-31

Now you can drag a crop exactly where you want it. You can use the handles on the edges (just like in Photoshop) to shrink or enlarge the window. You can also place your cursor inside the box (it turns into a hand icon) and move the image within the crop. *Figure 4-32*

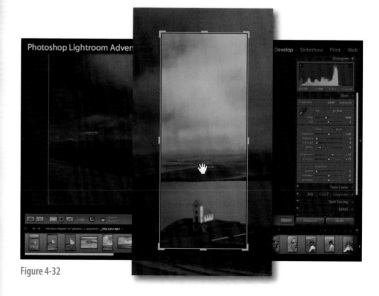

Figure 4-32

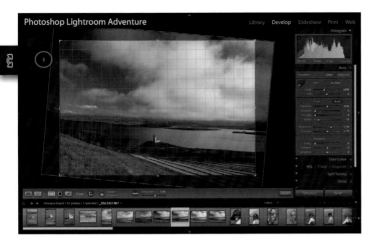

Figure 4-33

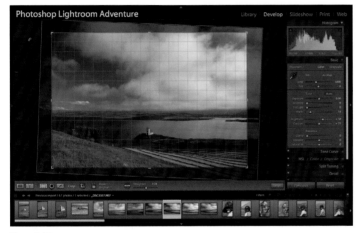

Figure 4-34

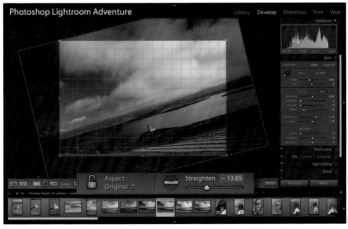

Figure 4-35

Straightening a Crooked Horizon

There are several ways to straighten a crooked horizon line. You can use a grid and line the horizon up visually, or you can use the Straighten tool.

Using a Grid with the Crop tool

With the Crop tool, simply place your cursor outside the image area (it turns into a curved arrow, circled) and click. *Figure 4-33*

This makes a grid appear over the image. Now when you move your cursor, the image rotates and you can line up the horizon to the straight gridline. *Figure 4-34* Press the Return key when you are done.

> TIP *Grid guidelines are useful for helping straighten a crooked horizon, but Lightroom offers several other useful guide overlays under View→ Crop Guide Overlay in the menu bar. You can cycle through the various options (including Thirds, Diagonal, Triangle, Golden Ratio, and Golden Spiral) by pressing the O key. Turn guide overlays on an off by pressing ⌘+Shift+H (Ctrl+Shift+H).*

Another way to do this is to use the Straighten slider in the toolbar. *Figure 4-35* When you click on the slider, the grid automatically appears and you can slide the slider back and forth until you get a horizon line that lines up with a straight gridline.

Using the Straighten tool

Finally, as if there weren't enough ways to do the same thing, you can use the Straighten tool which shows up in the toolbar when you select the Crop tool. When you click on the icon in the toolbar, the icon disappears, but appears in the image where you place your cursor. *Figure 4-36*

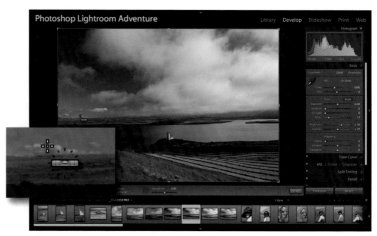

Figure 4-36

Click on a starting point, then drag along the line you wish to straighten. When you release your mouse, the image will automatically align. *Figure 4-37*

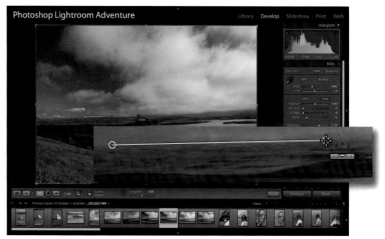

Figure 4-37

NOTE *Any crop you make in Lightroom is completely redoable. Nothing has been added or taken away from the original image. However, when you Export your image, either as a JPEG, TIFF or PSD file, the actual crop is applied. If you export to a DNG file, the crop remains redoable in Lightroom and Adobe Camera Raw. It may or may not be recognizable by another application.*

Crop Indicated with Thumbnail Icon

If an image has been cropped or straightened, a Crop icon appears in the both the filmstrip and Library grid mode thumb. *Figure 4-38* If you click on the crop icon from the Library grid mode or filmstrip, you will be taken directly to the Develop mode with the crop tool selected.

Figure 4-38

Lightroom doesn't have anywhere near the retouching capabilities of its parent, Photoshop, but it's very competent in simple, common tasks, such as removing artifacts caused by dust on a sensor or removing red eye. Like everything else about Lightroom, the tools are non-destructive and always redoable.

Retouching Tools in Develop

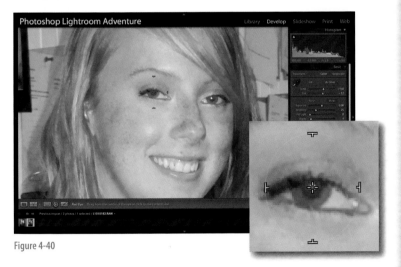

Figure 4-39

The Develop module retouching tools are located in the toolbar (circled). *Figure 4-39* If you select the Remove Spots tool, your options become Clone/Heal and Cursor Size. These tools can also be selected from the View menu.

Using the Remove Red Eye Tool

Let's start with the Remove Red Eye tool, which is very easy to use:

1. Select the tool from the toolbar by clicking on the eye icon. The dark pupil icon becomes red when you have it selected.

2. Place the pattern over the red eye with the crosshair positioned in pupil. *Figure 4-40* If the pattern is too large or too small, click and drag from the center of the eye until it is slightly larger than the eye. Release your cursor and the red should disappear.

3. To fine-tune the red eye removal, use the Pupil Size and Darken sliders in the toolbar. *Figure 4-41* The Pupil size slider will increase or decrease the size of the pupil (left). The Darken slider affects the opacity of the pupil (right).

4. Repeat this process as many times as necessary on other eyes that also suffer the dreaded red-eye effect. Select Reset from the toolbar to start over. Once you are finished with the Remove Red Eye tool, press the Return key. The "red" eye icon now returns to black.

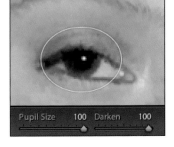

Figure 4-40

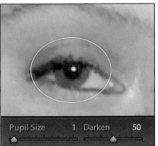
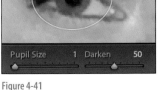

Figure 4-41

Using the Remove Spot Tools

A common problem with digital cameras is sensor dust which appears in the same spot on all images. Often, the resulting spot is not noticeable unless it appears in an area like the sky. This is what occurred with many of Peter Krogh's Iceland shots. As you can see, the spot is very conspicuous, and detracts from an otherwise beautiful landscape image. *Figure 4-42*

Here is what to do to remove spots like this, first on one image, then automatically, on others images shot with the same camera and suffering the same fate.

1. Select the Remove Spots tool from the toolbar. Click on the word Heal. The Healing tool works in a similar fashion as its Photoshop counterpart. It "blends" the target and source. (Lightroom's Clone tool, on the other hand, takes a copy of the source area and pastes it over the target area and blends the edges.)

2. Place your cursor over the sensor dust spot. Adjust the Spot Size with the slider until it is about 25% larger than the dust spot. (The bracket keys also enlarge or shrink the spot size as does the mouse wheel.) *Figure 4-43*

3. When you click and drag on the second spot that appears near the first circle, an arrow indicating a relationship with the target circle appears. Move the second circle around until a satisfactory "healing" occurs in the target area. *Figure 4-44*

Figure 4-42

Figure 4-43

Figure 4-44

Figure 4-45

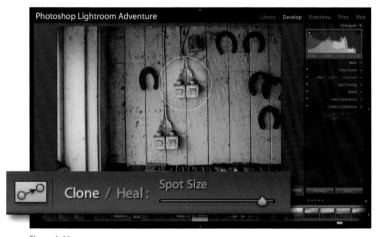

Figure 4-46

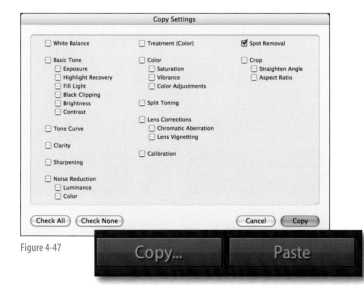

Figure 4-47

The entire procedure can be repeated as many times as necessary on the same image until all the spots are removed. *Figure 4-45* At any time, you can go back and relocate either the target or source. Delete unwanted selections by placing your cursor over the circle and using the delete key. Use the Reset button at the bottom right of the toolbar to remove all the selections. Hit the Return key or click on the Clone/Heal icon when you are done. You can go back to the image at any time and resume using the tool. And, very importantly, you can also apply your work to other images, as we will soon see.

Here is an example using the Clone tool. *Figure 4-46*

Apply Clone/Heal tools to multiple images

Sensor dust spots often occur in the same spot on multiple images. With Lightroom, you can create a copy of your settings from one image and then apply the fix to multiple images.

Use a spotted sample image to repeat what we did earlier, and use either the Clone or Heal tools to get rid of the offending spot. Now, in the left panel, click Copy. This will bring up the dialog box shown here. *Figure 4-47* Deselect all. And now select only Spot Removal.

In the filmstrip, select as many of the images you wish to "fix." Now click Paste from the panel. Done.

> NOTE *At this time, you cannot create a Preset to do this.*

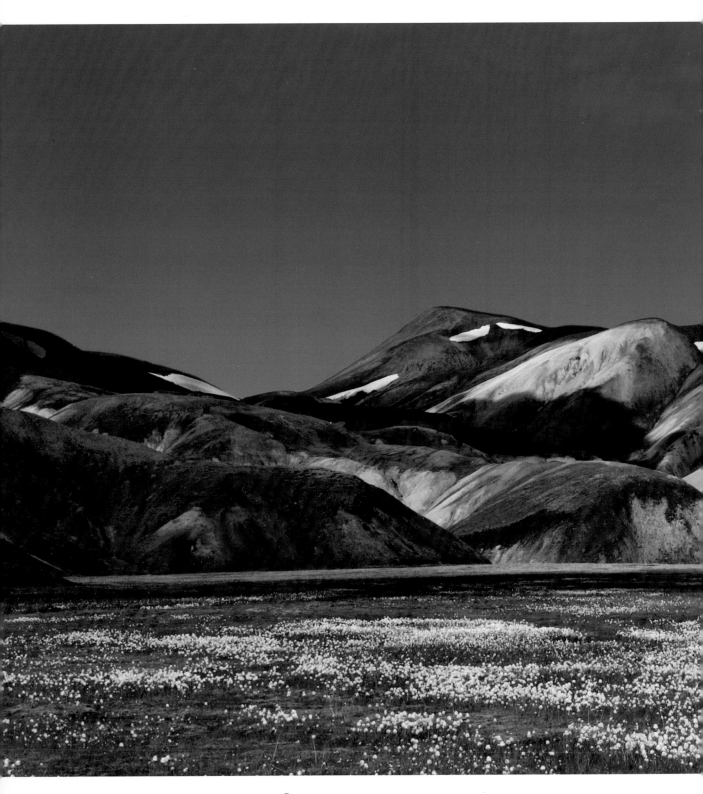

Melissa Gaul

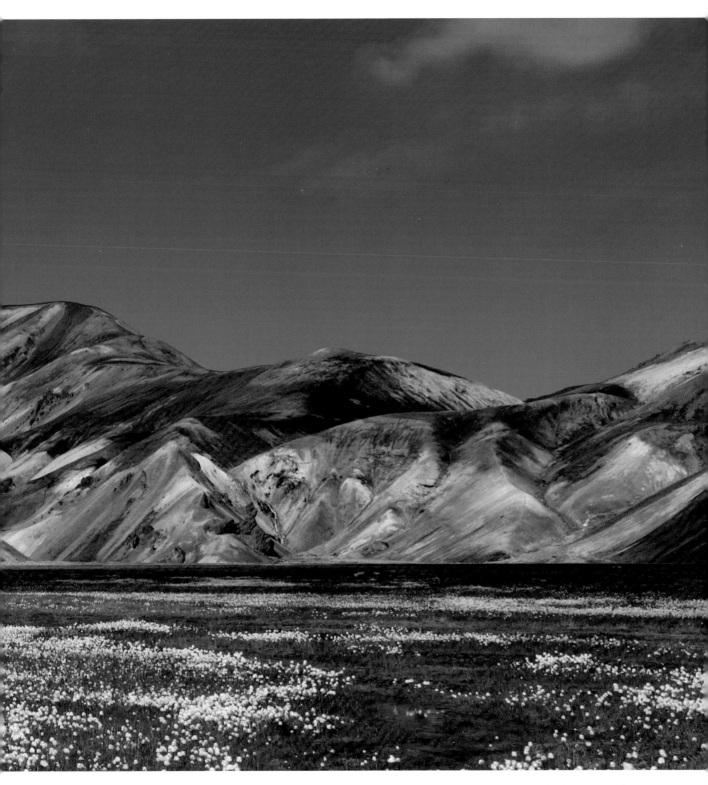

Melissa Gaul is one of the original Adobe Lightroom product team members. Her husband, Troy, is the lead engineer. The Iceland Adventure occurred at an auspicious time in the product release cycle: in midsummer, before Lightroom features were "locked," and before the absolutely crazy time leading up to the final release. Melissa was able to take a week off her busy schedule and join us. Not only did she contribute beautiful imagery, but she shared her in-depth knowledge of the product with the rest of us. She was able to communicate our needs as professional photographers back to the Adobe engineers, and we were amazed when fixes or improvements to the product showed up, sometimes as soon as the next day.

Noise Reduction

With varying degrees, all digital cameras produce electronic noise, extraneous pixels sprinkled throughout an image. Higher ISO, underexposure, long exposure, and oversharpening can increase this effect. Lightroom's Noise Reduction feature can easily reduce the effect of electronic noise, while maintaining image detail.

Lightroom's Noise Reduction controls are found under the Detail pane. *Figure 4-48*

NOTE **Noise isn't necessarily bad. It can give an image dimension and authenticity.**

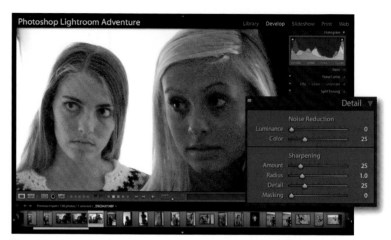

Figure 4-48

Examine Image First

Noise isn't always apparent when you examine an image at low magnification. Use Lightroom's magnifying tools to enlarge your image after applying tone and color controls (but before applying additional sharpening), and the noise will become apparent. *Figure 4-49*

Pay particular attention to areas of continuous tone and shadow areas. Note the makeup of the noise. Does it look like a colored patchwork quilt? Or is the noise speckled and monochromatic?

Some images actually contain a combination of chromatic (color) and luminance (monochromatic) noise. Getting a handle on the type of noise will help determine which Lightroom control —Luminance or Color, or both—will be more effective.

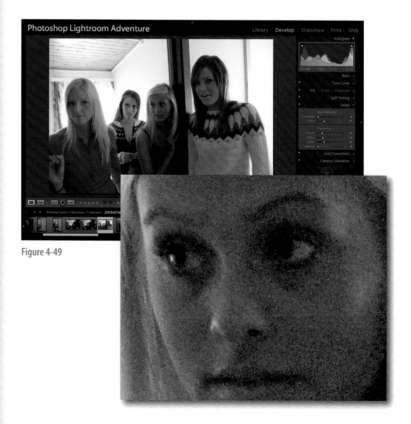

Figure 4-49

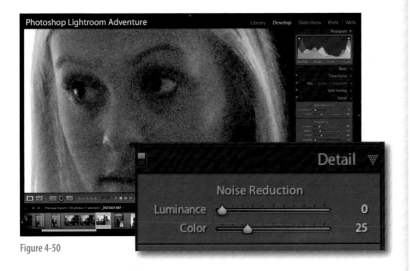

Figure 4-50

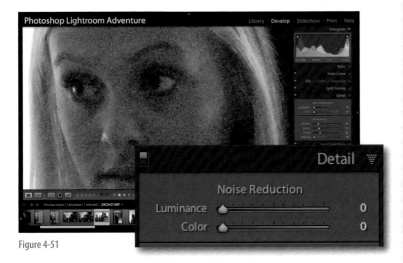

Figure 4-51

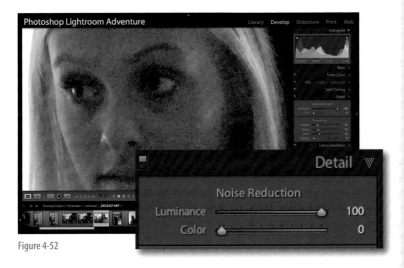

Figure 4-52

Noise Reduction Procedure

To begin the process of noise reduction, follow these steps:

1. Select the Detail pane. *Figure 4-50* If you are working on a RAW file, you'll notice the default Color setting is 25, while Luminance is set to 0. Unlike the Sharpness Amount setting number, 25, which is a relative value based on the type of camera you used, the Color setting is an absolute value. This value is applied generically, which may or may not be right for your camera or image, but it's almost always a good starting point.

2. Enlarge your image preview to at least 1:1 (100%), preferably higher. (Clicking on the [!] icon, if present, will automatically enlarge your image.

3. Start by sliding the Color slider to the left, down to 0. *Figure 4-51* Next, move the slider incrementally to the right, increasing the value. This affects the chromatic (color) noise and leaves details found in the Luminance (brightness) channel alone for the most part. If you go too far with the Color setting, you won't lose detail per se, but you'll compromise color accuracy.

4. If increasing the Color value doesn't do the trick, set it to zero and use Luminance. Go easy and increase the value incrementally. When working on the Luminance channel, you can quickly compromise image detail. *Figure 4-52*

5. Sometimes, a combination of Luminance and Color settings produces the best result. You'll have to experiment to get the correct combination, as the correct values vary from image to image. *Figure 4-53* Remember the trick is to reduce noise without losing too much image detail.

Making a Noise Reduction preset

Once you find an optimal setting for your camera, at a frequently used ISO, you can save specifically those settings and apply them to other similar images. To do this:

1. Select the [+] sign in the Presets tab.

2. In the New Develop Preset dialog window, select Check None (this unchecks all). Then check Noise Reduction. *Figure 4-54*

3. Name your setting and click Create.

The preset will now show up in the Presets pane in one of your Users folders (*Figure 4-55*) as well as in the Import dialog box, many contextual menus, and in the Library module's Quick Develop pane preset pop-up menu. If you are applying a preset from the filmstrip hold the Ctrl key (or right-click) and click on one of the selected thumbs. Be sure to click on the image area of the thumb, not the edges.

NOTE If you find Lightroom's Noise Reduction controls don't take you far enough, open Photoshop and use its more powerful, and feature-laden, Reduce Noise filter instead.

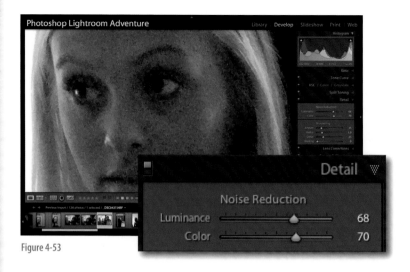

Figure 4-53

Figure 4-54

Figure 4-55

Lightroom's sharpening sliders, which are found in the Develop module's Details pane, offer sophisticated control. With just a basic understanding of what each slider does, you'll be able to produce images with crisp, clearly defined edge detail without introducing distracting noise or artifacts to other areas of your image.

Sharpening the Way You Like it

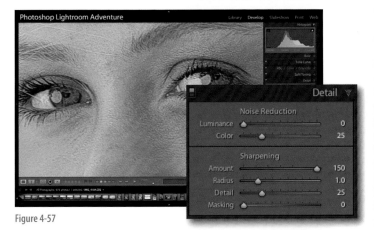

Figure 4-56

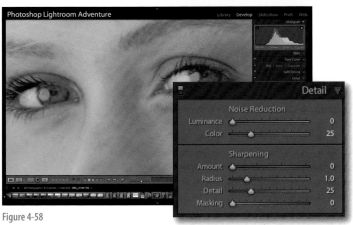

Figure 4-57

Figure 4-58

Lightroom has significantly ramped up its sharpening control from previous versions. Instead of one slider, there are now four. *Figure 4-56* For many, this added control will be welcome. For others, it may seem daunting. For those of you who don't want to spend a lot of time sharpening your images, I want to reassure you Lightroom's default settings are pretty darn good, especially if you are working with RAW files. There are also some out-of-the box sharpening presets that may be all you need.

Sharpening Fundamentals

Fundamentally, image sharpening is really just an exaggeration of contrast along edges, places where light and dark pixels meet. Lightroom's Amount slider controls the intensity of the edge contrast; the Radius slider controls how wide the edge is; the Details slider determines exactly what is an edge, and the Masking slider gives you more control over where the effects of the first three sliders occur. Let me show you what I mean.

Amount slider

The Amount slider controls the amount of contrast along the edges of an image on a scale from 1 to 150. In *Figure 4-57*, I bumped the Amount to 150 and kept the other default Sharpening Settings. In *Figure 4-58*, I set the slider to 0. You can see here the extremes. For RAW files, the

default Amount setting is 25, a relative number based on the characteristics of your digital camera (see sidebar on the next page). For other files, such as JPEGs and TIFFs, the Amount is set to 0, which means no extra sharpening is applied until you move the slider.

Radius slider

The Radius slider controls how wide the edge is in values from .5 to 3.0. The greater the radius value, the larger the edge and the more obvious the sharpening. If you go too far with the Radius setting, you'll get an unpleasant halo effect. Again, the best way for me to illustrate this is by example. I'll boost the Radius to 3 (maximum) and the Amount to 150 (maximum) so you can clearly see what is going on in this before and after shot. *Figure 4-59*

An even better way to show what this slider does is to hold the Alt (Option) key and then click on the slider. *Figure 4-60* shows a Radius setting of 0.5 (minimum), and, as you can see, a faint outline appears and few pixels are affected. *Figure 4-61* shows a Radius setting of 3 (maximum) and now you can clearly see the pixels outlined that will be affected when I move the Amount slider.

For all types of image files, the default Radius setting is 1.0, and this is a good starting point. With JPEG and TIFF and other non-RAW files, you'll have to move the Amount slider before you notice any sharpening.

Detail slider

This slider works in a similar fashion to the Radius slider, but instead of working on a wide range of pixel values, it works on very fine detail. A setting of 100

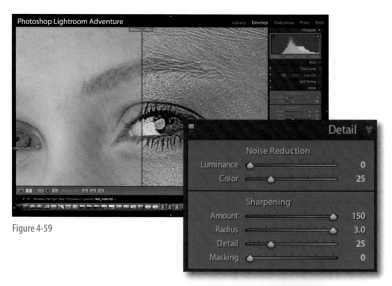

Figure 4-59

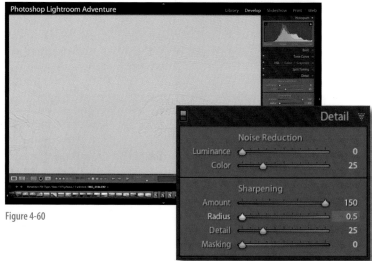

Figure 4-60

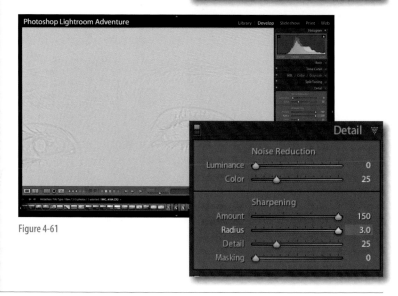

Figure 4-61

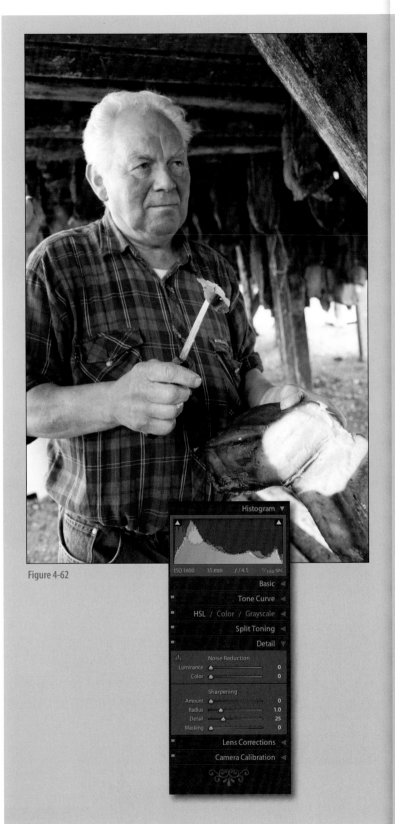

Figure 4-62

What's with the Number 25?

If you are working with a RAW file in Lightroom, you'll notice the sharpening Amount is set to 25, regardless of which digital camera you use. Why this number, and what does it mean? *Figure 4-62* (If you are working on a JPEG or TIFF, Amount's default is set to 0.) It helps to understand how Lightroom processes RAW files. Every RAW file is subject to a demosaicing algorithm that includes purposeful blurring. This blurring helps prevent color fringing by slightly blending adjacent pixels. Every digital camera model requires a different amount of blurring. The exact amount depends on many factors, including the size and characteristics of the camera sensor. Smaller sensors with many pixels typically produce a lot of noise and require more blurring during the RAW conversion in order to prevent the halo effect.

Lightroom uses information specific to a particular camera model to process a RAW file and determine how much blurring to apply. Since it knows how much blurring has been applied, it also knows how much sharpening is needed to compensate for that blurring. The number 25 represents the optimal sharpening strength for a particular camera. For example, a 25 value for a RAW file produced by a camera with a relatively small sensor will represent more sharpening than, say, 25 for a RAW file produced by a camera with a larger sensor.

(maximum) defines everything as a edge and increases contrast between all pixels equally. Lower values decrease the range and therefore the effect. Again, looking at the extreme setting is helpful. *Figure 4-63* shows a before and after view with a Detail setting of 100.

> NOTE *Lightroom isn't capable of selective sharpening and for so-called cosmetic sharpening; you'll need to turn to Photoshop. (Cosmetic sharpening means working on a localized area, e.g., the eyes, but not the freckles).*

Holding the Option (Alt) key while moving this slider clearly outlines which areas are affected at this setting. *Figure 4-64*

Masking slider

The Masking slider does just that: creates a mask that controls where sharpening is applied. This control is especially useful when you are working with portraits or other images that contain large areas of continuous tones that you want to remain smooth and unaffected by increases in contrast.

Again, lets' see how it works by example. Here I set the Amount, Radius, and Detail sliders to their maximum. In other words, I've totally oversharpened the image. *Figure 4-65*

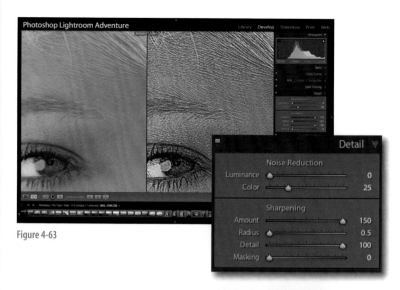

Figure 4-63

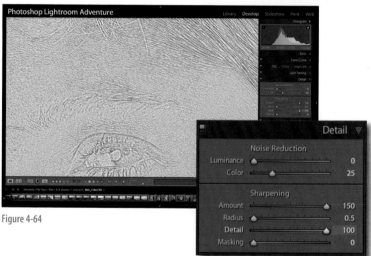

Figure 4-64

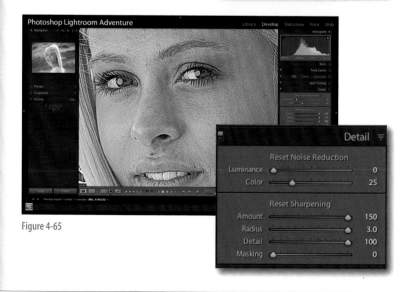

Figure 4-65

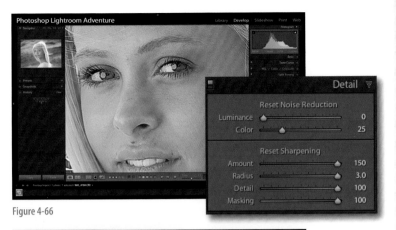

Figure 4-66

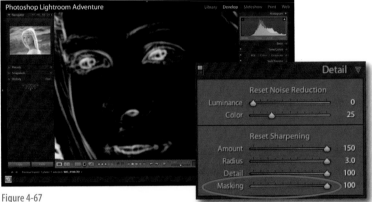

Figure 4-67

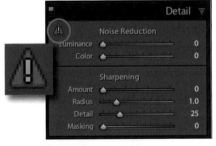

Figure 4-68

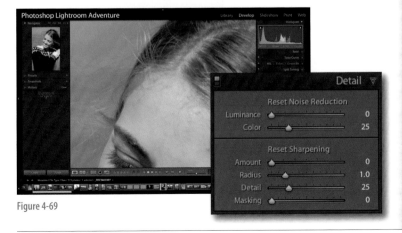

Figure 4-69

Next, I'll move the Masking slider to its maximum. You can see how the sharpening (or contrast enhancement) is not apparent in the skin tones. *Figure 4-66*

Holding the Option/Alt key while clicking on the Masking slider reveals the actual mask. *Figure 4-67* You can see the black areas are the areas that are masked, or blocked.

Sharpening Strategy

Just about every image will benefit from some sharpening. The default settings may be a good place to start, but if you are willing to take the time, you can certainly do better. Knowing that every image demands different settings, here is a general strategy to follow:

1. Make your color and tonal adjustments first. (These are detailed in subsequent chapters.)

2. Select the Detail pane. You can turn sharpening off and on by clicking the switch icon to the left (circled).

3. If your image isn't enlarged at least 1:1 (100%), a warning icon will appear in the upper left of the Detail pane (circled). *Figure 4-68* Click on this icon and Lightroom will automatically enlarge the image. Now pick an area that contains both detail and continuous tone (like an eye, hair, or tree branch against blue sky).

4. If you are working on a RAW file, the sharpening Amount setting is always 25 by default. I find it useful to start by sliding the slider to 0 and the examining the image to establish a baseline for my next adjustments. *Figure 4-69* Keep in mind; the effect

of a 0 sharpening setting will vary from camera to camera. With some digital cameras, the effect is barely noticeable. With others, it'll appear extremely noticeable.

5. Next, move the Amount slider to 150, which, most of the time, is way off. *Figure 4-70* Again, I go to the extreme to visually establish a range.

6. Through trial and error and going to extremes I come up with reasonable Radius and Detail settings. I look for a balance between sharpness of the edges, with no noticeable noise added to the continuous tone areas. You can mitigate noise in the continuous tone areas with the Masking slider. Hold the Alt (Option) key when using the Radius, Detail, and Masking sliders. You'll get a better idea of what parts of the image are being affected. *Figures 4-71 and 4-72*

7. The amount of sharpening will depend on the final output. If you are sharpening for screen, sharpen until it looks right. If you are sharpening for print, you likely will want to oversharpen to compensate for paper/ink absorption. (Print-specific sharpening is a whole topic into itself. There are so many variables to consider, including printer characteristics, print size, ink, paper, viewing distance, etc.)

8. Finally, don't worry about getting it perfect (whatever that may be). Lightroom uses a completely non-destructive process and you can go back at any time and start over.

You'll find additional sharpening control in the Lightroom Print module, which I'll cover in Chapter 11.

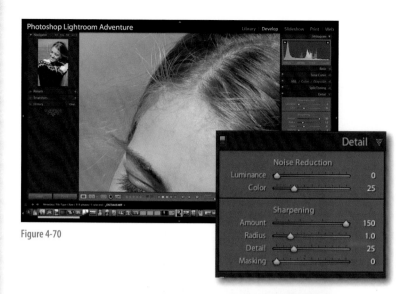

Figure 4-70

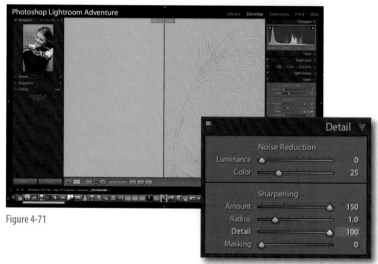

Figure 4-71

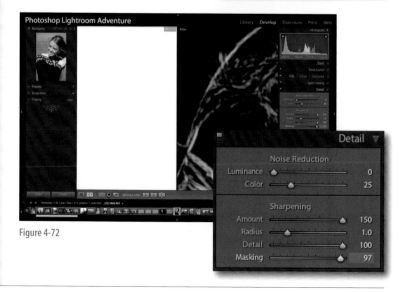

Figure 4-72

The Lens Corrections pane contains controls for fixing Chromatic Aberrations and Lens Vignetting. These are the same controls found in Adobe Camera Raw and can also be mimicked using Photoshop's Reduce Noise and Lens Correction filters.

Lens Corrections

Figure 4-73

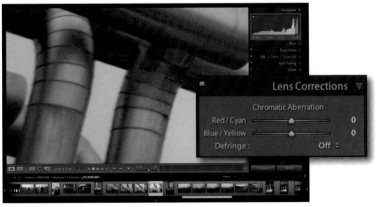

Figure 4-74

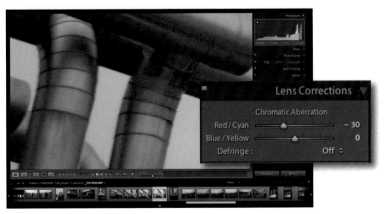

Figure 4-75

Chromatic Aberrations

Chromatic aberrations (CA) show up as anomalous color shifts, mostly on the outer perimeter of an image, in areas with distinct edge transitions. The fringing is sometimes there because when light passes through glass, different color wavelengths are separated and shifted in focus ever so slightly. They are mostly evident when wide-angle lenses are used, but can appear with longer lenses as well.

This image of a huge Icelandic power plant was taken near our hotel in Nesbud. *Figure 4-73* Although the chromatic aberrations are not visible at first glance, *Figure 4-74* magnification shows some annoying anomalies on the edges. *Figure 4-75*

This is how to reduce CA:

1. Magnify the image to at least 100 percent to Identify the color fringing. (An [!] icon appears if you are below that magnification setting. Click on the icon to automatically resize.)

2. Select the Lens Correction pane. (Make sure the pane switch icon is in the up position, otherwise the tools effects won't be visible.)

3. Select the appropriate slider. For this image, it took moving the Red/Cyan slider to -30 to get it right. (See the sidebar at the end of this chapter to learn exactly what each slider does.)

4. If neither of these sliders does the trick, try one of the two Defringe settings (Highlight Edges or All Edges) and see if that helps.

Lens Vignetting and Lightroom

Vignetting (darkening at the corners of the frame) can be caused by a mismatched filter/lens hood or a lens (e.g., using a filter on an ultra wide angle lens). It can also be caused by using wide angle lenses not optimized for digital capture (i.e. not optimized for even brightness across the fame). It's one of the easiest things you can fix with Lightroom's Develop module. Conversely, you can also add a vignette to your image which will draw attention to a specific part of any image.

To add or diminish a vignette:

1. Select the Lens Corrections pane. *Figure 4-76*

2. Adjust the Amount slider to the left or right. The edges will darken or lighten from a central radial point. In this case, I actually darkened the edges of the image to bring more attention to Peter Krogh posed to take his next masterpiece. *Figure 4-77*

3. Use the Midpoint slider to expand or decrease the range of the effect. You cannot, however, create multiple interest points. Adding a vignetting effect is therefore most effective when your image contains a single point of interest that you want to emphasize.

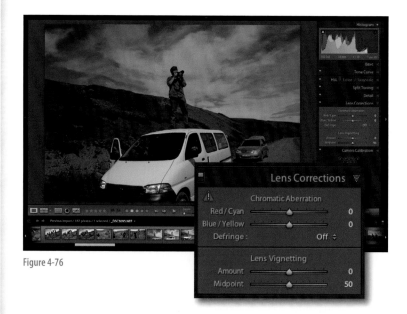

Figure 4-76

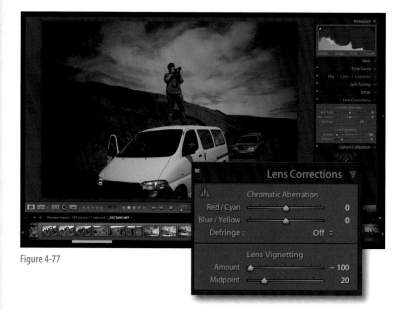

Figure 4-77

NOTE *Lens Vignetting is applied to the entire image, border to border, regardless of whether the image has been cropped. A heavily cropped image will therefore appear to have vignetting applied only to a portion of the image.*

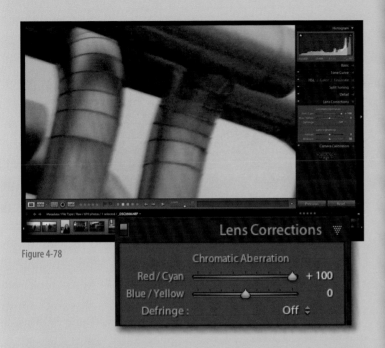

Figure 4-78

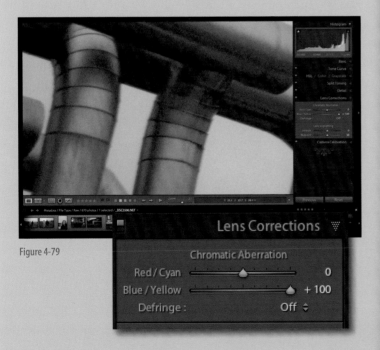

Figure 4-79

Understanding How CA Controls Work

It's very useful to understand how the CA controls actually work. They don't simply look for edges and remove or desaturate colors. If you move the control sliders radically one way or another, you will notice a subtle distortion of your image, growing in intensity from the center of the image out to the edges. In fact, the distortion is limited to select colors that are actually expanding or shrinking (i.e., distorting) based on your settings. For example, if you choose to fix Red/Cyan fringing, then either the red or cyan colors will be affected. *Figure 4-78* If you chose to fix Blue/Yellow fringing, only these colors will be affected. *Figure 4-79*

(The Defringe options—Highlight Edges or All Edges—slightly desaturates edges, which can help in some cases, but may also result in thin gray lines.)

The key point is there are important practical implications. First, don't crop your image, apply Chromatic Aberrations controls, and expect good results. The color distortions are based on a lens model; the minute you crop, you've changed that model. Second, don't expect this to work on other aberrations such as a dead pixel or a highlight blooming that appears in the dead center of an image. The effect is more powerful on the edges of your images, and diminished as you move closer to the center. Finally, the results you get will vary depending on the lens you use.

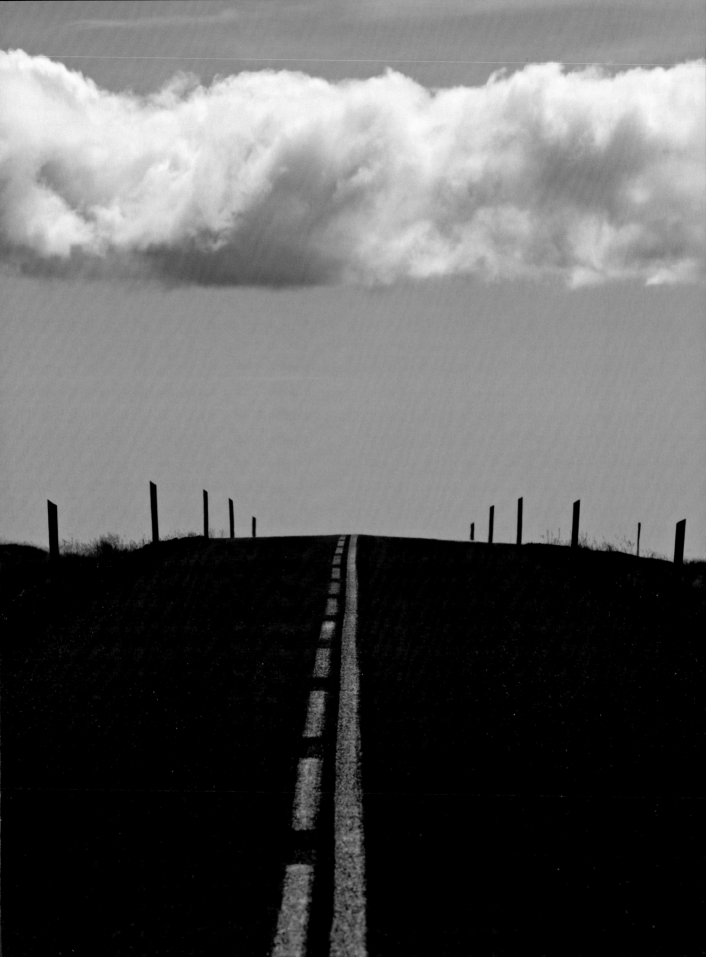

Develop Great-Looking Photos

The road to a great digital photo starts the moment you frame the shot and press the shutter release. Using Lightroom's Develop module, you can do a lot to bring out the best tonal qualities of that image and much more. In this chapter, I'll show you ways to use Develop module tools to evaluate your image to make sure it is adjusted correctly. I'll show you both how to determine the correct white balance and how to distribute tonal values based on a combination of technical and subjective criteria. In subsequent chapters, I'll focus on other aspects of the Develop module: color-related issues, black and white conversion, and special effects.

Chapter Contents

PHOTO CREDIT: Michael Reichmann

Evaluating Tonal Distribution & Color

What you see on your monitor, even if the monitor is perfectly calibrated, can be deceptive. What may look good on screen may have serious technical shortfalls that become evident later, especially when you go to print. Let's look at the various tools Lightroom offers to evaluate your images.

Lightroom's tonal distribution and color evaluation tools include a histogram, over/under exposure warnings, and a color tool for taking precise color readings.

Using the Histogram

Lightroom's histogram graphically displays the 8-bit Red, Green, and Blue (RGB) values of your selected image. In the case of a RAW file, the histogram is not a reflection of the actual RAW data (which is grayscale and linear), but a reflection of the processed RGB data with nonlinear tone-mapping applied.

The histogram updates in real time to reflect changes you make to the white balance or tonal distribution. As you'll see later in the chapter, distribution of the tonal values can be made directly from the histogram or from other panes in the right panel. The Lightroom histogram is much more accurate than the one associated with your digital camera, so don't be surprised to see a difference.

Note the image in *Figure 5-1*. It's fairly intuitive to figure out what the colors in the histogram represent. Gray represents pixels in all three channels: red, green, and blue. Red represents red pixels, green represents green pixels, and blue represents blue pixels. Cyan represents pixels in both the green and blue channels, magenta the red and blue channels, yellow the red and green

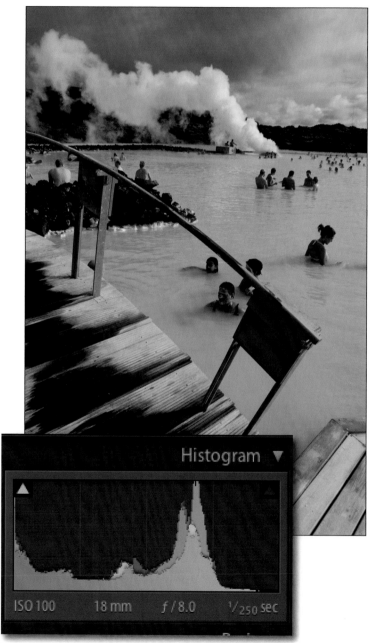

Figure 5-1

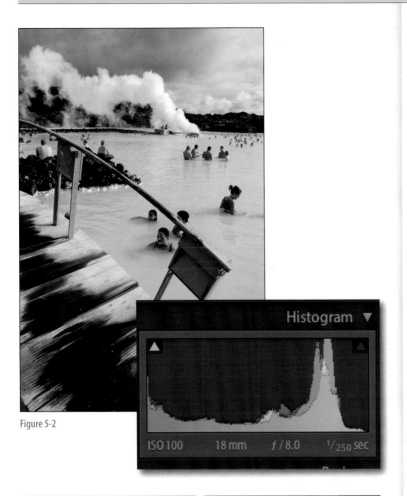

Figure 5-2

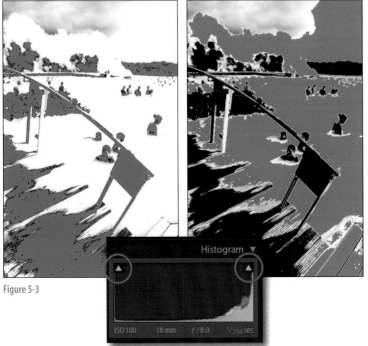

Figure 5-3

channels. A sharp line on either end of the histogram indicate clipping, meaning there is no detail in either a shadow or highlight area with the current adjustment settings. The height of the line is indicative of the degree of clipping; higher lines represent more clipping, lower lines indicate less clipping. Gray lines represent clipping in all three color channels. The color of the line tells you which color is actually clipped, so in this example, you can see no highlight clipping, and shadow clipping in all three channels.

Every image—and every tonal or color change to that image—will produce a different histogram. Here, I increased the exposure, lightening the image and thus automatically changing the corresponding histogram. *Figure 5-2* The goal is to produce a distribution of tonal values based on both subjective response and quantifiable criteria (such as highlight or shadow clipping). The histogram is not the final indicator, but it's an indispensable tool for getting you the image you want or need.

Clipping Warning Tools

If you pass your cursor over the triangle on the left at the top of the histogram (circled), and if your image contains shadow areas with no detail, your preview will light up blue in those areas. If you pass your cursor over the triangle on the right (circled), and if your image contains highlight areas with no detail, your preview will light up red in those areas. *Figure 5-3* These warnings take any tonal or color adjustments you make into consideration, so your original file itself might be fine, but show clipping warnings after an adjustment.

Histogram Options

Right-click anywhere on the histogram and you'll get a contextual menu. *Figure 5-4* Here you can control the visibility of tools and information that appears along with the histogram.

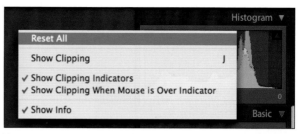

Figure 5-4

Hold Option (Alt) Key and Move Exposure Slider

You can get even more information about exactly which colors are clipped by holding the Option (Alt) key while moving the Exposure (circled), Recovery, or Black sliders in the Basic panel.

If you hold the Option (Alt) key while moving the Exposure and Recovery sliders, the image turns black and clipped areas appear white. *Figure 5-5*

Red, green, or blue colored areas indicate clipping in one of those color channels. If more than one color channel is clipped your preview will be indicated with cyan, magenta, or yellow.

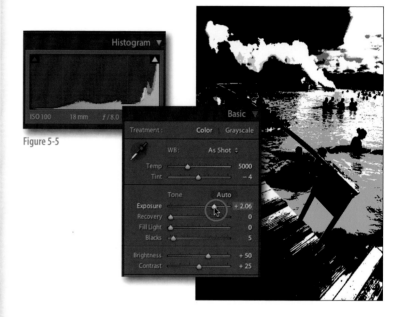

Figure 5-5

Do this with the Black slider (circled), and the image turns white and clipped areas appear black. *Figure 5-6*

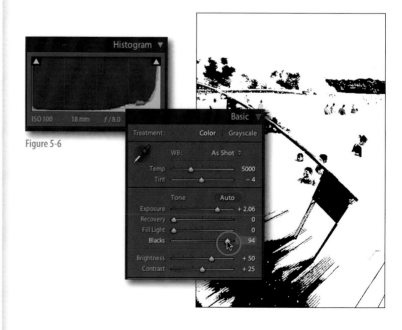

Figure 5-6

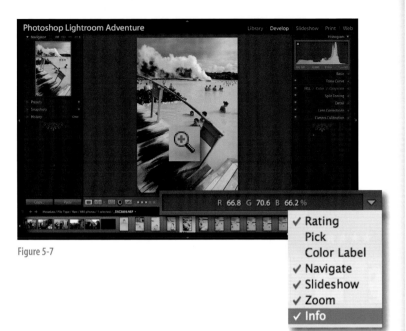

Figure 5-7

Color Samples

Place your cursor over a color in the preview window and the corresponding RGB color values will appear in the tool bar at the bottom of the image preview window. (You must select Info in the toolbar options pop-up menu for color values to appear.) *Figure 5-7* Color information is particularly useful if you have included a quantifiable color target in your image, or if you can find an area of your image that should be close to neutral. In that case, you can determine color cast by comparing the RGB percentage values. The closer they are to each other, the closer you are to a neutral color.

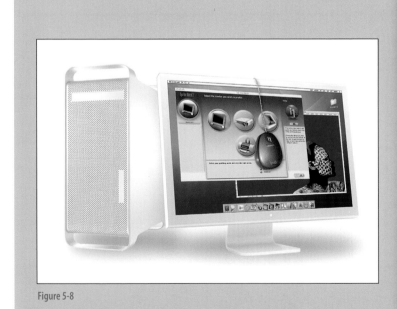

Figure 5-8

Monitor Calibration

If a monitor is too "contrasty," too bright, or if the colors are off, there is no way to predict what an image will look like when it is printed. A monitor can be calibrated using software alone, but hardware calibration is more accurate.

For a few hundred dollars, you can buy a product that attaches to your monitor and physically measures the colors and brightness, which creates a color profile that can be used to produce consistent results.

Shown here is the Eye-One Display 2, which costs about $249 (*www.gretagmacbeth.com*). *Figure 5-8* Software calibration comes with Mac OS X. It's called the Display Calibrator Assistant, found in the Utilities folder. Windows users will have to rely on third-party solutions.

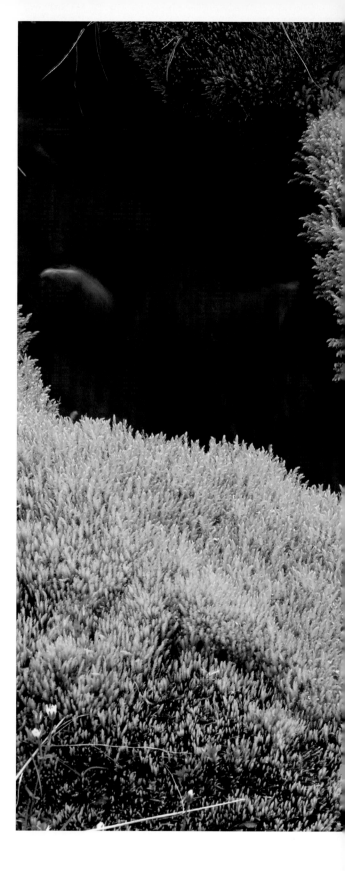

Bill Atkinson is a legend, both in the computer and the photography world. For the Iceland Adventure, he showed up with a bag full of Hasselblad/Phase One equipment, matching only Michael Reichmann's photographic arsenal in terms of image resolution and quality. Bill and Michael made quite a team, roaring off around midnight in their 4-wheel-drive Suzuki Grand Vitara to catch the best light and landscapes. We often didn't see them until the next afternoon, when they stumbled in, blurry-eyed, to work with us on the computers. This photo was shot at 1/8th of a second at f/22 with an ISO of 50. Little or no tonal corrections were made by Lightroom. Bill doesn't appreciate "labels," but for this image at least, he was a purist.

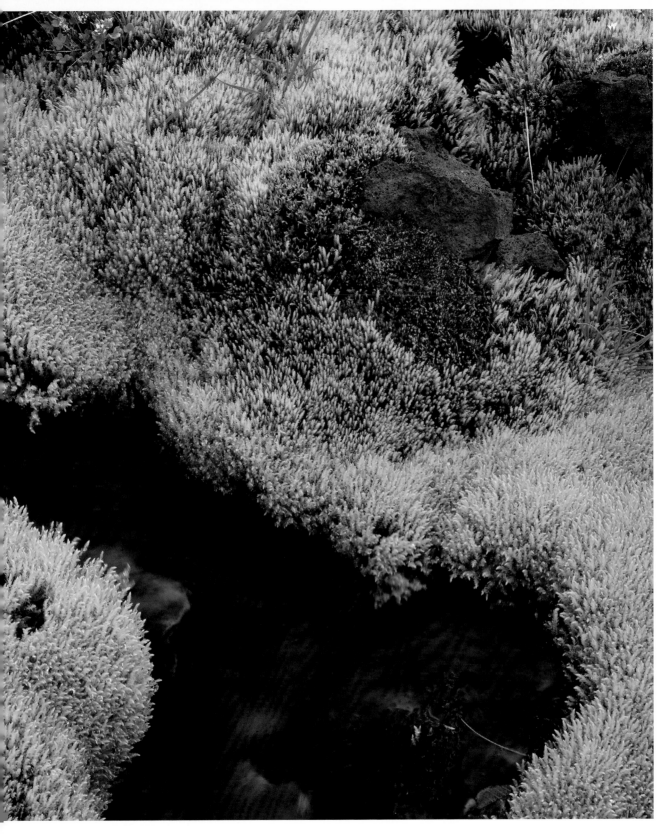

Bill Atkinson

Adjusting White Balance

Under simple lighting conditions, most digital cameras do a remarkably good job of setting an accurate white balance and making colors appear as you expect them to. When the white balance is off, don't fret. Lightroom can help you get it right, especially if you shot RAW.

There are a few ways to adjust white balance in Lightroom's Develop module. *Figure 5-9* You can do this via the Basic pane and these features:

- Presets
- White Balance selector tool
- Temp and Tint adjustment sliders

The goal is to use one of these methods to produce a pleasing balance of colors, yielding white whites and neutral midtones. (Of course, correct white balance can be subjective as well. Some images warrant warmer tones, while other images warrant cooler ones.)

Generally, establishing a correct white balance should be done before adjusting other tonal distribution and color settings. That's why Adobe placed the white balance tools at the top of the right panel, where image adjustments are made. After you make all your other tonal adjustments, it's advisable to go back and fine-tune your white balance settings.

White Balance Presets

If you are working with a RAW file, clicking on the triangle next to As Shot in the Basic pane brings up the White Balance (WB) pop-up menu shown on the left in *Figure 5-10*. If you are working with a non-RAW file such as a TIFF or JPEG, your choices are those shown on the right.

Figure 5-9

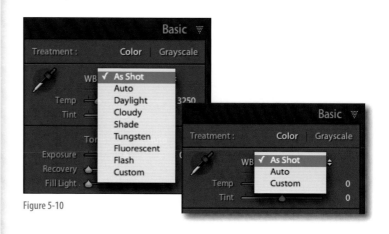

Figure 5-10

Figure 5-11

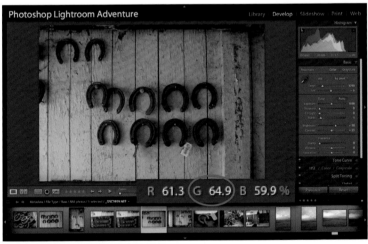

Figure 5-12

The Auto White Balance setting is also available through the menu by choosing Develop→Auto White Balance, using the keyboard shortcut ⌘+Shift+U (Ctrl+Shift+U), or the contextual menu displayed by right-clicking on the image preview. *Figure 5-11*

As Shot is the default setting in the Basic pane WB pop-up menu. Lightroom will apply the white balance setting that was recorded at the time of exposure. In my experience, when lighting conditions are simple—i.e., the light is provided by a single light source—I am generally happy with the As Shot preset both for RAW and JPEG files.

In situations where the light comes from multiple sources, correct white balance becomes more problematic, For example, in this shot, the light came from both natural light and a florescent bulb. *Figure 5-12* In this case there is a strong greenish cast, which is confirmed by placing my cursor over a "neutral" area of the image and noting the dominance of green in RGB values displayed in the toolbar (circled).

TIP *I often press the L key while checking white balance and evaluate my image against a Lights Dim or Lights Out view mode. In this example, I'm in the Lights Out view mode.*

Other White Balance presets

If you are not satisfied with the As Shot setting, you can try the other settings from the pop-up menu. Start with Auto, where Lightroom reads the image data and automatically attempts to adjust the white balance. Auto often works fine, but in this case, Auto gives our example image a bluish cast. *Figure 5-13*

Select the other presets and observe the changes in your image. Shown are the effects of various presets on my sample image. As you can see, none of the presets do the trick of producing a neutral white. *Figures 5-14 through 5-17*

TIP On the Iceland Adventure, many photographers used an ExpoDisc digital white balance filter like one shown here to create a custom white balance setting. (Expoimaging was a sponsor of the Adventure.) You can achieve a custom white balance setting with a simple gray card, but I find the results achieved with the ExpoDisc to be far superior. It's available for about $75 at camera stores and online at www.expoimaging.net.

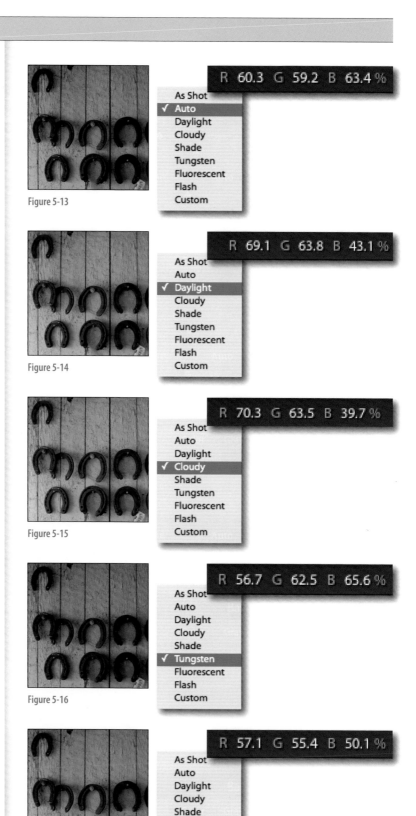

Figure 5-13

Figure 5-14

Figure 5-15

Figure 5-16

Figure 5-17

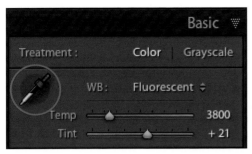

Figure 5-18

Figure 5-19

Figure 5-20

The White Balance Tool

The White Balance tool (circled) attempts to make the color exactly neutral. *Figure 5-18* The changes are reflected in he Temperature and Tint sliders. You'll also notice a change in the histogram. Sometimes this produces a satisfactory result, sometimes it doesn't.

Using the White Balance tool

The White Balance tool—accessed by clicking the eyedropper icon at the top of the Basic pane, under the View menu (View→White Balance Selector), or by hitting the W key—is very easy to use.

Simply select the tool and move your cursor over an area of your image that should be neutral gray or white. A 24-pixel enlargement (circled) shows you exactly where you are sampling. *Figure 5-19*

View the white balance changes in the Navigator window in real-time as you move the tool around. When you are satisfied, click your mouse and the new setting is applied.

Evaluating White Balance results

I suggest using the color sampler on a "white" area of your image and evaluating the results with the color sampler, or viewing your image in the Lights Out view mode. To undo the effect, use the History panel or type ⌘+Z (Ctrl+Z).

Using the White Balance tool, I was able to obtain the correct white balance, as confirmed when I placed my cursor over a "white" area of the image and saw the near-identical RGB values shown. *Figure 5-20*

Temperature and Tint Controls

Below the White Balance pop-up menu are two sliders—Temperature and Tint—that can be used to fine-tune the white balance or produce creative effects.

Move the Temperature slider to the left, and colors will appear bluish (become cooler). *Figure 5-21*

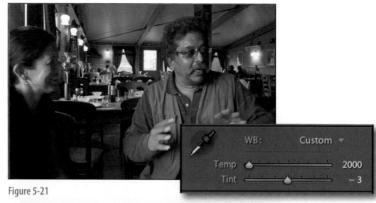

Figure 5-21

Move the slider to the right, and the colors appear more yellowish (warmer). *Figure 5-22*

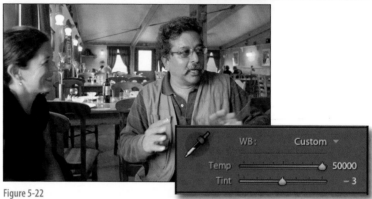

Figure 5-22

Move the Tint slider to the left (negative values), and you'll tint your image greenish. *Figure 5-23*

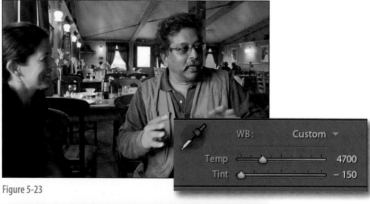

Figure 5-23

Move the slider to the right (positive values) and you'll tint it a magenta-like tone. *Figure 5-24*

Moving either slider will change the White Balance pop-up menu setting to Custom. Double-clicking on the slider triangle will reset the slider setting to its default setting. (This holds true for all sliders in Lightroom.)

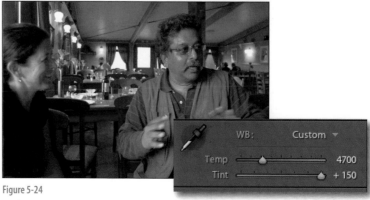

Figure 5-24

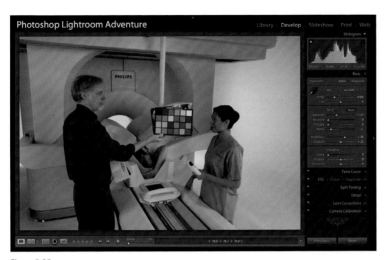

Figure 5-25

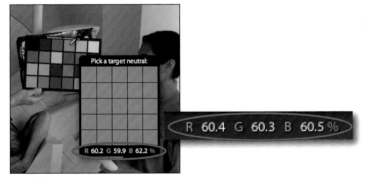

Figure 5-26

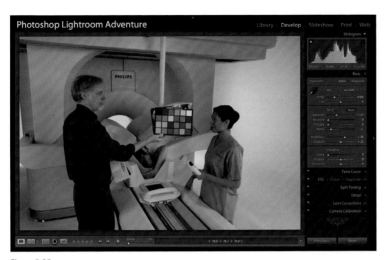

Figure 5-27

Determining White Balance from a Target

Including a quantifiable target in your shot will help determine if your white balance is perfectly correct. I find it very useful to include a GretagMacbeth color test chart in a shot whenever lighting or shooting conditions are relatively stable. *Figure 5-25* (Obviously, this example isn't from the Iceland Adventure, but from a shoot I did for Philips Medical Systems.)

A common, less-expensive, 18% gray card also works fine, but I like the added bonus of the reference colors. Then I simply select and position my White Balance tool over the target (in this example, a neutral square).

If my white balance is in the ballpark, the R, G, and B values at the bottom of the 25-pixel enlargement (circled, left) should be close, but not necessarily the same. *Figure 5-26* I then click on the target, and the RGB values that are now displayed in the Info window of the toolbar (circled, right) become nearly exactly the same, or neutral. Changes in the white balance are reflected in the image and histogram.

To selectively apply this white balance setting to other images, one at a time, click Copy on the bottom of the left panel. This brings up the Copy Settings dialog box. *Figure 5-27* Check only the White Balance check box and then click Copy. Then, select another image taken under the same lighting conditions from the filmstrip and click Paste on the bottom of the left panel. To apply the same white balance setting to multiple images, make your selection in the filmstrip, then click the Sync... button at the bottom of the right panel. In the Synchronize Settings dialog box, check only the White Balance check box.

Basic Tone Controls

Every digital image contains a range of tonal values, distributed over a range of light and dark tonal values. Often, even with properly exposed images, you'll want to redistribute these tonal values to meet aesthetic or quantifiable criteria. There are several ways to do this with Lightroom.

Lightroom's processing tools are organized systematically, providing a rough order to follow as you work on your image. After you have determined the proper Lightroom white balance (as we discussed in the previous section), it's time to start working on the tonal values found under the Basic tone pane or directly in the Histogram itself. *Figure 5-28*

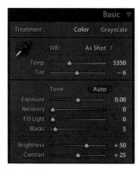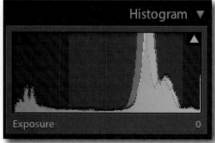

Figure 5-28

Auto Tone

A good place to start is with Auto. *Figure 5-29* When you click on the Auto button (circled), Lightroom creates a made-to-order tone map based on the individual characteristics of a particular image. It does not affect the Clarity, Saturation, or Vibrance controls. Auto often produces satisfactory results, but not always.

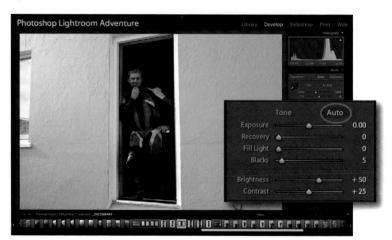

Figure 5-29

For example, in this image, Auto successfully darkened the light blue wall around the subject, but it darkened the subject too much at the same time. *Figure 5-30* I often keep the Auto setting, even if it's not perfect, and fine-tune the results with other tonal controls. For example, shortly, I'll show you how I used Fill Light get this image just right. If Auto is way off, use the keyboard shortcut ⌘+Z (Ctrl+Z) or step backward in the History tab. If you select Reset at the bottom of the Develop right panel, you'll go back to the original camera settings, which may or may not be what you want.

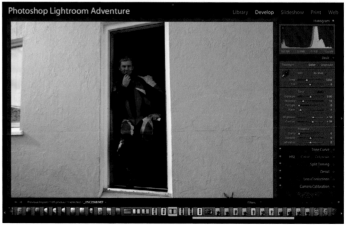

Figure 5-30

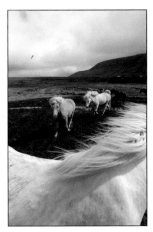
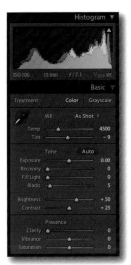

Figure 5-31

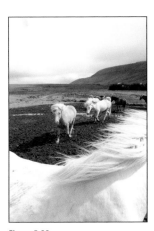

Figure 5-32

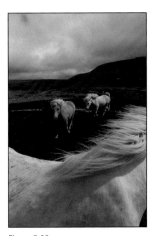

Figure 5-33

Exposure Slider

If Auto doesn't give you the tonal distribution you want, try using the Exposure slider. Take, for example, the image shown here. *Figure 5-31* As you can see from the corresponding histogram, the tonal values are shifted to the right, toward the highlights, and there is clipping (loss of detail) of these values.

If I move the Exposure slider to the right (positive values), the image brightens but there is even more clipping (loss of detail) in the highlights. *Figure 5-32* Even though I can recover some of the highlight detail using the Recovery slider—more on this later—increasing the exposure was obviously the wrong way to go with this image.

> NOTE *Exposure values—which can be typed in directly into the numerical field with a [+] or [–] prefix—are roughly equivalent to f-stops. From an exposure point of view, an adjustment of +1.00 is similar to increasing a camera's aperture one stop. Similarly, an adjustment of –1.00 is similar to reducing the aperture one stop.*

If I move the slider to the left (negative values) the image darkens and detail is revealed in the highlights. *Figure 5-33* Now I have a relatively good distribution of tonal values. However, to finish this image, I will use the Brightness slider. As you will see later, the Brightness slider works primarily on the midtones.

Recovery

This image is a perfect candidate for the Recovery slider, which comes after the Exposure slider. *Figure 5-34* (If you work directly from the Histogram, Recovery is found by moving your cursor to the right side of the Histogram.)

In the image shown here, the sky is lacking detail, as revealed by the red highlight warning on the image and the vertical line on the far right side of the histogram.

The intent of the Recovery slider is to recover details in the highlight areas that might otherwise be missing. It does this by looking individually at the Red, Green, and Blue channels, finding data in one channel, and then reconstructing the data across the three channels. It has the effect of darkening the highlights slightly without affecting the darker areas.

As you can see by the diminished clipping, it's particularly effective on the image shown here, bringing out details in the clouds, and leaving the rest of the image alone. *Figure 5-35*

Fill Light

The Fill Light slider opens up the shadow areas without affecting the highlights (to a point). I used Fill Light to finish up the image used in a previous example. *Figure 5-36* Notice how the biker and the doorway, which were previously too dark after using Auto, are now plainly visible. (Care should be taken when using the Fill Light slider not to push it too far, as shadow noise is often enhanced as well.

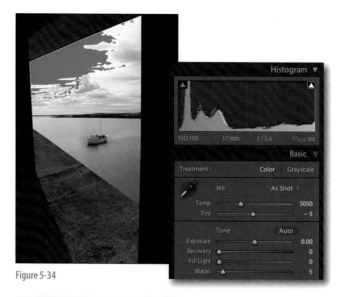

Figure 5-34

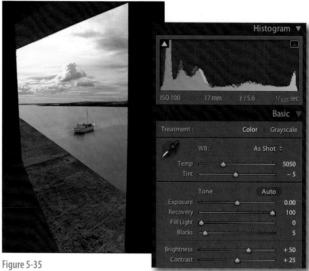

Figure 5-35

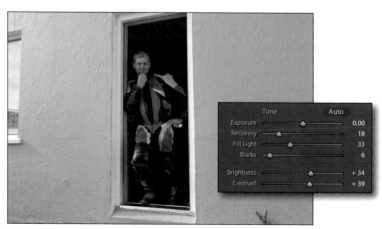

Figure 5-36

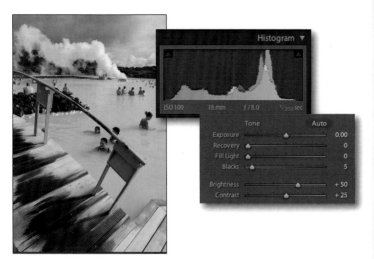

Figure 5-37

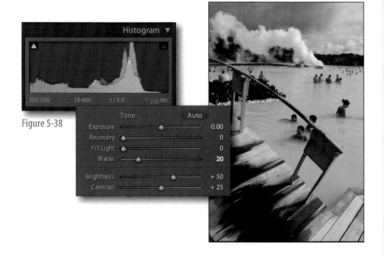

Figure 5-38

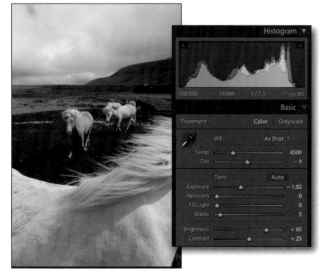

Figure 5-39

Blacks

I use the Blacks slider a lot. It darkens the darkest parts of an image (setting a black clipping point), while mostly leaving the rest of the image alone. It effectively produces the opposite effect of Recovery. I used the Blacks slider on this image, which, at first glance of the preview and its histogram, looked fine. *Figure 5-37*

But moving the Blacks slider just a little to the right (to 20) gave the image an appearance of more depth. I find many of my images benefit from a slight increase in the Blacks slider. *Figure 5-38*

Brightness

The Brightness slider is similar to the Exposure slider, but it redistributes the tonal values in an adjustment weighted toward the midtone values. While a positive Exposure setting may clip the highlights—moving the Brightness slider to the right doesn't result in highlight clipping—it compresses the highlights and opens up the midtone and shadow areas. Conversely, moving the slider to the left darkens an image by compressing the shadow areas and opening up the highlights. I used the Brightness slider here to give a final touch to the image I had previously adjusted using the Exposure slider. *Figure 5-39*

Contrast

This slider results in either increased or decreased contrast, while leaving the extremes alone. (You can easily observe this by watching the histogram as you move the Contrast slider.) In *Figures 5-40 through 5-42*, the first image has no contrast adjustment. The second shows the effect of sliding the Contrast setting to the left, and the third shows the image when the Contrast setting is set to the extreme right.

Resetting Tones

If you want to reset only the tonal changes to their original settings, go to the Basic pane and double-click on the word Tone, found to the left of the Auto button. This won't affect any changes made to the Presence sliders, which include Clarity, Vibrance, and Saturation.

Presence Sliders

The final Basic pane controls are grouped under the name "Presence" and they include Clarity, Vibrance, and Saturation. Since these sliders generally relate to color issues, I will go into detail on when and how to use them in the next chapter, Color Tuned Photos.

> TIP *Use Lightroom's Compare mode to view before and after versions of your image. Select the Compare icon in the toolbar or select View→Before/ After from the menu bar. Pressing the Y key cycles you between the Loupe and Compare view modes.*

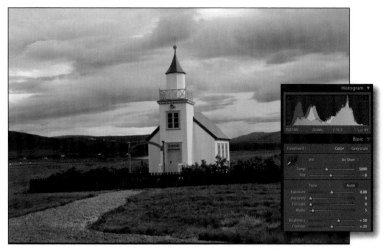

Figure 5-40

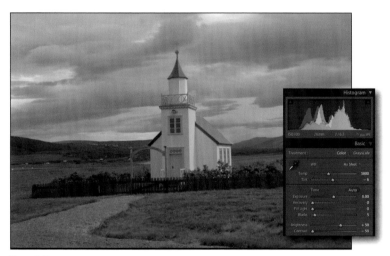

Figure 5-41

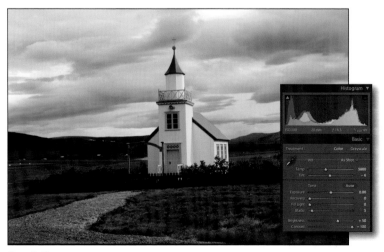

Figure 5-42

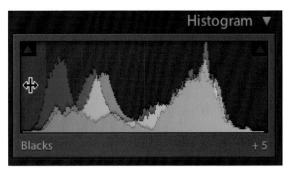

Figure 5-43

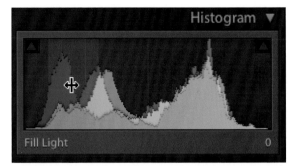

Figure 5-44

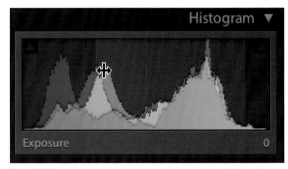

Figure 5-45

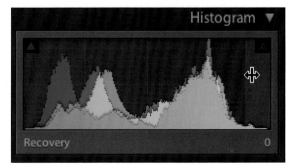

Figure 5-46

Adjusting Tone Directly from the Histogram

If you prefer, you can make your Basic tone settings directly from the Histogram. Place your cursor over the Histogram and drag to the left or right. Where you initially place the cursor will determine which tone setting is affected.

Moving from the left side of the histogram to the right, you access these controls:

- Figure 5-43 Blacks
- Figure 5-44 Fill Light
- Figure 5-45 Exposure
- Figure 5-46 Recovery

As you move your cursor, you will see the relevant Tone slider move as well.

I often work directly from the Histogram when I'm working outside of the Basic tone pane, for example, when I'm in the Split Toning pane. It saves me from having to scroll up the right panel, because I always keep the Histogram pane visible.

Basic Tone Step-by-Step Summary

Start by using Auto. Then, if necessary, fine-tune the Auto effect with any of the other tonal sliders. If Auto is completely off, start with the Exposure slider. Then, if necessary, the Recovery and/or Fill Light sliders, then the Blacks slider. Finish off with the Brightness and/or Contrast sliders. (Further fine-tuning can be done using the Tone Curve, detailed in the following section.)

Be sure not to rely only on the preview window. Use the Histogram or under/over warnings to evaluate the effects of your tonal changes.

Tone Curve for Advanced Control

After performing your major tonal corrections in the Basic pane, fine-tune your work with the Lightroom Tone Curve. I suspect you'll really enjoy working directly off the image preview with the breakthrough Target Adjustment tool.

I really like Lightroom's Tone Curve. Admittedly, you don't have as much control with Lightroom's Tone Curve as you do with Photoshop's Curves feature, but it's hard to mess up, which I appreciate. It's kind of like using training wheels...without giving up too much control. *Figure 5-47*

Just as with Photoshop's Curves, the horizontal axis represents the original intensity values of the pixels, and the vertical axis represent the new tonal values.

Instead of placing a multitude of points on the curve and dragging the curve to a desired position, with Lightroom's Tone Curve you basically work with four set points: Highlights, Lights, Darks, and Shadows. You can control these values directly from the curve with your cursor or up and down keys, with the sliders, or directly from the image preview using the Target Adjust tool. There are also preset point curves: Medium Contrast (default), Linear, and Strong.

NOTE Although you can achieve some selective control through Lightroom tonal controls, there is no substitute for the selective area tonal controls you get from using Photoshop's layer adjustments and masks.

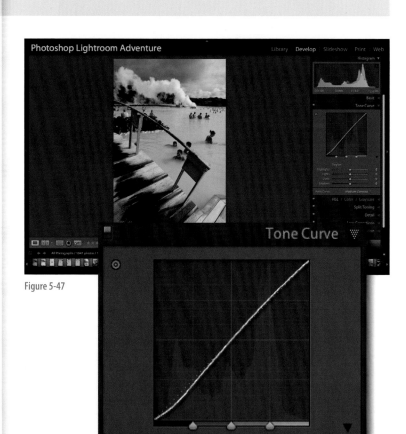

Figure 5-47

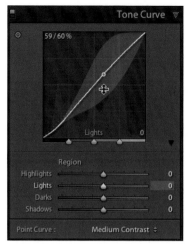
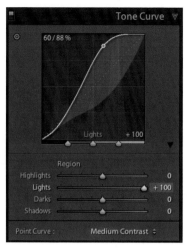

Figure 5-48

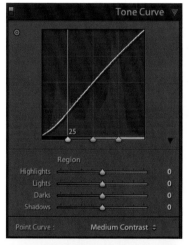
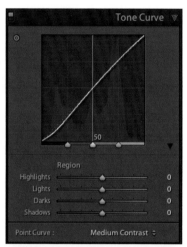

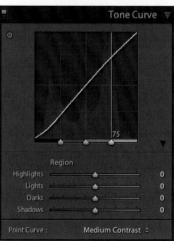
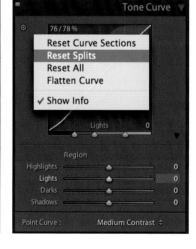

Figure 5-49

Curve on Training Wheels

No matter how much you try, you won't mess up too badly using the Tone Curve. Try this. Click anywhere on the graph. You'll see a bubble form around it. *Figure 5-48* Now drag any part of the curve up or down. (Up lightens the image; down darkens it.) You won't be able to move beyond the constraints of the bubble, beyond which would either clip the highlights (up) or shadow areas (down). If you are feeling ambitious and want to "get under the hood," you can create presets that defy these restraints. (See the sidebar at the end of this chapter.)

Split Point Sliders

Further control is found with the Split points; three triangles at the bottom of the curve graph. Drag the triangles horizontally left or right to control the width of the given tonal range. To reset the split point sliders, hold the Option (Alt key), click, and select Reset Splits from the contextual menu. *Figure 5-49* Double-clicking on a triangle will reset that specific region.

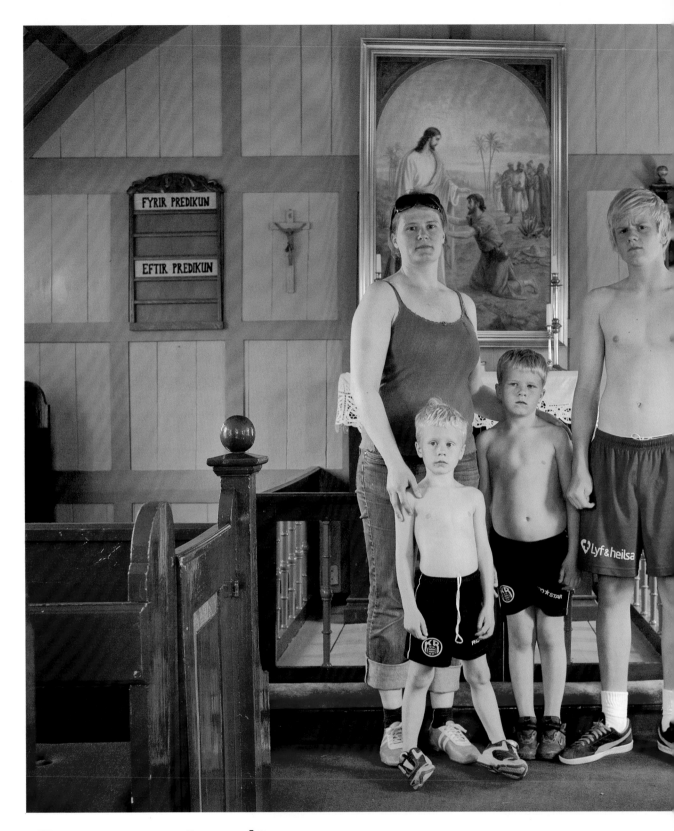

George Jardine

To me, George Jardine is synonymous with Lightroom. A couple of years ago, after an introduction by Adobe's Kevin Connor, George told me about the top-secret "Shadowland" project, as Lightroom was then known. He brought a number of the Shadowland team up to San Francisco to observe me working on a particularly complex commercial shoot. It was quickly apparent that George was watching out for us photographers, always looking for ways to make the Adobe project more responsive to our needs. In Iceland, I got to see another side of George: the photographer George, who produced many stunning images of his own, such as this one.

Using the Target Adjustment Tool

Since I'm such a big fan of this new tool, let's start right off using it. Begin by clicking on the Target Adjustment tool icon at the top left of the Tone Curve pane (circled). An up and down arrow will appear around the target. *Figure 5-50* (You can also select the tool from the menu: View→Target Adjustment→Tone Curve or the lengthy keyboard shortcut ⌘+Option+T [Ctrl+Alt+T]).

Figure 5-50

Place your cursor over the image on the area that contains the tones you wish to change (circled). *Figure 5-51* Now move your cursor up or down. Moving up will brighten areas containing the tonal values found under the tool; moving down will darken them. You can observe a corresponding movement in the histogram. Once you are satisfied, move the cursor to another area of the preview image that contains other tonal values you wish to change. Keep doing this until you are satisfied with the image.

To deselect the Target Adjustment tool, click again on the icon in the Tone Curve pane or use the Esc key.

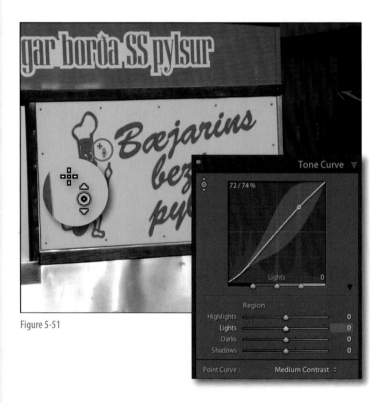

Figure 5-51

Off and On Control

View your image without the specific adjustments of the Tone Curve by clicking on the on/off switch icon in the upper left of the Tone Curve pane (circled). *Figure 5-52* Click on the icon again to turn adjustments back on.

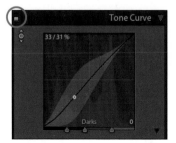

Figure 5-52

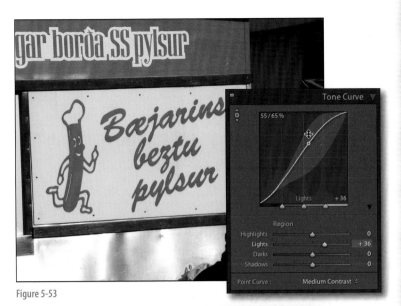

Figure 5-53

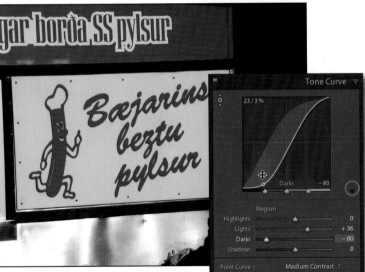

Figure 5-54

Controlling Directly from Curve

Of course, you can also control the curve directly from the curve itself. Place your cursor over the curve and a point appears. At the bottom of the graph, words appear that correspond with the four tonal sliders and tonal regions affected. Drag the curve up and the tones related to that area lighten. *Figure 5-53* Drag the cursor down and the tones darken. *Figure 5-54* Watch the sliders under the word Region move correspondingly. By the way, if you place your mouse over the curve, you can use the up and down arrow keys on your keyboard to move the curve as well.

Controlling the Curve from Sliders

You can also use the sliders under the word Region to control the curve. *Figure 5-54* Clicking on the arrow (circled) reveals and hides these sliders.

Tone Curve Defaults and Presets

Double-clicking on the curve resets that section of the curve to its default setting. Option-clicking (Alt-clicking) on the curve brings up a contextual menu with reset options. *Figure 5-55* Double-clicking on a slider triangle will reset the slider. Holding the Option (Alt) key changes the word Region into Reset Region. Click on the words to reset the sliders.

The default Tone Curve preset is Medium Contrast. The Linear preset creates a perfectly straight diagonal line in the tonal curve graph. This results in an image with no change from input to output, effectively ceding all control to the Basic tone pane control settings. Strong Contrast creates a curve that applies more contrast to the image.

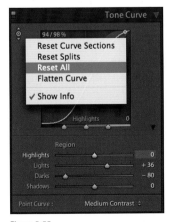

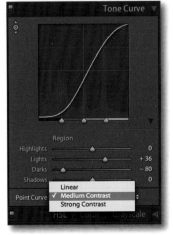

Figure 5-55

Under the Hood:
Curves Control

As I mentioned earlier in the chapter, you can't physically drag the Curve graph over or under the perimeter of the bubble, which if you could, would result in highlight or shadow clipping. *Figure 5-56*

This is great until you want to invert the curve or create a curve that replicates a solarizing effect.

So, here is a workaround:

1. Open the Develop Presets folder on your desktop. You can find the Develop Presets folder by selecting Help→Go to Lightroom Presets Folder from the menu bar. *Figure 5-57*

2. Mac users, make a duplicate of the preset called *Tone Curve–Medium Contrast. lrtemplate*. Open the duplicate in a text editor such as TextEdit. *Figure 5-58* Window users, open *Tone Curve–Medium Contrast.lrtemplate* using Notepad, or a similar text editor application, and immediately do Save As, renaming the preset "LR Adventure Invert" or whatever descriptive name you want, and save it in the Develop Presets/User Presets folder. Make sure it ends up with the *.lrtemplate* extension.

Figure 5-56

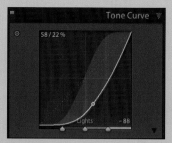

Figure 5-57

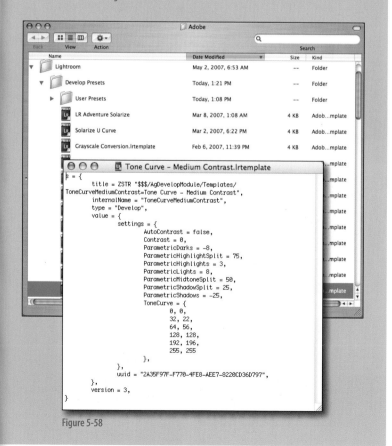

Figure 5-58

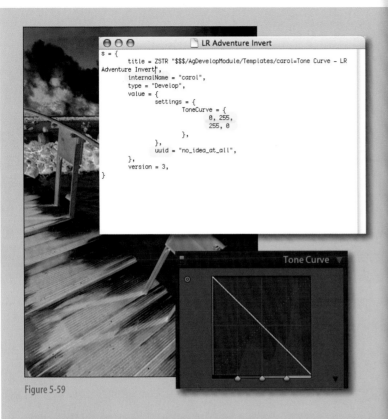

Figure 5-59

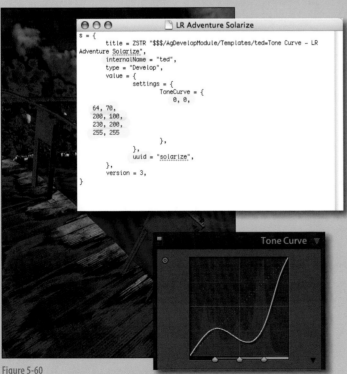

Figure 5-60

3. Replace the original text with the text and *ToneCurve x,y* coordinates you see here. *Figure 5-59* It doesn't matter what "internalName" or "uuid" you use, as long as the names are unique. Also note that the "internalName" can be anything, but must match the name found in the title line (in this case "Carol," and in the next example, "Ted").

4. Mac users, save and name your file (i.e., "LR Adventure Invert") and place it in the Develop Presets/User Presets folder. Make sure it ends up with the *.lrtemplate* extension.

5. If you duplicate what you see here in your open duplicate file, you'll end with an "inverted" graph which will produce the effect shown.

6. If you follow the previous steps and duplicate what you see in *Figure 5-60*, you'll end with a graph that produces a solarize effect like the one shown. Make sure you use a unique "internalName" or "uuid," or Lightroom won't load the preset. Name the new preset "LR Adventure Solarize." Make sure it ends up with the *.lrtemplate* extension.

7. Next time you fire up Lightroom, the new presets will appear in the Presets pane under User Presets.

If you don't want to do the coding yourself, just send me an email, and I'll send you the free presets (*mikkel@cyberbohemia.com*). Or go to *http://inside-lightroom.com*, where you can find lots of free presets.

Color-Tuned Photos

Adjusting colors in Lightroom is a snap. With Lightroom's
Develop module, you get sliders that help you make global
color adjustments, or you can place your cursor directly over
any color in your image and alter only that color with a click
and a simple up or down movement. Imagine supersaturating
a red apple, or changing a soft orange sweater to bright pink
without any special knowledge of color science. It is all possible
with Lightroom's color controls, and this chapter will show you
how. I'll also show you how to use Lightroom's Split Toning
pane for subtle control over color in highlight and shadow
areas and demonstrate how to create a custom camera profile
as well.

Chapter Contents

Controlling Vibrance & Saturation

In the previous chapter, we learned how to use white balance controls to globally fine-tune the color cast of an image. Now I'll show you how to use the Vibrance and Saturation sliders, found in the Develop module's Basic pane, under Presence. Both controls increase or decrease color intensity, but in very different ways.

Vibrance Versus Saturation

Vibrance is especially useful when you are working on images that contain areas of primary colors you wish to saturate or desaturate, while leaving areas of secondary shades—such as skin tones—alone. Saturation globally increases or decreases color intensity. As you will see, each slider has its appropriate use.

Look at the before and after shots shown here. *Figure 6-1* I left the Vibrance slider alone and increased the color Saturation to a value of 66. Note the increased saturation in the red bathing suit, which I wanted. However, also note the unpleasant shift in skin tones, which I didn't want.

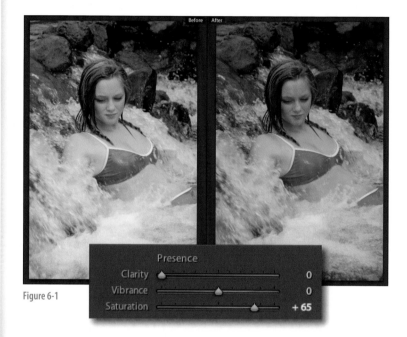

Figure 6-1

Now I will reset the Saturation slider to 0, and instead use the Vibrance slider. In the before/after shot shown in *Figure 6-2* the red bathing suit is more vivid, however the skin tones have remained pretty much untouched.

NOTE Vibrance and Saturation (along with a control called Clarity) are grouped in a category called Presence. I'll describe how to use Clarity (to give your colors pop) in the next section.

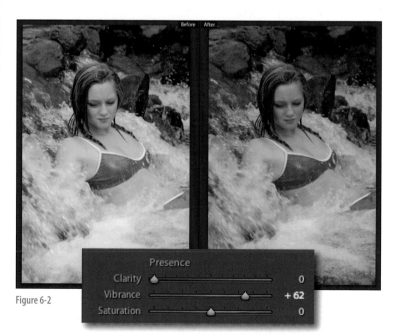

Figure 6-2

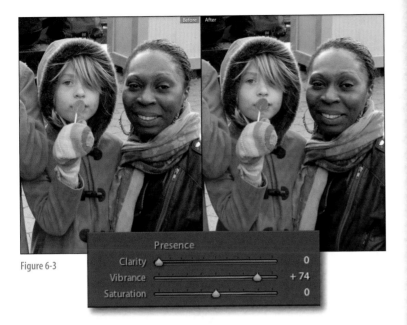

Figure 6-3

Using Vibrance

I find the Vibrance slider very useful when I work with portraits. Since skin tones are not primary colors, the Vibrance slider leaves pretty much all skin tones alone, regardless of color. *Figure 6-3*

> *TIP Reset the Vibrance and Saturation (and Clarity) sliders to their default settings by holding the Option (Alt) key so the title changes to Reset Presence. Click on those words and the sliders will reset. Double-click on a slider's triangle indicator (circled) to reset that specific slider.*

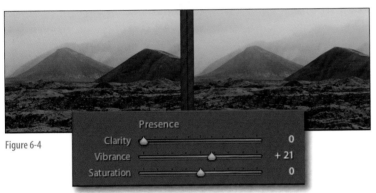

Figure 6-4

But the Vibrance slider isn't only for portraits. It can be used for other types of images as well. In *Figure 6-4*, for example, increasing the Vibrance nicely enhanced the mossy foreground of the image, while leaving the burnt umber mounds in the background alone.

Using Saturation

The Saturation slider works globally on all the colors of an image. This can be desirable, especially with images such the one shown here in Before/After view. *Figure 6-5* When I used Vibrance on the same image, it left the turquoise (or tertiary-colored) rope alone, which wasn't what I wanted. Saturation, however, boosted all the colors, as you can see. In Chapter 8, I'll show how photographer Martin Sundberg applies a slight Saturation boost to all his images, in order to mimic the look of his favorite film, Fuji Velvia.

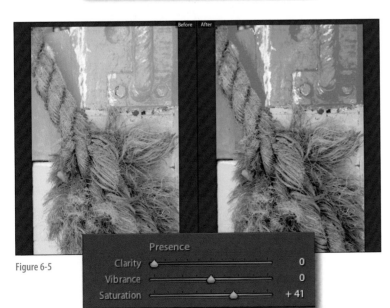

Figure 6-5

Adding Clarity

One of the easiest ways to add a punch to your images is with Lightroom's Clarity slider, found grouped with Vibrance and Saturation in the Presence section of the Develop module's Basic pane. Used in a small dose, like a sprinkle of salt, it will act like a secret sauce and give the colors in your images pop.

Power Photoshop users have long known the value of using the Unsharp Mask filter to apply local contrast enhancement. By setting the filter Amount to 20%, Radius to 50 and Threshold to 0, hazy photos become clear, dull images shine, and appearance of depth is enhanced. *Figure 6-6*

The technique works by selectively applying an increase in contrast to small regions of an image and leaving larger regions relatively alone. This prevents a loss of detail in shadow/highlight areas and gives an image more clarity, or "punch."

Figure 6-6

Lightroom's Clarity

Lightroom has incorporated the fundamentals of this technique into the Clarity slider, found in the Develop module's Basic pane in the Presence section. There is just one control that affects the intensity of the effect, and everything else is done in the background. *Figure 6-7*

Clarity works great on many types of images, as long as the amount is not overdone. Even though the effect may appear subtle on a monitor, when you go to print, it will likely seem more pronounced.

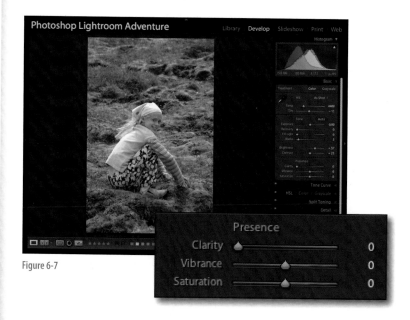

Figure 6-7

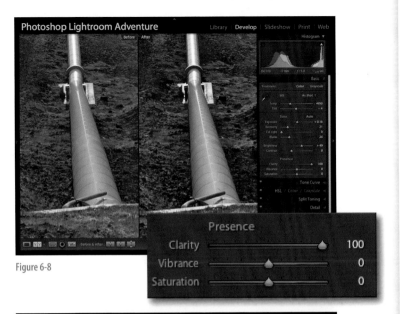

Figure 6-8

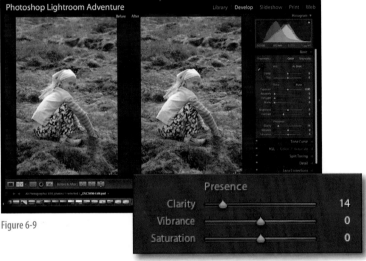

Figure 6-9

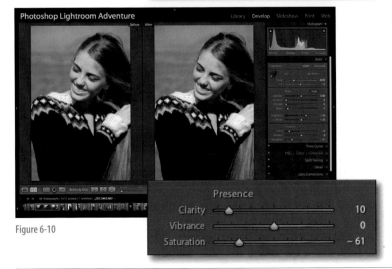

Figure 6-10

Clarity overdone

Let me show you what I mean about using this slider judiciously. In this example, I cranked up the Clarity setting to 100. *Figure 6-8* I also enlarged the image by 200% and included the before and after versions so you can see the effect better. Look at the transitions between the pipe and the ground and you can see what I mean when I say Clarity applies local contrast enhancement. In this case, the higher values don't improve the image.

Clarity just right

In the next example, I applied a Clarity setting of 14, which nicely sets the foreground off from the background and gives the overall image a nice punch. *Figure 6-9* If you look closely, you'll see the skin tones are still smooth.

Which Images Work Best?

Clarity should be used discriminatingly. I've found Clarity to be especially useful on low-contrast images caused by shooting through a dirty window or shooting with an inherently low-contrast lens. Images with lens flare also make good candidates for Clarity.

I urge you to use caution when using Clarity on close-up portraits. It's very easy to overdo the effect, which results in blotchy-looking skin. On the other hand, using Clarity in conjunction with a desaturated look, such as the one shown here, can be very effective. *Figure 6-10*

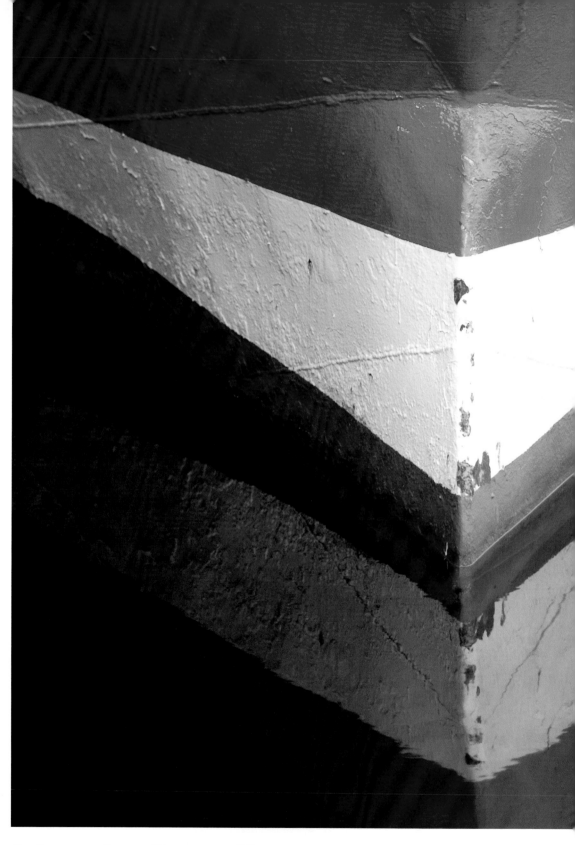

Martin Sundberg

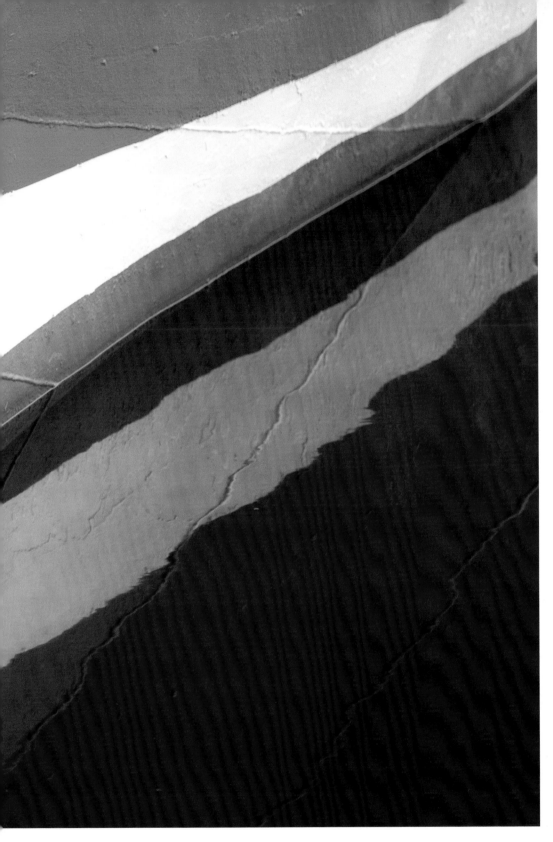

I was with Martin in a small fishing village in western Iceland when he shot this marvelous photo. I was busy shooting dead cod on the pier, but I love how Martin zoomed in tight and captured the essence of this old fishing boat with its chipped paint and rust. Later, he used Lightroom to slightly boost saturation, but otherwise left the photo alone.

The HSL Color Pane

Lightroom's HSL Color pane is where you'll get color control like you have never seen it before. HSL stands for Hue, Saturation, and Luminance, and Lightroom uses a method of defining and working with color based on these three values. Many people will find working with color this way intuitive, easy, and fun!

The HSL/Color Controls

Let's take the HSL Color pane apart. Right away you will see three choices: HSL/Color/Grayscale. *Figure 6-11* HSL and Color produce similar results, they just get you there in different ways. (I'll cover Grayscale in Chapter 7.)

Figure 6-11

HSL basics

If you click on HSL in the pane, you'll get the choices shown here. *Figure 6-12*

Hue sliders change the specified color. For example, change only the reds in your image to another color by sliding the Red slider left or right.

Saturation changes the color vividness or purity of the specified color. You can desaturate a specific color, say green, by sliding the Green slider to the left. You can saturate, say only the reds in your images by sliding the Red slider to the right.

Luminance changes the brightness of a specified color.

(If you select All, then Hue, Saturation and Luminance for all individual color ranges will all be visible in the panel. If you are working on a small screen, you will have to scroll in the pane to see them all.)

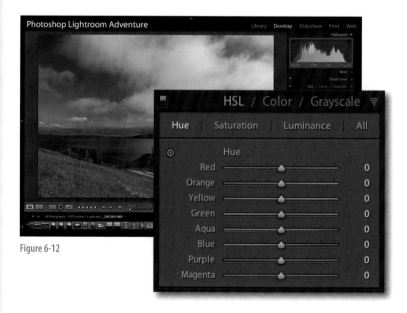

Figure 6-12

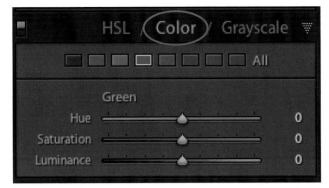

Figure 6-13

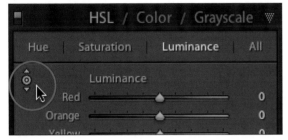

Figure 6-14

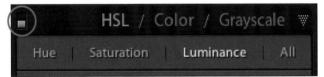

Figure 6-15

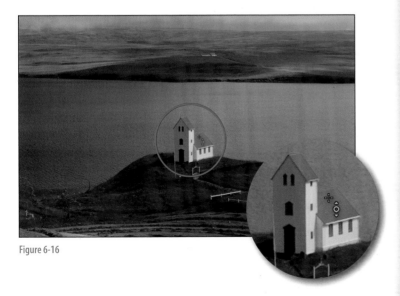

Figure 6-16

Color

If you select Color (circled) from the pane, you get the choices shown here. *Figure 6-13* In this case, start by picking the color you wish to work on, and then adjust the Hue, Saturation, and Luminance for that specific color. Again, you have the choice of selecting All.

Targeted Adjustment Tool

In the HSL mode, (but not the Color mode) click on the Targeted Adjustment Tool (TAT) in the upper left of the pane. *Figure 6-14* Now move your cursor over a color in the image preview you wish to adjust. Click your mouse and drag up and down, or use the up and down arrow keys to make the global adjustment.

Turn off color adjustments

At any time you can turn off the effects of your HSL/Color pane adjustments. Just click on the switch icon shown here (circled). *Figure 6-15*

Rooftop Example

Let's walk through some specific examples of how to use the HSL Color pane, starting with changing the color of the top of this Iceland church (circled) and then changing the Saturation and Luminance values. *Figure 6-16* I'll use the Targeted Adjustment tool (TAT), because I absolutely love the control I get with it. Of course, if you prefer, you can use the individual sliders instead. (In that case, the challenge will be to match the targeted colors with the appropriate sliders, which isn't always easy.)

Changing hue

To change the color of the roof, I simply select the TAT, and place my cursor over the color I wish to change. Then I click and hold the mouse button while I move the cursor up and down, stopping when I get a desired color change. As you move the TAT, changes in individual colors will be reflected in the sliders of the HSL tab. *Figure 6-17* (Most areas contain a mix of colors, so often more than one slider will move.) You can, as I said earlier, control the colors directly from the sliders in the HSL tab, but this requires knowing in advance the colors you wish to change. Remember these are global changes, and in the case of this particular example, any orange or reds elsewhere in the image will change as well.

Changing saturation

To change the saturation of the colors in the roof, I click on Saturation in the HSL pane. Once again, I place the TAT directly on the red roof. You can see that in the HSL pane, the Red and Orange sliders move to reflect the changes caused by clicking and dragging the TAT in an upwards motion. *Figure 6-18*

Changing luminance

To change the Luminance, I click on Luminance in the HSL pane. Using the TAT, I click and drag my cursor in a downward motion. You can see the changes in the Red and Orange sliders as these colors darken. Any other reds and oranges in the image will darken as well. *Figure 6-19*

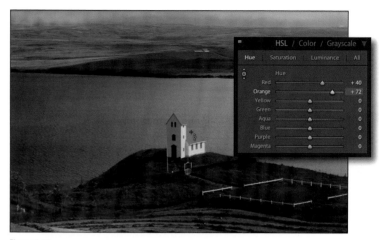

Figure 6-17

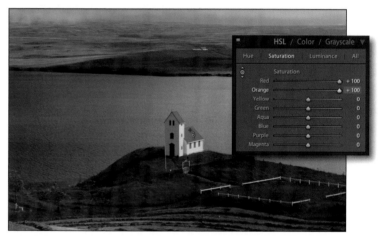

Figure 6-18

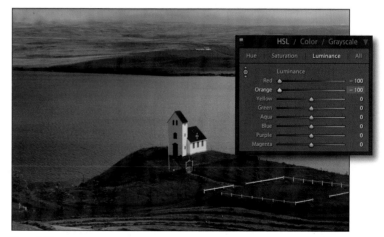

Figure 6-19

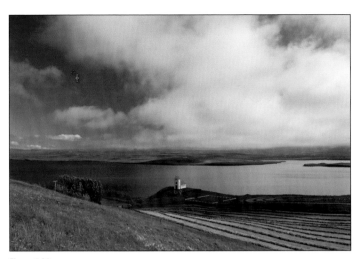

Figure 6-20

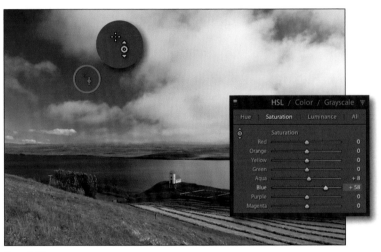

Figure 6-21

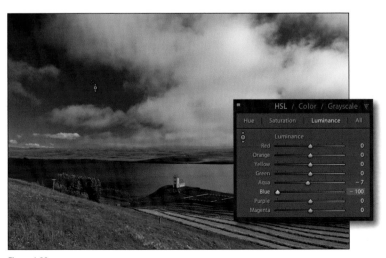

Figure 6-22

Create a Dramatic-Looking Sky

Here is an example using a combination of Saturation and Luminance controls. Again, I'm going to use Lightroom's TAT to turn this ordinary looking sky into a more dramatic one. *Figure 6-20*

I start by selecting Saturation in the HSL pane. (Make sure you have selected the TAT by clicking on its icon in the HSL tab.) Then I place the TAT over the blue sky (circled). Clicking and dragging my cursor in an upward motion produces a richer cobalt blue. *Figure 6-21*

Next, I click on Luminance in the HSL pane. Again, I place the TAT over the blue sky and move it in a downward motion. This darkens my rich blue sky and gives it even more distinction from the white clouds. *Figure 6-22*

NOTE *Look at the toolbar after you select the TAT. You'll see text that reflects which HSL mode you are in. You can change modes from the pop-up menu next to this text. The toolbar also gives you a RGB readout of the selected colors. Clicking on Done in the toolbar will deselect the TAT.*

A Tanned Beach Look

I'm going to use the HSL color tab to make a subtle shift in the facial tones of this image without affecting the white teeth or red lips. You will see a slight shift in the hair color, because some of the color values in the face are also present in the hair.

The before image is shown here. *Figure 6-23*

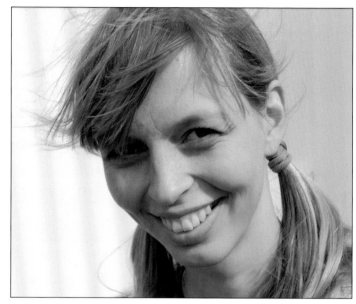

Figure 6-23

The after image is shown here, along with the HSL pane showing the movement in the Orange and yellow color sliders. *Figure 6-24.*

Again, I used the TAT, placing it directly on the face and clicking and moving my cursor in an upward motion to achieve this suntan look.

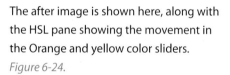

TIP You can quickly get to the HSL color pane from another Develop module pane with the keyboard shortcut ⌘+3 (Ctrl+3).

Figure 6-24

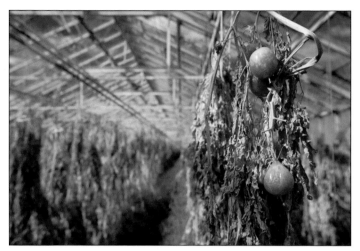

Figure 6-25

Using Color-Specific Control

The Targeted Adjustment tool (TAT) selects a range of colors appearing under your cursor. Sometimes it's preferable to target a specific single color, and that's when the Color control comes in handy.

This photo of an Iceland greenhouse by Richard Morgenstein will serve as a good example to illustrate what I mean. *Figure 6-25*

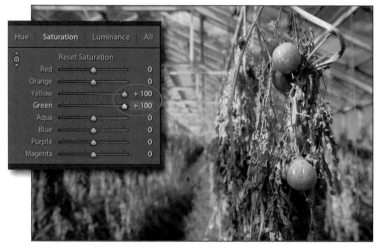

Figure 6-26

If I place the TAT over the green row, and crank up the saturation, both greens and yellows are targeted, and I get a boost in saturation in areas I don't want (circled). For example, there's an increase in the yellow saturation of the foreground plant. *Figure 6-26*

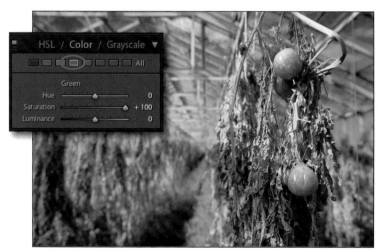

Figure 6-27

Using the Color mode, I select the Green color swatch (circled) and boost only the saturation of that color. Now only greens are affected, and I get the look I want which is close to the original with only an increase in the greens. *Figure 6-27*

The Split Toning Pane

The Split Toning pane is often referred to as a black and white tone control tool or a special effects tool, as we'll see in the next chapter. But it can also be used to subtly tweak color in just the highlight or shadow areas and create a more pleasing looking image. Let's see how.

Here is a John Isaac shot of Adobe's Russell Brown being attacked by a roll of killer toilet paper. *Figure 6-28* If we examine the roll of toilet paper closely with Lightroom's color sampler, we see it contains a lot of blue. (Place your cursor over the area you wish to measure. A RGB percentage readout will appear in the toolbar.) This blue cast is a result of the blue sky reflecting back to us via the white wrapping. (Color shifts like this are common in snow shots as well. Snow, while really white, can appear very blue because of the reflected sky.)

If we try to remove the blue via HSL controls, all the blues in the image will be affected. Not a good idea. However, if we just work on the blues found in the highlights or bright areas of the image, we are in business. And that is what we can do with Lightroom's Split Toning pane.

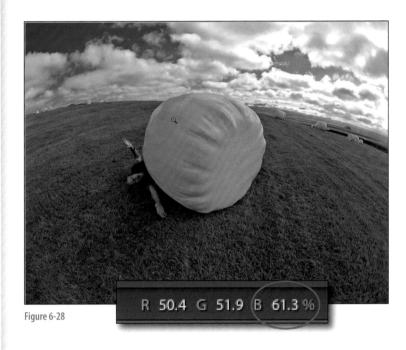

Figure 6-28

Split Toning to Remove Cast in Highlight

The Split Toning pane gives you specific control over highlight or shadow areas. I find it useful to use Lightroom's Compare view to observe subtle changes when I use the Split Toning controls. Click on the Compare icon found in the toolbar. *Figure 6-29*

The first thing you will notice when you use the Split Toning controls is that moving the Hue slider won't affect the image at all unless you Option-click

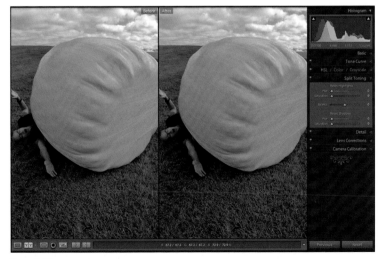

Figure 6-29

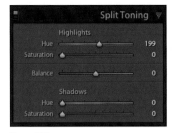

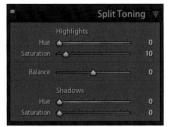

Figure 6-30

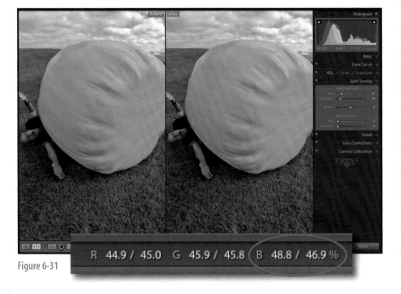

Figure 6-31

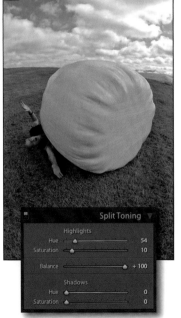

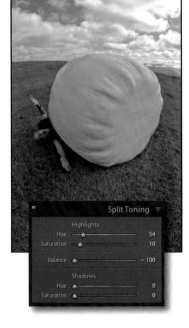

Figure 6-32

(Alt-click) on the slider at the same time, or bump up the Saturation slider value. *Figure 6-30* Option-clicking (Alt-clicking) produces a preview of the tint as if the Saturation slider were set to 100%. For subtle work like this, I prefer to start by setting either my Highlights or Shadows Saturation slider to at least 10. *Then* I move the Highlight or Shadow Hue slider and observe the changes.

As I move the Hue slider, I watch the effect on my image. I initially rely on visual inspection. At the point at which I think I'm close to removing the tint, I stop moving the slider and place my cursor over a part of the image I wish to sample, observing the RGB values displayed in the toolbar. In this example, because I am in the Compare view, the color values are shown as before and after. *Figure 6-31* A Hue setting of 54 combined with a Saturation setting of 10 lowered my blue value enough to remove the blue tint from the highlights in the bale of hay. The rest of the image, with the exception of the clouds—which are also highlights—remain untouched.

Using the Balance Slider

I could refine the way the Split Toning controls work with the balance control. Moving the Highlight slider to +100 spreads the effects of the Highlight settings into the shadow and midtone areas. *Figure 6-32* Moving the slider to −100 effectively removed the effect entirely. For this example, using the Balance slider wasn't necessary, but when you use both the Highlight and Shadow controls, the Balance slider will give you relative control over each. (See Chapter 7 to learn more about using the Split Toning controls with grayscale images.)

Color Calibrating Your Camera

Lightroom produces a image look based on camera profiles created by Adobe. Use the Camera Calibration pane to customize these profiles to your own look. You can save these settings as a Lightroom preset and apply them at any time, or have them applied automatically on a camera-by-camera basis.

You can use any image to calibrate, but an image containing a color chart, shot under controlled lighting, will produce more predictable results. *Figure 6-33*

> TIP The keyboard shortcut ⌘+7 (Ctrl+7) will take you directly to the Camera Calibration pane in the Develop module.

The Calibrate Process

In the Develop module, with the Camera Calibration pane open, select a photo and select a Profile set from the pop-up menu. *Figure 6-34* ACR (which stands for Adobe Camera Raw, Photoshop's RAW converter, which also uses the same profiles as Lightroom) versions will appear.

ACR 3.0 or higher are the new and improved camera profiles. Often ACR 2.4 is listed, which means your camera didn't require the updated ACR profile. If both 2.4 and a higher ACR profile are listed, you can choose either one. However, Adobe recommends choosing 2.4, which they say assures consistent behavior with older photos. If an image is in the TIFF, JPEG, PSD, or DNG format, and not RAW, a profile of Embedded will appear.

Next, use the sliders to create the look you are after. Start by moving the Shadows slider to correct for any green or magenta tint in the shadow areas. Then use the Red Primary, Green Primary, or Blue

Figure 6-33

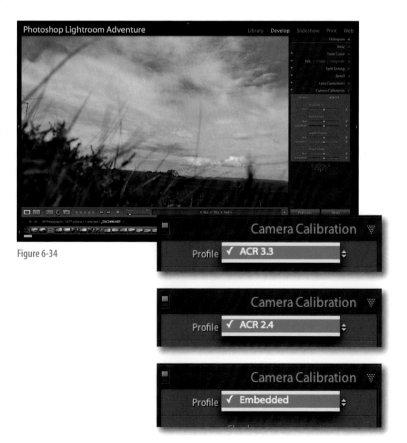

Figure 6-34

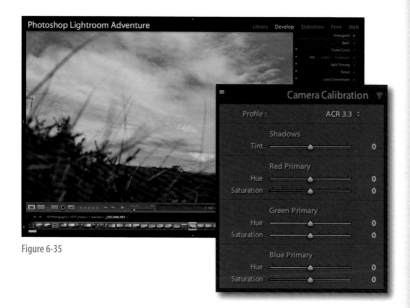

Figure 6-35

Figure 6-36

Figure 6-37

Primary sliders to fine-tune these colors. *Figure 6-35* Start with the Hue slider (which actually changes the color), then adjust the Saturation. (Negative values desaturate; positive values saturate.)

Check your adjustments visually or with the Color sample tool. Working in Lightroom's Before/After view is helpful. When you are finished, save your settings as a preset.

Save as a User Preset

You can save these settings to use again later. Do this by selecting the [+] symbol (circled) in the Presets pane. *Figure 6-36* This will bring up the dialog box shown.

You'll probably want to save only the Camera Calibration settings (circled), which then creates a starting point from which you can adjust each image individually. When you are finished, click Create. Now the preset will show up in the Users Presets category in the Presets pane and, upon Import, where you can apply the preset to a batch of images at once.

Save Default Develop Settings

You can also make your new calibration a default setting applied automatically to files from a specific camera. Do this by selecting Set Default Settings from the Develop menu, or Option-click (Alt-click) on Reset in the right panel. Then, in the resulting dialog box, select Update to Current Settings. *Figure 6-37*

> NOTE *In Chapter 8, I'll show you how photographer Angela Drury uses Camera Calibration controls to create interesting black and white effects.*

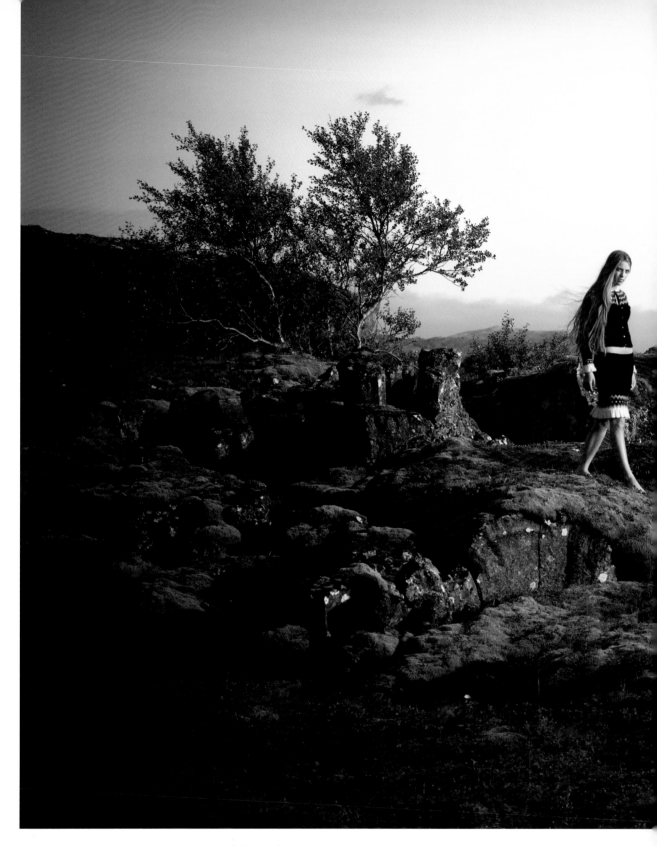

Maggie Hallahan

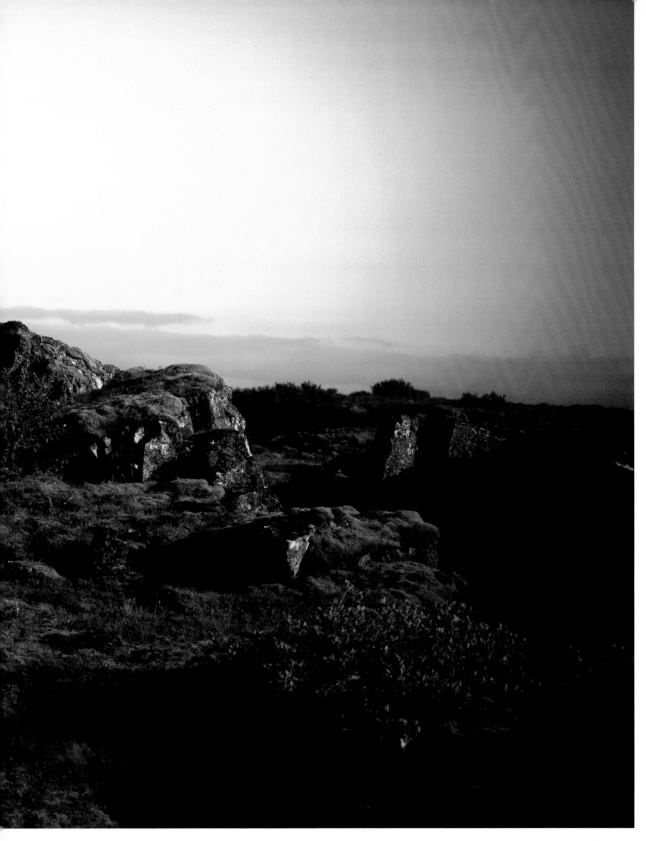

No, Maggie didn't chance upon an Icelandic beauty strolling causally through the barren Iceland landscape. With amazing foresight, she contacted a modeling agency in Reykjavik before we arrived and arranged everything. For this photo, Maggie used Lightroom's tonal adjustments and added a vignette to the edges. Her technique is explained in more detail in Chapter 8.

Black and White and Special Effects

Some images were made to seen in black and white, and Lightroom not only makes it possible to quickly convert a color image to grayscale, but to control the conversion of individual colors as well. The results are roughly equivalent to using different colored filters with panchromatic black and white film. You can produce dramatic skies or brilliant foliage and much more. It's up to you. Pushing the boundaries with special effects are also a slider away in Lightroom's Develop module, as you will learn in this chapter.

Chapter Contents

When to Convert to Black and White

Not all color images warrant conversion to black and white. A converted color image can be plain boring if there is neither good composition nor compelling content. It can also suffer if it is not converted properly. Let's see what works in black and white, what doesn't, and why.

Some images work equally well in color or black and white. Take the wonderful shot by Derrick Story, shown here in both color and in black and white. *Figure 7-1* (I've included larger before and after versions on the next pages.) As a color image, Derrick's shot is quite successful. I love the red dress complemented by the red flower. When converted properly to black and white using Lightroom's black and white controls, the photo is still quite good. In some ways, in my opinion, it's even better. Without the distraction of color, the composition and drama are emphasized.

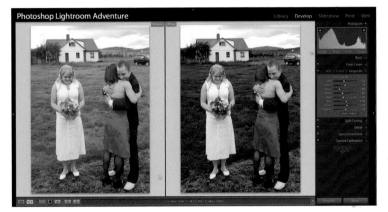

Figure 7-1

Doesn't Work

And then there are shots like the one shown here by John Isaac, that are substantially better in color. *Figure 7-2* Once converted to black and white, this shot becomes relatively mundane. The color is what holds the image together. There is little in the way of dramatic lighting or striking composition, which is apparent when the color is removed.

Figure 7-2

Figure 7-3

Figure 7-4

Figure 7-5

Works, but with Work

A bad conversion from color to black and white can also result in a boring image. Take the Maggie Hallahan shot shown in *Figure 7-3*. I converted it to black and white by simply clicking on Grayscale in Lightroom's Develop module, Basic pane. While this method works fine for some images, in this case, all the tones seem alike and the image is quite flat. (I have Lightroom's presets preferences set to "Apply auto grayscale mix when converting to grayscale." More on this later in the chapter.)

In this next example, I used Lightroom's Develop module Grayscale Mix controls on Maggie's image. By controlling the way certain colors convert to grayscale, I ended with an image worth looking at. (I'll get into the details of how I did this later in the chapter.) *Figure 7-4*

Simply Better in Black and White

And then there are images that are simply better in black and white. This shot taken by Jóhann Guðbjargarson is a good example of what I am talking about. *Figure 7-5* (I've included larger versions of these on subsequent pages.) In this case, the color doesn't add much, if anything, to the image. Take the color away and the image becomes moody and timeless and, I think, memorable.

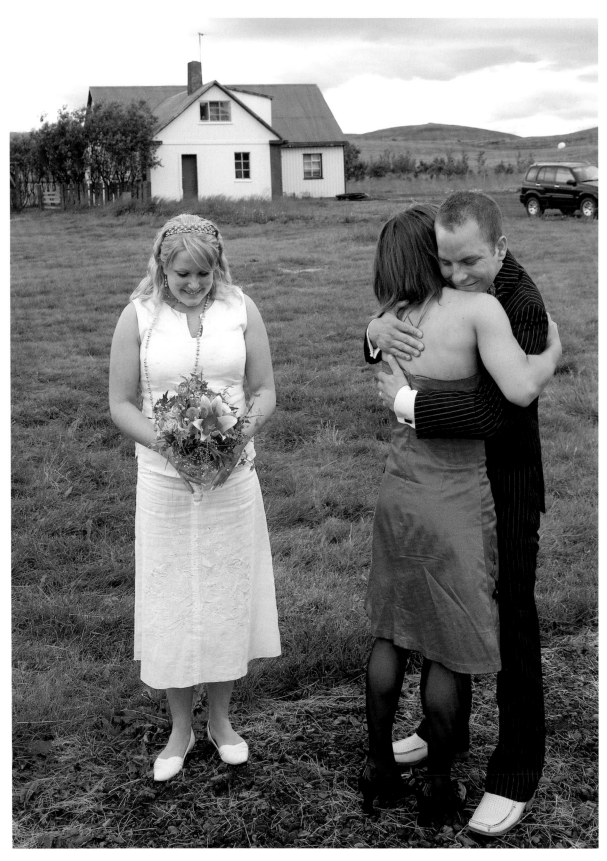

Derrick Story's photo is beautiful in color...

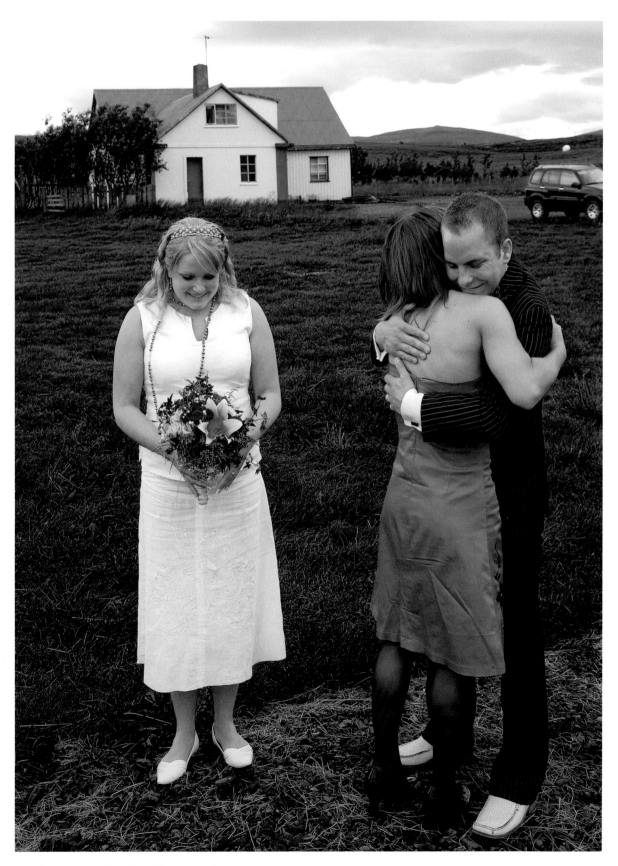

...and works equally well in black and white.

Jóhann Guðbjargarson's photo looks OK in color...

...but it works much better in black and white.

Basic Black and White Conversion

In Lightroom, black and white conversion is as simple or complex as you like. Let's start with the basic steps of converting an RGB color image into black and white. (In the next section, we'll move on to Lightroom's Grayscale Mix for fine-tuning control that will really give your work a professional look.)

You can quickly convert one or more color images to black and white from any of Lightroom's modules (except the Web module) by simply using an out-of-the-box preset. Here's how.

Using the Contextual Menu to Convert

In any module, except Web, place your cursor over the image preview window, and right-click. This brings up the contextual menu, where you can choose Convert to Grayscale from the Develop Settings subgroup. If you are satisfied with the results, you are done. Otherwise, you can go to the Develop module and fine-tune the results there. *Figure 7-6* The contextual menu is also available in the filmstrip. Be sure to place your cursor over the image area, not the frame.

Convert from Quick Develop

From the Library module you can convert to black and white via the Quick Develop pane. Select the image (or images) you wish to convert from the preview display. Select as many images as you wish. Select Grayscale from the Treatment pop-up menu. *Figure 7-7*

> NOTE *Press the V key at any time in any module (except Web) and the selected images will convert to grayscale. (Press V again to colorize.) Then, if you want, use the Develop module's Grayscale Mix to fine-tune.*

Figure 7-6

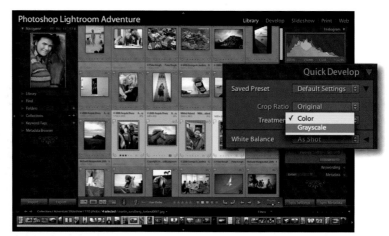

Figure 7-7

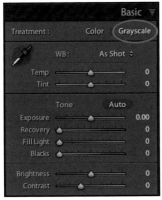
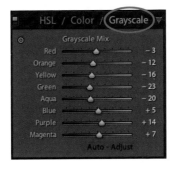

Figure 7-8

Conversion from the Develop Module

You can also convert to black and white from the Basic or HSL/Color/Grayscale panes. *Figure 7-8* Selecting Grayscale from either pane produces the same results. Using either of these methods opens up the world of the Grayscale Mix for the ultimate conversion control. (If you desaturate your image using the Saturation slider in the Basic pane, Grayscale Mix will be useless, but you can use Camera Calibration pane controls for fine-tuning.)

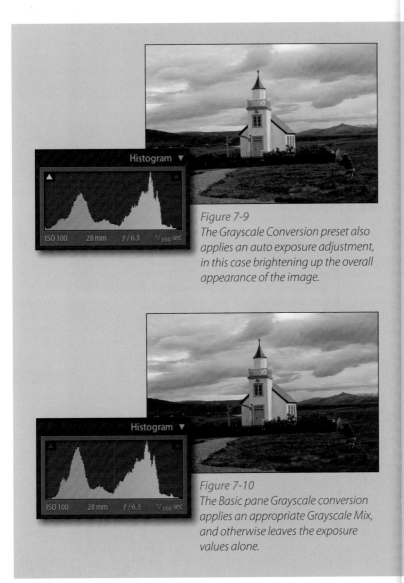

Figure 7-9
The Grayscale Conversion preset also applies an auto exposure adjustment, in this case brightening up the overall appearance of the image.

Figure 7-10
The Basic pane Grayscale conversion applies an appropriate Grayscale Mix, and otherwise leaves the exposure values alone.

Differences in Conversion

Both the Grayscale Conversion preset and the Grayscale conversion in the Basic and HSL/Color/Grayscale panes use a "smart" conversion that automatically creates an auto Grayscale Mix appropriate for a particular image. *Figures 7-9 and 7-10* This auto mix takes into account the fact that the human eye perceives luminance values differently based on color. For example, we see blue as much darker than green or red, even if it shares the same physical brightness value. When you use Lightroom's Grayscale Conversion preset, an auto-exposure setting is applied as well. Other grayscale conversion presets shipping with Lightroom include Antique Grayscale and Sepia Tone. These presets apply a Split Toning—created tint to the Grayscale conversion.

Note: if you don't want Lightroom to automatically apply an auto grayscale mix to your grayscale conversion, go to the Preferences/Presets tab and uncheck the "Apply auto grayscale mix when converting to grayscale" box.

Using Grayscale Mix for More Control

Lightroom's Grayscale Mix controls have revolutionized digital black and white conversion. Since using these controls, I've retired several of my more complex and time-consuming conversion techniques. I'll show you how and why I now turn almost exclusively to Lightroom for my black and white conversions.

To start, you need a color image. From a quality point of view, it's preferable to work with a native RAW file, but a JPEG, TIFF, or PSD will do, as long as it is in color. *Figure 7-11*

NOTE *Many digital cameras now offer a "Black and White" option. Lightroom's Grayscale Mix control won't have any effect on these images, unless they are saved as a RAW file, where the color data is always available. You can, however, "tone" these camera-generated grayscale JPEG or TIFF images with a Develop module preset , the Basic pane Tone sliders, or the Split Tone pane controls.*

Click on the word Grayscale (circled) in the HSL/Color/Grayscale pane. *Figure 7-12* Your image will appear unsaturated, but what you see is misleading. The underlying color data is still available, which means you can use Lightroom's Grayscale Mix control to determine how each color is converted. Once you export your image as a TIFF, JPEG, or PSD—even though it is saved in RGB—all color data is eliminated. If you export your converted image as a DNG file, the color is retained and can be retrieved, if necessary, in other programs such as Photoshop.

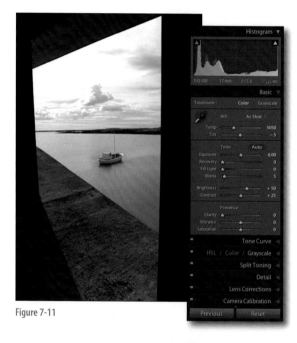

Figure 7-11

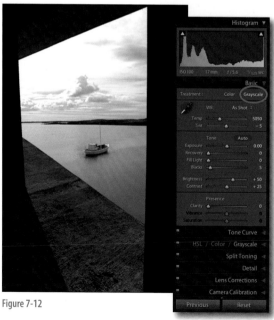

Figure 7-12

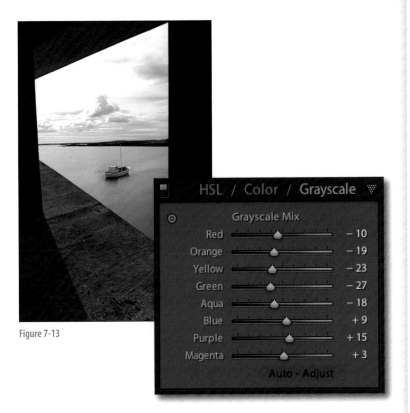

Figure 7-13

If we look closely at the Grayscale Mix sliders, we can see that they have not all moved the same amount. *Figure 7-13* Lightroom creates a "smart" custom auto mix (see the sidebar earlier in the chapter). Although this often produces pretty good results, I find it is mostly just a good starting point.

Often I want to interpret the color conversion differently. Let's say, for this image, I want to make the blue-purple sky appear darker. I can work specifically on that color in a couple ways. I'll show you what I mean.

NOTE *Compare Lightroom's basic grayscale conversion with other image editing applications, and I think you will be amazed at the difference. Lightroom does its conversion in the LAB color space at 16-bits per pixel, rather than in RGB at 8-bits per pixel. This effectively reduces or eliminates banding (noticeable strips) entirely, and subtle transitions between tonal values appear much smoother. (Wikipedia has a great article on the technical reasons why LAB color space is preferable.)*

Using the TAT for Black and White Control

By far my favorite method for this kind of adjustment is to the use the Targeted Adjustment Tool (TAT). I can start with the Auto-Adjust mix settings created by default, or I can hold the Option/Alt key and select Reset Grayscale Mix and start from a neutral point. *Figure 7-14*

Figure 7-14

I simply select the TAT icon in the HSL/Color/Grayscale pane (circled, lower). Then I place my cursor over the area I wish to work on (in this case, the sky, circled) and drag down to darken, or up to lighten. *Figure 7-15*

If you look at the Grayscale Mix pane, you will see the beauty of using this method. Even though I wasn't sure which colors were in the sky (remember, I'm looking at a grayscale version of my image), the TAT knew and the Blue, Purple, Magenta—and to a lesser degree, Aqua—sliders moved accordingly.

I can continue using the TAT on different parts of the image to lighten or darken areas based on the color values of the image that are under the tool.

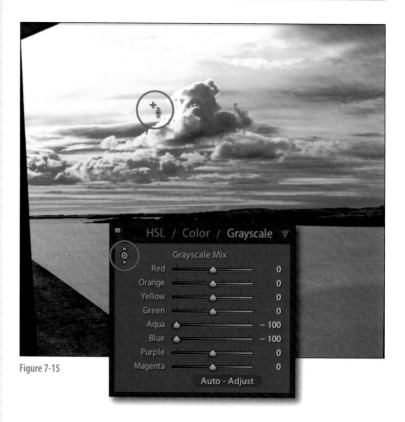

Figure 7-15

Using Before and After for Reference

If you want to work on a color-by-color basis using the Grayscale Mix sliders, it's difficult, unless you know which colors are where. There is an easy way to do this: use the Before and After mode.

In this example, I physically moved the Red, Yellow, Green, Blue, Purple, and Magenta sliders based on the colors in the Before view. My adjustments are immediately viewable in the After view. (By the way, to get to the Before/After view, select the icon in the toolbar at the bottom of the preview window (circled).

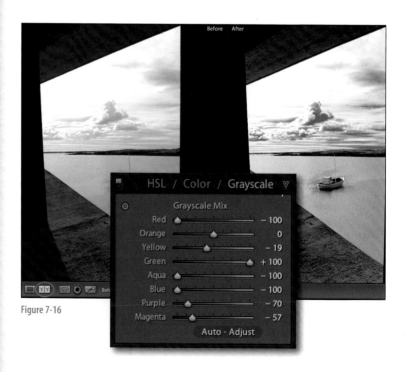

Figure 7-16

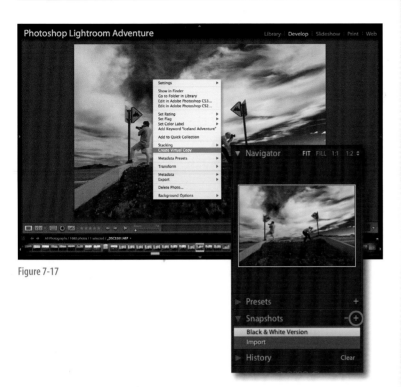

Figure 7-17

Creating Virtual Copies and Snapshots

You can create a virtual copy of your black and white conversion by placing your cursor over the image preview in any module or in the filmstrip. Right-click and select Create Virtual Copy from the contextual menu. *Figure 7-17* In the Library module, you can group your versions into a stack. Lightroom doesn't actually duplicate the image file, it creates a set of instructions that are saved in the Lightroom database and take up very little space on your hard drive. In the Develop module, you can also create a snapshot to save your settings. Click on the [+] sign in the Snapshots pane (circled) in the left panel and name your snapshot. It will remain in the Snapshots pane until you delete it by clicking on the [-] sign.

Figure 7-18
John McDermott took this shot with a Canon EOS 5D and set it to shoot black and white and save as a RAW file. On import into Lightroom the preview briefly reflected John's settings.

Figure 7-19
Lightroom automatically created its own preview and all the in-camera black and white settings were ignored.

Beware: Camera Black and White Settings Ignored

Many digital SLRs, and some digital point-and-shoots, offer sophisticated control over the way black and white images are converted in the camera. *Figures 7-18 and 7-19* If you are planning on using Lightroom, don't spend a lot of time fiddling with these controls or any other camera-based special effects. The settings are often encrypted and unreadable by Lightroom. On import into Lightroom, you will probably get a black and white thumbnail preview that appears to contain your camera settings. However, once Lightroom creates its own standard-sized preview, the original camera settings are not applied.

Angela was a last-minute addition to the Adventure team. She works for Adobe but wasn't directly involved with Lightroom, the product. She received a customer alert about the Lightroom beta from Jennifer Stern, who was organizing the Adobe side of things for the Adventure (and paying the bills from her budget). Angela emailed Jennifer, asking to be a part of the beta. A few weeks later, Jennifer invited Angela to be a part of the Adventure. I took one look at Angela's stunning online portfolio of flowers and nature and welcomed her heartily on board. Angela's Lightroom toning technique, which she used on this photo, is explained in Chapter 8.

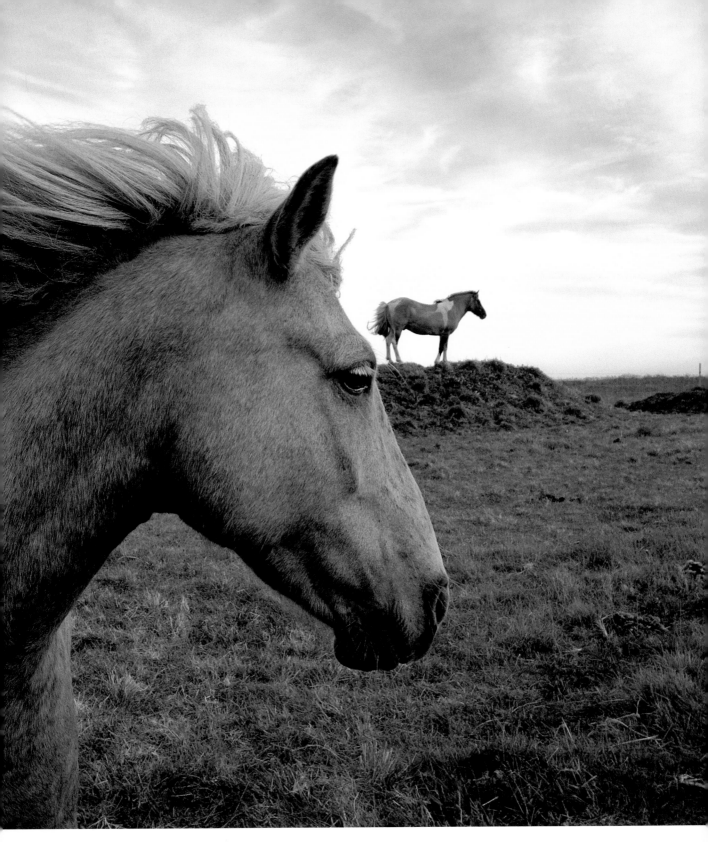

Angela Drury

Adding a Color Tint

Adding a color tint to a black and white photo has long historical precedent in traditional photography. I remember using tea bags to tint my silver halide prints! Who can forget the smell of the chemicals we used to create Sepia-colored prints? Anyway, it's a lot easier with Lightroom, believe me.

In the spirit of starting with the easiest method, let's turn our attention to the presets that ship with Lightroom, which can be used to color tint either a black and white or color image. The two most obvious ones are called Sepia Tone and Antique Grayscale. Another less obvious one is Cyanotype. These presets are available in the contextual menu, the Library module's Quick Develop pane, and in the Develop module's Lightroom Presets pane, where you can get a preview of the preset by hovering your cursor over it. If you have the Navigator pane open, the preview will reflect the changes (as it has done here when I passed my cursor over Sepia Tone). *Figure 7-20* To apply the preset, simply click on the preset name.

Figure 7-20

Using White Balance Tint Control

Another way to create a color tint from a color image is to simply change the White Balance Tint slider control, found in the Basic pane of the Develop module. Moving the Tint slider to the left shifts the colors to green, while sliding them to the right shifts the colors to magenta. *Figure 7-21* This method definitely works better on some images than others; it all depends on the colors of the image. It won't work at all if you have completely desaturated your color image or converted it to grayscale.

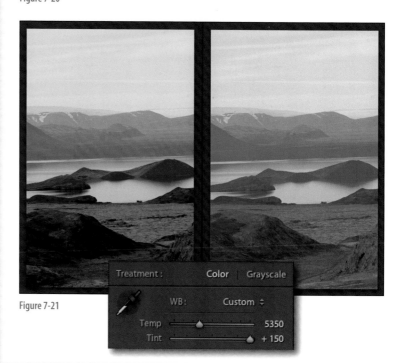

Figure 7-21

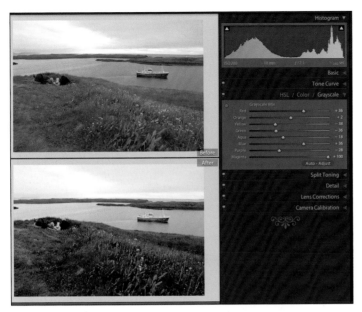

Figure 7-22

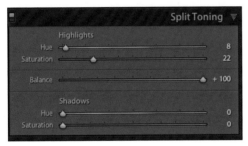

Figure 7-23

Figure 7-24

Using Spit Toning to Single Color Tone

You can also use the Split Toning pane to create a uniform tint to your image. (In the next section, I'll show you how to create a split-toned look, which distributes the tint to shadows and highlights differently.)

Here's how:

1. Convert your image to grayscale in the Basic or HSL/Color/Grayscale panes. Adjust the Grayscale Mix as needed. (You can always do this later, after applying a tone.) *Figure 7-22*

2. Open (or go to) the Split Toning pane.

3. Move the Balance slider all the way to the right, to +100. *Figure 7-23* (This effectively pushes the tint values to all tonal values equally, not just to highlights or shadows.)

4. Move the Saturation slider to a desired level.

5. Slide the Hue slider until you get the tint you want. Hold the Option (Alt) key while you do this to preview the actual tint color. You can control the intensity of the tint with the Saturation slider. *Figure 7-24*

NOTE The Develop module's Camera Calibration pane can also be used to tint an image, but it's more hit-or-miss so I generally don't use it for a single-toned look.

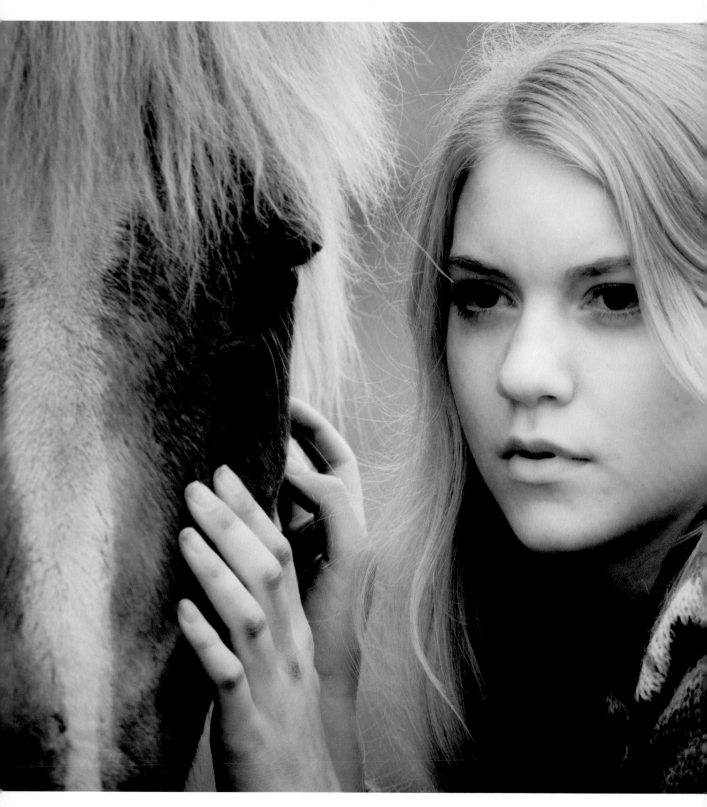

Maggie Hallahan

I've known Maggie Hallahan professionally and socially for nearly 20 years. She never sits still! When she is not photographing, she leads women's rowing parties all over the world. Maggie was responsible for hiring and organizing the Icelandic models. When the models first showed up on the Adventure, I confess, I was miffed. Many of the photographers dropped what they were doing and went off to join Maggie and her entourage. But now, when I look at the photos, especially this one, I'm thrilled. To learn how Maggie achieves this high-key look, see Chapter 8.

Getting a Cross-Processing Look with Split Toning

Cross-processing is a popular technique in the film world, where film was deliberatively processed incorrectly. The results were unpredictable, but often included interesting unnatural colors and high contrast. You can simulate this popular technique with Lightroom's Split Toning controls.

Let's start with the photo shown on the left. I'll convert it to grayscale (right) and experiment with the Split Toning pane controls until I get the cross-processing look I'm after. *Figure 7-25* The basic theory is this: You can control the tint and the saturation of the tint applied to the highlight areas of an image separately from those applied to the shadow areas. The Balance slider in the middle controls the range of each. You'll understand the Balance slider better after I show you some examples.

Figure 7-25

Getting It Right

First I'm going to show you how I got the cross-processing look I want, then I'll show you how the Balance slider works by going to the extreme.

To get what you see in *Figure 7-26*, I did the following:

1. Adjusted the Highlight Hue slider until I got the aqua tint you see in the horses and clouds (the highlights). You can hold the Option (Alt) key while you adjust the slider to more easily determine the color tint.

2. Adjusted the Shadows Hue slider until I got the magenta tint in the ground and mountains.

3. Increased the Saturation settings for both the Highlight and Shadows controls to a desired level.

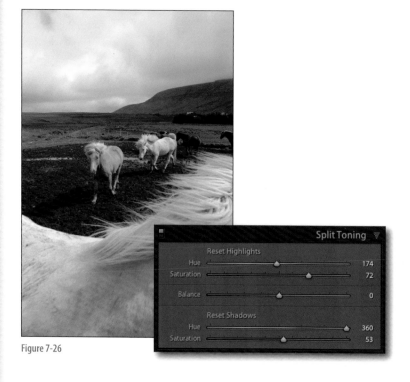

Figure 7-26

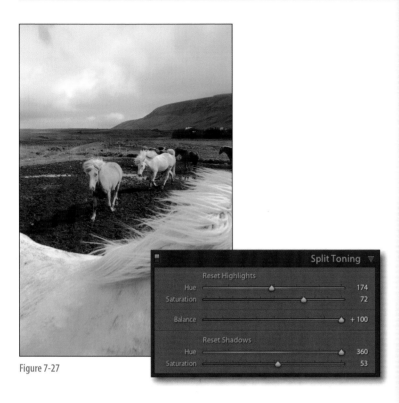

Figure 7-27

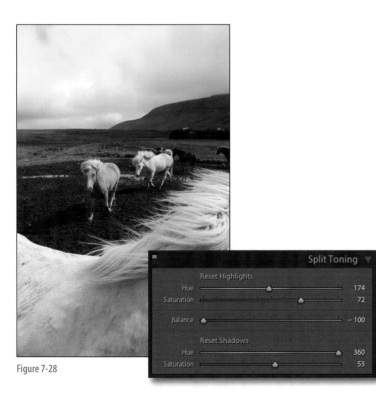

Figure 7-28

Going to the Extreme

Just so you can see how the Balance slider works, I'm going to crank up my Balance to +100. *Figure 7-27* Now you see that the aqua tint, which before was specific only to the highlight area, has "spread" into the shadows as well. If I slide the slider toward negative values, less and less of the aqua tint will apply to the shadow areas.

Here, I cranked the Balance slider the other way, to −100. *Figure 7-28* As you can see, the magenta has "spread" from the shadow areas into the highlights. Again, if I pull the slider the other way, toward the positive values, less and less of the magenta will spill over into the highlights.

Pushing the Boundaries with Special Effects

When you use the Develop module controls in Lightroom, you can create harmonious, realistic photos, or you can push the boundaries and create wild, unrealistic effects, all with the flick of a slider. The possibilities are nearly limitless.

Let's start at the top of the Develop panel, and work our way down through the panes to see which controls are useful for producing special effects. (In the next chapter, I'll get into some specific recipes other photographers use in their work, some of which also produce very interesting special effects).

Changing White Balance for Effect

If you shoot and save RAW files, the simple act of changing the White Balance setting in Lightroom's Develop module's Basic pane can produce unexpected, and often interesting, results on your RAW image. This is all I did to produce the effect shown in the After panel in *Figure 7-29*. I tried all the various white balance settings but settled on the Tungsten setting (circled).

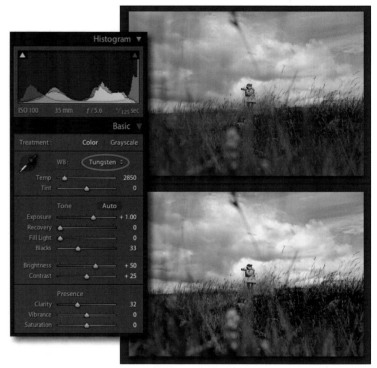

Figure 7-29

Maximize Fill Light and Black Settings

Another simple, and guaranteed, way to produce a special effect is to crank up both the Fill Light and Black sliders in the Basic tab to 100 (circled). This is what I did to produce what you see in *Figure 7-30*.

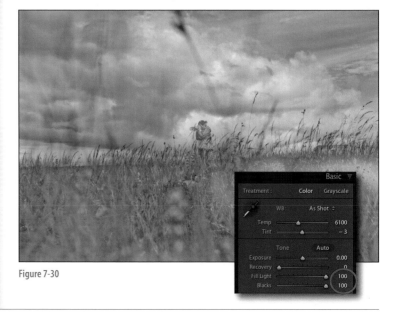

Figure 7-30

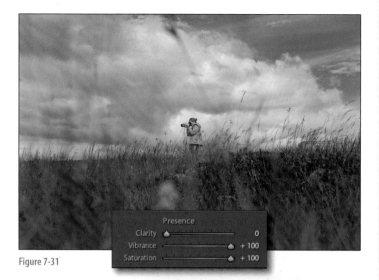

Figure 7-31

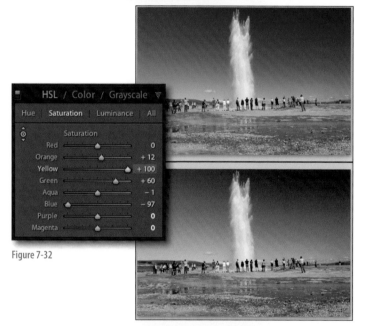

Figure 7-32

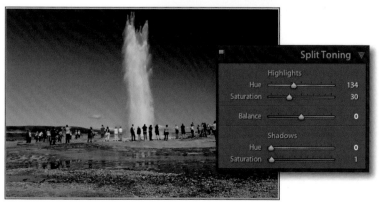

Figure 7-33

Use Both Saturation and Vibrance

The Saturation and Vibrance sliders in the Basic pane, under Presence, both boost color saturation, however they do it in different ways. (I discussed the practical use of both of them in the previous chapter.) Boosting *both* of them to their maximum settings with a color image will definitely produce an interesting—and sometimes pleasant—effect. *Figure 7-31*

Selectively Desaturate Colors (and More)

Special effects can be easily achieved by desaturating selective colors. That's what I did to create the shot you'll see on the next page. For this example, I used a combination of Develop pane controls, including HSL/Saturation and Split Toning.

Here is what I did, step-by-step:

1. Adjusted the Exposure setting. In this case, I adjusted only the Black slider in the Basic pane to give the photo more contrast.

2. Selected the HSL pane. I used the Target Adjustment Tool (TAT) to desaturate the blue sky. I also boosted the saturation of the foreground colors. *Figure 7-32*

3. Selected the Split Toning pane. First I boosted the Highlight's Saturation slider to 30. Then I adjusted the Hue slider to 134, which gave the entire image a slight aqua tint, mostly in the highlights (water spout). *Figure 7-33*

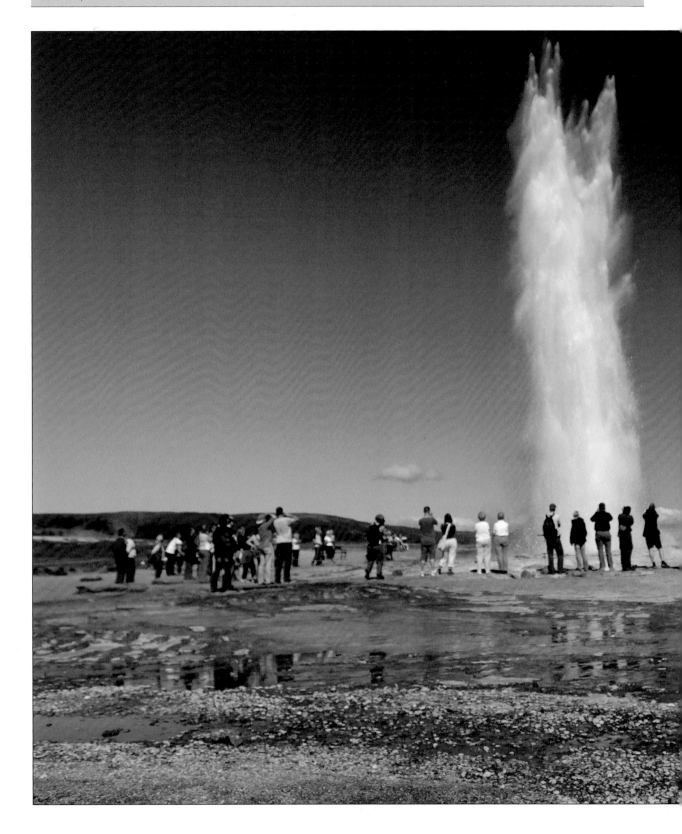

4. However, the aqua tone spilled beyond the highlights, so I adjusted the Split Toning Balance slider to −40, so the color tint applied only to the brightest highlights. The final image is shown here.

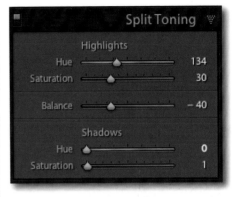

NOTE *In the next chapter, you'll see how Angela Drury uses the Camera Calibration pane for some of her special effects. I'm not going to go into detail here, except to say I find the controls much harder to use and harder for me to predict the results. I bring up the Camera Calibration controls because I know many of you might be familiar with Adobe Camera Raw's Camera Calibration tab, which does basically the same thing as Lightroom's controls. You may have grown comfortable with using it, and will likely want to continue doing so in Lightroom.*

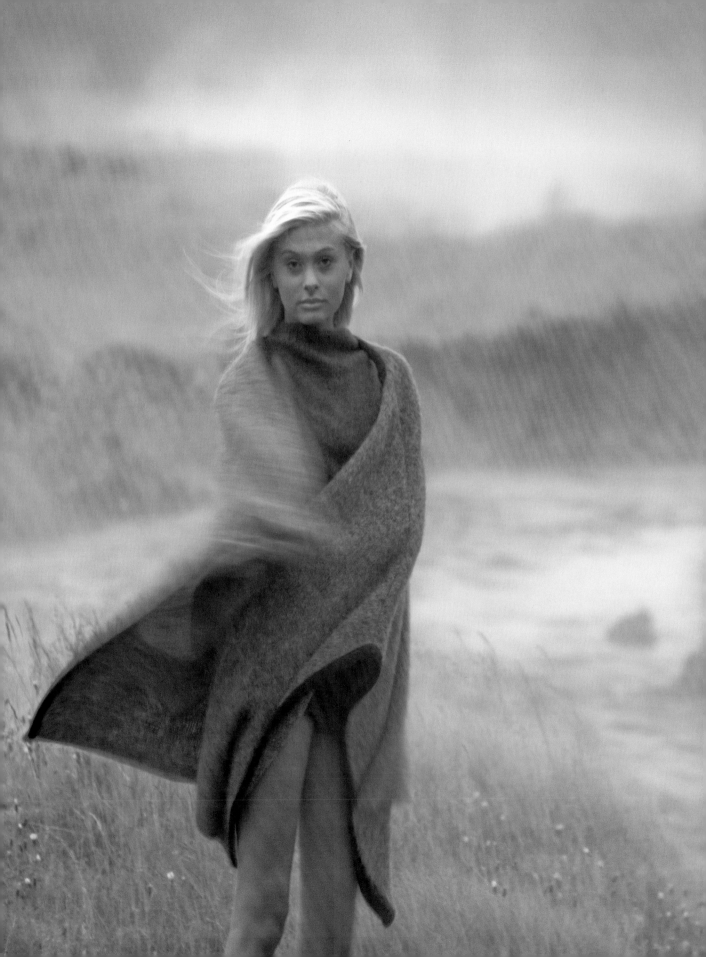

Develop Recipes from Iceland

As you learned in the previous chapters, it's really easy to apply a custom look and feel to your images using Lightroom's Develop module and tonal controls. Several of the Iceland Adventure team members did just that. Let's look at what they came up with, reveal their custom Develop settings, and give you a chance to try their recipes on your own images.

Chapter Contents

PHOTO CREDIT: Derrick Story

Michael Reichmann Recipe: Controlled Toning

Readers of Michael Reichmann's immensely popular web site The Luminous Landscape (*luminous-landscape.com*) know how Michael feels about Lightroom's Grayscale Mix controls and Split Toning controls. He absolutely loves them! He has fine-tuned a toning method that produces great results, especially when viewed as a gallery-quality print.

Michael's original shot for this example is a beautiful color Icelandic landscape. *Figure 8-1* When he finishes converting the color version into black and white and applies Split Toning to it, the results are stunning.

Figure 8-1

Here is what Michael does to produce his controlled toning effect:

1. Select Grayscale from the HSL/ Color/Grayscale pane. Michael starts with Lightroom's Grayscale Mix Auto settings. *Figure 8-2*

Figure 8-2

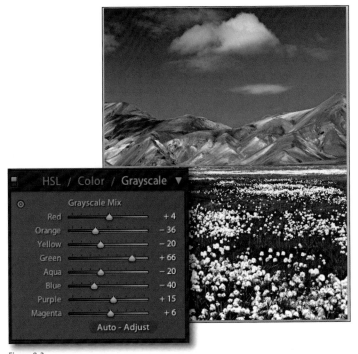

Figure 8-3

2. Work the Grayscale Mix color sliders to taste. In this image, Michael darkened the sky slightly with the Blue slider, used the Orange slider to build more contrast in the mountains, and increased the Green slider to lighten up the foliage in the foreground. *Figure 8-3*

3. Next, judge what the monochrome image needs in terms of toning. Sometimes an image needs toning in the highlights, sometimes in the shadows, and sometimes in both. Sometimes he does nothing, and just sticks with the monochrome conversion.

Using the Split Toning Controls

Michael's approach to using the Split Toning controls is as follows:

1. Boost the Saturation slider about halfway to 50, so that it's overdone, but obvious what the color is.

2. Choose the tone color by moving the Hue slider. Michael recommends warm tones for highlights and cool for shadows.

3. Slide the Split Toning pane saturation slider down to a desired level. In this case, he chose 20.

Michael's eventual Split Toning pane settings for this example are shown in *Figure 8-4*.

You can see enlarged versions of the before and after images on the following pages.

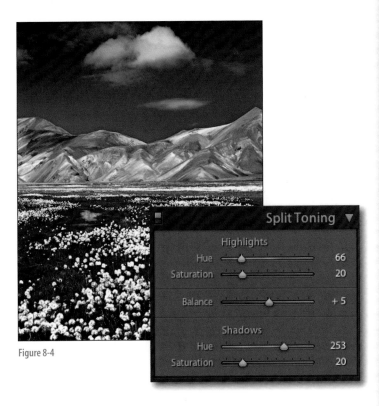

Figure 8-4

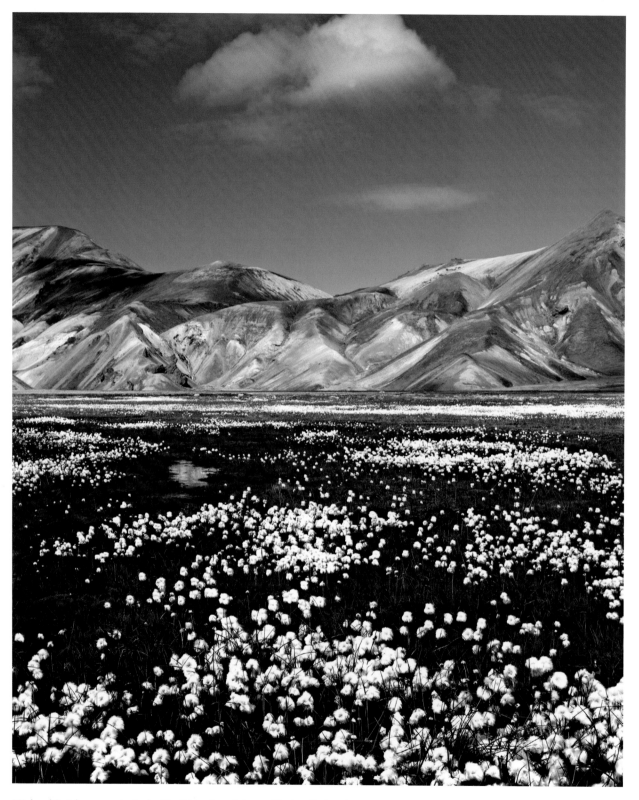

Michael Reichmann started with this color picture of Icelandic landscape.

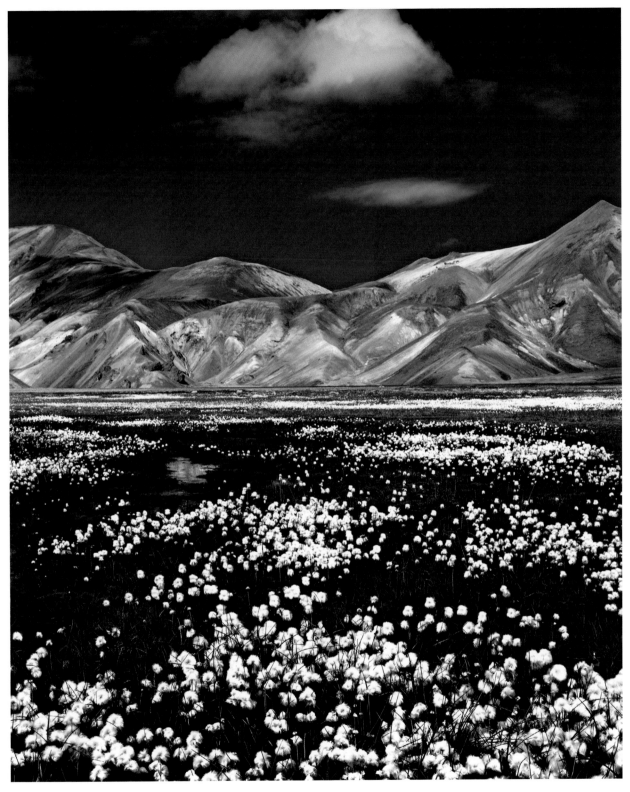

Using Lightroom's Grayscale Mix controls, Michael converted the image to black and white, then used Lightroom's Split Toning controls to warm the highlights and cool the shadow areas.

Richard Morgenstein Recipe: Mixing Light

For this recipe, Richard includes both a shooting and develop component. In the end, he creates an eerie look that works especially well on landscape shots (like the one used in this example) and portraits.

From a shooting point of view, Richard looks for a scene that contains a mix of natural and artificial ambient light. He sets his camera on a tripod and, in the case of this low-light shot, uses a long exposure (20 seconds at f/9) rather than bumping up the ISO and the camera's sensitivity. *Figure 8-5*

In the case of the example shown here, the result is a photo filled with unnatural colors. Pay particular attention to the tree in the photo. It is receiving light from the sky—which in Iceland in the summer never gets completely dark—*and* the mercury vapor street lights.

Figure 8-5

Once Richard imports his RAW photo into Lightroom and the Develop module, he does the following:

1. Pick one of the light sources to correct. In this case, Richard chose to correct for the mercury vapor lights by placing his white balance tool on the sidewalk, in an area that received the most light from the lights and clicking. *Figure 8-6* (To quickly select the White Balance tool, use the W key.)

Figure 8-6

Color-correcting for one of the light sources throws the other light source in an interesting and often pleasing direction. *Figure 8-7*

Figure 8-7

Figure 8-8

Figure 8-9

2. Adjust the tonal values. In this case, Richard increased the Blacks to +7 and decreased the Brightness from +50 to +5 to darken the image overall. *Figure 8-8*

Finally, open up the HSL tab and tweak the Hue, Saturation, and Luminance settings to get the desired look. *Figure 8-9* shows the settings Richard uses to get the look he's after.

(You can see the enlarged before and after images on the following pages.)

Other Uses for Richard's Recipe

Apply Richard's recipe to a person, and they can look really awful, or very interesting, depending on what you are after. With a landscape shot, you have a lot more leeway with unnatural colors because it adds interest and dimension. Also, people are more accepting of a wider range of colors in a landscape shot, especially one taken at night.

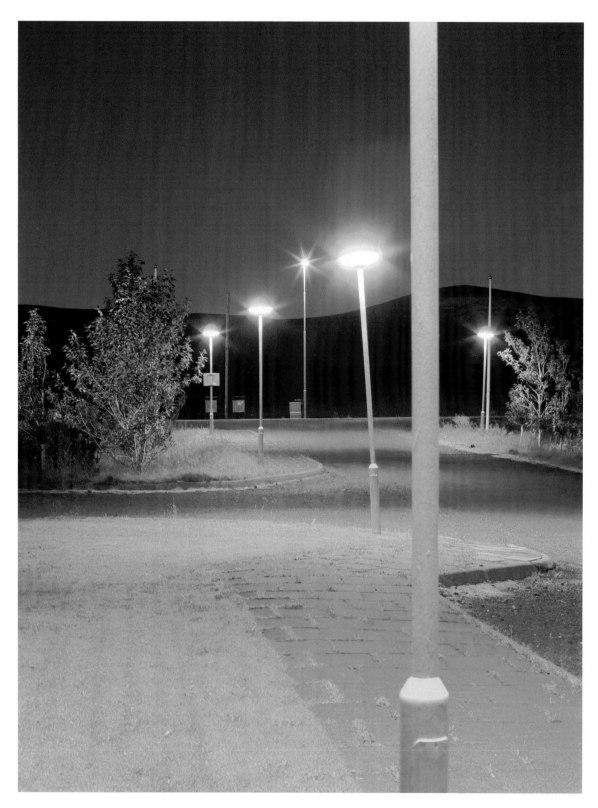

Richard Morgenstein starts with a shot containing a mixture of natural and artificial light...

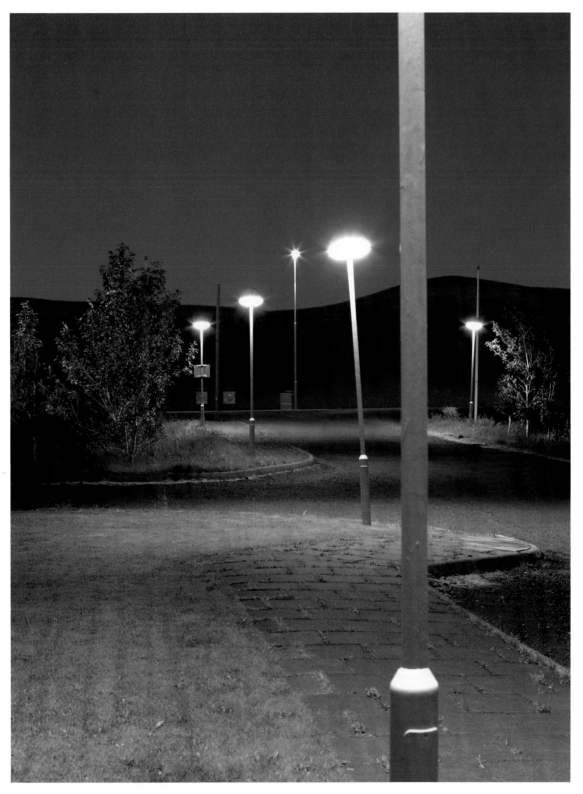

...and then corrects the white balance setting for one light source, throwing the other light source into an interesting and often pleasing direction.

Angela Drury Recipe 1: High Drama

Angela is the Iceland Adventure recipe master. Here is one of her favorite recipes, which you can use to apply this high drama to one of your own images. Two of Angela's other favorite recipes are explained in subsequent sections.

The original color image is shown here. *Figure 8-10* The model's face, which was shot without benefit of a fill flash, is dark and lacks dramatic tonal distinction. To create a more stunning image, Angela follows the following procedure, all within Lightroom's Develop module:

Figure 8-10

1. First, decrease the Basic pane's Saturation slider to −100, removing all color and creating a flat-looking image. *Figure 8-11* Angela doesn't use Lightroom's Basic pane Grayscale conversion because, as you will see, she prefers using the Camera Calibration pane to adjust contrast and tone and give her image a unique look.

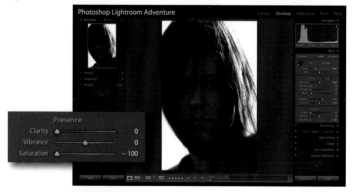

Figure 8-11

2. Adjust the exposure in the Basic pane as needed. In this example, Angela lightened up an otherwise dark image. *Figure 8-12*

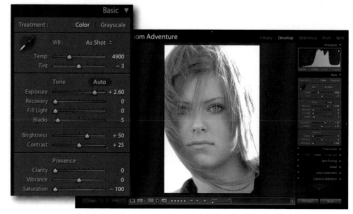

Figure 8-12

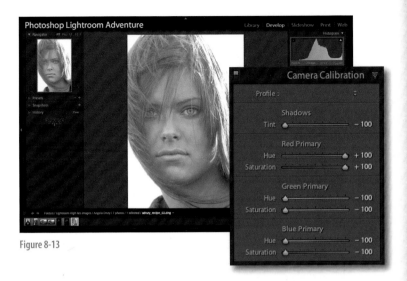

Figure 8-13

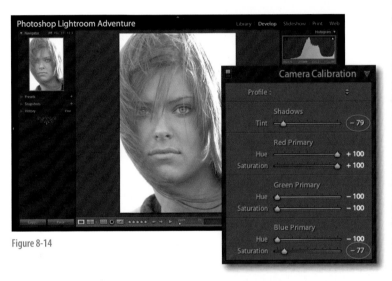

Figure 8-14

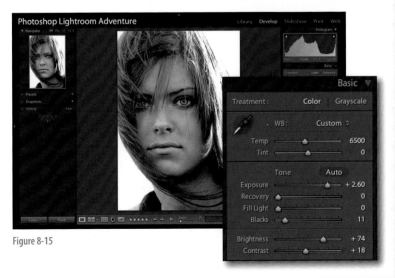

Figure 8-15

3. Angela's next step is to apply a custom Lightroom preset she created and named B&W Medium Contrast. She made this preset using the Camera Calibration pane settings shown here. *Figure 8-13*

4. Angela used this custom preset as a starting point. She then tweaked the settings in the Camera Calibration pane with the Shadows Tint and Blue Primary Saturation sliders (circled) to control skin tone and image contrast. *Figure 8-14*

5. Finally, back in the Basic pane, Angela tweaked the Temp, Blacks, Brightness and Contrast sliders, as shown, to further increase overall contrast. *Figure 8-15*

(You can see the enlarged before and after images on the following pages.)

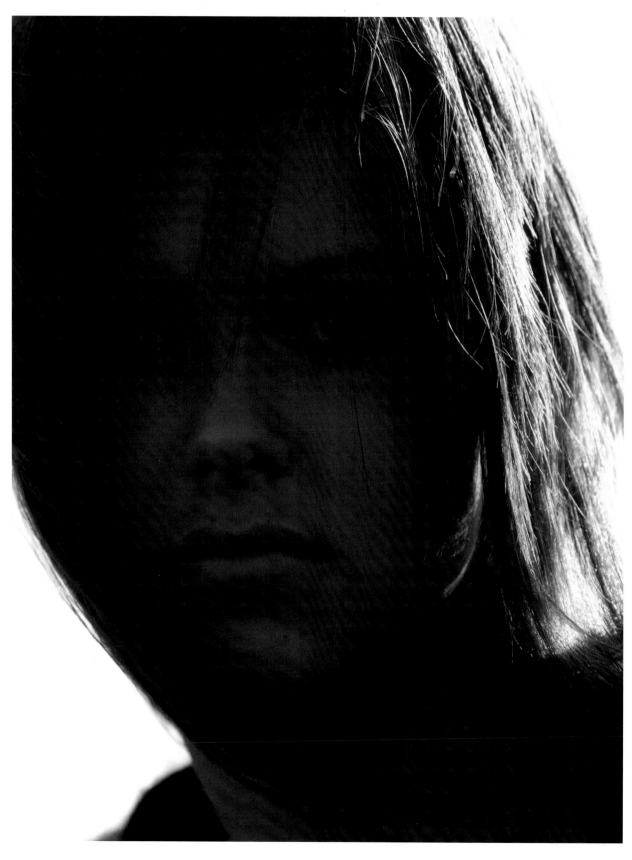

Angela Drury started with a relatively flat image containing very little tonal drama...

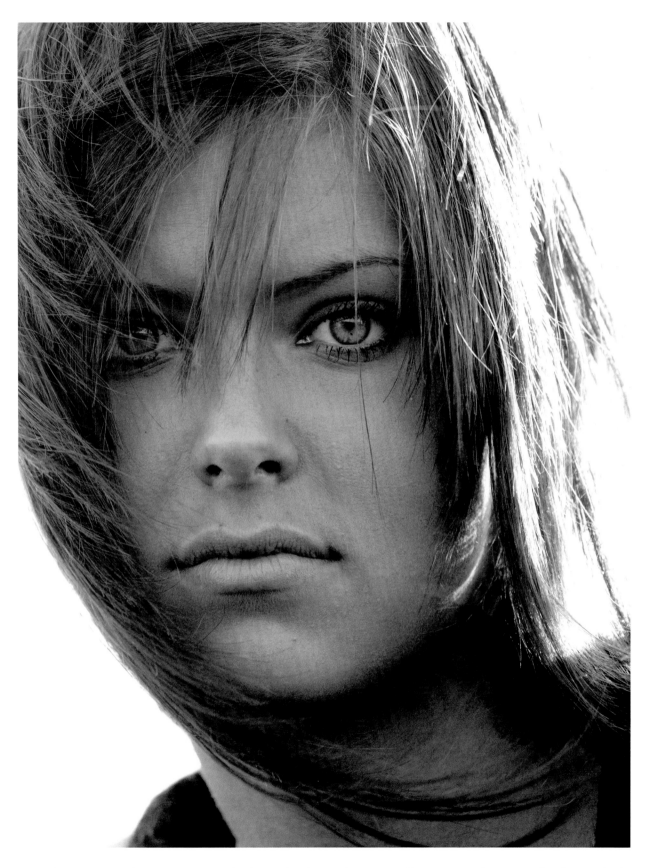

...but after converting the image to grayscale, she used Lightroom's Camera Calibration controls to create this dramatic look.

Angela Drury Recipe 2: A Cibachrome Look

This recipe starts with a Lightroom default preset called Direct Positive. Angela takes the preset a bit further to imitate a traditional photographic printing process known commercially as Cibachrome, or generically as R-type printing. The result is a new richness for an initially flat image.

For this image, Angela started with one of Lightroom's default presets called Direct Positive. *Figure 8-16* Initially, she liked the brightly saturated colors produced by this preset, but she ended up making minor modifications in the Basic, HSL, and Camera Calibration panes.

Figure 8-16

Here, step-by-step, is what Angela did:

1. She applied the Direct Positive preset to the image. It produced interesting tones, but there was too much yellow and there was a slight tint of green in the overall image. It was also a bit too dark. *Figure 8-16*

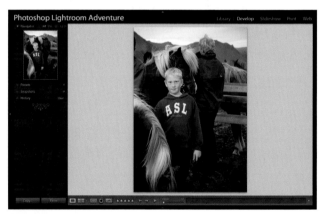

Figure 8-16

2. Modify the undesirable effects in the HSL pane. Angela decreased the Green and Yellow Hue values (circled), then decreased the Saturation on the Orange, Yellow, and Aqua sliders to tone them down from their preset settings. *Figure 8-17*

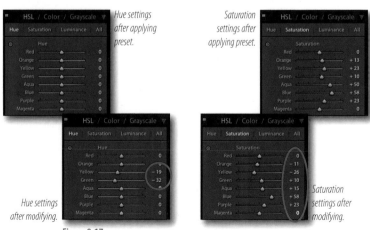

Hue settings after applying preset.

Saturation settings after applying preset.

Hue settings after modifying.

Saturation settings after modifying.

Figure 8-17

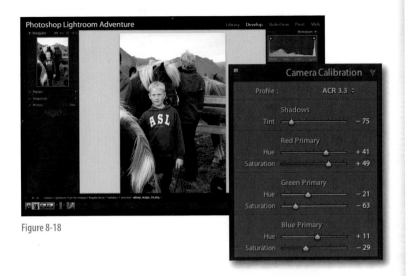

Figure 8-18

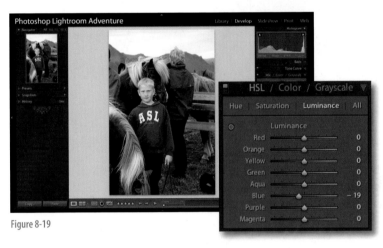

Figure 8-19

Figure 8-20

3. In the Camera Calibration pane, to further eliminate a slight greenish cast, the Green Primary Hue slider was adjusted to −21 and the Green Primary Saturation slider to −63. Other Camera Calibration sliders were adjusted from their default settings to those shown. *Figure 8-18*

4. Back in the HSL pane, to give the sky and mountains more contrast, Angela lowered the Blue Luminance slider from 0 down to -19, which darkened them slightly. *Figure 8-19*

5. The final steps included these adjustments: *Figure 8-20*

- Making changes in the Basic pane to lighten the darker areas of the image.

- Moving the Lens Vignetting sliders to produce a slight darkening at the edges.

- A slight lightening of the Darks and Shadows sliders in the Tone Curve pane.

You can see the enlarged before and after images on the following pages.

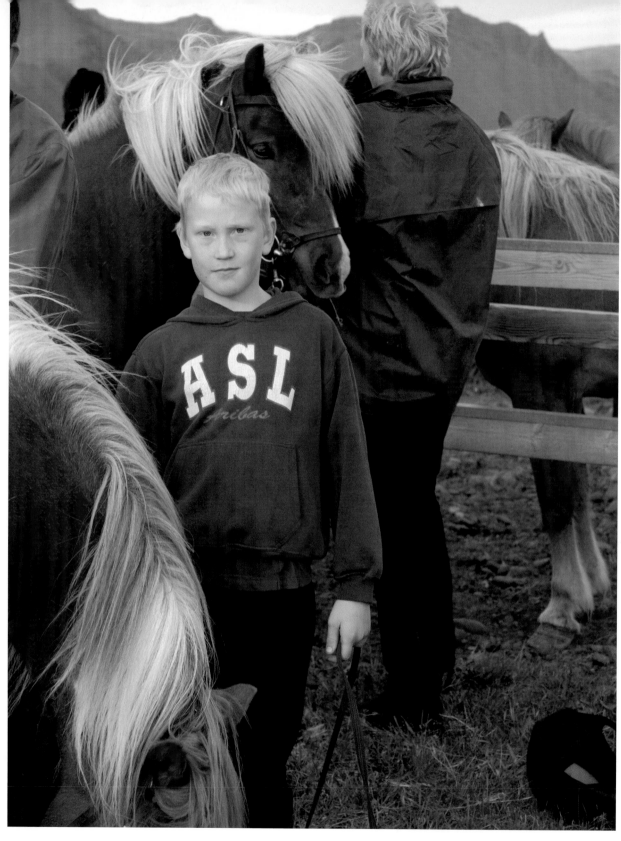

Angela starts with an otherwise flat image...

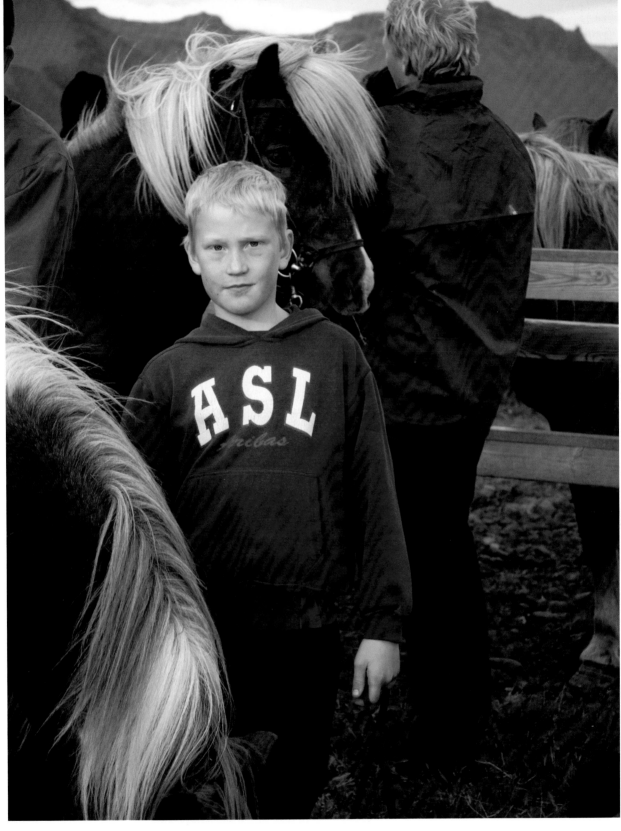

...but with her Cibachrome technique, she produces a picture with vivid, highly saturated colors and increased depth and richness.

Angela Drury Recipe 3: An Antique Look

As you saw in the previous chapter, toning is also easy to do with the Develop module's Split Toning pane. Angela has come up with a toning technique she uses that's a bit more complicated, but produces a unique look.

For the image shown in *Figure 8-20*, Angela used the following controls found in Lightroom's Develop Module: Temperature, Tint, and Saturation adjustments in the Basic pane; Camera Calibration; Lens Vignetting in the Lens Corrections pane; and tonal adjustments in the Tone Curve pane.

> *Note* **This is the basic formula Angela used in Chapter 7 to make the dramatic image of the two horses.**

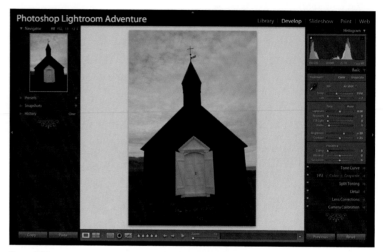

Figure 8-20

Here is Angela's step-by-step technique:

1. Set a custom temperature (12500) in the Basic pane, which warms up the image. She then makes a minor upward adjustment to Tint (+19) to give it a slightly magenta cast to the warmer temperature setting.
 Figure 8-21

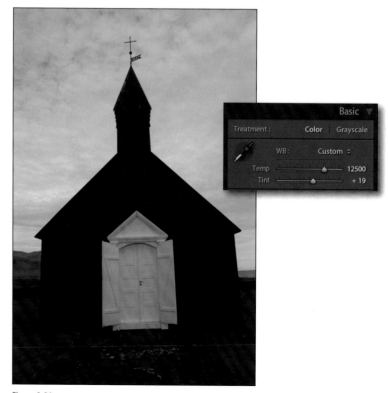

Figure 8-21

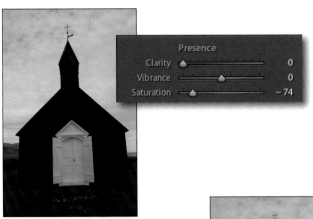

Figure 8-22

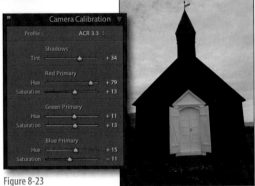

Figure 8-23

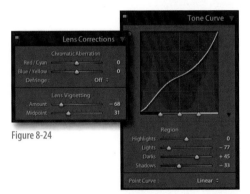

Figure 8-24

Figure 8-25

2. Greatly reduce the saturation. Angela dropped the saturation from 0 down to −74 to give it a black and white look. She didn't completely desaturate the image because she wanted some color left for tinting in the Camera Calibration pane. *Figure 8-22*

3. Use the Camera Calibration pane controls to create a sepia-toned look. Angela controls the amount of magenta in the image with the Tint slider, which adjusts the intensity of the sepia coloring. The Red Primary sliders fine-tune the sepia coloring and the Blue Primary sliders adjust redness and overall brightness of the image. *Figure 8-23*

4. Increase the drama in the sky using two steps. First, Angela applies Lens Vignetting from the Lens Corrections pane. *Figure 8-24, left* Then she adjusts the Lights and Darks sliders in the Tone Curve pane. *Figure 8-24, right* Decreasing the Lights slider brought out cloud detail and increasing the Darks slider lightened the building detail. The Shadows and Blacks sliders were slightly adjusted to get the right tone in the darker areas of the image.

5. Finally, she uses the Crop Overlay tool in the toolbar to correct the perspective of the building. *Figure 8-25*

You can see the enlarged before and after on the following pages.

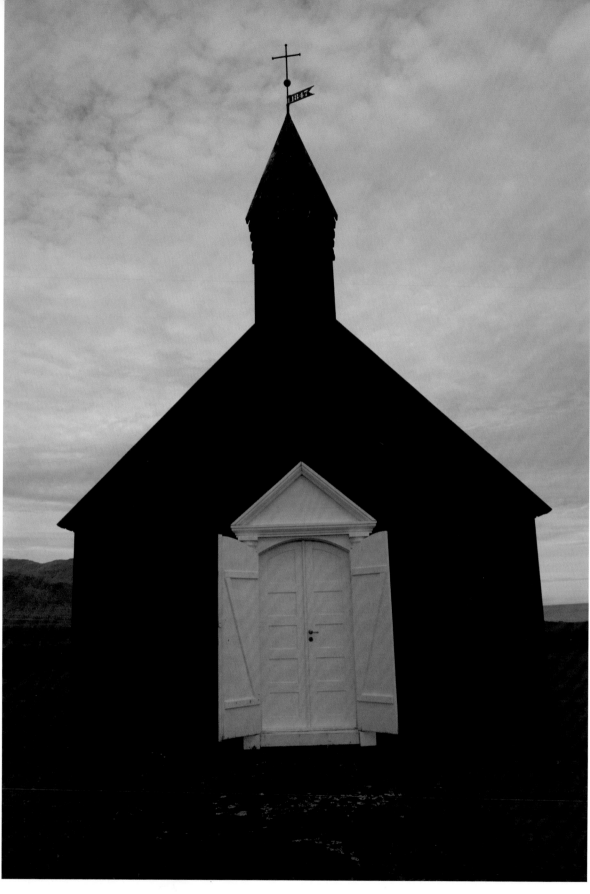

This Angela Drury photo is greatly enhanced by...

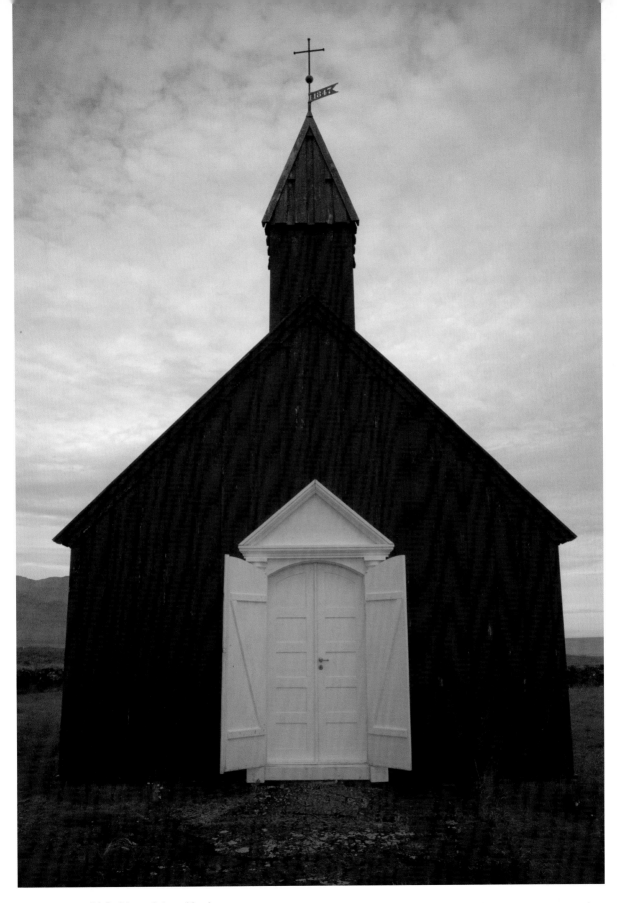

...giving it an old-fashioned tinted look.

Maggie Hallahan Recipe: High Key

Maggie's Iceland photos often get a "Wow!" from people, and not just because they often feature a beautiful model. Maggie adds a personal touch to many of her images during processing in Lightroom. This results in a distinctive look, setting Maggie's work apart.

Here is the original shot in color. *Figure 8-26* Maggie often shoots in so-called landscape orientation, even though she often ends up cropping her images into the vertical orientation. She has learned from years of experience that ad agencies and commercial stock houses often welcome the extra real estate on the sides, where type can be added to suit a client's needs.

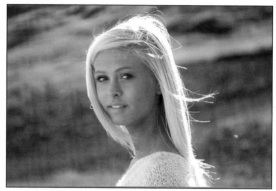

Figure 8-26

Here is Maggie's procedure and the Develop module settings that she used create the shot you see on the next page. You can apply them to your own image, taking into account, of course, individual image characteristics.

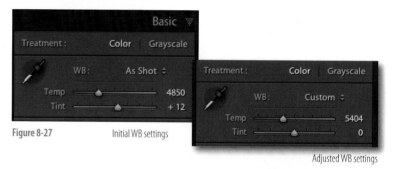

Figure 8-27 — Initial WB settings — Adjusted WB settings

1. Slide the White Balance Temp slider to the right, warming up the image. *Figure 8-27*

2. Adjust the Exposure and Blacks sliders. Here, she slightly darkened the image by dropping the Exposure slider to −0.34, and gave it more depth by increasing the Blacks slider to 15.

3. Adjust the Vibrance and Saturation sliders in opposite directions, increasing the Vibrance, and at the same time decreasing the Saturation. (I know, this sounds counterintuitive, but try it. It produces a very interesting effect!) *Figure 8-27*

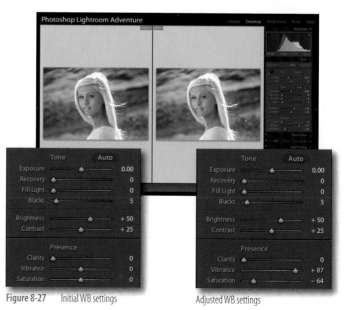

Figure 8-27 — Initial WB settings — Adjusted WB settings

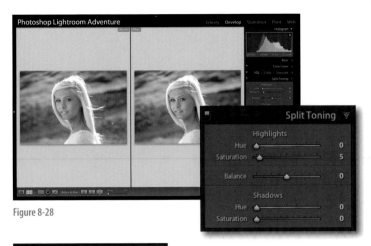

Figure 8-28

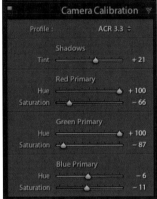

Figure 8-29

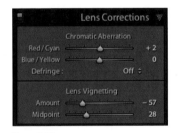

Figure 8-30

Figure 8-31

4. In the Split Toning pane, warm up the Highlight areas slightly. Maggie set the Hue slider to the far left and the Saturation setting to 5. *Figure 8-27*

5. Further adjust the tints in the Camera Calibration pane with the following settings, shown in *Figure 8-29*:

 • Shadows: +21,

 • Red Primary: Hue, +100, Saturation, −66;

 • Green Primary: Hue, +100, Saturation, −87;

 • Blue Primary: Hue, −6, Saturation, −11.

6. Apply a darkening affect around the edges with the Lens Vignetting slider. *Figure 8-30*

7. Crop the image into a vertical orientation using the crop tool in the toolbar. *Figure 8-31*

You can see the enlarged before and after images on the following pages.

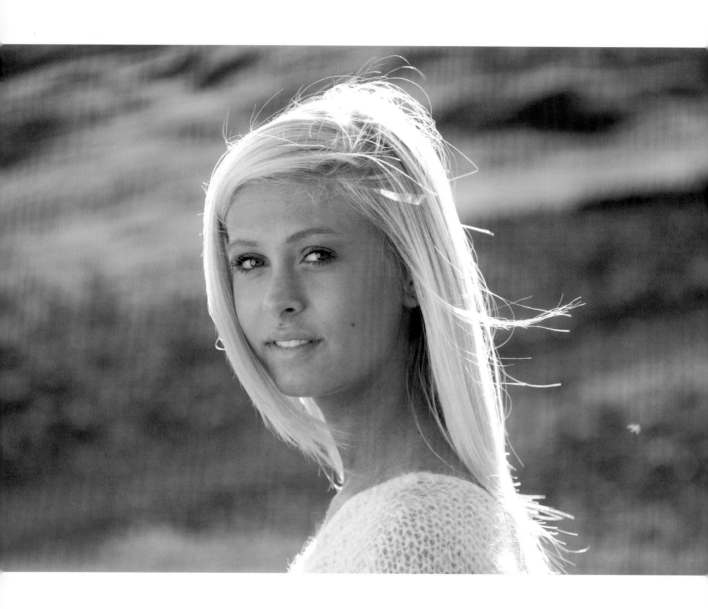

Maggie Hallahan starts with this landscape-oriented image...

...and ends up with this engaging, high-key vertical.

Martin Sundberg Recipe: The Velvia Look

Martin calls himself a straight-shooter, which means he does as little as possible to his images after he shoots them. Here is an extremely simple recipe Martin uses to create more vivid, intense colors. He used it on the horse shot shown in Chapter 3, as well as the example shown here.

Lightroom applies a specific look to an image based on its own color interpretation. If you shoot RAW and use another non-Adobe RAW converter, the conversions will differ. Of course, if you are like Martin, you'll want to tweak the look and feel of Lightroom to your own personal taste.

Martin's look is inspired by one of his favorite films: Fuji Velvia, often referred to as "Disney-chrome" because of its supersaturated look.

To recreate this Velvia look, Martin has created a very simple Lightroom preset that he applies to all his images on import. His recipe is very simple.

In the Develop module's Basic pane, increase the Saturation setting to +16. That's all. Do that and you're done.

Figure 8-32 shows the before image, with no Saturation changes. Martin increases the Saturation to +16 *Figure 8-33*, and gets the results shown on the opposite page.

Figure 8-32

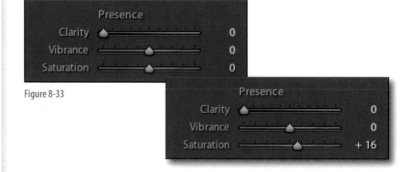

Figure 8-33

Jóhann Guðbjargarson Recipe: The Bergman Look

Iceland-born Jóhann has this recipe that produces what I call an Ingmar Bergman–like effect, after the Swedish filmmaker's dark and moody style. Jóhann turned a playful, light-hearted shot into a darker and more allegorical image. I've used variations on his settings on some of my images with similar results.

When he started working on the image shown in *Figure 8-34*, Jóhann's initial impulse was to use the Develop module's Basic pane exposure controls to try and bring back some detail in the sky. But as he worked on the image, he found he actually liked the blown out sky. It helped frame the top horse and he left the sky alone.

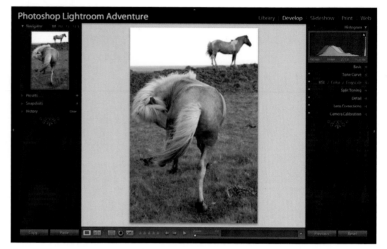

Figure 8-34

Here is Jóhann's procedure. It really works best on a RAW image. If you try this procedure on a non-RAW RGB file, you'll have to modify Step 1 because you won't have the same kind of White Balance control Jóhann had.

1. Start the Basic pane, set the Temp slider to 4700 and the Tint slider to +10. *Figure 8-35*

2. Set the Brightness slider to +9 and the Contrast slider to +89.

3. What comes next is counterintuitive. Increase the Vibrance slider to +86 and decrease the Saturation slider to –84. (Maggie Hallahan used this Yin-Yang approach earlier in this chapter.)

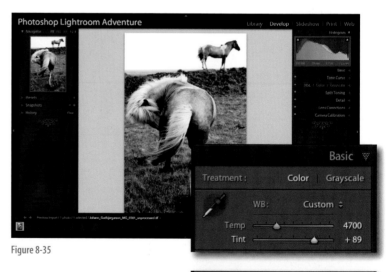

Figure 8-35

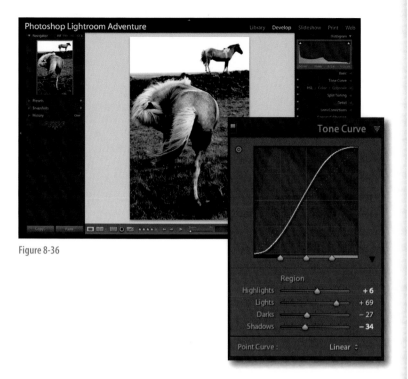

Figure 8-36

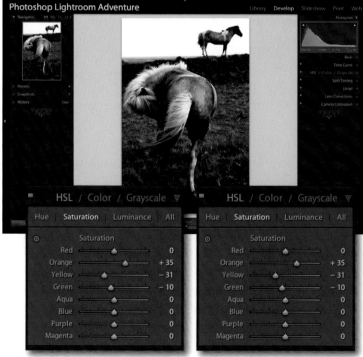

Figure 8-37

4. In the Tone Curve pane, set the Highlights to +6, Lights to +69, Darks to –27, and Shadows to –34. (Your exact settings will depend on your image.) *Figure 8-36*

5. Make final adjustments in the HSL/Color/Grayscale pane. *Figure 8-37* Jóhann started with Saturation and set the sliders as follows:

 Orange saturation: +35
 Yellow saturation: –31
 Green saturation: –10

 Then, in the Luminance box, he set the sliders as follows:

 Yellow luminance: –5
 Green luminance: –17

You can see the enlarged before and after images on the proceeding pages.

The Art of Cooking in Lightroom

As you might have noticed, there is a certain amount of improvisation that goes into cooking with Lightroom. I use the word cooking purposefully. The best chefs know to taste their concoctions as they go along, adding a dash of salt here, or a pinch of oregano there, as needed and not based on absolute values. It's the same with Lightroom. As you try the recipes in this chapter on your own images, remember that every image is different and requires a slightly different approach and settings.

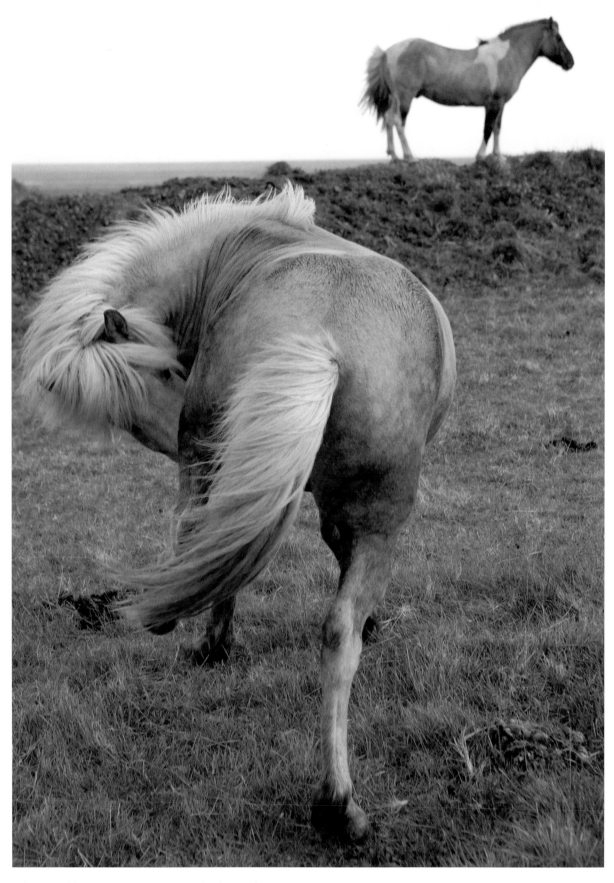

Jóhann Guðbjargarson's recipe gives this horse shot...

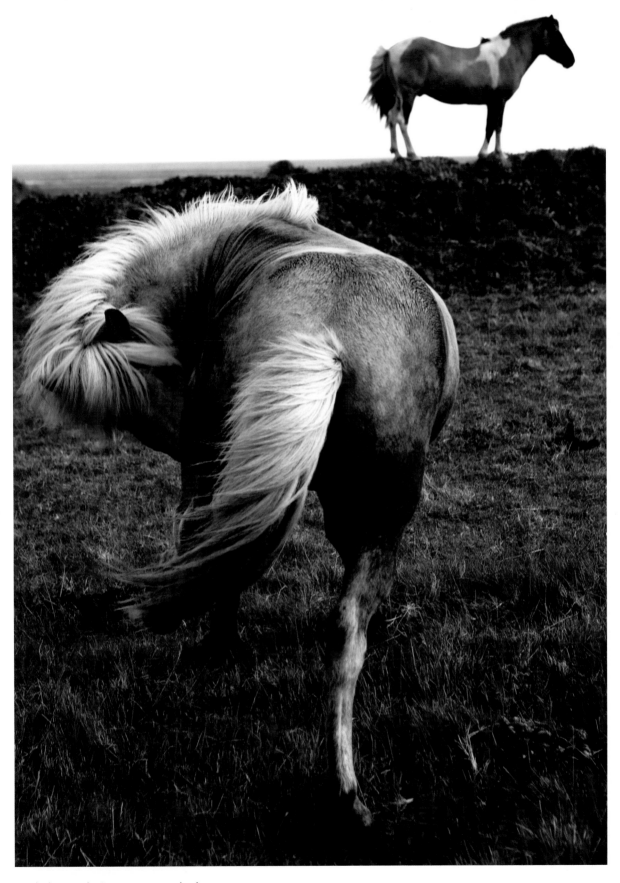

...a dark, moody, Bergmanesque look.

Mikkel Aaland Recipe: Oz Colors

Follow the yellow brick road to my own recipe, which I've dubbed "Oz Colors." The recipe produces a super-saturated look, with a very golden tint. It works well on some images and looks completely terrible on others. There is no way to predict results. Just try it. (I also used the Oz look on the Chapter 9 opener.)

I started with the image you see here. *Figure 8-38* Then I threw everything you can imagine at it from the Develop module's arsenal. About the only pane I didn't turn to was the Camera Calibration pane! I ended up with something I could never have normally duplicated again. Luckily, I created a preset and can retrace my steps for you to follow.

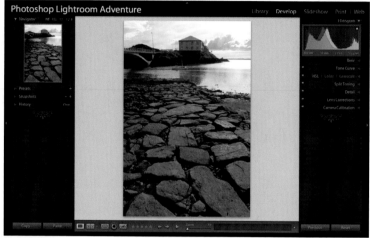

Figure 8-38

1. In the Develop module, I started by making some pretty radical adjustments in the Basic pane. I only slightly increased the Exposure slider to +0.68, but I slid the Recovery, Fill Light, and Blacks sliders all the way to their maximum value of 100. I set my Brightness slider to +10 and my Contrast to +25. I boosted the Vibrance slider to +11. (Like I said, I was just experimenting but ended up with some cool effects.) *Figure 8-39*

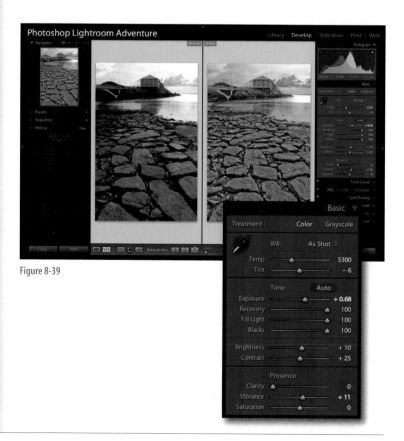

Figure 8-39

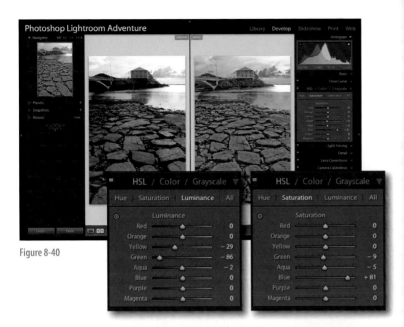

Figure 8-40

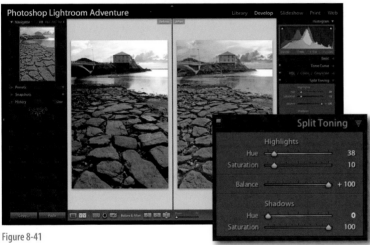

Figure 8-41

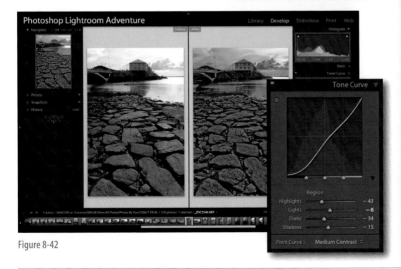

Figure 8-42

2. In the HSL pane, I also made some radical adjustments. With the Hue controls, I decreased the Yellow slider to −29 and the Green slider to −86 and the Aqua slider to −2. With the Saturation controls, I decreased the Green slider to −9 and the Aqua slider to -5 and increased the Blue slider to +81. *Figure 8-40*

3. In the Split Toning pane, I set the Highlights Hue to 38 and the Saturation to 10. I set the Balance slider to +100. I left the Shadows Hue slider at 0 and set the Saturation slider to 100. *Figure 8-41*

4. For a final tweak, I went to the Tone Curve pane and set the Highlights slider to −43, Lights to −6, Darks to −34, and the Shadows to −15. *Figure 8-42*

And that's that. We aren't in Kansas anymore!

You can see the enlarged before and after images on the following pages.

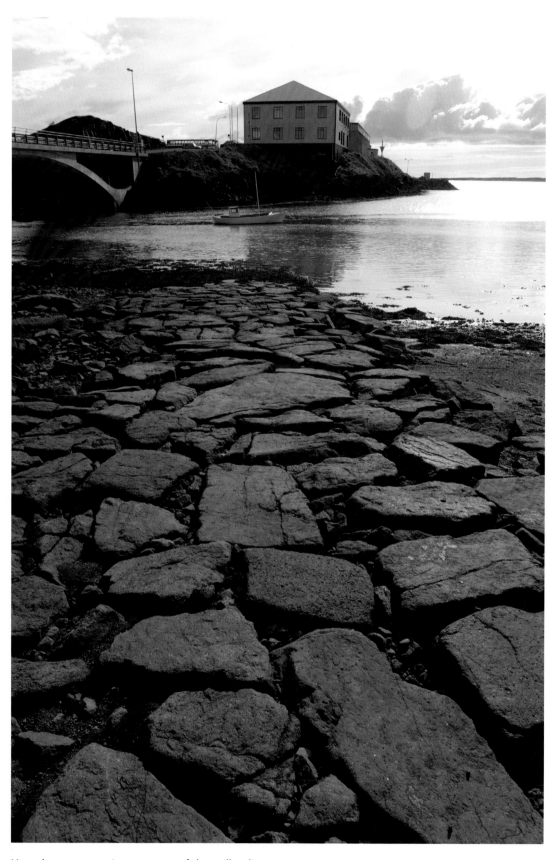

Here the stones are just your run-of-the-mill ordinary stones...

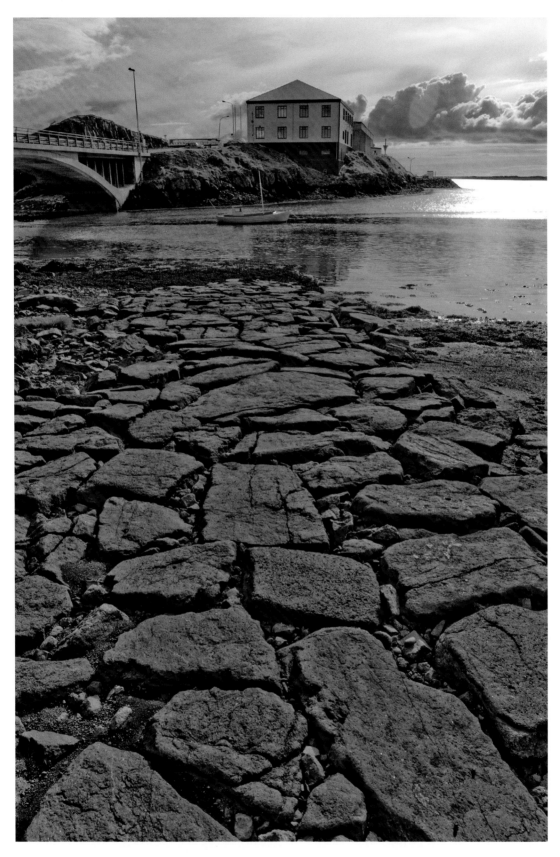

...but after applying the Oz recipe, they turn to gold.

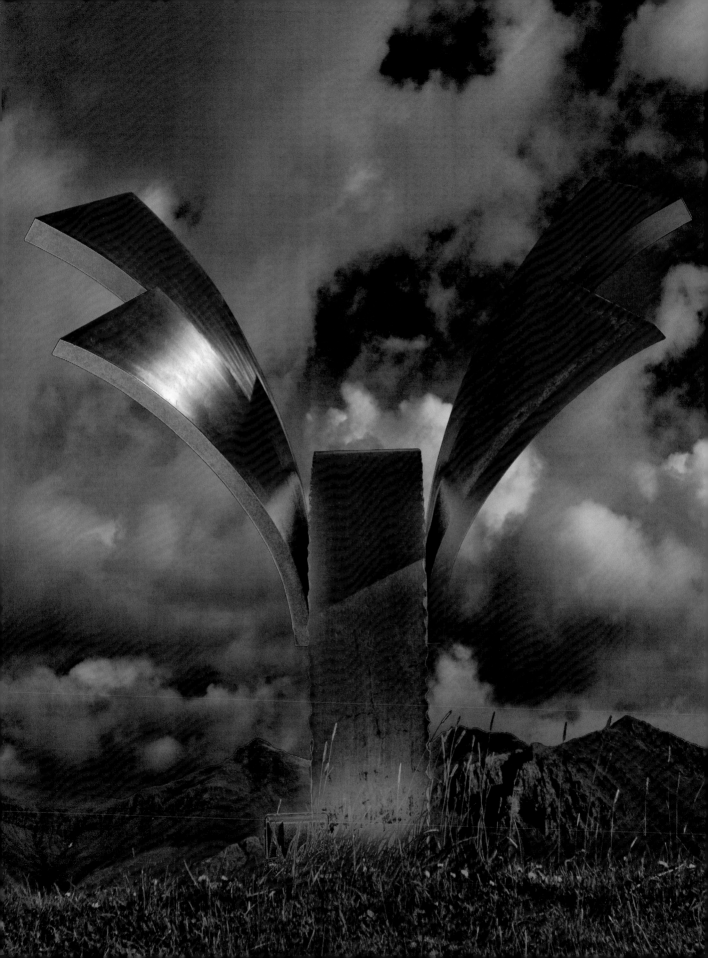

Exporting Files

Within the Lightroom environment, you don't actually save your image files as you might with other applications. As you work on an image, Lightroom automatically saves a set of instructions that are applied to your image whenever you open the application and select that image again. However, as soon as you decide to work outside the Lightroom environment or share your images, you will need to export them or make sure the Lightroom instructions accompany the image file. This chapter shows you how to do so, as well as how to export selected images as a Lightroom catalog, so they're ready to be imported and incorporated into another Lightroom catalog. Finally, I'll also cover compatibility between Lightroom and external editors such as Photoshop and Photoshop Elements.

Chapter Contents

PHOTO CREDIT: Mikkel Aaland

Exporting Revealed

With Lightroom, you can export one photo at a time, or as many as you wish. Export choices are made in the Export dialog box, where you can enter a name, select the file format, size, color space, and more. If you are exporting a Catalog, the process occurs in the Export as Catalog dialog box. Let's see how it works.

You can export images from any Lightroom module by using the filmstrip to make your selection (circled). Make your choice, then use the menu command File→Export. *Figure 9-1* Or you can use the keyboard shortcut ⌘+Shift+E (Ctrl+Shift+E). This brings up the Export dialog box, which I'll go over shortly.

You can select and export one batch of images with one set of settings (for instance, save as JPEG), and then, before the export process is complete, start another export with a different set of settings (for instance, save as TIFF). The export progress is noted in Lightroom's Progress bar (or bars, if you have two operations running at once). *Figure 9-2*

Export from the Library module

To export from Lightroom's Library module, start in the Grid view and select the image you wish to export. Select File→Export from the menu, or click on the Export button at the bottom of the left panel. *Figure 9-3*

Other Export Commands

Here are some other useful export menu commands:

Export with Previous

The menu command File→Export as Previous bypasses the Export dialog box and applies the last Export dialog box settings to your images. It places your images in the previously

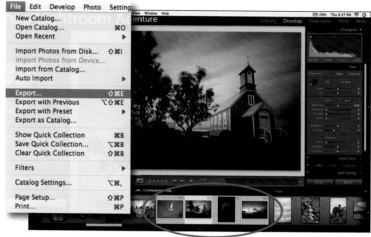

Figure 9-1

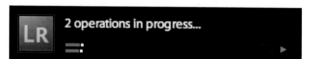

Figure 9-2

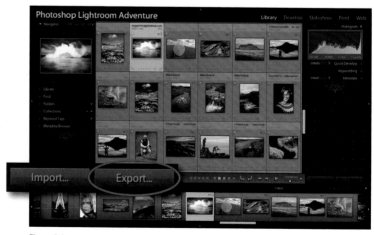

Figure 9-3

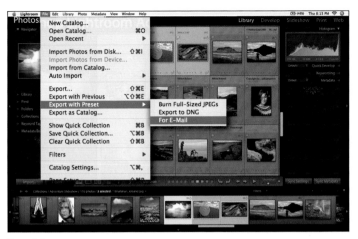

Figure 9-4

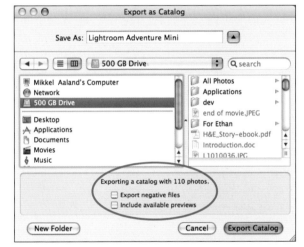

Figure 9-5

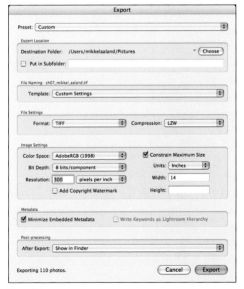

Figure 9-6

designated destination folder or location.

Export with Presets

Selecting File→Export Presets makes all your export presets (both the default presets and those created in the Export dialog box) available without having to go through the Export dialog box. *Figure 9-4*

Export as Catalog

This option is relevant if you want to create a new Lightroom catalog that contains previews and references to selected images. This "mini" catalog, once created, can be imported and incorporated into another Lightroom catalog on another computer.

Export as Catalog Options

When you select File→Export as Catalog from the menu bar, you get this dialog box. *Figure 9-5* Name the new catalog and choose a location on your hard drive. Lightroom will automatically add the required *.lrcat* file extension upon export. Deselect Export negative files and Include available previews (circled) if you want a very quick export that doesn't include the original image files or previews. Make sure the version of Lightroom used to import a new catalog is at or above the version number used to export.

Export Options

Here is the Export dialog box you get when you choose Export from the File menu or the Library's left panel. *Figure 9-6* Here, you make export choices such as destination, file name, file type, etc. Let's go through all the options.

Choose a preset

Lightroom ships with some commonly used Export presets: Burn Full-Sized JPEGs, Export to DNG, and For E-Mail. *Figure 9-7* These are the same presets you'll see when you select File→Export Presets from the menu bar. You'll likely want to make some of your own as well. I'll show you how, later in this section.

Export location

Here, you choose a destination by clicking Choose. If you click on the triangle next to Choose (circled), you will get a pop-up menu with shortcuts to the last destinations selected. *Figure 9-8* If you check Put in Subfolder, you can name a new folder that will reside in the selected folder.

File naming

You can customize a file name in this field, or just leave it as is. *Figure 9-9* A preview of the file name appears in the Export dialog box (circled). Regardless of what you do, Lightroom will automatically add the appropriate file extension based on your file format choice. File Naming presets are also available, as shown in the Template pop-up menu. If you select Edit from the Template pop-up list, you can make a preset of your own.

The Filename Template Editor dialog box appears when you select Edit. *Figure 9-10* In Chapter 3, I discussed how to use the Filename Template Editor. When you are finished, select Save Current Settings as New Preset from the Filename Template Editor Presets pop-up menu (circled).

Figure 9-7

Figure 9-8

Figure 9-9

Figure 9-10

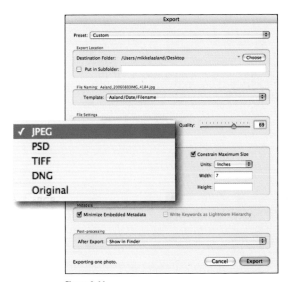

Figure 9-11

Figure 9-12

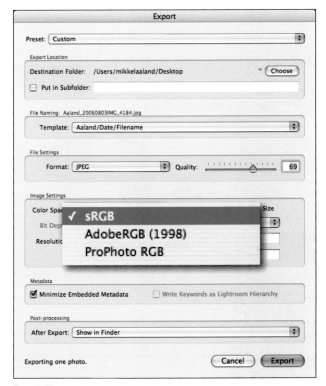

Figure 9-13

File format settings

You can choose from the following file formats: JPEG, PSD, TIFF, DNG, or Original. *Figure 9-11* You can Export only one file format at a time, but as I said earlier, you can start one export before another is finished, effectively exporting multiple formats nearly simultaneously.

File format image settings options vary from format to format. When you choose JPEG, for example, you can also choose the amount of compression with the Quality slider (circled). *Figure 9-12* If you select TIFF, you can choose between Compression: None, Compression: LZW (which is a lossless compression algorithm), and Compression: ZIP (another lossless compression algorithm). If you choose Original, there are no image-setting options. Original, after all, sends an exact copy of your original image to the destination of your choice. If you choose DNG, there are several important options to choose from, which I'll cover in detail later in this chapter.

Image settings

If you choose JPEG, PSD, or TIFF as a format, you are presented with several Image Settings options. *Figure 9-13* Here is a summary of your choices:

Color Space

Choose between sRGB (narrower space, used for the Web and many desktop printers), AdobeRGB (wider space, commonly used in image editing applications), and ProPhoto RGB (wider color space, but not widely supported).

Bit Depth

If you select the TIFF or PSD file formats (but not JPEG), you can choose between 8 or 16 bits/component. *Figure 9-14* It's best to use 8 bits unless you are planning to perform more image processing in another application where the extra bits give you more data to work with.

Figure 9-14

Resolution

Enter a resolution as pixels per inch or pixels per centimeter. The default is 240 pixels per inch. *Figure 9-15*

Figure 9-15

Constrain Maximum Size

If this option is left unchecked, Lightroom exports your image at its original pixel dimensions. Checked, you can set a maximum size for the Width or Height in a unit of your choice (circled). *Figure 9-16*

Figure 9-16

Add Copyright Watermark

Check this option and Lightroom adds the name that's entered in image's IPTC copyright field to the lower left corner of every image (circled). *Figure 9-17*

Minimize Embedded Metadata

If you don't select this option, Lightroom includes all the metadata entered in the IPTC fields. Select it and only copyright metadata will be included with the exported photos.

Metadata

Regardless of which file format you choose, you'll have a choice of how keyword metadata is organized. If you check the box to Write Keywords as Lightroom Hierarchy (circled), *Figure 9-18* applications that don't support this option will still display your keywords, albeit without hierarchical structure.

Figure 9-17

Metadata
☐ Minimize Embedded Metadata ☐ Write Keywords as Lightroom Hierarchy

Figure 9-18

Figure 9-19

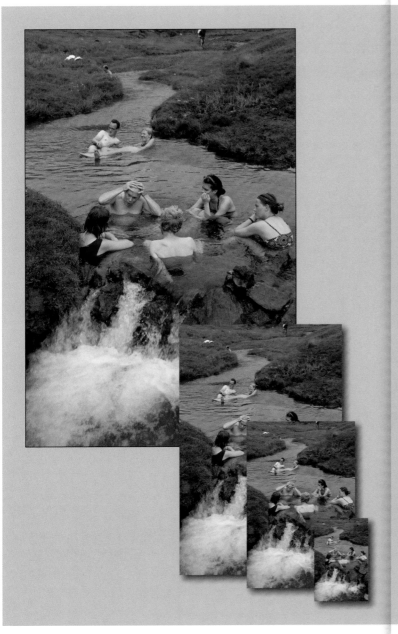

Post-processing

You can instruct Lightroom to do several things after export is complete.

Figure 9-19

Do nothing

> If you select this, after export you'll return to the Lightroom module in which you were previously working.

Lightroom Interpolation

When Lightroom resizes for export (or, for that matter, for a print or web gallery) you don't get a choice of interpolation methods as you do with Photoshop or Photoshop Elements, where your choice is based on whether you are sampling up or down. What is Lightroom doing...and is it good? I asked Lightroom's "father," Mark Hamburg, and this is what he said:

"Lightroom is using a Lanczos kernel interpolation method. But the really big difference is it resamples in linear space. Depending on the image, this can create a huge difference. For example, with a Photoshop resampling, if you look closely, you can see a darkening around edges, because Photoshop doesn't generally work in linear.

Which results one likes for resampling are in part a matter of taste and also depend on the image content. In general, Lightroom should be at least as good as Photoshop and in some cases—such as upsampling—it should be clearly better."

Show in Finder/Explorer

If you select this option, after export, the files are displayed in an Explorer window (Windows) or Finder (Mac OS) window. *Figure 9-20* I love this export option, and use it all the time. It saves me from the "where the heck did that file go?" frustration.

Figure 9-20

Burn the exported images to a disc

If you select this option, after export, you are prompted through the process of burning the files to a writable CD or DVD. *Figure 9-21*

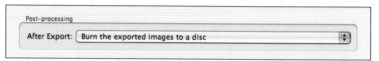

Figure 9-21

Open in Adobe Photoshop CS3 (or other designated editor)

Opens an exported image in the designated external editor *after* Lightroom applies the parameters (file format, bit depth, size, etc.) set in the Export dialog box. *Figure 9-22*

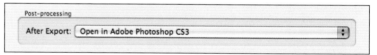

Figure 9-22

Go to Export Actions Folder Now

This takes you to and opens the Export Actions folder where you can place any executable application, shortcut, or an alias of an executable application. *Figure 9-23* If you do this, the next time you choose Export, the alias you added to the folder will be listed in the After Export menu of the Export dialog box. You can also add Photoshop droplets or script files to the Export Actions folder.

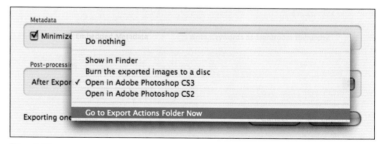

Figure 9-23

Making custom presets

Lightroom ships with three presets. You can modify these presets, create new presets based on the original presets, or create custom presets from scratch. The options in the Preset pop-up list will vary depending on your selections. *Figure 9-24*

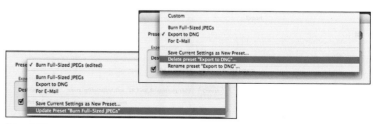

Figure 9-24

Figure 9-25

Figure 9-26

Figure 9-27

NOTE DNG stands for digital negative. Use Lightroom to export proprietary RAW data files—or JPEG or TIFFs— into DNG. (File→ Export, or, in the Library module, Library→Convert Photo to DNG.) This will archive your photos, accompanying metadata, the original RAW file, and a full-size JPEG preview (if you wish) into an open format that is more likely to be compatible with future software applications.

NOTE You can revert to the original Export preset settings in Lightroom's Preferences. In the Presets tab, select Restore Export Presets. Your custom presets won't be affected. Here you can also select Store Presets in Catalog which will maintain your presets on a catalog-by-catalog basis.

DNG Export Options

Here are the choices you have in the Export dialog box when you choose to export a DNG file (circled). *Figure 9-25*

JPEG Previews

Choices: None, Medium Size, and Full Size. Larger sizes increase total file size, but provide ready-to-print proofing.

File Extension:

Choose between an upper- and lowercase extension.

Interpolation Method

It's best to use Preserve Raw Image. Select Convert to Linear Image only if you know your RAW file contains unusual mosaic patterns not supported by all converters. *Figure 9-26*

Options: Compressed (lossless)

Select this and your DNG file will be about a 1/3 smaller than the original RAW file with no tradeoff in quality. *Figure 9-27*

Options: Embed Original Raw file

Select this, and an exact copy of the original RAW file is embedded within the DNG file, which becomes about 2/3 larger than the original file. At this time, you'll need the Adobe DNG converter to retrieve the embedded RAW file from the DNG file.

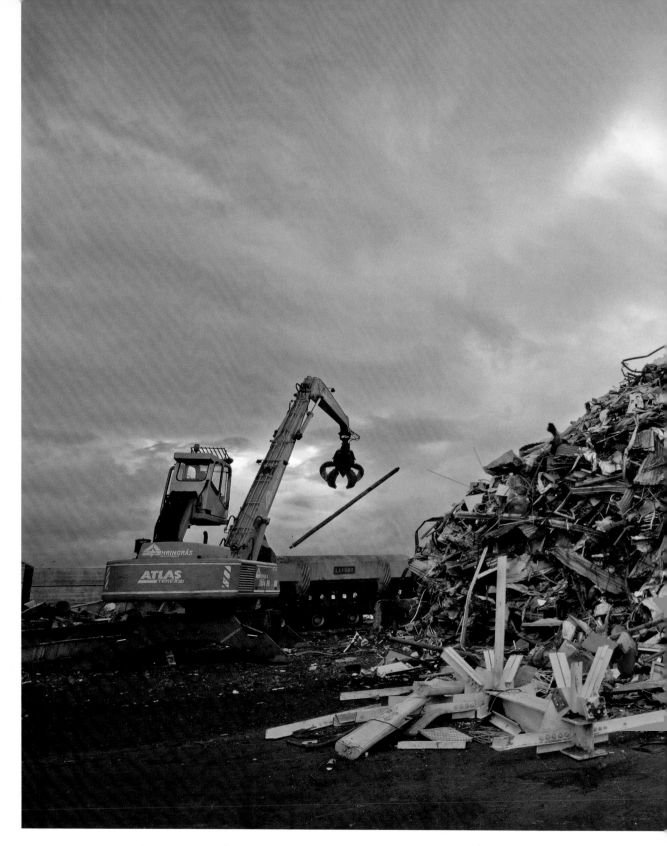

Peter Krogh

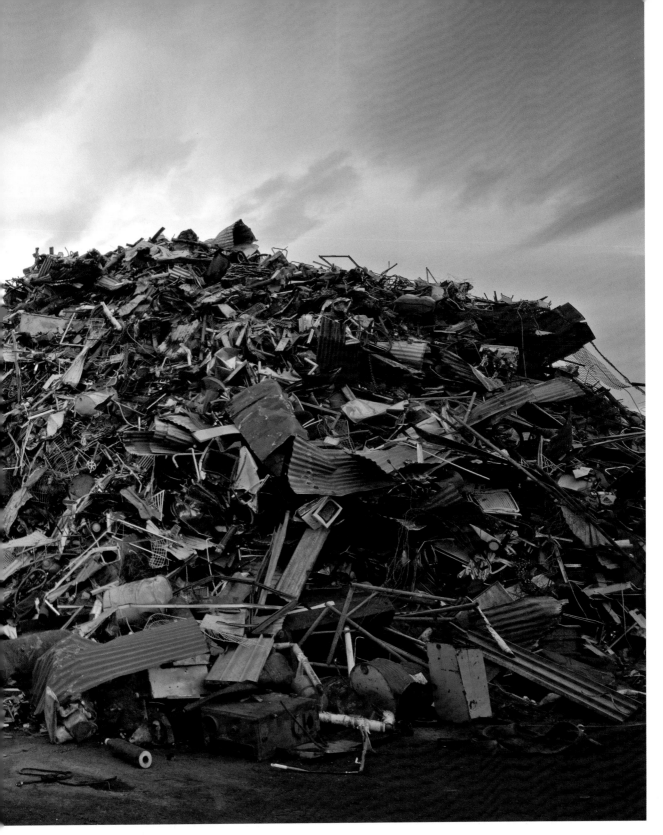

Peter shot many angles of this Icelandic junk heap, but just when he found the perfect spot and fired his camera, the crane dropped a metal pipe. Talk about the decisive moment! The image received minimal processing in Lightroom and Peter used Lightroom's Lens Vignetting control to "burn" the edges and give the image more drama.

Editing in Photoshop and Other Applications

For some, Lightroom is an all-in-one solution. For others, however, there will be times when you'll need to leave the Lightroom environment and edit your work in another application, such as Photoshop or Photoshop Elements. Here is what you need to know when you do this.

If you have Photoshop or Photoshop Elements installed on your computer, Lightroom will offer these applications for use as an external editor by default. *Figure 9-28* You can choose an additional image editing application in Lightroom's Preferences under the External Editing tab. (I'll get into more detail on this later in this section.)

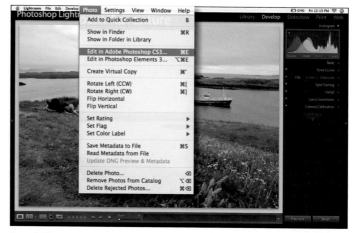

Figure 9-28

Editing Outside Lightroom

Jump to an external editor from the Library, Develop, or Print modules by right-clicking on the image in the preview window or filmstrip and selecting Edit in [*External Editor*] from the contextual menu. *Figure 9-29* From the Library and Develop modules, you can also use the File menu command (Photo→ Edit in [*External Editor*])

Drag and drop to outside editor (Mac)

On a Mac, you can drag and drop a non-RAW file from the Lightroom Library or Develop modules directly into another application such as Microsoft Word or Adobe InDesign. However, your Lightroom settings are not applied. You can also drag and drop an image from Lightroom onto the application icon in the Dock or on the desktop. *Figure 9-30* This will open the image in that application, using the parameters set in Lightroom's External Editing Preferences, which I will get to shortly.

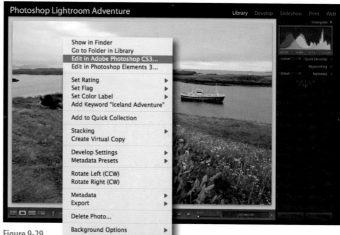

Figure 9-29

Figure 9-30

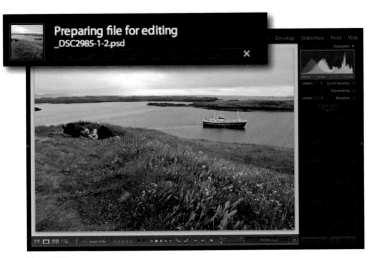

Figure 9-31

Figure 9-32

Edit as many images as you want

You can select and send as many images to an outside editor as you want. However, if you are working with DNG or RAW files, Lightroom renders a new version of these images into a readable file format (PSD or TIFF). Depending on the number of images you select, this can take time. The conversion process is monitored by the status bar in the upper left corner of the Lightroom application window. *Figure 9-31*

Setting External Editing Preferences

In Lightroom's Preferences dialog box there are several important preferences relating to External Editors. *Figure 9-32* If you use Photoshop or Photoshop Elements you will have the following choices (circled):

File Format PSD or TIFF (if you select TIFF, you get a compression option as well).

Color Space ProPhoto, sRGB, or AdobeRGB (1998).

Bit Depth 16 bits/component or 8 bits/component

> NOTE *These choices appear again in the Edit Photo dialog box when you go to use an outside editor. This way you can make choices on a case-by-case basis. Adobe recommends using 16-bit ProPhoto RGB as the choice for best preserving color details from Lightroom and I see no reason to disagree. Frankly, TIFF and PSD are very similar file formats so the choice isn't that critical.*

Selecting Additional External Editors

Start by selecting Choose (circled) and navigate to the application of choice. *Figure 9-33* Once you have done this, you have the same choices as described earlier, but setting recommendations may differ from the ones I mentioned earlier. 8-bit files, for example, may be desirable because they are smaller and more compatible with various programs and plug-ins, even though they will not preserve fine tonal detail as well as 16-bit data. The sRGB color space cannot encompass the full range of color available with Lightroom, but is more widely used. Your final choice really depends on the application you choose to use

Edit nomenclature

In the External Editors Preferences, you can also control the file nomenclature. To enable the custom text field, select custom text field from the Template pop-up menu. To enable the Start Number field select Filename-Sequence. *Figure 9-34*

Edit Photo Dialog Box

When you send an image to an external editor, you get this dialog box. *Figure 9-35* If you are working with DNG or RAW files, you only have one choice. With TIFFs and JPEGs you have three choices. Let's see what these choices are.

Edit Original

If your original file is in the JPEG, TIFF, or PSD format and you select this option, Lightroom sends the original file to the external editor without Lightroom adjustments. After you work on it in an external editor, you can choose to save the changes and your original file will be overwritten.

8-bit files are smaller and more compatible with various programs and plug-ins, but will not preserve fine tonal detail as well as 16-bit data. The sRGB color space cannot encompass the full range of colors available within Lightroom.

Figure 9-33

NOTE To open an original RAW file with another application such as Adobe Camera Raw (ACR), you need to know the location of the original RAW file. You can easily find it (or any original file) from within Lightroom by right-clicking on the image preview in Lightroom's Library or Develop modules and selecting Show in Finder (Mac) or Show in Explorer (Windows) from the contextual menu.

Figure 9-34

Figure 9-35

Edit a Copy
Edit a copy of the original file.
Lightroom adjustments will not be visible.

Figure 9-36

Edit a Copy with Lightroom Adjustments
Apply the Lightroom adjustments to a copy of the file and edit that one.
The copy will not contain layers or alpha channels.

Figure 9-37

▼ Copy File Options

File Format:	PSD
Color Space:	ProPhoto RGB
Bit Depth:	16 bits/component

☐ Stack with original Cancel Edit

Figure 9-38

NOTE *When should you use an external editor? Here are just a few things that you can't do in Lightroom which can done in an external editor such as Photoshop or Photoshop Elements: localized editing with layer masks or selection tools, adding and controlling type, using layer styles, creating high dynamic range (HDR) images, creating panoramas, using special effects and filters, and much more. I think you get the idea.*

Photoshop Format Options

☑ Maximize compatibility

⚠ Turning off Maximize Compatibility may interfere with the use of PSD or PSB files in other applications or with other versions of Photoshop.

This dialog can be turned off in Preferences > File Handling > File Compatibility.

OK
Cancel

Figure 9-39

Edit A Copy

This option creates a copy of the original file, without Lightroom adjustments. *Figure 9-36* Like the previous option, this option is available only for non-RAW or DNG files. The newly created file is renamed with "Edit" added and automatically placed in the Lightroom Library. (Don't use Save As and rename your file; the file won't be added to the Lightroom Catalog if you use this method.)

Edit A Copy With Lightroom Adjustments

This option sends a copy of the original file, with Lightroom adjustments visible to the external editor. *Figure 9-37* This is your only option if you are working on a RAW or DNG file.

Copy File Options

These are the same options found in the External Editors Preferences, albeit applied on a case-by-case basis. *Figure 9-38*

Stack with original

If you check the Stack with original check box, your edited file and the original Lightroom file will be stacked together in Lightroom. To unstack them, or otherwise organize the stack in the Library module, select Photo→ Stacking from the menu bar.

Maximize Compatibility

When you save PSD files in Photoshop or Photoshop Elements, check the Maximize Compatibility check box. If you don't, the files won't be recognized by Lightroom. Do this either in a warning dialog box (shown) that appears when you save a PSD file or in Preferences/File Handling. *Figure 9-39*

Richard Morgenstein

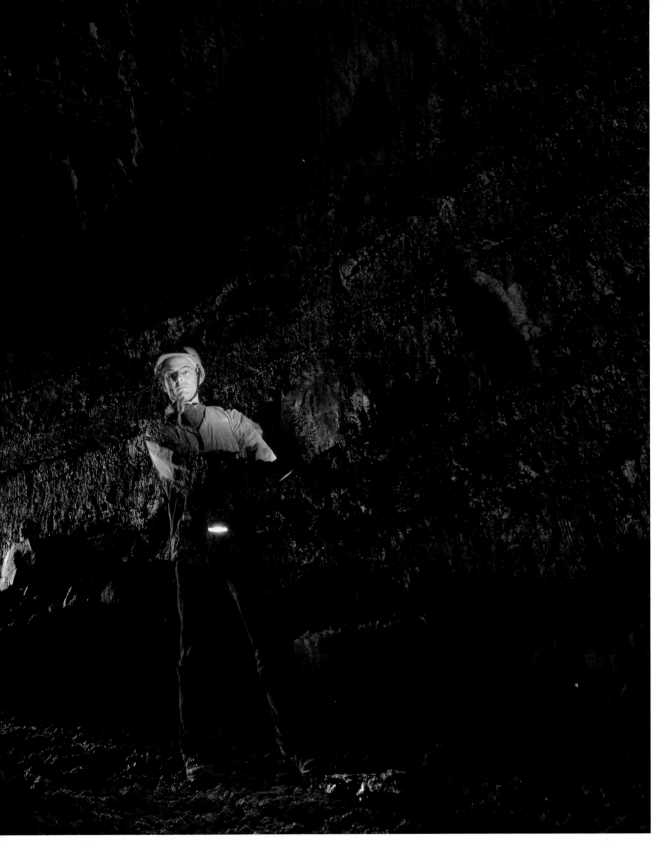

This is not a photo of a miner exploring one of Iceland's many lava tube conduits. It's actually a self-portrait of Richard that he shot by setting his camera on the ground. He used the Bulb shutter selection, and, while the shutter was open, ran back into the picture and flashed himself with a strobe. And yes, Richard showed up at the airport in Iceland with the hard hat! The image required some opening in the shadow areas with the Lightroom Develop module's exposure slider.

Saving Metadata to the Original File

In order to properly open or view your Lightroom adjusted image files in Adobe Camera Raw or Adobe Bridge—or another application that reads Lightroom-generated processing instructions—you'll need to make sure these develop settings travel with the file. In this section, I'll show you how to do so.

Before I get into the actual how-to of saving your Lightroom-generated metadata to an original file, here is some useful background information.

As long as you remain within the Lightroom environment, your images will look the way you intended. Lightroom keeps a record of the critical information associated with an image in a central catalog database and uses this information in conjunction with the original image to create a proxy (or preview) for you to view in Lightroom. This catalog database resides on your hard drive in a specified location. *Figure 9-40*

Pushing Develop Instructions onto the Original Image File

You can "push" the develop instructions from the Lightroom database onto the original image file if you want. This is necessary only if you plan to view or work on your images in an application such as Adobe Bridge or Adobe Camera Raw, as shown here. *Figure 9-41* If you open your original image in an application that isn't capable of reading this information, the image might open, but you won't see any of your Lightroom adjustments.

If you converted your image to black and white in Lightroom, it will appear in its original color form if you open it in, say,

Figure 9-40

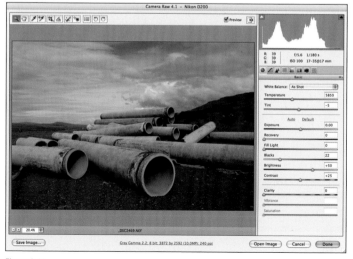

Figure 9-41

Figure 9-42

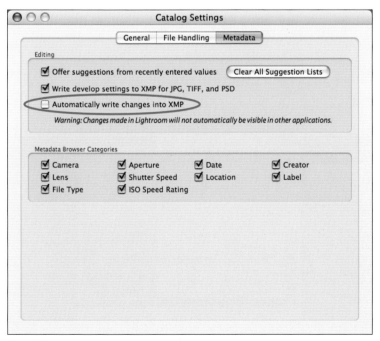

Figure 9-43

your systems default viewer, which I have done here. *Figure 9-42* In this case, if you want your image properly viewed, you need to export a copy of the image in a common file format such as JPEG or TIFF, as described earlier in this chapter.

What Is XMP?

To encode the develop instructions, Lightroom uses an open standard for embedding information into an image called XMP which stands for eXtensible Metadata Platform. Although adding XMP metadata to an original image file only adds a few kilobytes to the file size, there are reasons not to apply this data indiscriminately. There *is* a downside to applying XMP metadata to an original file. It only takes a brief moment to push this data onto a single image file. However, if you are working with thousands of images, performance speed is affected. There is also the very small, but possible, chance that you may actually corrupt an original image file. Lightroom pushes this data to the original file differently depending on the original file format. RAW files, for example, which generally aren't overwritten, are handled differently than JPEGs, TIFFs, and DNGs, which are. Let's start with RAW files.

XMP Metadata to RAW Files

Because RAW files from your digital camera are fundamentally untouched, Lightroom creates instead a separate XMP file, often called a *sidecar*, which contains the relevant develop settings and other metadata. By default, Lightroom won't automatically generate these XMP sidecars unless you check Automatically write changes into XMP in the Catalog Info dialog box. *Figure 9-43*

Go to the Metadata tab in the Catalog Info dialog box to find this check box (File→ Catalog Settings). You can, if you want, manually tell Lightroom to do this on a case-by-case basis. In the Library module, select your images. Then, from the menu, select Metadata→Save Metadata to File. *Figure 9-44* The XMP sidecar files are automatically placed in the same location as the original files. They take up only a few kilobytes of space.

XMP metadata to other files

With PSD, JPEG, and TIFF files, Lightroom writes the relevant XMP develop data directly into the file itself, without the need for a separate sidecar file. (You can "view" this data if you open your image file in a text editing application. *Figure 9-45* If you want this data automatically updated to your file, select Write develop settings to XMP for JPG, TIFF, and PSD in the Catalog Settings dialog box (File→ Catalog Info/Metadata tab). You can also do this manually in the Library module from the menu bar (Metadata→Save Metadata to File).

XMP metadata to DNG

With a DNG file, Lightroom writes the relevant XMP develop data directly into the file itself, without the need for a separate sidecar file. To have this done automatically, check Automatically write changes into XMP from the Catalog Settings preferences dialog box. Or, to do it manually, in the Library module, select Metadata→Update DNG Metadata & Preview from the menu bar, on an image-by-image basis. *Figure 9-46*

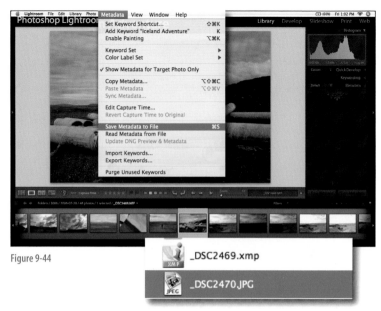

Figure 9-44

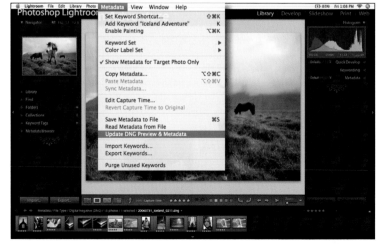

Figure 9-45

Figure 9-46

Figure 9-47

Figure 9-48

How do you know you need to update?

There is an easy way to see if the data in Lightroom's database matches the data saved to your original file. Look at the thumbnail shown here. *Figure 9-47* See the (circled) icon in the upper right corner? That is telling me there is a mismatch between the Lightroom database and the XMP metadata attached to the original file.

If you click on the icon, you'll get the dialog box shown here. *Figure 9-48* Select Save if you want to update the XMP metadata to the original file.

Import XMP metadata from file

You can also have Lightroom read and apply XMP metadata created by Adobe Bridge or Adobe Camera Raw. Do this manually via the menu bar (Metadata→ Read Metadata from File). *Figure 9-49*

What About Informational Metadata?

Up to now, I've been talking about XMP metadata relating to the Lightroom develop instructions. You may be wondering about the other metadata, such as keywords, ratings, etc. The same holds true for them. You need to push this data onto an original file if you want it to travel with the file outside of the Lightroom environment. You can do this on an image-by-image (or selection-by-selection) basis from the Library module menu command Metadata→ Save Metadata to File. Or you can set your catalog preferences so it's done automatically to all files and all file types (File→Catalog Settings/Metadata tab, then check Automatically write changes into XMP).

Metadata	View	Window	Help
Set Keyword Shortcut...			⇧⌘K
Add Keyword "Iceland Adventure"			K
Enable Painting			⌥⌘K
Keyword Set			▶
Color Label Set			▶
✓ Show Metadata for Target Photo Only			
Copy Metadata...			⌥⇧⌘C
Paste Metadata			⌥⇧⌘V
Sync Metadata...			
Edit Capture Time...			
Revert Capture Time to Original			
Save Metadata to File			⌘S
Read Metadata from File			
Update DNG Preview & Metadata			
Import Keywords...			
Export Keywords...			
Purge Unused Keywords			

Figure 9-49

NOTE If you use earlier versions of Adobe Camera Raw (before v4.1), some of Lightroom's Develop adjustments are not read. It's best to update your ACR, which is free from the Adobe site. For the optimal compatibility, upgrade to Photoshop CS3 and ACR v4.1 or higher.

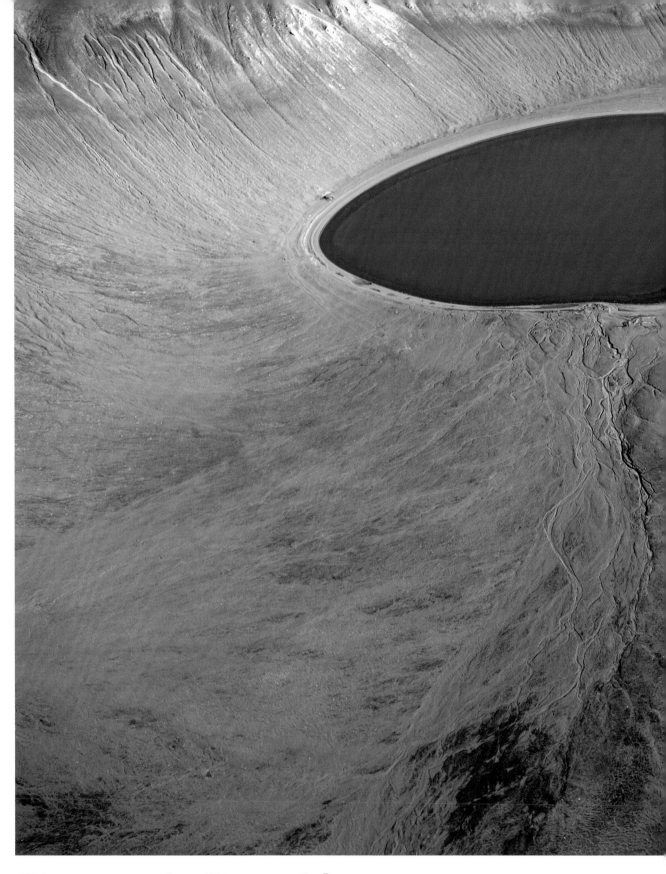

Sigurgeir Sigurjónsson

This is another one of Sigurgeir's amazing aerial shots, taken from a helicopter on assignment for the Adventure. He had some luck on his side with two days of very unusual perfect weather, but it was no luck that he knew exactly where to go—and where to aim his camera—to get these spectacular shots.

Lightroom Slideshows

Lightroom is more than an image organizer or image processor. It is a complete environment where you can feel comfortable sharing your images directly with friends or clients. One of the best ways to do this is with a self-running slideshow. In this chapter, I'll show you how to use Lightroom's Slideshow module to sequence images, add music and text, and set pacing. I'll also show you how to export your work as a PDF file and—with a simple workaround—in the QuickTime format.

Chapter Contents

PHOTO CREDIT: Bill Atkinson

The Slideshow Module Revealed

Let's start by going over the basics of the Lightroom Slideshow module. Then I'll show you how we created the Iceland Adventure slideshow step-by-step, giving you details about adding text and captions and exporting your finished work to either a PDF slideshow or a Quicktime movie.

Get to the Slideshow module by clicking on Slideshow in the Module picker, or using the keyboard shortcut ⌘+Option+3 (Ctrl+Alt+3). Images from the Lightroom Library viewing area will be automatically included in your slideshow. *Figure 10-1* You can change to another recently viewed selection without leaving the Slideshow module via the filmstrip pop-up menu; click the arrow icon in the filmstrip toolbar (circled).

You can also make a selection of images in the filmstrip and play only that selection. Do this by making your selection in the filmstrip (circled), and then selecting Play→ Which Photos→Play Selection from the menu bar. *Figure 10-2*

The Lightroom Slideshow module is organized much like the other modules already discussed, and should feel very familiar by now. There is a left and right panel, a viewing area, a toolbar, and the filmstrip.

As you learned in Chapter 1, you can customize the work area by closing panels or expanding or shrinking the filmstrip.

Let's go over these components as they apply to the Slideshow module.

Figure 10-1

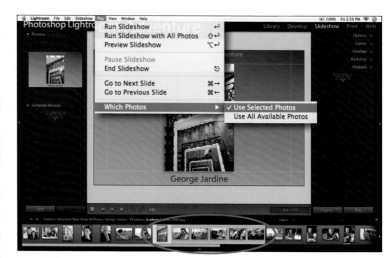

Figure 10-2

Figure 10-3

Figure 10-4

Left Panel of the Slideshow Module

The left panel contains the Preview window, the Template Browser, and Add/Remove buttons for creating and deleting template presets. *Figure 10-3*

Preview In the Preview window, you can see a preview of how your first image will look, without guidelines or other distractions.

Template Browser Lightroom ships with several slideshow templates, and you can make your own as well. Preview a template without applying it to all the images by passing your cursor over its name in the Template Browser pane. A preview will immediately appear in the Preview window.

Add/Remove Buttons To create a custom template, select Add and give it a name in the resulting dialog box. To remove an existing template, select it and click Remove. You can rename templates by double-clicking on the name and typing.

Main Viewing Area

The main viewing area displays the image, backdrop, guides, and text associated with a specific slide. *Figure 10-4* You can control the size of the image in relation to the frame by clicking on and dragging the guidelines or via the Layout pane in the right panel. Right-click on the canvas outside the slide, and you'll get a contextual menu with background choices. These choices impact only the surrounding work area. The slideshow backdrop is controlled by the Backdrop pane.

Right Panel

The right panel contains controls for customizing a slideshow. *Figure 10-5*

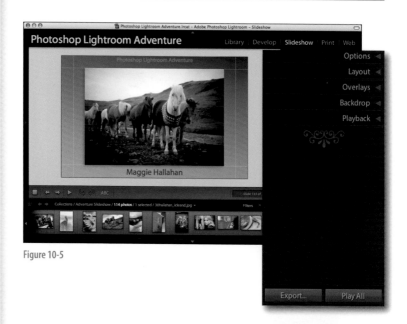

Figure 10-5

Options pane

The first pane is the Options pane. *Figure 10-6* Select Zoom to Fill Frame and the image will fill to the guides and crop the image to make it fit, if necessary. (Position the image within the cropped area by clicking on the image and dragging it into position.) Select Stroke Border to add a solid border around the perimeter of the image. Control the color of the stroke by clicking on the color patch (circled) and choosing from the resulting color picker. Control the thickness of the border with the Width slider. Select Cast Shadow to create a drop shadow that gives your slide depth. Use the sliders to control the Opacity, Offset, Radius, and Angle of the drop shadow.

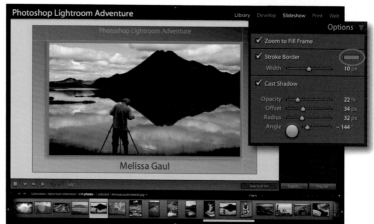

Figure 10-6

Layout pane

If you select Show Guides, the guides will be visible in the screen window. *Figure 10-7* You can control the guides (and thereby the size of the image area) directly from the viewing window by clicking on them and dragging them into position (circled). Or you can use the Layout pane sliders. Clicking Link All maintains a constant aspect ratio.

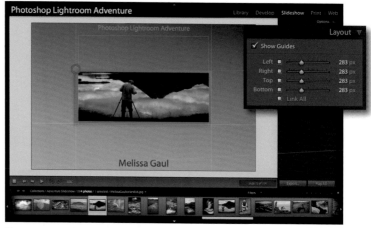

Figure 10-7

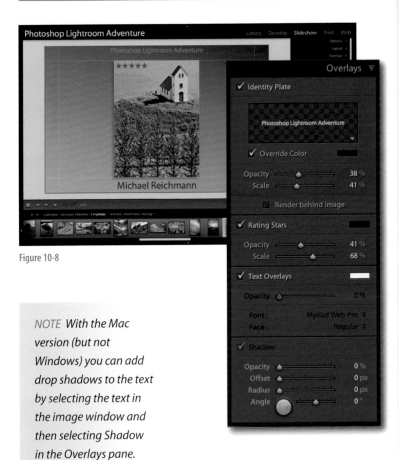

Figure 10-8

NOTE *With the Mac version (but not Windows) you can add drop shadows to the text by selecting the text in the image window and then selecting Shadow in the Overlays pane.*

Figure 10-9

Overlays pane

Add an Identity Plate to each slide by checking the Identity Plate box. *Figure 10-8* You cannot use multiple Identity Plates at the same time. (I covered making Identity Plates in Chapter 1.) Checking Override Color gives you specific control of the Identity Plate color via the adjacent color patch. Click on the patch and pick a color from the resulting color picker. Control the Opacity and Scale of the Identity Plate with the sliders. Checking Render behind image places the Identity Plate (or part of it) behind the image area.

Checking the Rating Stars box does just that, adds stars. If an image hasn't been rated, no stars will appear. You can control the color of the stars via the adjacent color bar, as well as via the Opacity and Scale sliders. Select the stars in the image window. You can also select Shadow in the Overlays pane, controlled by the Opacity, Offset, Radius, and Angle sliders. Check Text Overlays to control any selected text Opacity, Color (via the color patch), Font, and Face (Style). Text is added via the toolbar, which I'll cover in a separate section.

Backdrop pane

The Color Wash control lets you create a graduated background that is controlled by the Opacity and Angle sliders. Select a color in the color box. If this color is different from the Background Color, you'll end up with a multicolored graduated background, as shown here. *Figure 10-9* For a simple single-color background, select Background Color only and pick a color from the color box.

You can also use an image for a background by checking the Background Image box. *Figure 10-10* Drag an image from the filmstrip into the box. Control the opacity via the Opacity slider.

Playback Pane

You can add sound by selecting Soundtrack, and then clicking on the arrow next to Library (circled). *Figure 10-11* On a Mac, you'll be able to choose from your iTunes playlists. In Windows, click on the text that says "Click here to select a music folder," and select the audio of choice. Your slideshow playback options are very simple. You an control the duration and fades. The only transition is a simple dissolve. Checking Random Order does just that: instead of following the selected order, slides are displayed in random order and will continue doing so until you stop the slideshow.

If you have a second monitor attached, you'll see this option appear in the Playback pane. *Figure 10-12* Here, you can control which screen is used for a Slideshow playback. Click on the appropriate screen. The unselected screen will go dark when the slideshow begins.

Export/Play

When you are ready, select Play from the bottom of the right panel. *Figure 10-13* If you selected Play→Which Photos→Use all Available Photos from the menu bar, the words Play All will show, instead of Play. After you do this, your display will go dark and the slideshow will start. Each slide will fill up the monitor. Stop the show by hitting the Esc key. Select Export

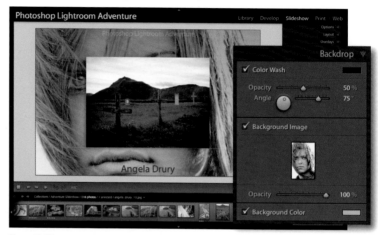

Figure 10-10

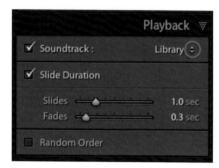

Figure 10-11

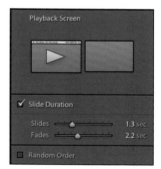

Figure 10-12

Figure 10-13

Figure 10-14

TIP *While the slideshow is previewing or running, image ratings can be set or changed for individual images by using the number keys, 1–5.*

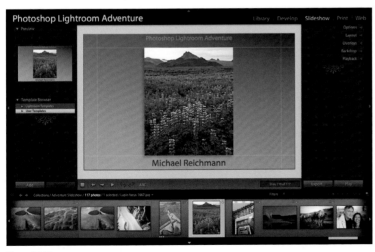

Figure 10-15

if you want to export to a PDF slideshow. I'll show you how to do this later in the chapter.

Slideshow Toolbar

The first icon in the Slideshow toolbar, is a square (circled). *Figure 10-14* When you click it, the first slide appears. The left and right arrows take you to the previous or next slides, respectively. Clicking the triangle starts a preview of the slideshow within the Slideshow module, complete with transitions.

The curved arrows rotate the selected adornment clockwise or counterclockwise (be it a text box, star ratings, or Identity Plate), but does not rotate the image.

The ABC button is the gateway to really great features of the Slideshow module. Here you can add custom text or (this is so cool) use metadata to generate captions. In the next section, I will describe how to do this.

Using the Filmstrip to Choose Slides

The filmstrip displays images that can be included in your slideshow. *Figure 10-15* Include them all, or make a selection and include only those images. (Lightroom version 1.1 and higher.) If the images in the filmstrip come from a Collection or Folder (and not from All Photographs), you can change their order. Do this by clicking on the image area of the filmstrip (not the outside border), dragging the thumbnail to its new location, and releasing the mouse. In the Slideshow module, you can still access a contextual menu for any image by right-clicking on a thumbnail in the filmstrip.

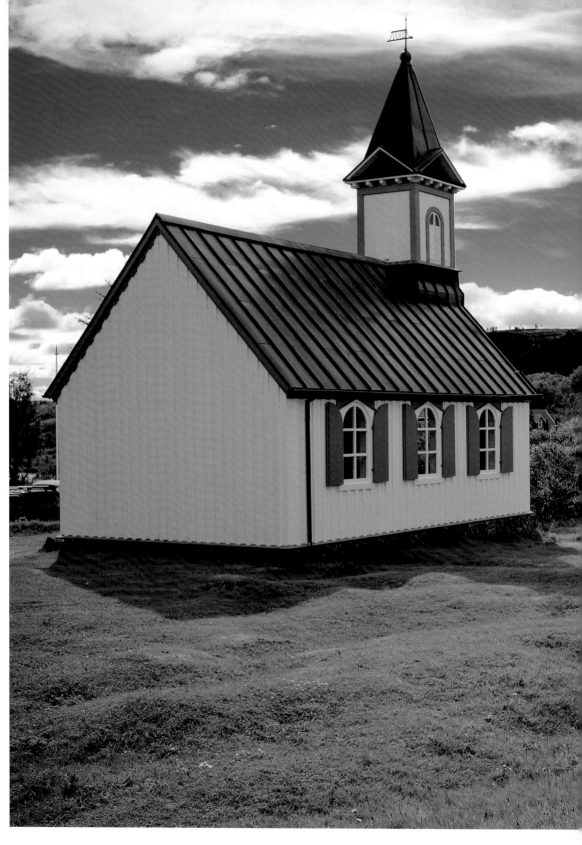

George Jardine

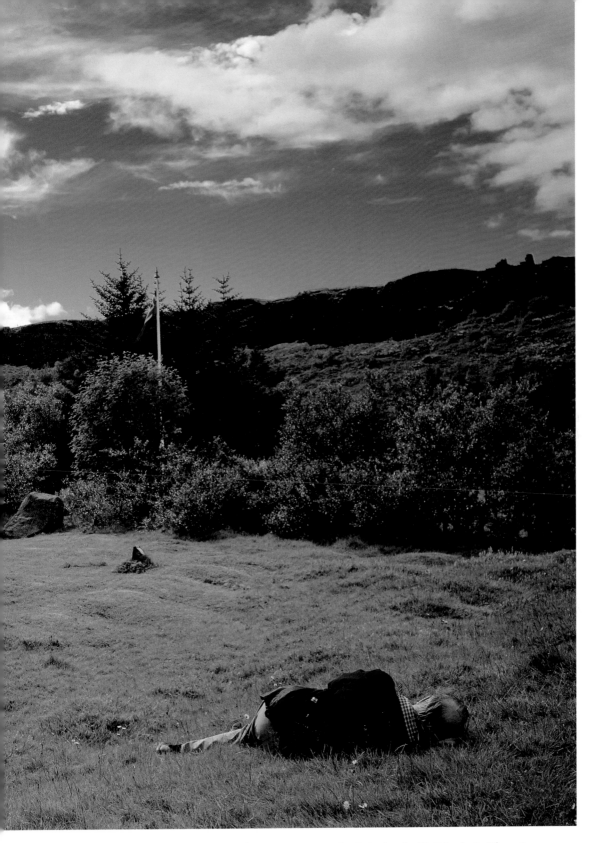

George perfectly captured the feeling of a warm summer day in Iceland with this photo. There is something so peaceful about this shot. Just looking at it makes me want to curl up in the grass and nap. Maybe it is the simple church, the outcrop of rock, the Icelandic flag fluttering in the breeze, a hint of a river in the background, the blue sky. Maybe it is the middle-aged man with a checkered collar. It all adds up.

Real World: Creating the Adventure Slideshow

The clock was ticking and we had only hours to put together a slideshow of our week's work for a reception at the Apple Store in Reykjavik. Amazingly, even working with a beta version of Lightroom, we were able to do the job. Here (modified to take into account the latest versions of the software) is what we did.

Starting in the Library Module

Although it's possible to make a selection and arrange the order of images in the Slideshow module, it's a lot easier if you do all that first, in the Library module.

Here's what we did after importing a selection of photos (1600 × 1200 pixels each) from the Adventure photographers:

1. We created a collection in the Library module and named it Adventure Slideshow. *Figure 10-16*

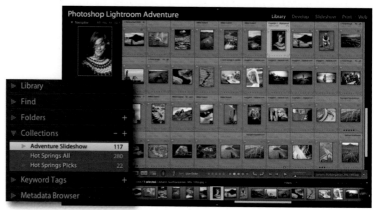

Figure 10-16

2. We dragged and dropped the thumbs into order. Do this by placing your cursor over the image area of the thumbnail, click, then drag the image into position. A dark line will appear in between the two existing images. *Figure 10-17* Release the cursor and the image will settle in place. Note that you can't sort if you select All Photographs in the Library pane. You need to be in a Folder or Collection. You can also sort a Folder or Collection from the filmstrip. (After custom sorting, the Sort criteria in the toolbar will revert to User Order.)

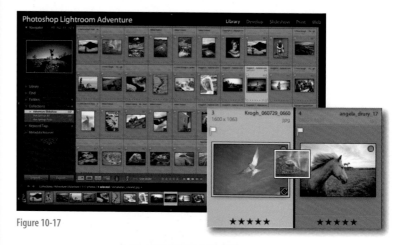

Figure 10-17

3. We checked to make sure the Creator field in the Metadata pane (circled) was filled in correctly with the photographer's name. *Figure 10-18* (Most of the photographers submitted their work with this field filled in, making our job easier.)

Figure 10-18

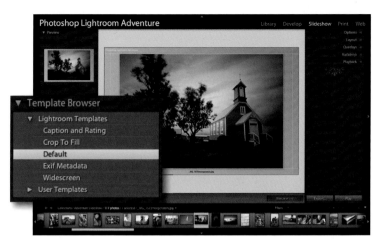

Figure 10-19

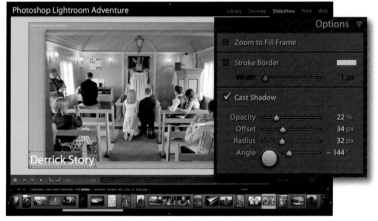

Figure 10-20

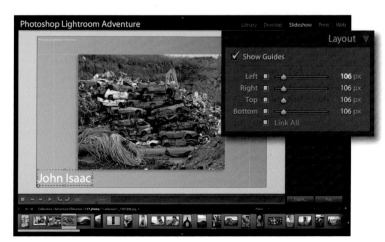

Figure 10-21

Switch to the Slideshow Module

Next, we switched to the Slideshow module. We started with the default template (called Default) shown here. *Figure 10-19* But then we customized it. The default template contained text boxes based on Identity Plate and file name. We deleted the file name box by selecting it and choosing delete. We made a custom text box, one based on the Creator field. (I'll show you how to do this in detail in the next section.) We left positioning of the caption and Identity Plate until last.

Choosing the Righthand Panel Settings

Here are our custom settings for the various panes in the right panel:

Options

These settings gave our slides a hint of depth: *Figure 10-20*

- Cast Shadow: checked

- Opacity: 22%

- Offset: 34 px

- Radius: 32 px,

- Angle: −144 degrees.

Layout

These layout settings gave us enough room for our captions and framed our images nicely: *Figure 10-21*

- Show Guides: checked

- All sliders: 106 px

Overlays

At first, we tried using a graphic Identity Plate. *Figure 10-22* But wasn't readable, so we switched to a textual one.

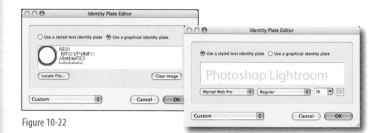

Figure 10-22

There are a couple ways to bring up the Identity Plate Editor. In the main viewing window, double-click on the Identity Plate text box. From the Overlays Pane, with Identity Plate selected, Option-click (or Alt-click) on the box and select Edit from the contextual menu. *Figure 10-23*

Figure 10-23

In the Overlays pane, our Identity Plate settings are as follows: *Figure 10-24*

- Override Color: Checked

- Opacity: 38 %

- Scale: 41%.

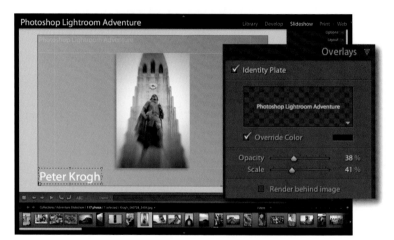

Figure 10-24

We didn't elect to use Rating Stars. We were showing our work in a party environment as entertainment, and not to clients who might have found ratings useful. *Figure 10-25*

Figure 10-25

We selected Text Overlays and used the following settings: *Figure 10-26*

- Font: Myriad Web Pro, which is very readable

- Face: Regular

Figure 10-26

Figure 10-27

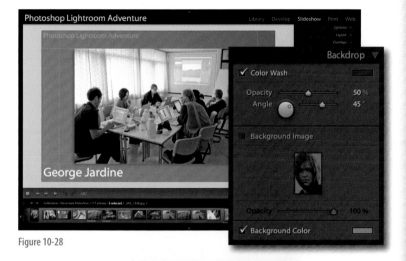

Figure 10-28

Figure 10-29

Figure 10-30

We didn't add a drop shadow to the text. *Figure 10-27*

Backdrop

We created a backdrop with a slight Color Wash and a neutral gray color. *Figure 10-28* Our settings were:

- Opacity: 100%

- Angle: 75 Degrees

- Background Image: deselected

- Background Color: selected

Playback

In the Playback pane we opted to use a Soundtrack (a classic Icelandic melody). *Figure 10-29* We set our Slide Duration as follows:

- Slides: 1.0 sec

- Fades: 0.3 sec

Final Step

As a final step, we sized and arranged our text boxes directly from the main viewing area. I'll show you how to do this in the next section.

Press Play

Once we created the slideshow and hit the Play button, the elegant Lightroom interface went away and our images were revealed in all their glory, one by one. *Figure 10-30* You can see our final creation by going to *http://digitalmedia. oreilly.com/lightroom/* and checking for Lightroom Adventure Iceland Slideshow in the Resources pane.

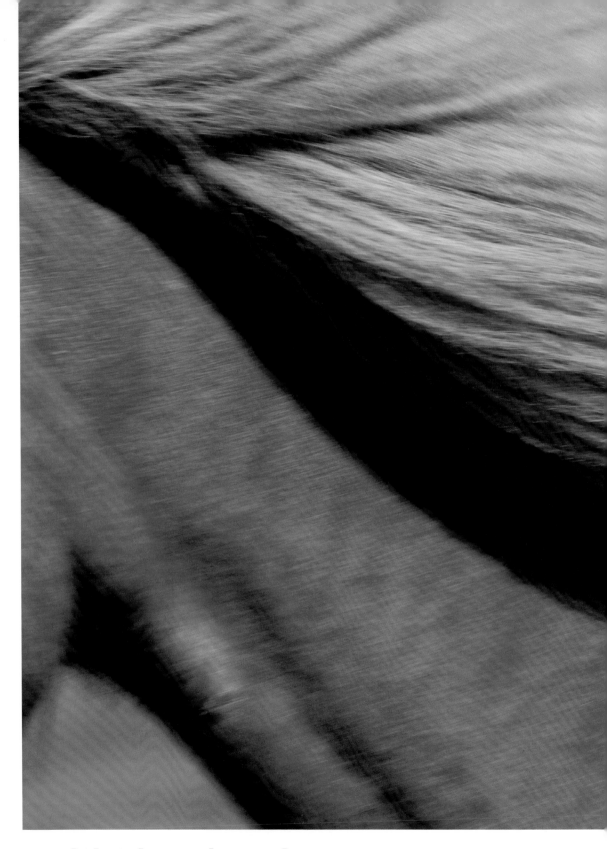

Mikkel Aaland

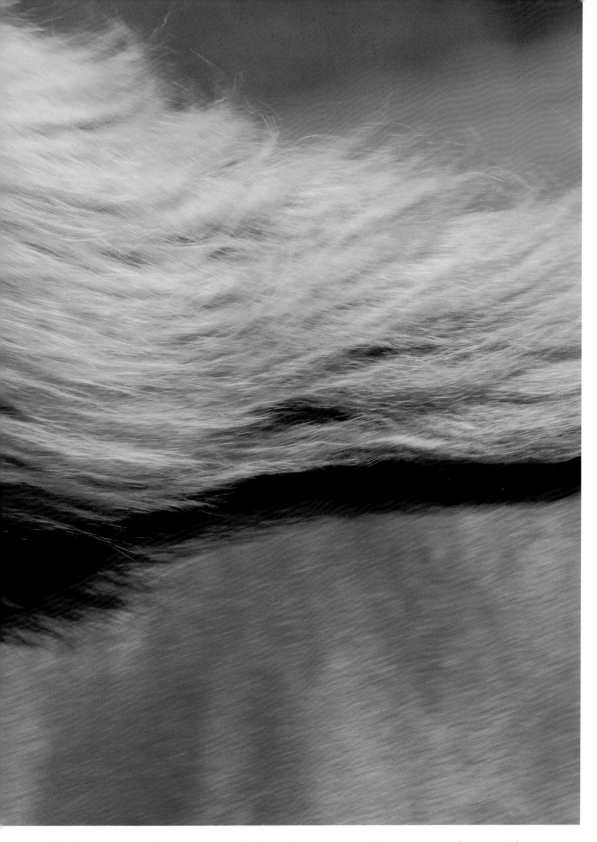

Suddenly, as we were driving on a rugged dirt road on our way to Geyser, a group of women riders appeared. We pulled to the side of the road, and I took many shots of them smiling as they rode by. Then another group of riderless horses followed, trotting smoothly past us. This particular horse caught my attention with its lion-like mane bouncing up and down, reflecting the morning sun. The shot is slightly blurred, because I shot it with a 300mm at 1/180th a second, but I like the way the motion conveys the spirit of the powerful horse.

Using Metadata and Custom Text for Slideshow Captions

Possibly the single most compelling feature of the Lightroom Slideshow module is the ability to turn metadata associated with an individual image into a slide caption which is totally sizeable and positionable. You can also add custom text that applies as a global caption to all the slides. Here's how.

To create custom text that will appear the same on every slide, click on the ABC icon in the toolbar (circled) and in the resulting Custom Text text box, start typing. *Figure 10-31* When you are done hit the Return (Mac) or Enter (Win) key. The text will appear in the work area in a bounding box where it can be resized or repositioned.

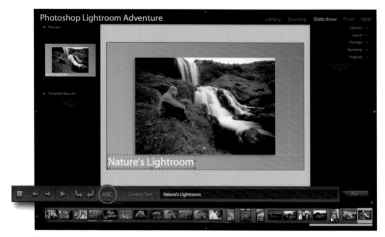

Figure 10-31

To use metadata as a slide caption for a specific image, use the presets that appear in the pop-up menu when you click on the up and down arrows next to the text box. *Figure 10-32* If none of these presets are appropriate, select Edit. This opens up the Text Template Editor, where you'll have many more options.

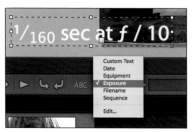

Figure 10-32

Using the Text Template Editor

In the Text Template Editor, shown in *Figure 10-33*, you can create a new preset that will appear next time you click on the triangle next to the toolbar text box. To create one using the IPTC Creator field, for example, go to the IPTC Data section of the dialog and choose Creator from the first pop-up menu (circled, bottom), then click Insert. An example will appear at the top of the dialog box (circled, top). To save your new preset, select Save Current Settings as New Preset from the Preset pop-up menu, Name your Preset and select Create, then click Done.

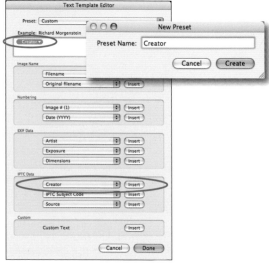

Figure 10-33

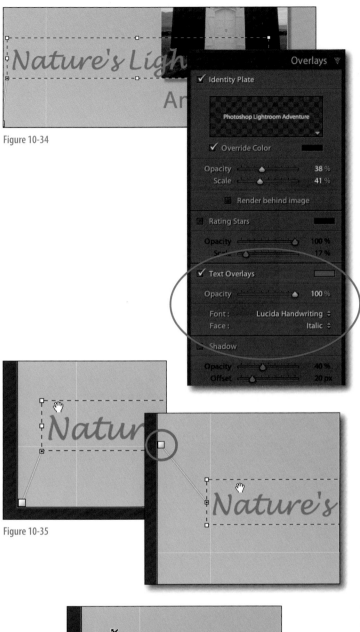

Figure 10-34

Figure 10-35

Figure 10-36

Adding Multiple Captions

You can add as many text boxes as you want. To add multiple text boxes, click the ABC icon in the toolbar. Make your selection from the pop-up menu, or type in text and hit the Return key. Then, click the ABC again to create another text box.

Working with Text

You can go back at any time and edit, resize, or change the properties of a text box. To change the color or font properties, click on the bounding box containing the text. Go to the Overlays pane in the right panel. The Text Overlays section is automatically selected. Make your changes here (circled). *Figure 10-34*. You can't have different fonts and colors within the same bounding box, but you can change text properties on each box.

Moving and scaling text

Move the bounding box by dragging the box from within. As you do this, the box tethers itself to points on the image's border. The text will now float next to an image or within an image at a consistent distance from the border, regardless of the size or orientation of the image. *Figure 10-35* (circled) Scale the text by dragging the corners to the desired size. *Figure 10-36*.

Changing and deleting text

To delete a text box, click on it in the image view window, then hit the Delete key. To change custom text, select the text box, then change the text in the toolbar's Custom Text box. (To change text based on metadata go to the Library module and re-enter the text in the Metadata pane.)

Exporting to a PDF Slideshow

If you want to share your slideshow outside of the Lightroom environment, you have only one out-of-the-box choice at this time: saving it as a PDF slideshow. I'll show you how to do this here. (In the next section, I'll also show you a workaround that allows you to save your slideshow in the QuickTime format).

After you are finished making your slideshow, select Export from the right panel or from the menu bar (Slideshow→ Export Slideshow). *Figure 10-37*

> NOTE *Obviously, the PDF slideshow has limited capabilities, especially when it comes to transitions. Besides the QuickTime workaround described on the next page, consider creating a Flash-based "slideshow" in Lightroom's Web module. You can share your slideshow via the Web with smooth transitions (but not sound), or burn the files to a disc and share it that way.*

After you do this, you will get the dialog box shown here. *Figure 10-38*

Your only options are JPEG quality and image size. If you select Automatically show full screen, the slideshow is played automatically at the full screen size.

Note this text in the dialog box: Adobe Acrobat transitions use a fixed speed. This means that any speed or transitions you set in Lightroom are ignored. Also, any music you added to your slideshow is not exported.

In order for someone to view your PDF slideshow they need Adobe Acrobat Reader (which is free) or Adobe Acrobat (which is not).

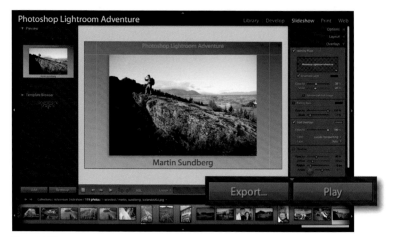

Figure 10-37

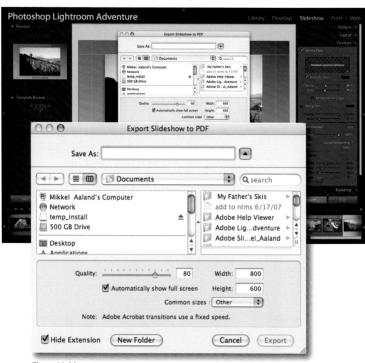

Figure 10-38

I love it when the real world meets the book-writing world, as it did when I was finishing up the Slideshow chapter for this book. The result is a nice workaround to the limitations of Lightroom's Export to PDF slideshow feature, and a way to create a QuickTime movie instead.

Note You can see the final product of our workaround at the O'Reilly Inside Lightroom site: digitalmedia.oreilly.com/ lightroom. Check out the Resources pane. (There's also lots of other good Lightroom resources there!)

Figure 10-39

Figure 10-40

Richard Morgenstein

George Jardine

Figure 10-41

Creating a QuickTime Slideshow

Background: my buddy and fellow adventurer Derrick Story was down from Sebastopol, and we were in my studio creating a new Adventure slideshow for an online presentation. We used Lightroom's Slideshow module, of course, and then we tried to export.

The Problem

As I explained earlier, the Lightroom PDF slideshow is very limited. Lightroom transitions, for example, aren't honored, nor is sound possible. A PDF slideshow was not the right way for us to go.

The Solution

I have Snapz Pro X loaded on my Mac which I mostly use to capture screen shots for my books. *Figure 10-39* We set my computer screen to 800 × 600 pixels and "recorded" the slideshow using Snapz Pro X's video capture at 15 frames a second. *Figure 10-40* Derrick edited the QuickTime movie in QuickTime Pro—adding a Flash intro—and we had a movie that can be viewed anywhere. *Figure 10-41* (Snapz Pro X cost around $69 from Ambrosia Software. Window's movie capture application is available from Techsmith, makers of SnagIt.) QuickTime Pro isn't required, but it comes in handy if you want to edit or resize your movie ($29.99 for Windows and Mac). You can find our finished QuickTime movie at the O'Reilly Inside Lightroom site.

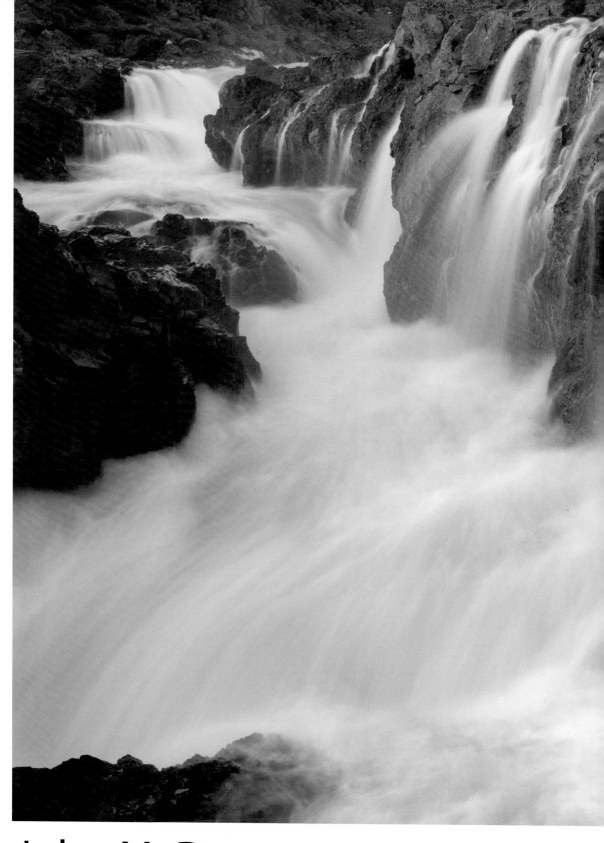

John McDermott

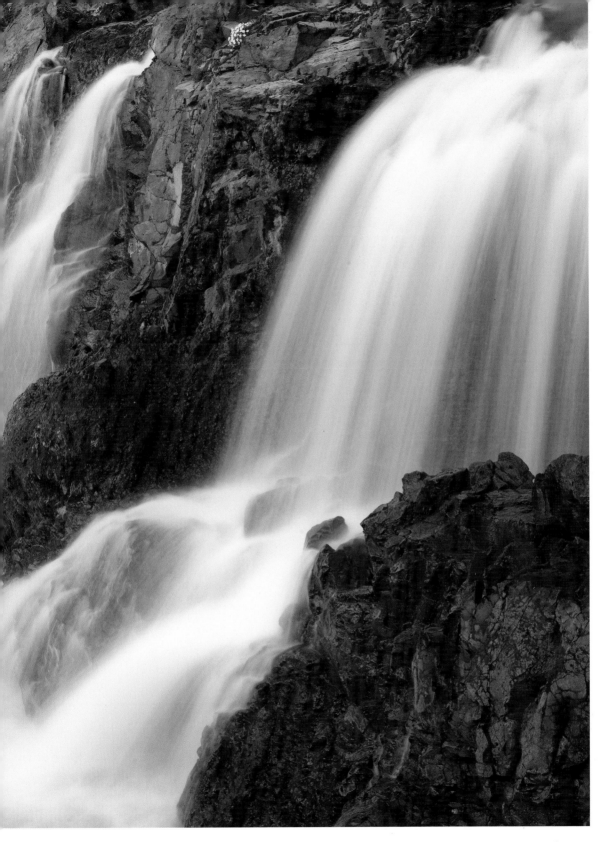

John shot this with a 50mm lens at f/20 at 1 second (on a tripod, of course!) The shutter speed was slow enough to blur the water, but the original image lacked much important detail in the highlights. John used the the Develop module's Recovery slider in Lightroom to reveal those highlights and slightly increased the Saturation setting as well.

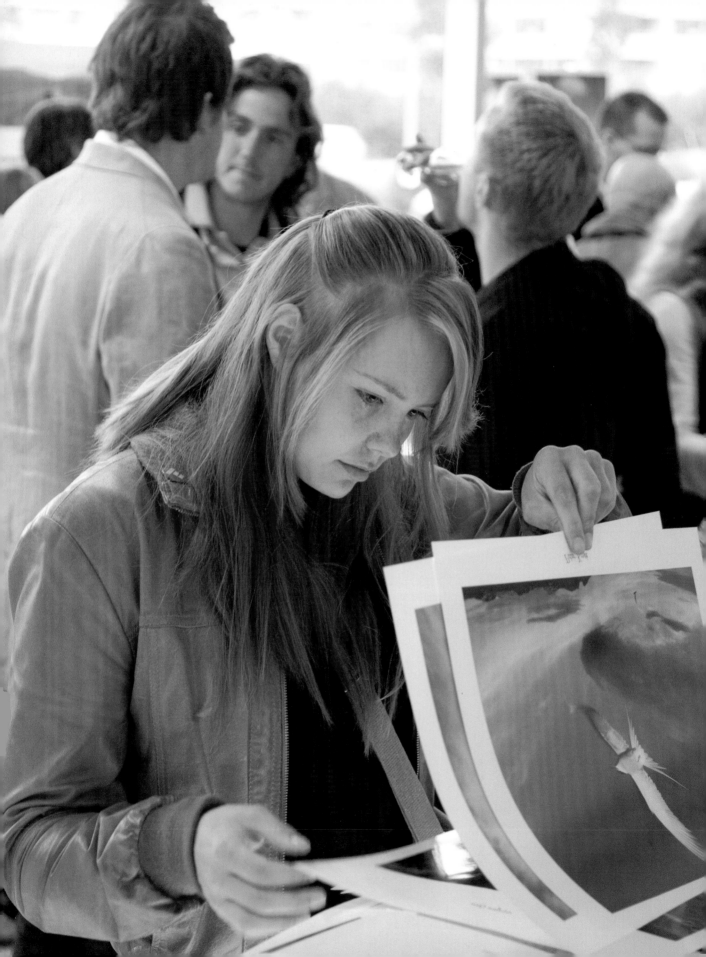

Power Printing

At some point in your digital photography workflow, you'll likely want to make a print. With Lightroom's Print module, you are not limited to sending one image at a time to your printer. With a click of a the print button you can send an entire collection to the printer. Ready-to-use presets turn your selected images into a variety of sizes, including contact sheet size. You can also create your own custom presets as well. It's easy to add custom text—or text based on image metadata—to the image border, or place an Identity Plate anywhere, at any size, on a page. This chapter shows you how.

Chapter Contents

11

PHOTO CREDIT: Derrick Story

The Print Module Revealed

Before we jump in and start printing, let's take the Print module apart and see what it offers. Then, in subsequent sections, I'll show you how to print single or multiple images, change page layout, and add text. We'll finish up with a section on color management.

Here is the full Print module, with left and right panels, workspace, toolbar, and filmstrip visible. *Figure 11-1* Of course, as you've learned throughout this book, you can customize the work area by closing panels or expanding or shrinking the filmstrip.

Preview Pane

In the Preview pane, at the top of the left panel, you can view preset page layouts from the Template Browser. Just place your cursor over a template name, and it will appear in the preview window. No images will appear, just an outline of the selected layout.

Template Browser Pane

In the Template Browser pane, *Figure 11-2* you can either select page layouts, or preview them by passing your cursor over the template name in the preview window. You can also create custom templates by clicking the Add button at the bottom of the panel. To remove User Templates (Lightroom Templates can't be changed), select the name and click Remove. To update a user template to your current settings, right-click on the User Template name and choose Update with Current Settings from the pop-up menu. (You can't do this with Lightroom Presets. Instead create a new template by selecting Print→New Template from the menu bar.)

Figure 11-1

Figure 11-2

Figure 11-3

Figure 11-4

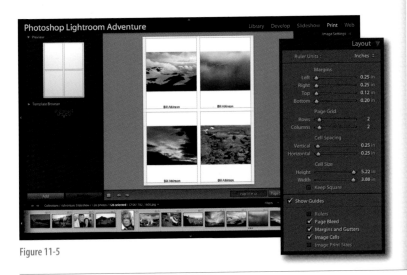

Figure 11-5

Display Work Area

The display work area consists of the image layout, the info overlay, and the rulers and guides. *Figure 11-3* You can control the visibility of the info overlay, rulers, and guides from the View menu bar or keyboard commands (circled).

Image Settings Pane

Let's move to the right panel and the Image Settings pane. Here, using Zoom to Fill Frame, Auto Rotate to Fit, and Repeat One Photo per Page, you determine how the images fill the cells. *Figure 11-4* You can also check Stroke Border (circled) to create a simple colored border, which will apply to all selected images.

Layout

In the Layout pane, you can customize the page layout or simply observe a selected template's settings. *Figure 11-5* Use the Margins sliders to size the individual cells. Use Page Grid to determine how many cells in each row and column. Use Cell Spacing to determine the distance between cells. Use Cell Size to determine the size of the cells. (The size of each cell is determined by the total amount of cells and page size.) Check Keep Square if you want proportionally sized cells. In the Layout pane, you can also control the visibility of the Guides, Rulers, Margins and Gutters (space between images), Image Cells, and Image Print Size.

Overlays Pane

In the Overlays panel, you control which text and other options (such as page numbers, page info, and crop marks) are printed along with the images. *Figure 11-6* The text can be based either on a Identity Plate or image metadata. Custom text is also possible. For text based on metadata, the font sizes are limited, and you can't choose a different font. Larger sizes and different fonts are made possible by creating a custom Identity Plate.

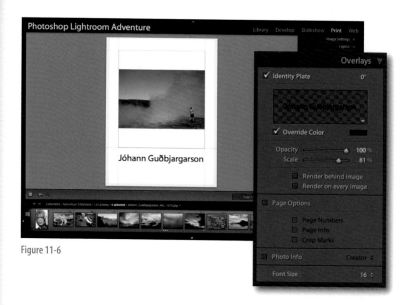

Figure 11-6

Print Job Pane

Print Job is where you specify the print resolution, color management, and sharpening. *Figure 11-7* If you check Draft Mode Printing, you can quickly print a screen resolution version of your image. If you leave Print Resolution unchecked, Lightroom uses only the original number of pixels in your image file and does not interpolate. This means the actual print resolution will differ, depending on the print size and original file size.

Figure 11-7

Print Resolution

With Print Resolution checked, Lightroom uses 240 ppi as the default Print Resolution, but you can type in higher or lower values between 42 and 480 ppi, if you want. *Figure 11-8* For many desktop printers, using values higher than 240 ppi doesn't significantly increase quality, but it does increase printing time.

Figure 11-8

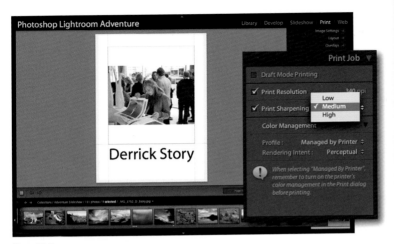

Figure 11-9

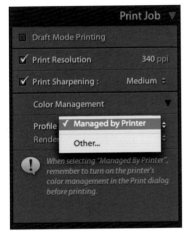

Figure 11-10

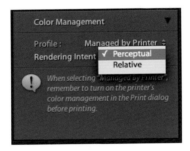

Figure 11-11

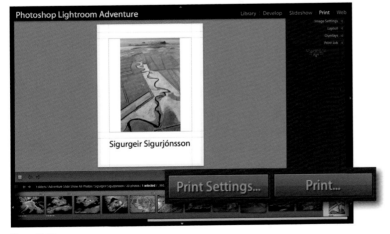

Figure 11-12

Print Sharpening

There are only three sharpening settings: Low, Medium, and High. *Figure 11-9* However, it's not a simplistic as it sounds. The amount of sharpening is "smartly" applied, relative to the size of the image, which is what you want. Adobe sums what to do nicely:

"Sharpening is often a matter of personal taste. Experiment to see what amount produces the results you like. As a starting point, use Low or Medium for prints that are 8.5 × 11 inches and smaller, and use High for prints that are 13 × 19 inches or larger."

Color Management

You can choose to have color managed by your printer or by a custom profile. *Figure 11-10*

Choosing between Perceptual and Relative Rendering Intent *Figure 11-11* will also give you control over how your color is managed. I'll go in to more detail on color management later in the chapter.

Print Settings and Print Buttons

At the bottom of the right pane are the Print Settings and Print buttons. *Figure 11-12*

If you click Print Settings, a dialog box specific to your operating system and printer will appear.

Here is the Print dialog box for my Mac and a Canon i9900 printer. *Figure 11-13* Here you can set quality and other controls. Clicking the Print button brings up similar controls specific to your computer. If you create a custom template after entering these values, you need not enter them again, as long as you use that particular template.

Figure 11-13

Print Module Toolbar

The toolbar at the bottom of the display work area has only a few controls that are mostly relevant if you are printing more than one page. The square icon will bring you to the first image; the arrows take you back and forth between pages. *Figure 11-14* (You can also select images to view from the filmstrip). If you have more than one page, it will also be noted in the toolbar (circled). The Page Setup button takes you to your operating system's Page Setup dialog box, where you can enter page size and other print parameters.

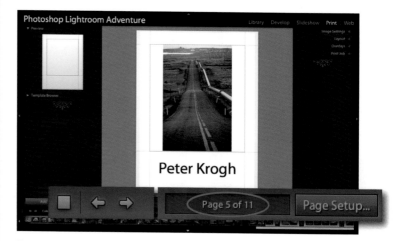

Figure 11-14

Filmstrip in the Print Module

The Print module filmstrip can be very helpful. *Figure 11-15* Here you select and deselect images to print.

Figure 11-15

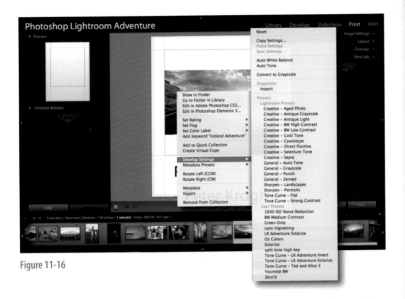

Figure 11-16

You can also, if you want, apply develop presets without leaving the print module by right-clicking on an image and selecting a preset from the contextual menu. *Figure 11-16* (The contextual menu, of course, provides many more options that can be applied to your images, without leaving the Print module.)

Figure 11-17

If the images you want to print aren't showing in the filmstrip, use the pop-up menu (circled) and display your entire library of images, or a previously viewed collection. *Figure 11-17*

Lightroom Interpolation

Lightroom automatically samples up or down images to fit a specified print size. (If you leave the resolution box in the Print Job pane unchecked, Lightroom doesn't resample at all.) You don't have to open up an Image Size dialog box and enter dimensions and interpolation method as you do in Photoshop. *Figure 11-18* Is this a "convenience" at the cost of quality? As I explained in Chapter 9, Lightroom resamples in linear space and—with technical explanations aside—this is a good thing. Obviously, if you radically enlarge a low-resolution image, quality will suffer, but no less so than if you had used Photoshop. (I haven't compared Lightroom to other up- or downsampling products, such as Genuine Fractals.)

Figure 11-18

Selecting & Printing a Single Full-Page Image

OK, now let's look at a simple procedure: selecting and printing a single, full-page image with no text. In the following sections, we will build complexity by adding text and then learning to print multiple images on the same page or on multiple pages.

Start by clicking an image to select it. *Figure 11-18* You can do this in the Library module, or, if the image is visible, in the Print module filmstrip. To get to the Print module from any other module, click on Print in the module picker. The keyboard shortcut is ⌘+Option+4 (Ctrl+Alt+4).

Figure 11-18

Pick the Maximize Size Template

In the Print module, select the Maximize Size template from the Template Browser pane. *Figure 11-19* A preview of the template will appear in the Preview window. (Later, I'll show you how to modify existing templates and make your own.)

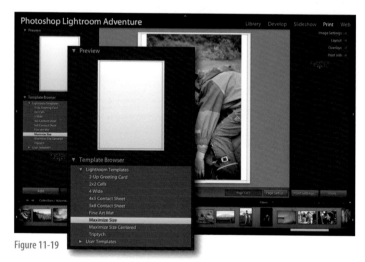

Figure 11-19

Set Page Setup

Select Page Setup from the toolbar, or from the File menu (File→Page Setup). In the resulting dialog box (which is different for Windows and Mac), select the appropriate printer and page size. *Figure 11-20* The template will automatically scale the image to fit.

Figure 11-20

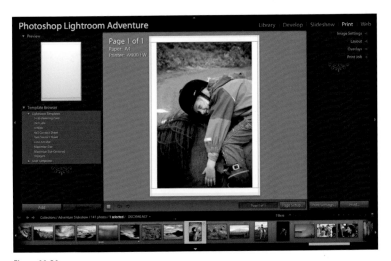

Figure 11-21

You should see something that looks like this. *Figure 11-21* To display the page-related information directly on the work area canvas (circled) select View→Show Info Overlay from the menu bar, or hit the I key. To show the rulers on the sides, select View→Show Rulers, or ⌘+R (Ctrl+R).

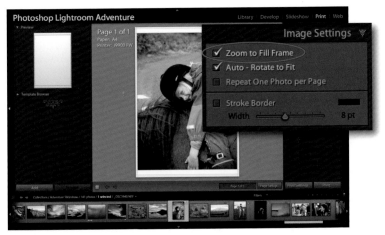

Figure 11-22

Zoom to Fill Frame

If you select Zoom to Fill Frame (circled) in the image Settings pane, you'll get even more out a sheet of paper. The image, however, might be cropped to maximize coverage. *Figure 11-22.*

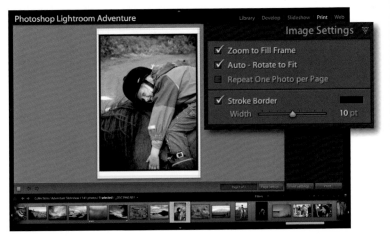

Figure 11-23

Add a Border

Add a simple color border by selecting Stroke Border from the Image Settings pane. The width is determined by the slider and the color by the color box. The image was created with a 20 pt black border. *Figure 11-23*

Modify the Size

We started with the Maximum Size template, which automatically attempts to fill the page. You can manually adjust the image to a different size or position if you want. Do this via the Layout pane, *Figure 11-24* or by hand using the guides in the image work area. Place your cursor over one of the guides and drag up or down (circled). As you do this, you can see the sliders move correspondingly in the Layout pane.

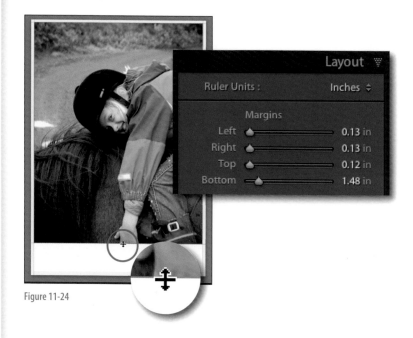

Figure 11-24

Final Settings (Almost)

You are almost ready to print. Make your final settings in the Print Job pane. *Figure 11-25*

Draft Mode Printing Select this only if you want a very quick, screen resolution quality image. Lightroom uses cached photo previews. All other print options are dimmed when you choose this option.

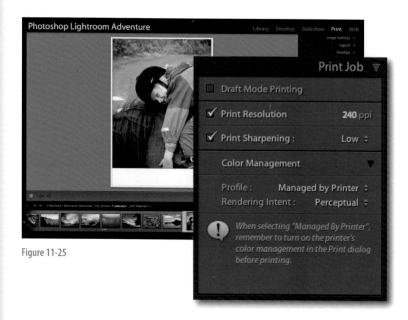

Figure 11-25

Print Resolution In the Print Job pane, check Print Resolution and select a print resolution. The default setting, 240 ppi, works well for most desktop printers. (Generally, the larger the ppi value, the longer it takes to print.) If you leave Print Resolution unchecked, Lightroom doesn't resample the image and the ppi is determined by the original number of pixels in the image and the print size.

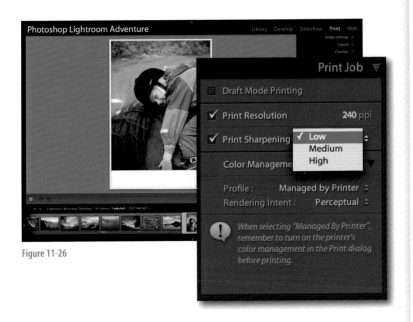

Figure 11-26

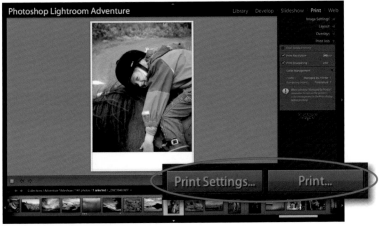

Figure 11-27

Print Sharpening Choose Low if you are satisfied with the Detail settings you set in the Develop module. *Figure 11-26* The other two settings "amplify" the existing sharpening based on the selected print size and ppi. There are many variables that determine the correct sharpening setting, including type of printer, type of paper, type of ink, type of image, etc. The best thing to do is experiment.

Color Management In the Print Job pane, you also need to choose how you want your print color managed. (I cover color management later in this chapter.)

Press Print Settings/Print Button

Finally, select either Print Settings or Print from the bottom of the right panel. *Figure 11-27* Print Settings brings up your operating system's Print dialog box where, depending on your print driver, you can choose image quality, paper, etc. If you choose a custom profile from the Print Job pane's Color Management Profile pop-up window, be sure to turn off the printer's color management, or there will be conflict.

> NOTE *When you are finished, I suggest you make a custom template. Do this by selecting Add from the bottom of the left pane. "Untitled" will appear in the New Template dialog box. You can rename the template later by double-clicking on it in the Template Browser and typing in a new name. All your print settings will be saved, including the ones you entered in the Print dialog box.*

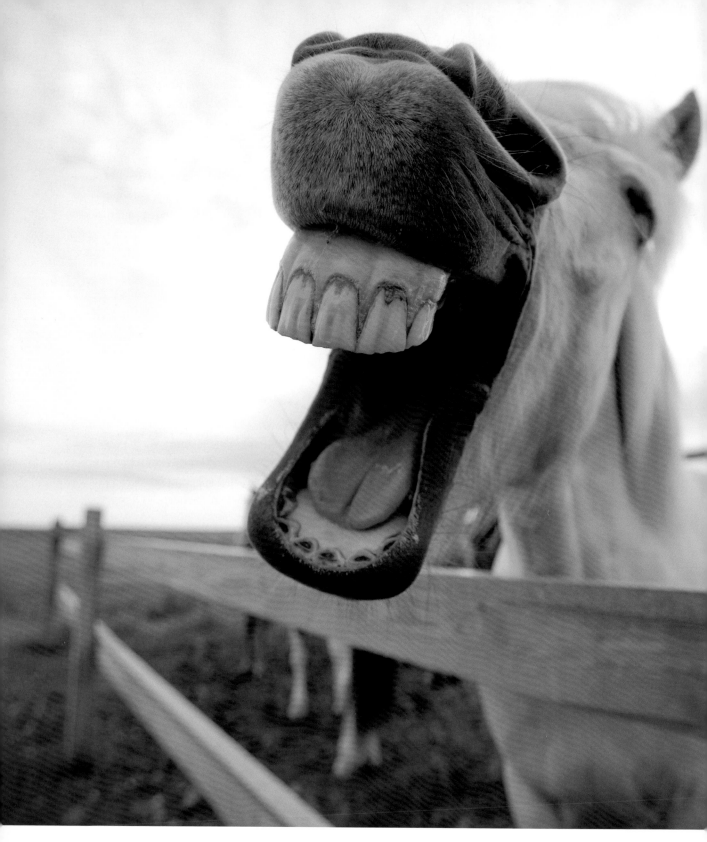

John McDermott

Iceland's horses have a very romantic image, but John captured another side with this shot. I've repeatedly asked John what he said to the horse, but he has yet to answer me. John shot this with a Canon EOS 5D. He used a 16–35mm lens set to 16mm, f/4 at 1/500th of a second. John did minimal post-processing in Lightroom, slightly dropping the Exposure value −.33 and using the Develop module's Recovery slider to bring out more detail in the sky.

Adding Text to Prints

There are a couple ways to add text to your prints. You can print an existing Identity Plate that contains text, create custom text, or use metadata such as file name, title, caption, creator, and keywords attached to your image file. Let's see how.

Let's start by assuming you have an existing Identity Plate containing text. (The Identity Plate can be a graphic, of course, in which case, everything I write here still holds true...except for the part where I talk about editing the text.)

In the Overlays pane, *Figure 11-27* select the Identity Plate check box (circled). Your current Identity Plate will appear in the box. It will also appear in a bounding box in the display work area.

Identity Plate Placement

You can change the orientation of the bounding box in the Overlays pane by degrees in the upper right side of the pane. (Clicking on [0 °] degrees brings up a pop-up menu.) Select Override Color and choose another color for the text by clicking on the color selection box. You can also control the Opacity and Scale of the text (or graphic) with the sliders.

Checking Render behind image places the Identity Plate, or part of the plate, behind the image. Choosing Render on every image places the content of the Identity Plate directly in the middle of every image in your layout. *Figure 11-28* Use the Opacity and Scale slider in the Overlays pane to control the content of the box.

If you haven't checked Render on every image, you can also work directly in the bounding box in the work area window.

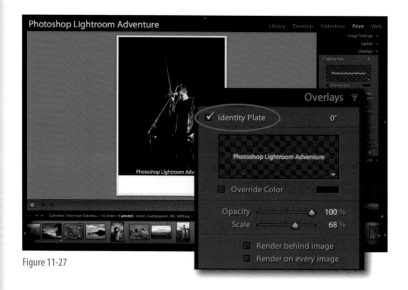

Figure 11-27

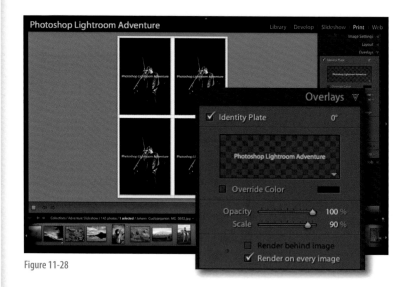

Figure 11-28

Figure 11-29

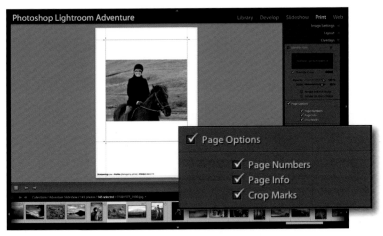

Figure 11-30

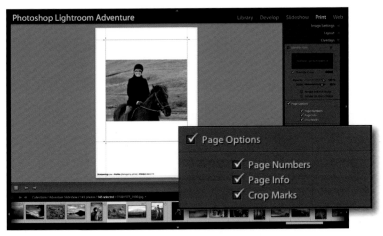

Figure 11-31

NOTE *If you select Sequence from the Photo Info pop-up menu, Lightroom will apply sequential numbers to the photos based on how many photos you're printing (e.g., 1/10, 2/10, etc., for a 10-image set).*

Click inside the bounding box and drag it to your desired location. *Figure 11-29* The text will fill only one line and can be enlarged only to the width or length of the page.

Creating custom text

To create a Custom text Identity plate, double-click on the bounding box in the work area window, or, in the Overlays pane, select Edit from the pop-up menu. *Figure 11-30* Either action will bring up The Identity Plate Editor dialog box shown here where you can type, and choose another font or style.

Adding page numbers, etc.

Select Page Options in the Overlays pane and you can selectively add page numbers, page info, or crop marks to the print. *Figure 11-31* You can't control the size or position of the options; page numbers and Page Info all appear at the bottom of each page. You can choose to include Page Info (Print Sharpening setting, Profile setting, and printer name at the bottom of each page) or crop marks around each photo (to use as cutting guides after printing) by clicking the appropriate check box.

Using metadata for page info option

If you select Photo Info in the Overlays pane, you can add text based on available image metadata to your photo, or create your own custom text. The text will always appear at the bottom of the image, with limited choice of font size and no choice of font style or color. Select from one of the presets or choose Edit, which brings up the Text Template Editor, where you can create your own template based on one of the image data fields or add custom text of any length.

Printing Multiple Images

You can print multiple images on single or multiple pages, or you can print multiple copies of the same image on the same page. You can also crop images to fit a particular layout. And it's all really easy! Let's see how.

I'll start by making a contact sheet, and then move on to other layouts.

Creating a Contact Sheet

To create a contact sheet, start by selecting the images you want to include. You can do this in the Library module, or in the Print module via the filmstrip. For this example, I started in the Library module. I selected my Adventure slideshow collection, and then used ⌘+A (Ctrl+A) to select all the images. *Figure 11-32*

(Once you are in the Print module, you can also use ⌘+A (Ctrl+A) to select all the images in the filmstrip. ⌘+D (Ctrl+D) will deselect all the images.)

In the Print module, confirm that the images you want are all selected by observing the number in the info overlay (circled, top) or lower right side (circled, bottom). *Figure 11-33*

Choose one of the default contact sheet templates from the Lightroom Template folder or select one of your own from the User Template folder. In this example, I selected 4 × 5 Contact Sheet. *Figure 11-34* Deselecting an image or images from the filmstrip will remove the them from the contact sheet. To deselect one image at a time, hold the ⌘ key (Ctrl key) while clicking on the thumbnail of the image you wish to remove in the filmstrip.

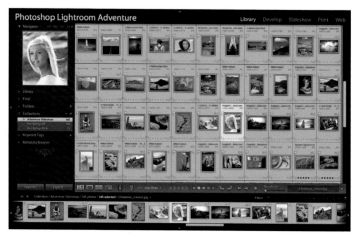

Figure 11-32

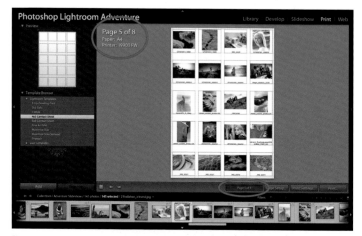

Figure 11-33

Figure 11-34

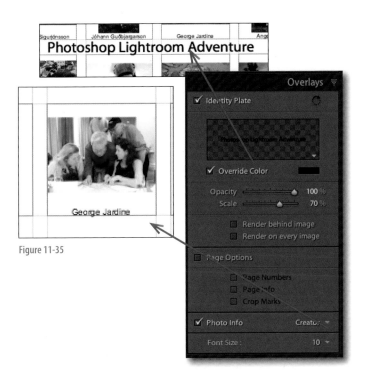

Figure 11-35

From the Overlays pane in the right panel, decide on the text you wish to include. For this example, I included a textual-based Identity plate that reads "Photoshop Lightroom Adventure" and positioned it near to the middle of the page. I also selected the metadata Creator field. This placed the individual photographer's name under each image. *Figure 11-35* (Another useful bit of information for a contact sheet might be the file name.)

You can customize the contact sheet layout in the Image Settings and Layout panes. When you are finished, select Print from the bottom of the right panel. Save your custom layout as a template by clicking the Add button from the bottom of the left panel.

One Image Per Page, Multiple Pages

Figure 11-36

Let's say you are done printing a contact sheet, as in the previous example. Now you want enlargements of several images from the same collection. All you do is select another template from the Template Browser. For this example, I chose Fine Art Mat. *Figure 11-36* As you can see from the Info Overlay (circled, top), all 192 of my images are ready to print using the new layout. I don't want to print all 192 images, though, so I used the filmstrip to deselect the ones I don't want. (Remember, ⌘+click [Ctrl-click] on the thumbnail in the filmstrip to deselect.) Now I'm down to 22 (circled, bottom). As you can see, I also added an Identity Plate and a Creator field from the Overlays pane. The Identity plate will print on all 22 pages, exactly as you see here, and the creator field will reflect the name that appears in each image Creator IPTC metadata field.

One Image, Multiple Times on a Page

If I want, I can also repeat the same image multiple times on the same page. For this example, I selected the 2 × 2 Template from the Lightroom Templates folder in the Template Browser. *Figure 11-37* In the Image Settings pane, I selected Repeat One Photo per Page.

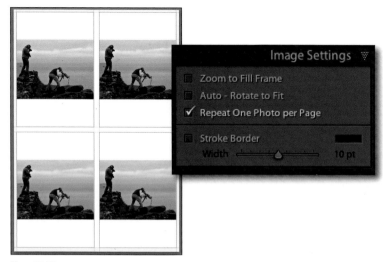

Figure 11-37

Because the image is horizontally oriented, it doesn't fill the cells. However, if I check Auto-Rotate to Fit from the Image Settings pane, as I did in *Figure 11-38*, the image fills the cells.

Figure 11-38

Positioning Images

In this example, I choose the 4 Wide template from the Lightroom Templates folder in the Template Browser. *Figure 11-39* As you can see, the images are cropped because they are a different aspect ratio than the cells and the Zoom to Fill Frame option is selected (by default) in the Image Settings pane.

Figure 11-39

If I deselect Fill to Frame, the images are now uncropped, but this still isn't the effect I want. *Figure 11-40*

Figure 11-40

What I can do is reselect Fill to Frame in the Image Settings pane, then move the individual images within the cells to position them so only the parts I want to show are viewable. To do this, click on an image, then drag it around in the cell until the area you wish to see is revealed. Do this with each cell. *Figure 11-41*

NOTE *You can change the size of cells in the Layout pane of the Print module. However, at this time, you can't have a variety of cell sizes on the same page. All the cells are the same size.*

Figure 11-41

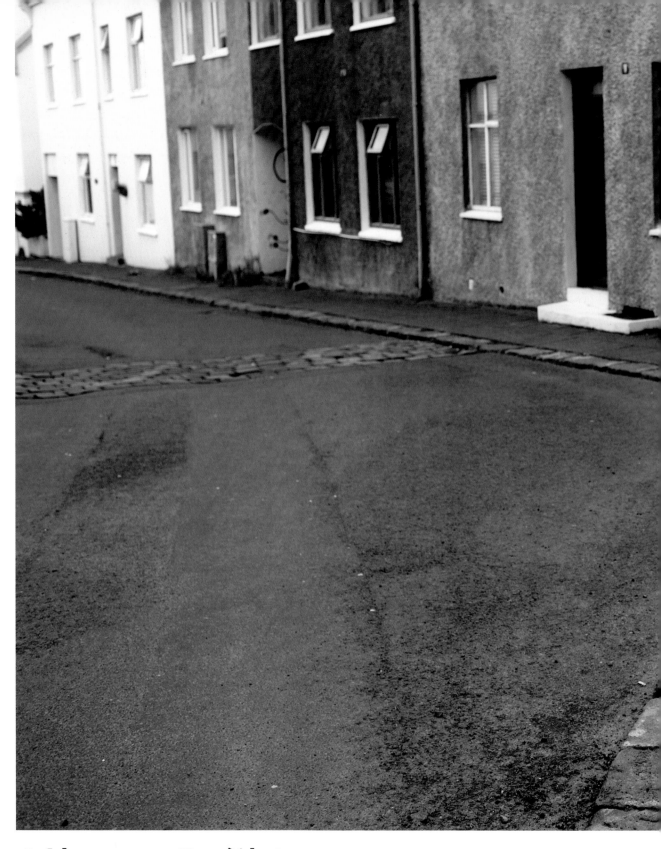

Jóhann Guðbjargarson

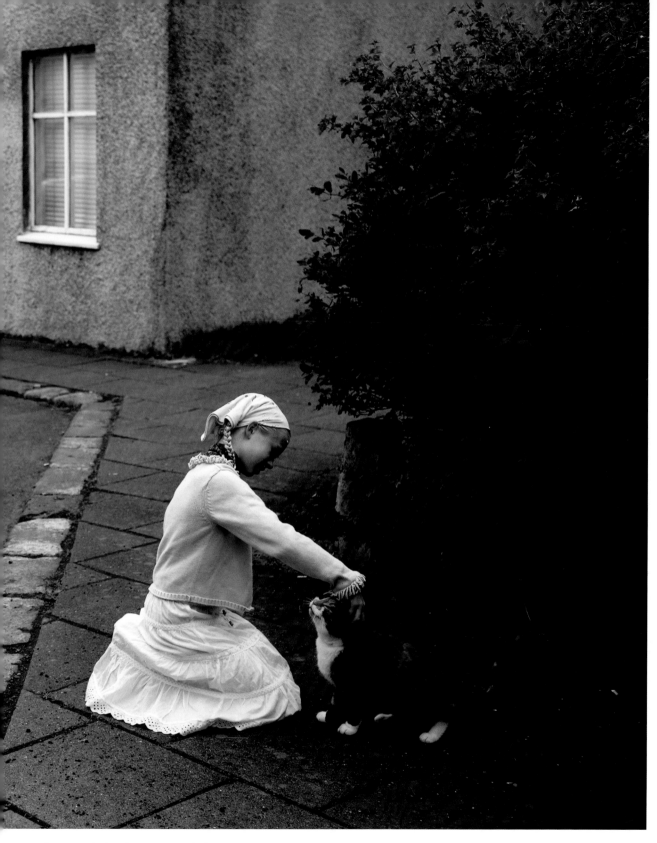

Jóhann took this shot on a small downtown street in Reykjavik on the last day of our adventure. I love the composition and the way it captures the feeling of this quiet city. It also is a very nice shot of my daughter Miranda, who flew in with her sister Ana and my wife, Rebecca, to join us before heading home. The photo was taken with a Canon 5D, using a 35mm lens at f/1.4. Here are Jóhann's Develop module parameters: Exposure: −0.61, Recovery: 9, Brightness: +44, Contrast: +91, Vibrance: +13.

Lightroom Color Management

You have a couple choices when it comes to Color Management in Lightroom's Print module. You can use a custom printer profile, or you can turn over the color management to your printer software. You'll also have a choice of how Lightroom converts the image into a printing color space. Here you'll learn how.

CM Profiles

There are two pop-up menus in the Profiles section of the Color Management Pane.

Manage by printer

If you select this option, you hand over control of how the color is handled to the printer driver software that came with your printer. Before you print, you must open the printer driver and select the appropriate settings. Every printer driver is different, but I use a Canon i9900 and this is what I get when I click on the Print Settings box at the bottom of the right panel of the Print module. *Figure 11-43* The critical thing here is, under Color Options, to select Colorsync (Mac) or ICM Color Management (Windows) as a Color Correction option. You also need to choose the appropriate Quality setting and Media (but you need to do this regardless of which color management method you use).

Other... option

If you select Other, a dialog box will appear. *Figure 11-44* This is a list of printer profiles that came with your printer or you have loaded yourself. (If no profiles are loaded, this dialog box will be empty.) These profiles take into account many factors including the printer, color space, and type of paper. Check the box or boxes next to the profile or profiles you want to use (circled).

Figure 11-42

Figure 11-43

Figure 11-44

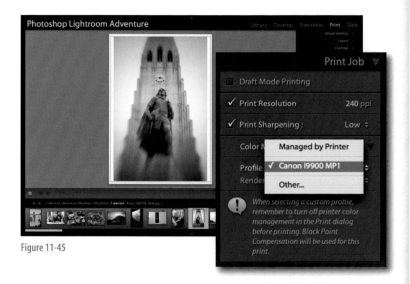

Figure 11-45

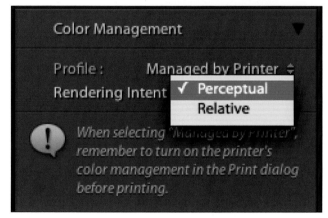

Figure 11-46

Perceptual *rendering* attempts to preserve the visual relationship between colors, and is generally the best choice when printing color images. However, colors that are in-gamut may change as out-of-gamut colors are shifted to reproducible colors.

Relative *rendering,* on the other hand, preserves all in-gamut colors and shifts out-of-gamut colors to the closest reproducible color. The Relative option preserves more of the original color and may be desirable if you have few out-of-gamut colors. The only way to know for sure which method to use is to try both and compare the results.

The chosen profile will appear as a choice in the pop-up menu. *Figure 11-45* To remove it, select Other again and deselect your choice. To add custom printer profiles, place the profile in your computer's Colorsync (Mac) or Color (Win) folder. On the Mac, this folder is found in the Library folder. In Windows, the Color folder a bit hidden, so I suggest searching for the *.icm* extension to find it. After placing the new profile in the folder, restart Lightroom, and the next time you select Other, the profile should appear in the list. Let me amplify the warning found in the Print module Color management pane: if you use a custom profile, it's very important to turn off the color management in your printer driver dialog box. You don't want the custom and printer management to *both* manage your colors.

Choosing Rendering Intent

One last option for color management via the Lightroom Print module is to choose the rendering intent. You have two choices: Perceptual and Relative. *Figure 11-46* Suffer with me a moment for a brief explanation of how Lightroom handles color space. Lightroom's working color space ProPhoto RGB, is an extremely wide and accommodating color space. If you edit your photo in the Develop module, and, say, supersaturate it, this color space is large enough to handle the expanded colors. However, when you go to print, your computer—and often the printer—isn't set up to handle the expanded range of colors. Choosing Perceptual or Relative will determine how any out-of-gamut colors are handled. The box to the left sums up which to use when.

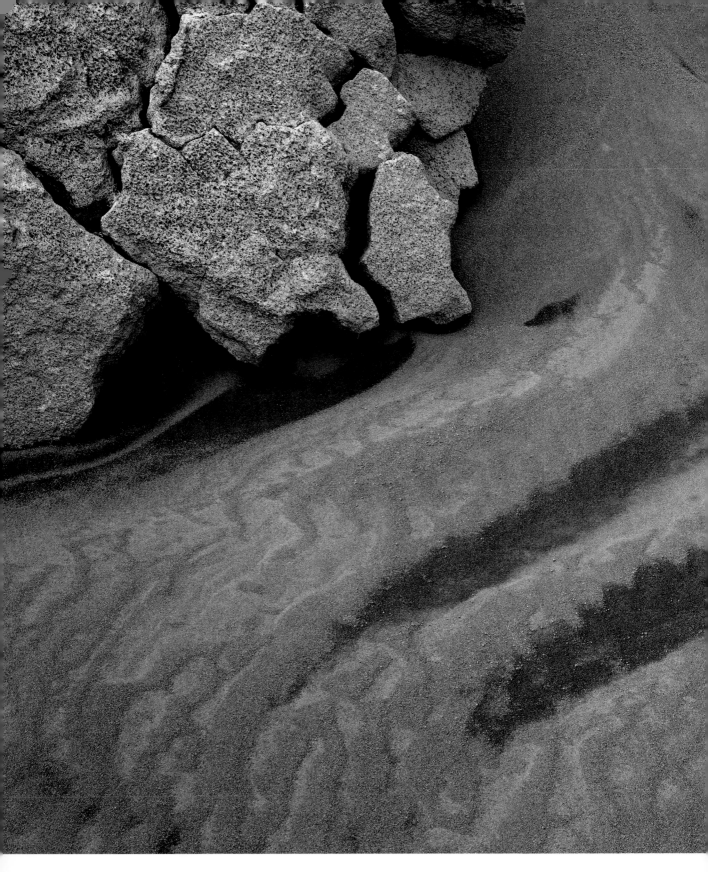

Bill Atkinson

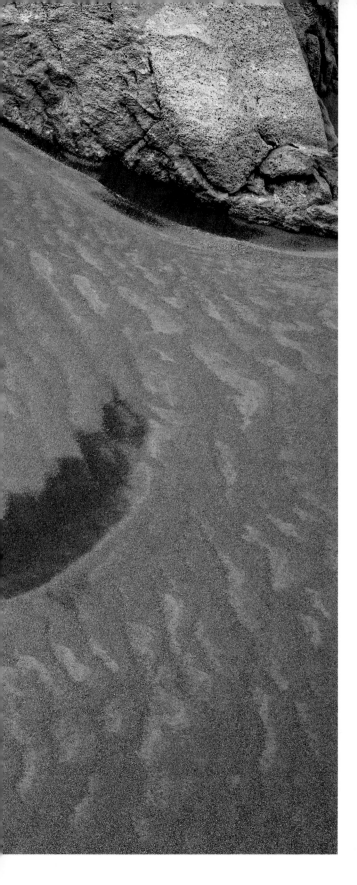

Iceland was used by the Apollo astronauts to train for the original moon landing, and I think Bill's close-up conveys a lunar feel. It also has a Zen serenity. Bill used a Phase One P45 back on a Hasselblad body and a 50mm lens. He shot this at 1/6 sec at f/18. He did very little post-processing in Lightroom, as is his preference.

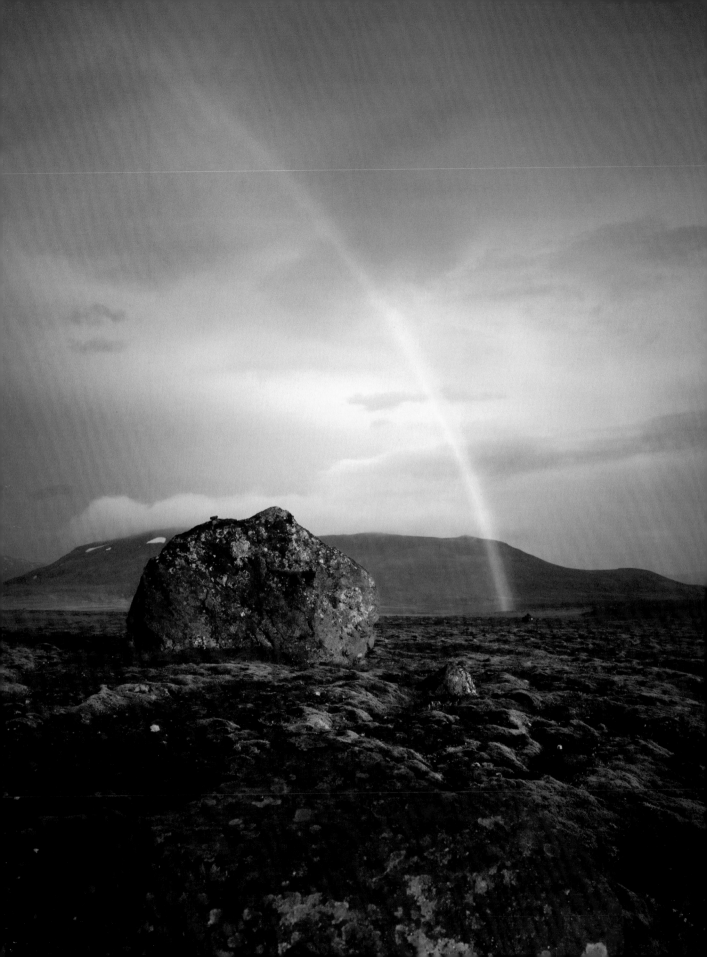

Creating a Web Gallery

Selecting a series of photos and creating a unique web photo gallery can be accomplished quickly and easily from within Lightroom's Web module. Lightroom generates all the components you'll need for your web site, from thumbnail images to larger preview versions of the photos, to the necessary code that binds everything together. You can choose either standard HTML or the more flashy "Flash" style. Lightroom will even upload your ready-to-go web gallery directly, if you choose. This chapter shows you how.

Chapter Contents

The Web Module Revealed

Web galleries are created in Lightroom's Web module, which is stating the obvious, right? OK, let's break the Web module down to its specific components and describe it that way. Then, in subsequent sections, we'll see how to put the Web module to practical use.

Here is the Web module, in full, with left and right panels, workspace, toolbar, and filmstrip visible. As is true with all the Lightroom modules, you can customize the work area by closing or resizing panels and expanding or shrinking the filmstrip. *Figure 12-1*

> NOTE If you create a Lightroom Web Gallery using HTML, it will be viewable on all web browsers. Preview images will be viewed at the size you set in the Lightroom Web module. If you create the gallery using Flash, the viewer will require a widely available browser plug-in for Flash. Flash Web galleries produce online slideshows with smooth transitions and auto resizing based on the size of the viewer's browser window.

Figure 12-1

Web Preview Pane

In the preview window, you can view template page layouts from the Template Browser. Just hold your cursor over a template name and it will appear in the preview window. *Figure 12-2* You can tell if you are creating a HTML- or a Flash-based gallery by looking at the icon in the lower left corner of the Preview window (circled).

Figure 12-2

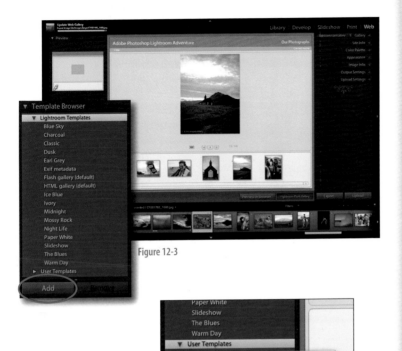

Figure 12-3

Figure 12-4

Web Module Template Browser

Here in the Template Browser, you can either select a gallery style, or, as I mentioned earlier, preview a style in the preview window. When you select a template, Lightroom immediately begins generating the new style, which can take some time, depending how many images are selected and the template style in use. You can also save custom templates by clicking the Add button at the bottom of the left panel (circled). *Figure 12-3* To remove a custom template, select the template name and click Remove. (To remove a template from the Lightroom Templates folder, you'll need to find the actual file on your hard drive and trash it from there.)

If you right-click on one of the templates in the user folder, you'll have the option via the contextual menu to "Update with Current Settings," which basically means, "Change template from here on out to reflect the adjustments I just made." *Figure 12-4* This is not an option with templates in the Lightroom Templates folder. To achieve basically the same thing, customize the template, then select Web→New Template from the menu bar, and give the template a name. The new template with the updated settings will then appear in the User Templates folder or a new folder of your choice.

Display Work Area

The display work area displays the Web gallery pages almost exactly as they will appear in a browser. *Figure 12-5* The gallery is fully operable and you can click on thumbnails and active links and preview the effect. You can also view the slideshow (Flash only). Operability of

Figure 12-5

the gallery might take some time while Lightroom generates all the necessary thumbnails, large images, and code. A status bar at the upper left corner of the Lightroom window indicates the progress. You can stop the progress at any time by clicking on the X at the end of the progress bar (circled). *Figure 12-6*

Figure 12-6

Web Module Right Panel

The right panel is where you can add descriptive text, customize colors, and set image sizes. It's also where you go to export your gallery files or upload your finished gallery directly to a server. *Figure 12-7*

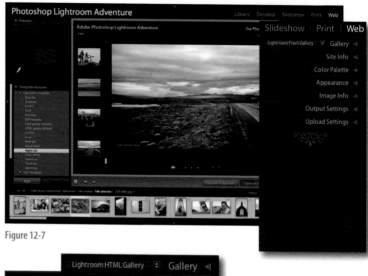

Figure 12-7

Gallery pane

In the right panel, starting at the top, is the Gallery pane, which indicates what type of gallery you are working with. If you choose a template using HTML, Lightroom HTML Gallery will show (left). *Figure 12-8* If you choose a gallery using Flash, Lightroom Flash Gallery will show (right). Because Flash and HTML Galleries are fundamentally different, the customizing choices you will see in subsequent panes may differ substantially.

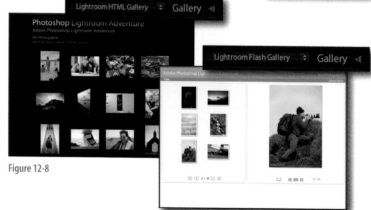

Figure 12-8

Site Info pane

In the Site Info pane, you can add fixed titles and a description, your contact information, and email address. *Figure 12-9* Type size, font style, and location are set by the template. HTML and Flash panes are basically the same, except in the HTML pane you also have the option to add an Identity Plate. (For Flash Gallery styles, the Identity Plate option is found in the Appearance pane.)

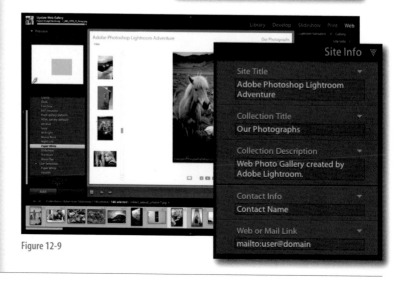

Figure 12-9

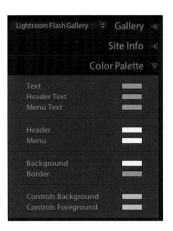

Figure 12-10

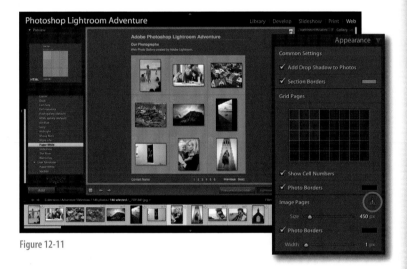

Figure 12-11

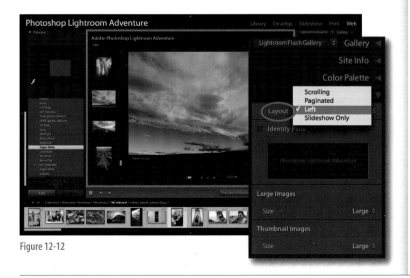

Figure 12-12

Color Palette pane

In the Color Palette pane, you set the text, background, and other web component colors. Just click on a color swatch box to bring up a color picker. As you can see, there are different choices in the HTML (left) and Flash (right) Color Palette panes. *Figure 12-10*

Appearance pane

In the HTML Appearance pane, you can choose to include a drop shadow, add section borders, choose a color for them, and add photo borders with a specified width and size. *Figure 12-11* You can set how many thumbnails appear on each page by clicking on the grid. You can control the size of the full-sized image pages—from 300 to 2071 pixels—but not the size of the index pages. If an index page is showing in the display window, a warning [!] (circled) instructs you to click on an index thumbnail to open a page with a large images, and see the effects of moving the Size slider. More pixels means a larger page and a larger image, which is fine if you know your viewers have a large screen. However, it also means a large file size (which you can reduce somewhat by setting a higher JPEG compression in the Output Settings pane).

In the Flash Appearance pane, *Figure 12-12* you can determine where the thumbnails appear on the page with the Layout pop-up menu (circled). You can select an Identity Plate. You can also control the size of the large images and thumbnail images via the size pop-up menus. There are four options: Extra Large, Large, Medium, and Small. Lightroom actually creates three versions of each photo to accommodate different sized browser windows.

Figure 12-16

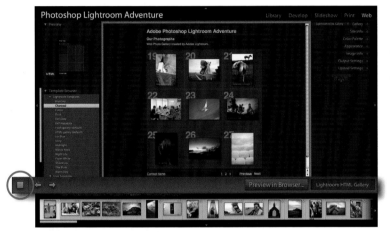

Figure 12-17

Figure 12-18

NOTE It is possible, if you are knowledgeable, to go under the hood and do even more customizing of the Lightroom Web gallery. You need to know something about HTML or Flash coding and you also need to know exactly what parameters you can change or alter. Adobe is in the process of preparing documents specific to working with the Lightroom Web Gallery. Check out the O'Reilly Inside Lightroom site for updates on this.

Export and Upload buttons

Click the Export button in order to save your files to another location. *Figure 12-16* You can load them onto a server or open the files and further customize the code. Click the Upload button, and Lightroom automatically places your gallery on a server, based on the information entered in the Output pane. You need to be online and have an Internet Service Provider (ISP) for this to work, obviously!

Web Module Toolbar

Just a few controls: the square icon (circled) will bring you to the first image in the filmstrip, and the arrows take you back and forth between images in the filmstrip. *Figure 12-17* Click the Preview in Browser button to open your gallery in an actual Web browser. (This can take time depending on your choices; Lightroom generates all the necessary information and saves it before the preview can occur.) The box to the far right of the toolbar shows you at-a-glance which style you are working with, HTML or Flash.

The Filmstrip in the Web Module

In the filmstrip, you can apply develop presets without leaving the Web module by right-clicking on an image and selecting a preset from the contextual menu. *Figure 12-18* To switch to another collection or folder, use the pop-up menu (circled) which displays your entire library of images or a previously viewed collection. You can directly select or deselect individual images for the Web gallery from the filmstrip. Do this, and then select Web→Which Photos→Use Selected Photos from the menu bar.

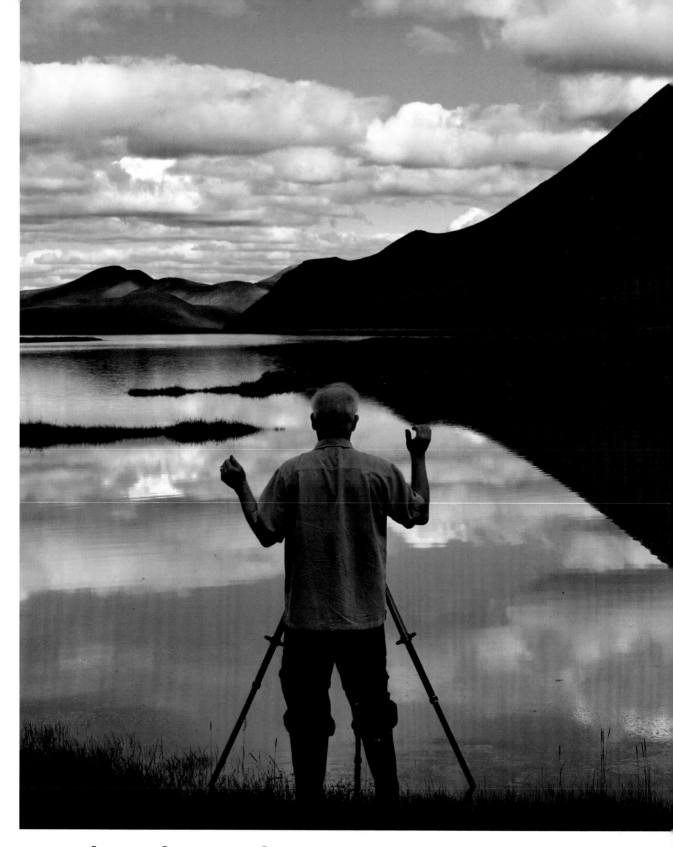

Michael Reichmann

At one point, Michael's lovely shot of Bill Atkinson was our cover shot. Well, actually, before that there was another shot taken by Melissa Gaul of Bill (at the same time) that was first in line. But in that shot, Melissa caught Bill leaning over, as if to pick up a dropped lens. (He was really checking the adjustments on this tripod, but once George Jardine said it looked like he'd just dropped his favorite lens in the lake, we couldn't look at the shot any other way.) Michael's shot depicted Bill commanding the heavens, but then someone said it looked like he was being held up by Icelandic bandits, and from that moment on no one could get that caption out of their mind. So the next choice was a horse by Martin Sundberg (you can see it in Chapter 3), but that is another story.

Customizing a Web Gallery

Lightroom ships with several templates for creating web photo galleries. You can customize these templates and save your own version. Choose between building an HTML or Flash gallery. When you are finished, export all the necessary files and place them on a server yourself or let Lightroom do it for you. Let's see how.

To start, you must first select the images you wish to include in the Web gallery.

Selecting Images

In the Library module, select a folder, collection, or keyword. *Figure 12-19* If you are not in the Library module, hit the G key, and you'll be taken to the Library module's Grid view. Any image appearing in the display work area will be included in the Web gallery. I usually create a unique collection for each Web gallery. That way, I can preserve my image order, and it also makes it easier for me to update my Web gallery at a later date. You can also make your selection in the Web gallery filmstrip and then go to the menu bar and select Web→Which Photos→Use Selected Photos.

Figure 12-19

Select the Web Module

Now go to the Web module. If you are not there already, get there by clicking Web in the module picker or use the keyboard ⌘+Option+5 (Ctrl+Alt+5). As soon as you enter the Web module, Lightroom begins generating or updating the gallery. You'll see the status of this operation in the status bar. *Figure 12-20* You can modify the order of images in the filmstrip.

Figure 12-20

Figure 12-21

Figure 12-22

Figure 12-23

Select a Web Template

Select a Lightroom Template from the Template Browser. You can see a preview of the layout in the Preview window. In the lower left of the Preview window, a graphic indicates whether the style is HTML or Flash (circled in each example). Here —taking into account variations in color, type, and captions—are your basic Lightroom template gallery choices:

- Galleries with separate windows of thumbnail images that lead to windows of full-sized images. This basic style can be either HTML or Flash. *Figure 12-21*

- Galleries with a single window containing thumbnail images that when clicked on, display an adjacent full-sized image. This is only available as a Flash style. *Figure 12-22*

- Galleries which consist of a user-controlled slideshow with no thumbnails. This is only available as a Flash style. *Figure 12-23*

Create a Title and Description

After you select a template, go to the Site Info pane to add all the pertinent information about your gallery. *Figure 12-24* The Site Info pane for HTML- and Flash-based galleries is pretty much the same, except Identity Plate settings are found in the Site Info pane for HTML and in the Appearance pane for Flash. If you click on the triangle near a text field (circled), you'll get a pop-up menu of previously used text. You can't change the size of the text or the font.

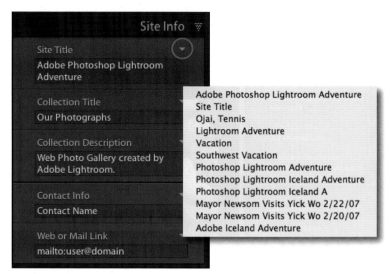

Figure 12-24

Control the Color

In the Color Palette pane, you can change the text colors, background, etc. *Figure 12-25* You'll see a difference between the HTML and Flash versions. Flash galleries tend to be more complex, therefore there are more choices in the Flash version. To change colors in either pane, click on the color swatch. This brings up a color picker where you can make your color selection.

> NOTE *Lightroom uses sRGB as its color space for web-destined photos. You can't change this, nor would you likely want to.*

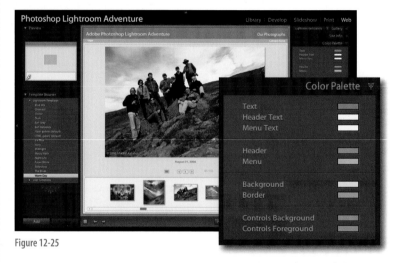

Figure 12-25

Change and Control Thumbnails

Both HTML and Flash thumbnails are controlled from the Appearance pane. You cannot change the size of the HTML thumbnails, but you can control how many appear on an index page via Grid Pages. Click on the grid to reduce or expand the number of cells. *Figure 12-26*

Figure 12-26

Figure 12-27

If you select Show Cell Numbers, each cell will contain a sequential number (circled), the visibility of which is dependent on the particular template or your color choices in the Color Palette pane. *Figure 12-27*

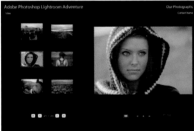

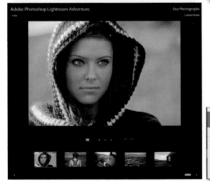

Figure 12-28

In the Flash Appearance pane, you can choose where the thumbnails appear, how they are displayed, and what their size will be. Click on the triangle to the right of Layout (circled) and a pop-up menu appears with choices. *Figure 12-28* Slideshow Only removes the thumbnails entirely.

You can set the thumbnails on the left (top), use a paginated option (center), or have them set for scrolling (bottom).

You have a choice of four thumbnail sizes from the Size pop-up menu: Extra Large, Large, Medium, and Small.

Change Large Image Sizes and Quality

You also control HTML and Flash large image sizes from the Appearance pane. There are fundamental differences between the HTML and the Flash panes. HTML large image sizes are controlled from the Image Pages Size slider by pixels to a fixed size, regardless of the size of the viewer's browser window. *Figure 12-28*

Figure 12-29

Flash large images can be Extra Large, Large, Medium, or Small. *Figure 12-30* In reality, Lightroom creates more sizes than that. In fact, it generates three sizes for each category. That way, when a viewer resizes their browser window, the thumbnails and previews adjust accordingly.

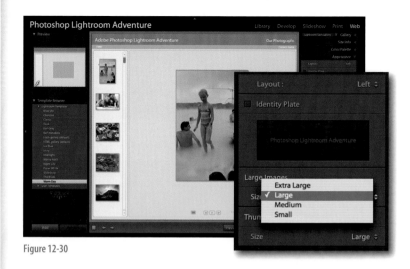

Figure 12-30

The JPEG quality of large images can be set for both HTML and Flash styles in the Output Settings pane. *Figure 12-31* The higher the Quality number, the better the quality (less compression). Higher quality numbers also create larger file sizes and potentially a slower download speed on the viewer side.

Add Copyright Notice & Metadata

The Output pane for either HTML or Flash styles is also where you can add a copyright notice to the images (circled). Lightroom places the copyright information in the lower left corner of each image based on EXIF metadata. You have no control over where the information is placed, or font type, size, or style.

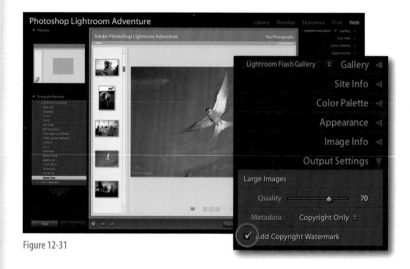

Figure 12-31

Add Info Text and Identity Plate

Both the HTML and Flash gallery styles give you the option to add a title or caption based on EXIF data. This is done from the Image Info pane. *Figure 12-32* You can also use an Identity Plate to add custom text or graphic. I'll show you more on this in the next section.

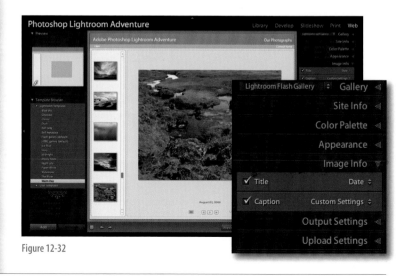

Figure 12-32

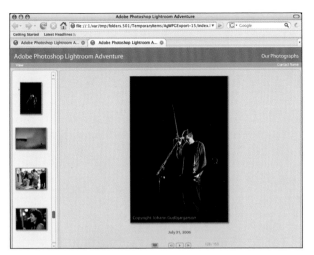

Figure 12-33

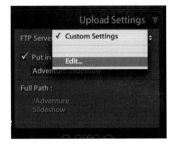

Figure 12-34

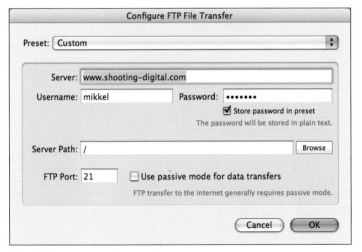

Figure 12-35

NOTE In the Web module Label's pane, for both HTML and Flash Galleries, you can enter your email address. Do this knowing that by including your email address on your site you are now susceptible to web bots that automatically harvest web sites for email addresses and sell the addresses to spammers.

Preview & Create a Custom Preset

When you are finished, you can Preview your Web gallery in a browser by clicking the Preview in Browser button in the toolbar. Your gallery will eventually open in your default web browser. *Figure 12-33* If you are satisfied with the results, make a User Template by selecting Web→New Template from the menu bar. Name your template and place it in the User folder or create a new folder and put it there.

Publish your Work Online

Lightroom will place your finished Web gallery directly onto a server of your choice. In the Upload Settings pane (HTML and Flash are the same) select Edit from the pop-up menu (circled). *Figure 12-34*

In the Configure FTP File Transfer dialog box, fill out the appropriate address, password, etc. *Figure 12-35* Pay particular attention to the fact that Lightroom saves your password in plain text, which can be readable by anyone with access to your computer. Also note that many servers require the passive mode for data transfers, but not all. I had to turn this option off in order to successfully upload a gallery to my shooting-digital.com site.

Click the Upload button at the bottom of the right panel, and as long as you are online, Lightroom will do the rest. You can also export the files to a location of your choice and place them manually on your site.

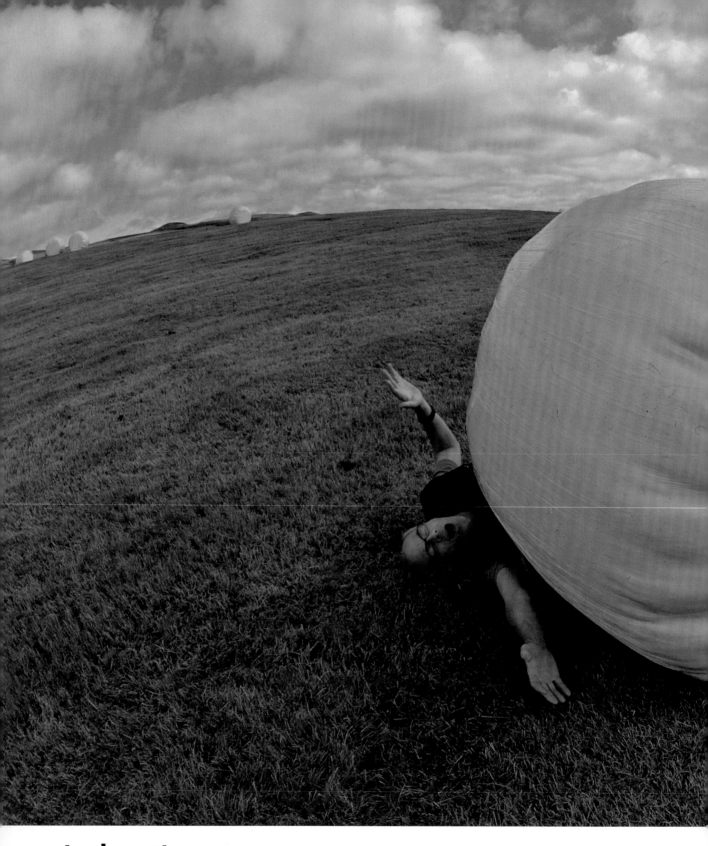

John Isaac

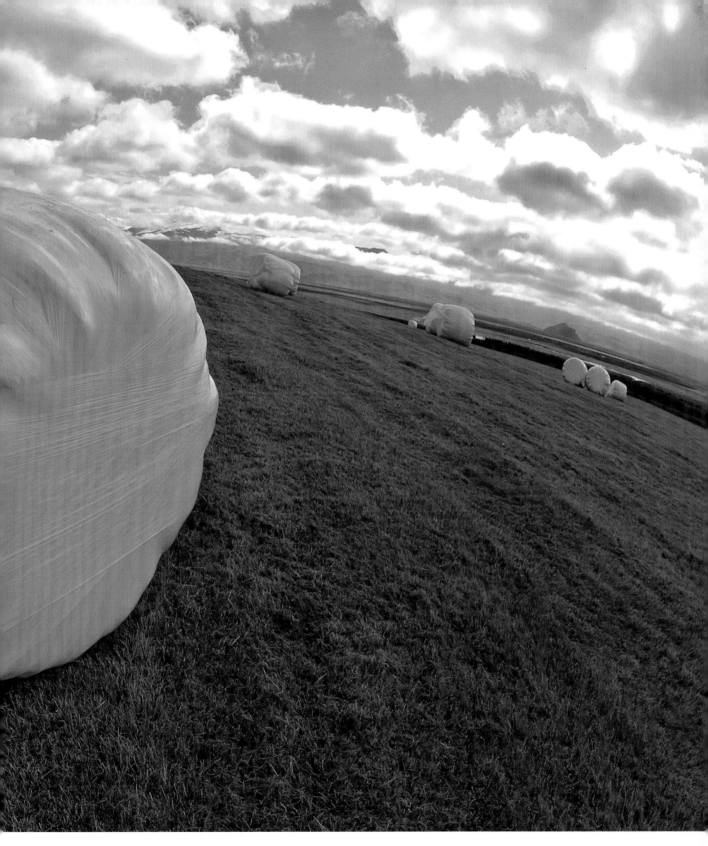

The man in the photo is Adobe's Russell Brown, who is sometimes referred to as a "rock star" for his entertaining presentations. In this performance, John caught Russell as he was being crushed by a Viking god's monstrous toilet paper rolls. (In truth, these were bundles of hay and Russell was hamming it up for the camera. Not everything on the Adventure was work, you know.) John used Lightroom's Highlight Recovery feature to bring out details in the clouds but otherwise left the RAW file alone.

Adding Text to Web Galleries

Lightroom creates web pages that emphasize your images. But text is important, too. Not only will you want to credit your work so everyone can see, sometimes it's useful if you include other information about where, when, and how your images were made. Let's see how.

You can add text from the Site Info pane in the right panel or directly in the image work area by clicking in the text field (circled). *Figure 12-36* Click on the arrow to the right of a text field and list of previously used text appears for you to choose from. You can't control the size or font without going under the hood and re-writing code yourself, but on a Mac you can spell check by right clicking on the text field and using the pop-up contextual menu. This is not an option with Windows.

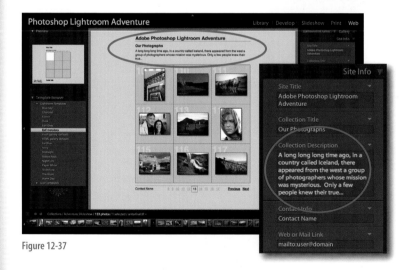

Figure 12-36

You can type as much text as you want in the Collection Description field (circled) and Lightroom will automatically add the line returns when necessary. If you are using an HTML style, the Collection Description text will appear below the Site Title and Collection Title text on the thumbnail pages (circled). *Figure 12-37*

Figure 12-37

If you are using a Flash style, the Collection Description text will appear in a separate window when a viewer selects View→About These Photos (circled). *Figure 12-38*

Figure 12-38

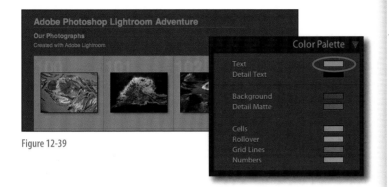

Figure 12-39

Changing Type Color

Change the color of type in the Color Palette pane. Click on the color swatch box (circled) and pick a readable color from your operating system's color picker. *Figure 12-39*

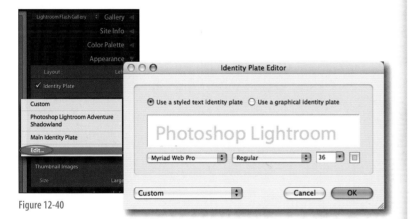

Figure 12-40

Using an Identity Plate

You can also add text (or a graphic) to your web page via the Site Info (HTML) or Appearance (Flash) pane. To add custom type, select Edit from the pop-up menu (circled). *Figure 12-40* Then, in the Identity Plate Editor, which will appear after you select Edit, type in the text you want to include. You can select a font, style, and size as well. If you are using a Flash template, your font size will never appear larger than approximately 36 pt regardless of what you set. With HTML, you can select just about any font size you want, although the type may not fit on the page.

Subtitles and Captions

You can add subtitles and captions, based on EXIF metadata or custom text, in the Image Info pane. *Figure 12-41* When selected, both Title and Caption offer various options via the pop-up menu. Choose Edit to bring up the Text Template Editor to further customize the options. (I explained how to use the Text Template Editor in Chapter 10, in the section "Using the Text Template Editor.")

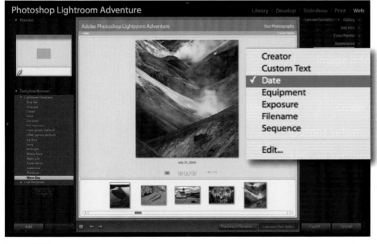

Figure 12-41

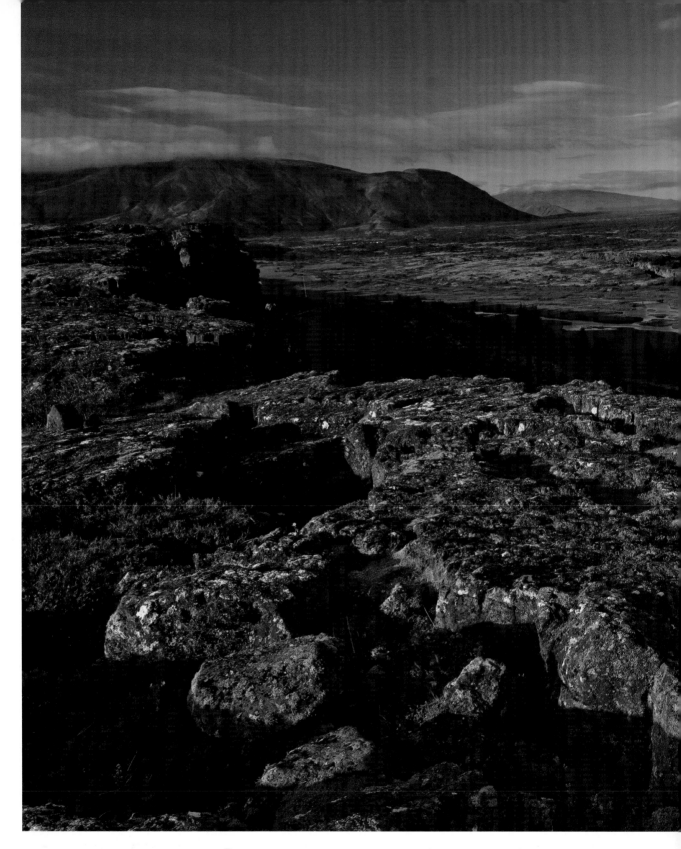

Peter Krogh

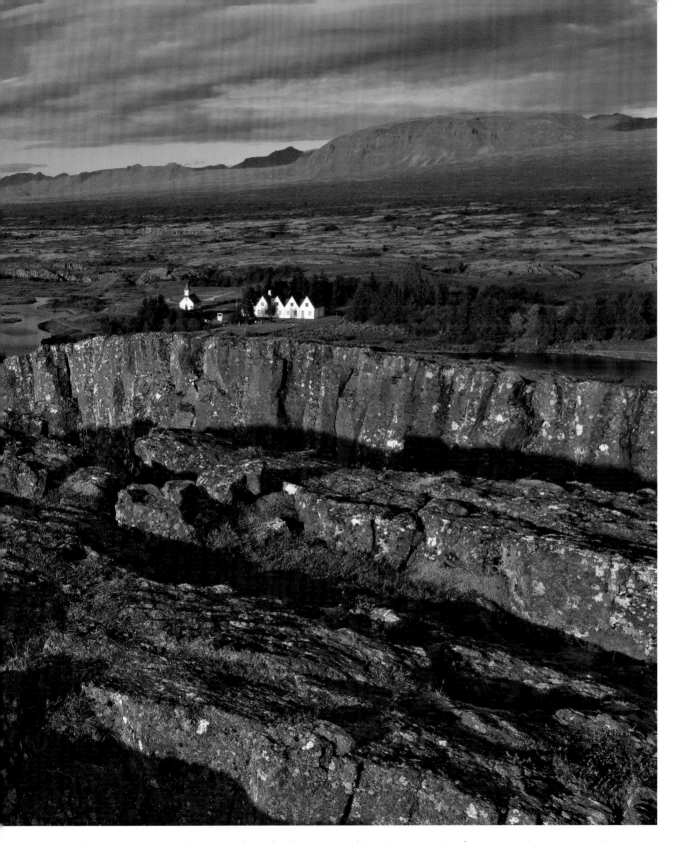

You are looking at the exact location where the European and American tectonic plates are tearing apart, creating new land between. Peter also captured a beautiful view of Pingvellir National Park and the site of the Thingvellir, the old Viking Parliament, one of the world's first cracks at a parliamentary government (way back in the 10th century). I've seen many shots of this area, but I particularly like how Peter included more of the volcanic foreground with just a hint of the amazing Icelandic sky.

Index

About the Author

Mikkel Aaland is an award-winning photographer and author of 10 books, including *Photoshop CS2 RAW* (O'Reilly), *Shooting Digital: Pro Tips for Taking Great Pictures with Your Digital Camera* (Sybex), and *The Sword of Heaven* (Travelers' Tales). Visit his web site at *www.shooting-digital.com*.

Colophon

The cover image is an original photograph by George Jardine. The cover font is Frutiger. The text and heading font is Myriad Pro.

Where innovation, creativity, and technology converge.

There's a revolution in how the world engages ideas and information. As our culture becomes more visual and information-rich, anyone can create and share effective, interactive, and extraordinary visual and aural communications. Through our books, videos, Web sites and newsletters, O'Reilly spreads the knowledge of the creative innovators at the heart of this revolution, helping you to put their knowledge and ideas to work in your projects.

To find out more, visit us at digitalmedia.oreilly.com

O'REILLY®

Capture. Design. Build. Edit. Play.

digitalmedia.oreilly.com

©2007 O'Reilly Media, Inc. O'Reilly logo is a registered trademark of O'Reilly Media, Inc. All other trademarks are the property of their respective owners. 70366